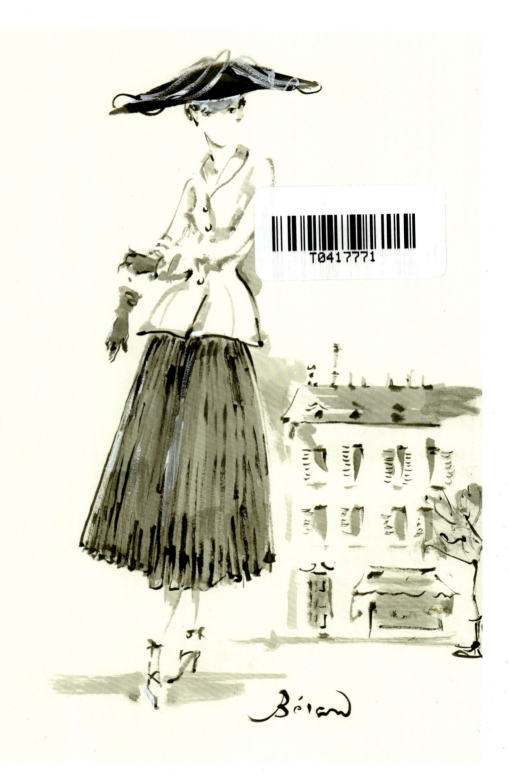

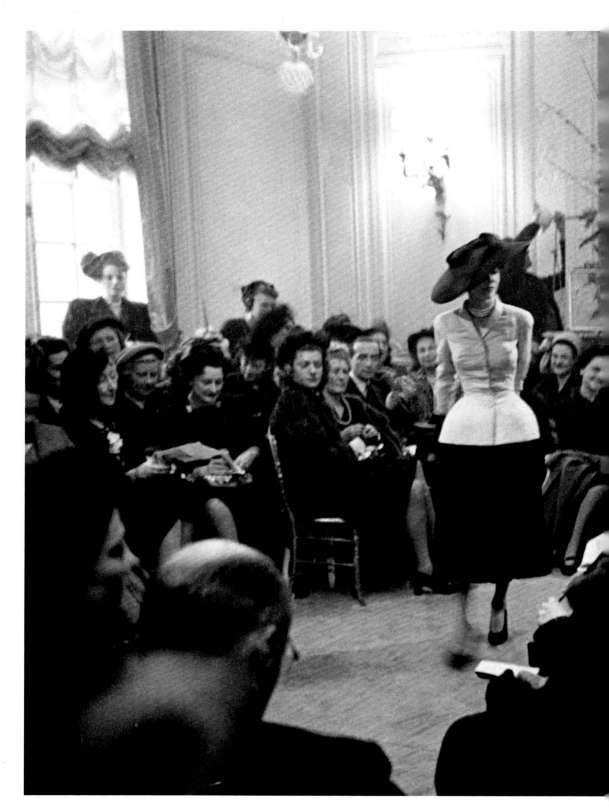

Previous page:
Christian Bérard, *Bar* suit, published in *Vogue* Paris, May–June 1947. Christian Dior, spring-summer 1947 haute couture collection, *Corolle* line. Ink, watercolor, and gouache on paper. Granville, Musée Christian Dior.

Eugene Kammerman, Presentation of the *Bar* suit worn by model Tania at the first Christian Dior fashion show in the salons of 30 Avenue Montaigne, Paris, February 12, 1947. Christian Dior, spring-summer 1947 haute couture collection, *Corolle* line. Front row, back, Christian Bérard opposite Marie Laure de Noailles. On the salon mantelpiece, two pastels by Christian Bérard given to Christian Dior: a portrait of a young woman and the *Hommage à Christian Dior* [Tribute to Christian Dior].

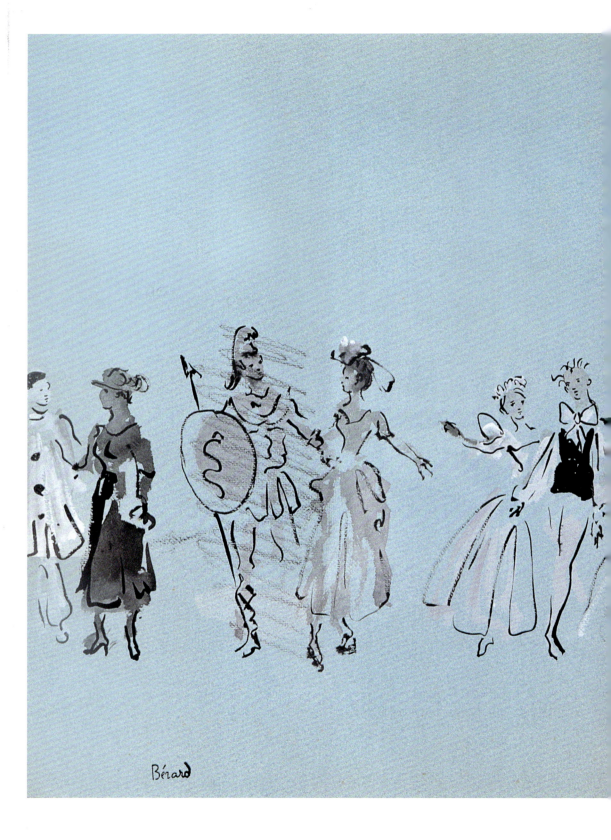

Christian Bérard, *Le Bal masqué* [The masked ball], undated. Watercolor. Private collection.

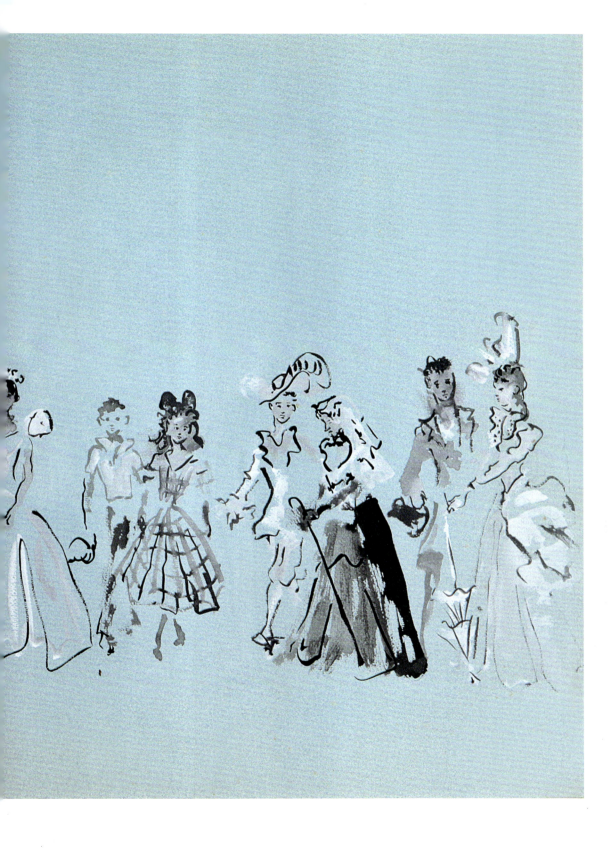

Irving Penn, Christian Dior, 1947. Irving Penn, Christian Bérard, circa 1949.

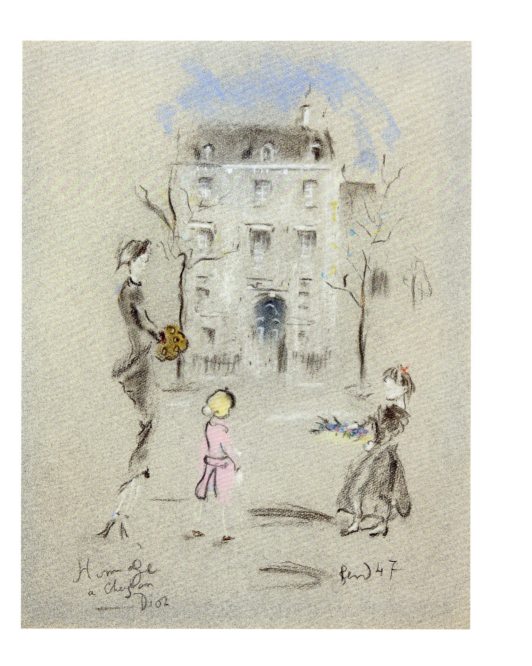

Laurence Benaïm

Christian Dior
Joyful Melancholy
Christian Bérard

Translated
by Kate Deimling

Gallimard

Previous page:
Christian Bérard, *Hommage à Christian Dior*, 1947.
Pastel. Paris, Dior Héritage.
Bérard presented Dior with this drawing of one of his models
in front of 30 Avenue Montaigne on the occasion of his first
fashion show. The work was displayed on the mantelpiece
of one of the presentation salons of the haute couture house.

Foreword

All of Dior is in Bérard; all of Bérard is in Dior. This book is not a two-headed biography; it is a meandering in the heart of a history haunted by dreams, affinities, and secrets sewn in the lining of vanishing time. It tries to grasp this uniquely complex link braided between the couturier of happiness and the "painter of Anxiety."[1] It tells the story of the living in light of the dead, Madeleine and Marthe, the respective mothers of Dior and Bérard, and their painful relationship with their respective fathers, Maurice and André. Galvanized by absences and biographical gaps, I have ventured along the rifts where each constructed himself, alone like an actor facing multiple roles: gallerist and couturier for one of them; painter, costumer, set designer, and illustrator for the other. In Paris, from the era of Le Bœuf sur le Toit to postwar Café Society, Dior and Bérard recognized, influenced, admired, and supported each other. "The day Christian Dior presented his first collection, the other Christian, seated between a duchess and a wealthy Argentine, gave the starting signal for applause. Bébé liked the New Look: it was adopted," wrote Françoise Giroud[2] about this "spare and magnanimous king,"[3] who counted among his friends Christian Dior, the "ignored model maker"[4] who became the emperor of Paris fashion. I do not know if we can take a life apart the way we turn a piece of clothing inside out. Sometimes, it's by listening to silence that voices reach us. The truth never seems so true to me as when I venture through the creases of existence, those that history has ironed into place. The intuitive feeling of pilled fabric, scratches, and irreparable snags on my palm seems to do justice to these two figures who are both real and romantic and who embody the charm and precision of French taste.
L. B.

On the walls, paintings and drawings by the man who was Dior's "discovery," a wealthy young art collector and then a ruined gallery director. Christian Bérard is this friend from dark or prosperous days. Loyalty to an admiring friendship.

André Fraigneau, *En bonne compagnie*, Paris, Le Dilettante, 2009, pp. 60-61.

Introduction

Two syllables to make the single name they shared. "Cri" for Bérard, "Tian" for Dior: those are the nicknames that their respective parents gave them. This close friendship acted as a developer in the chemical sense of the word, like a bath that causes the reaction of silver particles on film. With their encounter in the late 1920s and the crucial influence they had on each other and on their respective careers, we can weave the story of an era through two personalities that were completely different yet completely overlapping.

Christian Dior sought "fashion built on foundations."[5] He was the landscape gardener of a rediscovered dream, that of these postwar silhouettes that appeared like flowers in the garden of renewal. Painter, illustrator, decorator, and tastemaker, Christian Bérard eluded all schools and all styles, as if his palette diffused a light that could not be reduced to a period whose memory his eye captured. A spot of pink like Watteau and now a dress; a bright green glove, and the red hair appears. But the fancy of his watercolors contrasts with the seriousness of his figures with "eyes illuminated by invisible energies" but "beset by obscure forces."[6]

With the founding of his maison de couture in 1946, the name of Dior embodied the spirit of attractive clothing: "Dressing women and [...] making them beautiful"[7] was the promise of the man whose company at 30 Avenue Montaigne looked like something out of a fairy tale. Bérard contributed to the interior design of Dior's first shop. "Underneath seeming disorder, he had created life,"[8] Dior wrote of Bérard, "the arbiter of all festivities and all kinds of elegance."[9]

They both shared a sense of the fantastic. Bérard's world trembled with "flimsy veils that make every woman a little cloud of light in transparent evenings."[10] The couturier Christian Dior redefined "the art of pleasing,"[11] making his maison de couture a Parisian star. While Dior created a world of fairies, Bérard gladly sided with demons, sketching in a nighttime landscape setting the apparition of the Comtesse de Castiglione: "the monster is dressed in a roomy domino that covers the crinoline."[12] Bérard represented a palette

that intuited drama, but also a pure line, and Dior was the architect of the line to the very end. The feathers must not get broken when the collar is stitched. The seamstresses knew how much the life of a dress hung on a thread. They worked, altered, reworked. They knew that, despite the stitches, nothing should look stitched. In the atelier Flou (where the loosely cut, flowing designs were made), a dress had to produce the illusion of coming into being without ever having been touched. "Little" was one of their favorite adjectives: little tops, little threads, a little bit gray, the little iron… everything was little with these pink-fingered women. With Bérard, "the vague murmur of the immense dress"[13] was not part of the secrets of the workshop, but the magic of the theater, where stagehands burn their hands lighting the moon.

The time they spent together counts less than the time they reinvented through so many correspondences and elective affinities. Between them, there is the Wheel of Fortune, the Queen of Coins, the Eight of Cups, the Star, the mystery of the seventeenth-century tarot de Marseille. These are cards that they dealt, sometimes face up, other times face down, to win their game of success. United by their doubts as much as by their sense of the fantastic, they were both crazy about prophetic symbols, these cardboard oracles in which they glimpsed the promises of a day, a life. With them, time gleamed, a true constellation linked by imaginary lines in which we think we see Berenice's hair and the Bird of Paradise, the Lyre and Leo Minor, these familiar spirits that move depending on the direction of the sky. Their life was a ball of manifestations worthy of what their friend Cocteau had stated as his supreme rule: "I tremble, I die, I start again every morning."[14]

Christian Bérard considered Stravinsky's music to be sorcery;[15] he never signed on to modernity. Going against the tide of Cubism, he was first one of the most promising painters of the so-called "neo-humanist" movement of the late 1920s, before letting himself by devoured by a variety of activities, from costumes to theater sets. As for Dior, he was opposed to any kind of school; what he defended was first and foremost the profession of couturier.

"Inside a gold ring, the whole circus came running: clowns, jugglers, horsewomen, trapeze artists hanging onto his hair, populating his River beard. The Sky descends in the blue of his eyes, between his pudgy hands that he raised and waved like bouquets of fireworks, loaded with stars, lighting up."[16] Conversing with illusion, suggesting perspectives, dancing on the crest of dreams — all that seemed to Christian Bérard more necessary than compromising himself in the pretense of an all-too-real existence. "Parisian glory will have too lastingly eclipsed Bérard's secretive and serious genius."[17]

"What I'm looking for is unease."[18] Bérard painted at night, Dior worked during the day, with the ideal of being classified as a good artisan, concerned about defending the skill of his workshops with their golden fingers: "I gave up a whole part of the peaceful life that was dear to me."[19] Women's favor became his "reward."[20] Deemed too classical by some, too elitist by others, and partly erased by historians of modern art, Bérard remains the "smiling dead"[21] mentioned by Elsa Triolet. "He knew how to do this extraordinary thing: relate his dreams, fix their fleeting beauty. Shaggy, red-headed, pink, panting, eyes wide with wonder, flowery dressing gown, ragged pants. Covered in powdered pastel, charcoal, and gouache, grandiose as a man of the forests, with his small, peeled hands bringing out of all that scrub, on any rag of paper, these drawings, these colors, these plans for scenery of miraculous clarity, sharpness and grace."[22]

To stay lighthearted, always. Cri-Tian. A set of echoes from each side of a thicket of truths and lies, doubts and aches long silenced. Excelling in staging himself, Bérard was in that respect entirely different from Dior, who looked like a "friendly country priest made of pink marzipan"[23] and hardly resembled "pin-up boys or decadent Petronius types who are the image of the fashionable couturier,"[24] and who built, in under ten years, not just an empire, but a legend. As for Bérard, he sacrificed his art in the whirlwind of a high-society life that was not entirely his type. "The more his work as a set designer grew, the more renowned, appreciated, applauded, and celebrated he was, the more he missed the silence, the quiet, and

perhaps even the solitude of his workplace, whether it was his bedroom or the cabin in Les Goudes, standing on the seaside in a landscape of jagged rocks, where he liked to set up his easel in the summertime."[25]

Bérard sketched lines of misty mousseline on his notepads. Dior made seduction a shield; Bérard, a reflection. They did not try to astonish so much as to enthrall. Initials CB-CD. Living to dazzle, playing to live, seeking to conquer the public, to enter on stage, to walk straight, "to have feeling in your body,"[26] "to breathe sentences," to feel "filled by a character with the character before you";[27] each in his own way, Dior and Bérard adopted this art of the theater expressed by Louis Jouvet, whom they admired so much. With them, the line became an apparition; they kept their eyes on that "uproar of applause [...], that recognition whose warmth exalts and fulfills,"[28] as described by that master of the stage.

From theaters to haute couture salons, they remained his inspired disciples: "The approval of the public, its applause, are ultimately the only goal of this art that Molière called the 'great art' and which is the art of pleasing."[29] Dior had his army of seamstresses who traced, adjusted, and left no millimeter to chance; Bérard, the Don Quixote of caprice, "eluded the line, suspended beauty in flight, turned his back to the sea of his beaches and ran to seek refuge in rooms of luxury or crime."[30] Dior hid behind his curtain of gray satin. If he came out, it was to indulge "in the marvelous affection"[31] of his friends. Bérard was not only one of them, but the one who would reveal him twice: the first time, through his paintings, and the second, by introducing him to his cousin, who taught Tian to draw and later gave him a place to live when the future couturier had lost everything and did not know what future to aim for. A future he would be unsure of until the very end: the last name written on his calendar was that of his psychic.

I was forming solemn friendships that composed and will compose until my last day the serious foundation of my life.

Christian Dior

Granville-Passy

From the top of their cliff, the Diors were among the well-known families that made Granville "the Monaco of the North," a seaside resort that was proud of its tourist office, its Normandy Hotel, and its tossed flowers and confetti during Carnival. "Charming villas framed with greenery carpet the sides of our hills, and are the fortified castles of merchants and shipbuilders, the true rulers of our era," local guidebooks related. Born on January 21, 1905, in the Villa Anna, a neo-Renaissance manor house, Christian grew up in a house of pink roughcast decorated with white trim. The house was originally called "Les Falaises" ("The cliffs") and was then named "Les Rhumbs" after a term for the angles of a ship's compass, which was also known as a "wind rose." Madeleine and Maurice Dior bought it from the bankrupt shipbuilder. At Les Rhumbs, two bay windows on each side decorated the second floor with its balcony of chiseled ironwork. The children's rooms featured windows with pagoda-style red lintels. Above, the glazed slate roof was ornamented with a metal frieze. Old rosebushes danced above the sea when storms blew in. The Chausey Islands were swimming in the mist like lobsters in cream. Christian Dior spent his first five years there, but why on earth was he not baptized at Saint Paul's Church until age three? Was Madeleine still hoping for a daughter till the very end? While the owners of the Anglo-Normand villas suffered the full brunt of the commercial fishing crisis, Tian's childhood was a kingdom safe from all dangers, especially the curse of tuberculosis, which made everyone fear contagion and dirty laundry.

Christian Dior's parents purchased a second house on the side of the cliff: Villa Le Lude, reserved for guests. A bit farther, at the edge of the property, behind the bamboo plants, was a third location, like a refuge between sky and sea, standing on the rocky spur. It looked like a shoebox with large windows cut out of its cardboard sides. It was not a greenhouse or a cabin. Was this the original model for this "office of dreams"[32] that Dior would recreate on Avenue Montaigne? Everything — from the balcony shaped like a stone alcove to the pool of water designed by young Dior himself in the arbor (which he would

reproduce homothetically in front of the château of La Colle Noire) — made Les Rhumbs an architectural ideal. Above the northern beach, the house hid under its skirt of hydrangeas and roses. The noises from the town were those of a silent film.

Granville also had flower festivals and regattas of the fishing boats called "bisquines," with the small cannon of the Maison du Guet sounding the departure. In season, there were children's dances on Sunday and Thursday afternoons. Operas, operettas, vaudeville shows — this part of Normandy cheerfully showed off for the drizzly, cranky town of Cabourg. Carefree Granville was a resort town that was so sunny that the ladies had to hide in their ultramarine-striped tents. The flowered coast versus the coast of the ports. Here, the pennants floated in the wind like ribbons on straw hats.

In the upper-middle-class families, the food was "flawless," the girls enjoyed "dancing the Boston two-step," and the children were "charming." Tian wore a white suit and went for walks with his friend Serge Heftler-Louiche. He didn't smile, but posed on the rocks for a photo. Here he is bundled up in a navy wool coat with gold buttons, under the watchful eye of his German nanny. The family rented a changing room by the year. The twill bathing costumes were decorated with white braids. This seaside display wouldn't be anything without the toy giveaways, the little horses, the tossing of flowers. Within a single day, there were several climates stirred up by the sky between brief showers and clearings, light breezes, and surprise gusts. Later, Christian Dior would draw on this for his clothing lines every season, recalling his hometown, where rain is the color of hope, and the splendid appearance of the sun represented His Majesty the Carnival. In Granville, even the neighbors seemed like characters from a little street performance. Wasn't the owner of the oldest Anglo-Norman villa named the Vicomte de la Potiche?

How could Christian Dior's childhood have been anything but protected? Villa Les Rhumbs did not face the open sea, but huddled behind a hedge of umbrella pines; it looked pregnant, for the greenhouse that Madeleine Dior had had built swelled the façade with a half-bubble of glass: "Since my mother loved green plants, without

the least concern for harmony, we stuck a bump onto the façade, the winter garden with Art Nouveau ironwork."[33] The inside of Les Rhumbs was organized as a series of illusions: the Louis XV salon, the small Empire salon, the Henri II dining room, the Japanese-style entrance with its prints decorating the staircase up to the ceiling to create "kinds of pagoda roofs also made of bamboo and straw,"[34] of which the couturier would later say: "These interpretations of Utamaro and Hokusai were my Sistine Chapel."[35] Was this unforgettable bamboo reincarnated forty years later as Kentia palms in the salons of his couture house at 30 Avenue Montaigne?

Enjoying "the company of plants,"[36] Christian Dior grew in the heart of this enchanted world of the Belle Époque, already nostalgic for its own greatness. "For nine months, Granville was a peaceful little port, and for three months in the summer, an elegant neighborhood of Paris,"[37] he later wrote. The porcelain candy dishes and Sunday beef stew accompanied a provincial existence that the couturier would never stop embellishing. Marked by the image "of a happy, peaceful time, adorned with feathers, where everything was made only for the joy of living,"[38] he would always define his ideal as what reassured and protected. But what, in fact, was he protecting himself from? The rock slides from the cliffs that would one day destroy "the cabin," which was replaced by the casino in 1911? The uneven topography and windy climate? The jealousy of Raymond, who was six years old when little Tian was born and saw his kingdom collapse? The funny appearance of little Bernard, the youngest, with his round little face? Maurice's annoyance with his mother-in-law, Madame Martin? Or local jealousies, perhaps?

Five sons, two cousins — including Maurice, Christian's father — strengthened the family business, phosphate mines in the departments of the Meuse and the Ardennes. "The Diorists have always deceived, exploited, and pressured the people, whom they care nothing about. Don't vote for the candidate of the aristocracy and the clergy. Vote for Fontaine." Dior, Fils & Compagnie was both admired and repudiated. But the festivities persisted, eclipsing winds and sorrows. "A torchlit procession marched through the main streets of the city to the irresistible momentum of the brilliant music

of the second-line infantry."[39] Happiness would last only two-and-a-half more years. From the Rue des Juifs to the plateau of Le Calvaire, from the Rue du Pont to the Cours Jonville, the *cité corsaire* lit up as floats passed by with gentle names like Madame Chrysanthème or Éclipse du Soleil. "The twilight stretched out, night was falling, and I lingered, forgetting my books, my brothers, looking at the women do their needlework around the oil lamp."[40]

Tian dreamed; Bérard looked at the sky. Tian had the passion of what he planted in this land swept by the southwester and, like his mother, he scoured the catalogues of the Vilmorin-Andrieux seed merchants, true botanical almanacs where perennial artichokes, magenta spreen, strawberry plants, and other flowering bulbs stood like guests at a horticultural ball announced on the cusp of spring by the primroses and forget-me-nots, cheerful as bridal bouquets. Herbaceous or woody stems, petiolar or oval leaves, tuberous bulges — every plant was a presence inside this *plein air* reception room, "the enclosed garden that protected [my] childhood."[41] Very young, Tian sifted through advice about seeds and planting, and learned the names of the roses by heart. His mother imparted to him this love of gardens, a defiance of death that lurked below in the wind-whipped cemetery. In their beloved Normandy, the Diors struggled against the sun, the wind, the rocks, and the fear of typhoid fever, which was suspected to be transmitted by oyster farms.

These family fears created a gulf, eliminating the possibility of encountering others. At low tide, they said the mollusks hid from the sun. In life, that was how conventional people avoided those who could be predators or bad influences. So it was better to stay up high. They only came down for the festivities. And the holes remained; the worms created mounds that made them even more visible. Yes, true friendships are preceded by their ghosts.

Christian Bérard, if he had been there, would surely have mingled with the kids on the pebble beach at Hérel, called the "southern" beach, where children in wooden shoes slid along the tracks of tallow left by fishermen and turned over the cod so it would dry. He would have been at home in this world where the Dior family hardly

ventured: the low town and its "talard," the huge hill of oyster shells stretching all along the port. In the Bérard family, he was the only child, born on August 20, 1902, and he provided a perfectly whimsical presence. If he always laughed a bit too loudly, perhaps it was to make people look elsewhere. Just by prancing about, he learned to become a circus character. His way of charming others was to attract them so that he could sketch them better, and he had already developed his favorite role: "Sometimes the child lost in Snow White's forest, sometimes the ogre."[42]

He was a pure child of Paris, in his flannel shorts with his nanny in her white apron. His favorite entertainment was the Cirque Médrano. There was Umberto, called "Antonet," the master clown, with a white face and a scarlet dot on his nose. He started off playing the clumsy clown, paired with his brother Cesare, who was called "Bébé." The audience applauded all these agile performers, the farce of four at the cross, acrobats on horseback, and others, blockheads and blunderers, who were even more impressive. Look at Aristodemo Frediani, alias "Béby." After numerous falls, this former acrobat, his body deformed by having two performers stand on his shoulders, became a clown. He put lipstick on his temples, walked barefoot in his big green shoes, and his wig was a rabbit pelt turned inside out. One day, he played a haunted house; another, a broken mirror. This clown was one of the Parisian attractions. What could be a more wonderful gift for little Cri, raised in a family with a funereal brand that not only made a living but prospered from death?

Marthe, his mother, was the granddaughter of Comte Henri de Borniol, a pioneer of tailor-made funeral services who owned the oldest French funeral home. From a dynasty of master glassmakers in Nevers, the count had made his name through that of the deceased. He had conquered his place in Paris by making good marriages for his seven daughters. When they hosted a ball, the family opened all the doors wide and dancing processions wove through the rooms, whose walls were papered with illuminated photographs: "View from first class," "fourth-class hearse," "decoration of a bier," "hearse for abroad." Borniol had gotten rich on death.

Two children in the Belle Époque

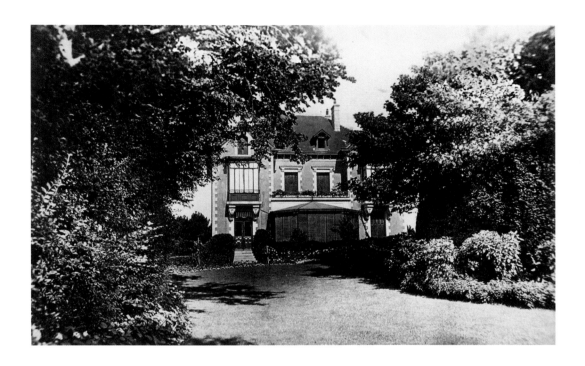

Marcel Vasseur, Villa Les Rhumbs, Granville, circa 1925.

Anonymous, The Dior family (Madeleine, Christian, Raymond, Bernard, Jacqueline, Maurice), circa 1915.

Marcel Vasseur, View of Granville Bay from Les Falaises garden of Villa Les Rhumbs, circa 1925.

Christian Bérard, *Deux visages d'enfants sur fond d'île* [Two children's faces on an island background], 1941. India ink wash, watercolor, and gouache on paper. Private collection.

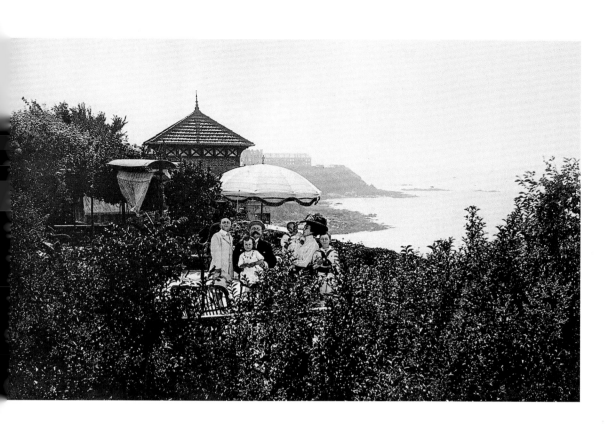

Anonymous, The Dior family on the terrace of Villa Les Rhumbs, Granville, circa 1912.

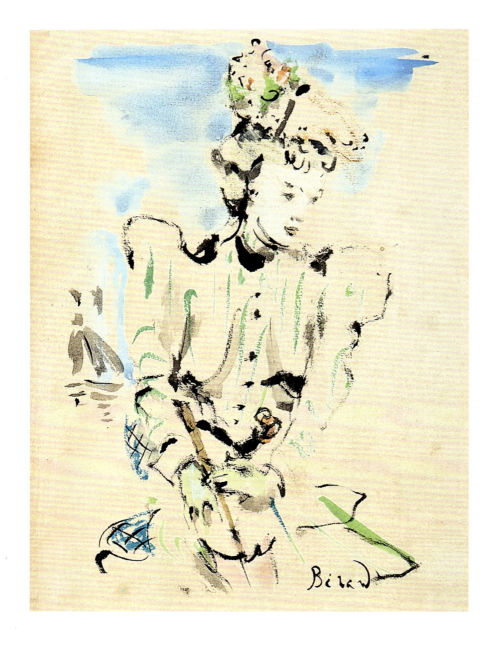

Christian Bérard, *Élégante* [Stylish woman], undated. Watercolor. Private collection.

Anonymous, Marthe Bérard, undated.
Richard Haines Collection.

Anonymous, Madeleine Dior, circa 1904.

Anonymous, Christian Dior (fourth child from left) in disguise among his classmates, 1910.

Christian Bérard, *Les Saltimbanques* [The acrobats], 1946. Oil on canvas. Private collection.

Anonymous, Christian Dior and Serge Heftler-Louiche
at the Carnival, Granville, circa 1907. Colorized photograph.

Christian Dior, Costume sketch of the character of Madeleine
Célestin for the film *Silence is golden*, by René Clair, 1946.
Ink and gouache on paper. Paris, Dior Héritage.

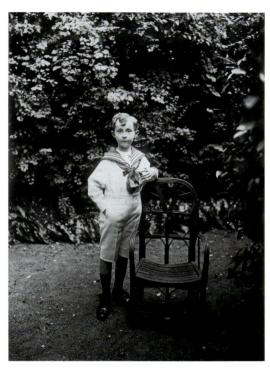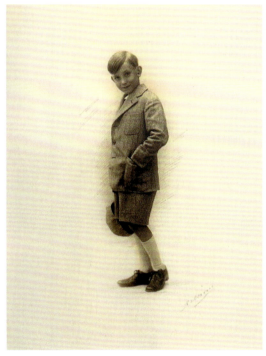

Anonymous, Christian Dior, circa 1915. René Boivin, Christian Bérard, circa 1908.

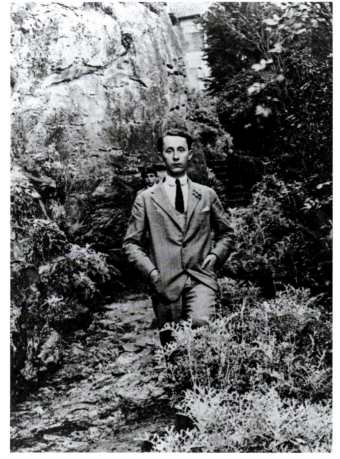

Anonymous, Christian Dior in Les Falaises garden of Villa Les Rhumbs, Granville, circa 1920.

Christian Bérard, *Portrait de jeune homme* [Portrait of a young man], undated. Watercolor. Private collection.

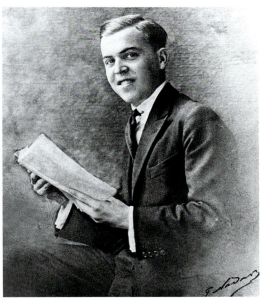

Nadar, Christian Bérard, circa 1920.

Christian Bérard, *Portrait de jeune homme sur fond bleu* [Portrait of a young man on a blue background], undated. Ink on paper. Private collection.

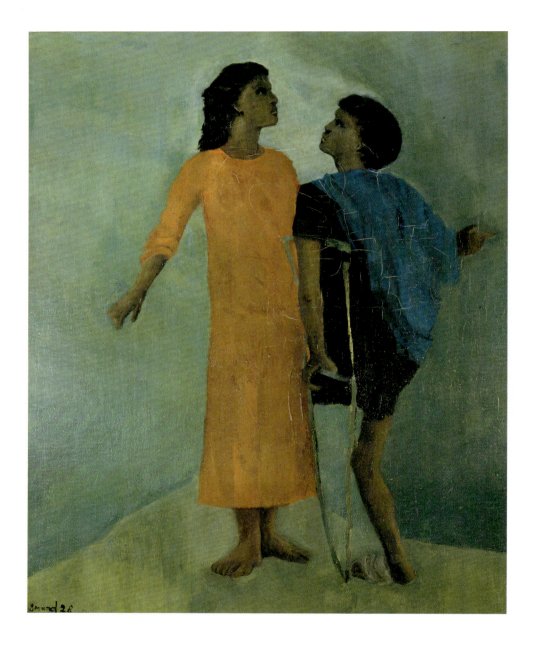

Christian Bérard, *La Rencontre*, or *Le Béquillard*
[The meeting, or The crutch walker], 1928.
Oil on canvas. St. Louis, Saint Louis Art Museum,
gift of Mr. and Mrs. Joseph Pulitzer, Jr.

Evaluating "a mortuary scene of the first order" with Sarah Bernhardt in the title role, the critic of the *Journal amusant* once concluded: "Borniol wouldn't have done any better."

Cri had always been fascinated by acrobats and magicians; his own family history contained enough characters to inspire him. The press had widely mocked the deformed spines of his uncles, the two sons of his maternal grandfather: "Due to their physique, they could not continue in business, for, to lead a funeral ceremony, one must be tall and self-interested. They remained self-interested." In June 1912, one of the hunchbacks was even the victim of a serious accident. With a triple fracture of his left leg and a double fracture of his skull, he was found dying on a railroad between Paris and Caen – where he was to vacation all summer with his brother, the owner of the Grand Hôtel. He was thought to have been attacked, and two peddlers were suspected. But Maurice de Borniol had just rolled out after unexpectedly opening the door of the train car. Did this inert body, this limp figure in the middle of nowhere, hatch a vocation? For Christian Bérard, drawing would be his salvation. "For everything was a battle in him, but everything seemed to be self-evident."[43]

Bérard's imagination found its source in the village of Passy. He was a pure Parisian, who had been sketching the people in his city since his earliest childhood. The pencil was his first companion; drawing was like breathing for him. For Bérard, the first kind of writing was recording sensation, extended by the gesture: as Degas affirmed, "it's quite well to draw what you see. It's much better to draw what you see only in your memory." But no one is born a virtuoso. For a long time, Bérard worked, erased, redid his perspectives, one by one. At the Académie Ranson, his teacher was Maurice Denis, the painter of *Paysage aux arbres verts*, also titled *Les Hêtres de Kerduel*. This Granville native gave him the keys to illusion. "Remember that a painting, before being a war horse, a nude woman, or some anecdote, is essentially a flat surface covered with colors assembled in a certain order."[44] As for Dior, he was so attached to his garden that he never imagined he would have to leave it.

Faces of absence

"Uprooted."[45] The adjective used by Dior four decades later expressed the violence of a shock. In 1911, the Dior family left Villa Les Rhumbs. From then on, they would spend only three months' vacation a year there. The Dior company headquarters was moved to Paris. The family moved to Rue Louis-David, in the sixteenth arrondissement, which still kept the memory of its villages, as Auteuil, Passy, and Chaillot had only become part of the city under Napoléon III. Even though the wall of the Fermiers Généraux had been demolished, a world separated this residential enclave from the City of Light. For many children, the memory of this trip between two worlds was linked to the Passy-Bourse bus, with the whip cracking above their heads on the upper deck: "I had the wonderful impression of leaving on a great journey."[46] For this provincial family that was already in mourning, Paris presented a hostile appearance: the damp city had been devastated a year earlier by flooding and cold. The clown of the Seine had drowned. And the Dior family preferred to keep to itself. "Enough lawyers in the Chamber – we want experienced businesspeople to manage our affairs," blustered the thundering voice of Lucien Dior – the cousin of Maurice, Christian's father – who was a candidate for the legislature on April 24, 1910.

The Bérard family resided in a mansion on the Rue Spontini, steps away from the Bois de Boulogne: Villa Spontini. That was where the couturier Jacques Doucet lived and collected, annexing neighboring apartments to set up his art and archeology library with its thirty reading rooms. The Bérard family lived in a house of shadows filled with lamps dressed in satin pleats, chandeliers with electric candles, and porcelain tea sets.

In Granville, the husbands paid, and the women spent. Even in bad weather, the seaside city was entertaining. There were games, like the rabbit game and the goat kid game, and the *Egmont* overture was played by the second infantry regiment. In the grandstand, Christian Dior's father, a town council member, attended the festivities on Bastille Day. The Bérards also had a house in Normandy, but no tourist trains stopped there. Around them, the land had absorbed

men for a long time. The village of Laize-la-Ville was so flat that it seemed to drown in the river of the tanners. A stone vase and flame decorated the top of the old canonry. There was damp half-timbering everywhere, and the water from the river made the barns moldy. The summer activity with his cousins was to go fly fishing for trout. Aunt Suzanne wasn't much fun; her husband was the mayor of the village.

Tian, the "quiet little student"[47] of the Gerson Catholic school, and Cri – whose entire education took place at the public high school Janson-de-Sailly – recognized each other before they met. "I hardly ever got extra homework or detention despite the annoyance caused to some teachers by my mania for covering my school books with the constantly repeating curves of a women's leg in high heels,"[48] Christian Dior would recall.

The secret is to get behind the lines, to find beauty on the other side of death and mud. The advertisements bragged "L'engrais Dior, c'est de l'or" – "Dior fertilizer is gold." They were all over burlap sacks, detergent packets, caddies for bottles of bleach, toys, and blotting paper. In the lower part of town, the washerwomen accused the Dior clan of dirtying their wash. Crossing the Coutançais and the Avranchin, the Boscq is polluted. It was the patriarch, Louis-Jean Dior (1812-1874), a farmer in Savigny-le-Vieux, who became a phenomenal merchant. He succeeded in importing guano from Chile and Peru, fertilizer to which he would add "Dior black," obtained from carbonized and fermented bones. At Dior, "black 98" was always one of their top sellers. In the Borniol family, black decorated illustrious coffins. "It looks like Borniol!" theater audiences would say if the set was too gloomy. "It stinks of Dior!" Some residents would grumble, because of the fertilizer. Dior-Bérard. All they had to do was to dress the bare frame of life in their scattered dreams. To be reborn, by drawing, by writing, so that they could divide themselves, and multiply infinitely. Their story would be the unpremeditated encounter of nostalgia and imagination.

Near his "exquisite mother"[49] Christian Dior continued to live within an Eden where figures from Perrault's fairy tales moved about. "Of the women of my childhood, what remains above all is the memory

of their perfume, persistent fragrances – much more so than those of today – which scented the elevators long after they had left."[50]

Under her hat of dark feathers, Madeleine Dior watched over her children's education. During vacations, she could be spotted at the shows at the Hôtel des Bains in Granville or the horse races in Donville. She was too old for riding jackets; her dresses, as austere as her face, veiled her body in a strange mist. What was she hiding under that severe appearance? How many stillborn children, how many family secrets contributed to isolating her in the dark cabinet of melancholy? Christian Dior liked to dress up as a marquis. Buttoned up into an embroidered Louis XV suit, his brother Raymond wore a wig, and his little sister Ginette, called "Catherine," smiled at him in a dress with panniers skimming immaculate ankle boots. Everyone swore that "the German eagle will be conquered, along with tuberculosis."

In August 1914, mobilization took them by surprise during vacation. And the Fräulein, the German nanny who "at first refused to leave"[51] nevertheless told the stupefied family that she was ready, if necessary, to go "bang-bang at French soldiers."[52] Like everyone else, they believed a "cataclysm impossible."[53] Christian's childhood friend, little Serge Heftler-Louiche, spent his vacation at Villa Les Tourelles, just below Villa Les Rhumbs. During the town carnival, the two boys had shared the same flowered floats. In 1914, happiness was shattered. Although he was exempted from military service because of his position as public prosecutor, Emile Heftler, Serge's father, had volunteered to fight. He died at the very beginning of the conflict, leaving behind two orphans. Serge would be raised by his grandparents, whose name he also took.

At first, this war, which was just a "little war"[54] for Christian Dior and his friends, was accompanied by "great freedom,"[55] "fanciful studies under the supervision of teachers who were also pretty fanciful."[56] He started secretly reading *Fantômas* and *Arsène Lupin*. His parents hired a new nanny, Madame Marthe Lefebvre, whom the children would soon call "Ma." She would never leave the family. Maurice, his father, was absorbed by everything that the Dior company was committed to producing: sulfuric acids for the production

of the explosive charges of shells, electricity for the train station. Christian's mother was away now, busy making shredded cloth for wounded soldiers. As a volunteer in a military hospital, she traded her three-cornered mollusk-fishing hat for a white nurse's veil.

Marthe, the other Christian's mother, had never been so close to him. Living in Étretat, she once wrote in a love letter to her future husband, André Bérard, "your shy fiancée allows herself to extend the little hand that will one day belong to you,"[57] and now she seemed to have discovered her son because of the war. Cri and his mother shared the suffering caused by his father's absence. He listened to her reading and rereading aloud his letters scribbled from the front: "Tonight the moon is full and I imagined an undesirable visit from the Krauts and their bombs, but the weather suddenly became cloudy and we're sleeping peacefully."[58] As a soldier in squadron C 56, André Bérard spent his time observing the sky. Christian's father complained about loneliness and the lack of paper. So, again, he wrote perpendicularly, the words crossing over each other, forming an indecipherable spider web of ink. "I am so far from everything that I can't imagine being able to lead a different life. I have sort of come to terms with it, but, in truth, I don't see peace near."[59] He rarely mentioned Cri. "I see that our boy is getting by and isn't repeating a grade. Next year it will get more interesting."[60]

Cri, an unstable, worried child, grew in the middle of a void, like a reproach. This weather that was "admirable, hardly foamed by the explosions of shells on planes"[61] would become the chromatic framework of his future artwork. A gray that was gaping, disaffected, failed. Its wan light thickened the sky in a "perfect harmony of ocher and gray, sand and pearl-gray, silica and oyster concretion, which, artistically, on a purely sensory and abstract level, expressed and extended a dream tinted with the nightmare that it represented."[62] The lozenges, canned cherries, cigarette papers, and wool balaclava that André Bérard asked his wife for transformed into a palette of hopes:[63] "Here death is such a normal thing, we hear it talked about so often, that I am prepared to get sad news."[64] Bérard's father evoked the horizon "foamed by explosions," the "mournful, infinite

plain" around "a little wood of shrunken pines" where they washed in the morning "in the icy water."[65]

Isolation seemed to fire André Bérard's senses: a "Yankee" orchestra that came to entertain the troops enchanted him. The *Havanaise* by Saint-Saëns had been inspired by the crackling of the wood in his hotel room in Brest, and it was a bit of sun that shone into a man's bruised heart. The military orchestra had only to play a Brahms dance for the ugliness to dissipate: "I think of the French shows at the front where the women are provocative, made-up, [...] where the music is vulgar."[66] Christian Bérard would make these visions his own, holding close these letters that weren't addressed to him, but which he would tap into for the essence of himself: "Don't worry, expel from your imagination all dark or sad ideas, see only the beautiful nature around you that cares nothing for the madness of men."[67]

Maurice, Dior's father, did not have this disposition of wonder. Sporting a virile mustache, impeccably dressed in his dark suit and wing-collar shirt, he was physically present to his son, but a wall separated them. An agricultural engineer promoted to co-director of Dior, Frères et Fils at age twenty-four, he left the care of the garden to his wife. How many tons of soil poured into the villa's garden, how many dreams shared by Tian and his mother, who was so extravagant when it came to planting! In the fall, they imagined the springtime, dividing the perennials, seeding, transplanting, burying bulbs in the still-warm soil, and mulching. In the spring, they dug, turning over the soil in the early morning to plant lupine, lavatera, and pansies. So many shapes, bells, stars, or corollas, so many wonderful names, bellflower or Venus's mirror, so many gentle colors, the white and mauve of the lilacs, the white corymbs of the wild hawthorn, the anise-flavored yellow of the euphorbia, the French blue hydrangeas, the rosebushes with their queenly bearing!

It would be an understatement to say that young Christian constructed himself in complete opposition to his paternal figure, the town councilor attached to order, education, athletics, music, and propriety. "As for my father's office, it filled me with a sacred

horror. It held a decorative Renaissance border of pewter with halberdiers who seemed especially dreadful to me [...]. Engravings of musketeers based on Roybet, thunderous and mustachioed, finished unsettling me."[68] As is easy to imagine, Tian was much more attracted by his mother's elegant flowerbeds than by the industrial deposits of his father, a distant, severe, and dreaded figure. In his office, Monsieur Dior had hidden the Bakelite telephone inside the box of a large wooden clock. With one foot on land, the other in the water, Dior spoke familiarly to Orion, Ursa Major, and Cassiopeia, the stars that always protected him. In Granville, sailors and freemasons who were part of a literary society once met in olden days to applaud artists: "Live free or die" was their motto.

The noose was tightening around the Dior family. A shadow on the family scene, Raymond Dior, Christian's older brother, was no longer the child who would dress up as a prince or a little girl. The game room had a "dark cabinet"[69] where he liked to venture. He was boiling inside with hatred of "Fritz," "the Krauts," "the "Jerries." Raised within those "magic bars that were the family, human respect, shyness, friendship, the idea of class,"[70] he wanted to free himself from the family yoke. In this world where they covered their ears as soon as Stravinsky was mentioned, he would be the first to pull off the mask of conventions and choose another, one that was more warlike. On December 20, 1917, he was only twenty years old when he decided to get the jump on the draft by volunteering as a private at the town hall of the sixteenth arrondissement. On leave in Granville, he wore his "bluish iron-gray" greatcoat, the famous horizon blue of soldiers before the sea of mud and blood. Assigned to the 90th heavy artillery regiment of Villers-Cotterêts, he was plunged into raw horror: the region was inundated with mustard gas. Six months later, he was the sole survivor of his platoon when it was wiped out by an enemy shell.

As for Christian, he already knew he was confined in his paradise: "Verdun was hell, but behind the lines we listened to the rhythms of the two-step, and then the one-step and the foxtrot. All this was just for show, and, ultimately, a kind of courage for enduring

the hardest test that men and women ever had to suffer."[71] This awareness was so painful that he would never mention Raymond, preferring to leave him out, as if these two worlds were irreconcilable, isolated from each other by the gaping hole of terror. The only brother he would identify himself with would be Christian Dior himself, his guardian alter ego, "a brother whom reputation earned for me and who does not resemble me."[72]

A time for discovery

Dior adjusted his presence as if he were turning up the collar of his jacket on a chilly morning. From then on, he had to keep a low profile. Like the robust rescuers who rowed furiously on the Channel to keep their dinghies in place, Christian Dior was trying not to make any waves. "Officially, I was studying for my baccalaureate exam on the Tannenberg course, but I had already joined up with friends who loved music, literature, painting, all the 'expressions of the new art.'"[73] For him, what was important was "rushing around so I wouldn't miss an opening or a party, enjoying this unique privilege of being full of youthful folly, just like the century. An age for dancing at all hours no matter what, of all-nighters and Negro music, of waking up without a wrinkle, of hangovers without nausea, of carefree love affairs, of serious friendships, and, above all, of 'availability.'"[74] In addition to the loving friendship that seemed to link him to Jacques Bonjean — who was about to start an art gallery in an apartment with his literary associate Maurice Sachs — there was also a fascination with Paris. The discovery of the capital, particularly of the Left Bank, was a source of wonder that he wanted to keep under wraps. The tiny bungalow of Jeanne Bucher, the "severe and charming priestess of the Naïfs and the Cubists,"[75] German Expressionist films, the Ballets Russes, the singing recitals of Raquel Meller, who bombarded the room with violets — all this produced a stunning display for the young man that would change his life. "My parents despaired at having a son who was so incapable of concerning himself with anything serious. They were wrong: in this

colorful atmosphere, not only was I developing my taste, but I was forming solemn friendships that composed and will compose until my last day the serious foundation of my life."[76]

Christian Dior learned very young not to frighten his mother, not to disturb her when she stayed in her room on her bad days, when Villa Les Rhumbs would be plunged into silence like the grave. He saw her once more among these women in dresses and ankle boots, with the sound of the copper horn that recalled the heedless; from afar, they seemed to tremble. Was it just the wind? Like a good son, he listened thoughtfully to the speech of Lucien Dior, who had become Minister of Commerce in 1921, and who inaugurated the monument to the dead on the Cours Jonville with great ceremony: "We will make permanent, in stone and bronze, the memory of our victory and of those who purchased it with their suffering and their blood."

This painful experience of troubled times marked Bérard's youth. His early years were shattered in a personal confrontation with World War I. He knew of the total unpreparedness of the soldiers in the trenches, as their commanders threw them into a deadly offensive with crushing losses beginning in 1915: "It's shameful; horrible; it's impossible to imagine such carnage. We'll never be able to get out of this hell. The dead cover the landscape. Krauts and Frenchmen are piled on top of each other in the mud [...]. We attacked twice [and] gained a little terrain – which was completely drenched in blood. [...] Well, I must not despair – I may be wounded. As for death, if it comes, it will be a relief."[77]

Christian Dior's much gentler youth continued in an Eden carpeted with flowers; waiting in the wings of the capital as it reeled from the aesthetic shock of *Parade*,[78] he glimpsed the signs of a coming break with the old world, although he did not experience it yet. The world of his parents, his family, and all these good pious souls who were convinced that at the opening of *Parade*, the devil was in the Théâtre du Châtelet. As if to escape from this all-too-determined destiny, Christian Dior invented the character of an Englishman on holiday with a deceptively skinny appearance,

narrow shoulders, and a wide forehead who wore lavender water cologne. His seersucker suits and his straw hat protected him without smothering him. In the western part of the garden in Granville, where he put in an arbor and a blue pond, the plants exhaled their scents of honeysuckle, reseda, and rose. An account by James de Coquet, a journalist for *Le Figaro*, who was invited for tea by Madeleine Dior, offers a view of this open-air greenhouse: "It was a delightful garden made of cardinal sage and heliotrope. With this flora as the cottage garden, they made flowerbeds in the style of Le Nôtre, whose paths were lost along the white fringes of the sea. The property [...] overlooked the Channel, just on the edge of Granville, and what made this garden so excellent was that it was part of this marine landscape,"[79] the chronicler recalled. He continued: "The misty clouds of the sky of Normandy replaced the grove and arbors and composed, on a permanent structure, a set that changed according to the wind. I complimented the mistress of the house on this success and told her that her gardener had the makings of a landscape architect. To this, Madeleine Dior replied: "My gardener is my son Christian! He is at Sciences-Po but he adores flowers."[80]

Dior cultivated this love of flowers like Proust in *Le Côté de Guermantes*, treating them as individuals, the way much later he would consider his dresses: "And I will tell your Highness that Swann always told me a great deal about botany and showed me extraordinary marriages of flowers, which are much more amusing than marriages of people, plus there is no lunch or religion involved."[81] In the encounter between the Baron de Charlus and the narrator, Proust was the first to highlight the connection between the botanical sciences and homosexuality, the orchid becoming in his writing the fetish flower of Sodom. Proust was not featured in the family library, but nevertheless this young Granville resident found in nature a silent accomplice, and this garden, by the happiness it provided him each day, erased the troubles of his own difference, which was unacceptable to his family. "I felt in his voice a tinge of disapproval,"[82] James de Coquet related. "Basically, flowers are a rather frivolous passion for a young man around twenty years of age whose

46

father is a producer of chemical fertilizer going back three generations and whose uncle is an under-secretary of state. Another sign of frivolity: I learned that it was Christian who designed and constructed costumes for his brothers, sisters, and cousins when needed for costume balls at the casino. Let's be frank: this is not how one prepares to become prefect of the department of the Deux-Sèvres and certainly not an ambassador [...]. At teatime, I met this lover of gardens and trinkets. [...] I discovered a young man of an exquisite sensibility, but who was not at all impulsive but perfectly analyzed his emotions and preferences."[83]

Living meant renouncing boredom by inventing a different life, transforming a rocky promontory into a southern Eden, following in the footsteps of Florence Trevelyan and her Victorian follies, her Kentia palms and Chamaedorea palms coiling lasciviously above the Mediterranean. Living meant seeing the perennials thrive in the shadow of the plump hydrangeas. On sunny days, didn't the garden of Les Rhumbs look like a Sicilian version of Normandy, like the Isola Bella of the British philanthropist with such a green thumb, who also found in nature and its enchantments a way of staving off loneliness?

Dior was hungry for flowers, just as Bérard was hungry for Paris. The Borniol heir wanted to see everything, know everything – words and images flowed in his veins like sap in the vessels of the trees. Two years of military service in the 151st infantry regiment in Mainz, then in Koblenz, would deprive him of his terrestrial food. His father, who subscribed him to the *Nouvelles littéraires*, became his long-distance personal secretary. Christian asked him for "Cadum soap, Eau de Cologne, *Dostoevsky* by André Gide, the *Nouvelle Revue française*, the memoirs of R. de Montesquiou (not Montesquieu), a new novel by Cocteau that had recently been published, not *Le Grand Écart* which I own, *La Revue musicale* of December, the special issue on Stravinsky, and then, my dear Papa, a little pack of butter if possible, *Les Liaisons dangereuses*, *Les Caves du Vatican*."[84]

In the midst of so much loneliness, the words of Gide, whose calling card read "on a journey," represented liberation for an entire generation: "Thus sometimes, in the very heart of disgrace, suddenly,

47

I cause you worry, but have confidence. I want so much to be a great painter and to make something beautiful.

Christian Bérard

bizarre, sentimental delicacies are uncovered, the way an azure flower grows in the middle of a pile of manure."[85] And that was a significant difference with Dior, who would remain faithful to Catholic traditions until the very end, because they were connected to his family's values. On the contrary, Bérard, an only child, had never agreed to absorb them. The heir of the Borniol family on his mother's side, Cri was on his father's side the grandson of Édouard Bérard (1843-1912). The diocesan architect of Besançon and Sens, he was especially known for having invented a construction technique using filler panels allowing the insertion of steel rods. People were still driving horse-drawn carriages when Édouard Bérard was filing patents for vaults, domes, and flooring of reinforced concrete. This ancestor, the student of Eugène Viollet-le-Duc, the head architect of Historical Monuments, built Cœur-Immaculé-de-Marie Church in Suresnes, Notre-Dame-de-l'Assomption in Rungis, the main chapel in the Saint-Sulpice seminary in Issy-les-Moulineaux, and the Sainte-Jeanne-d'Arc Chapel in Paris. His grandson Christian preferred stucco to cement, the grayish glimmers of charcoal to the precision of the compass. The saints he had chosen no longer wore crowns. They were the pariahs of the *extra ecclesiam nulla salus*, all those whom the Church rejected, the harlequins, the queens of the proscenium. He invited them all underneath his imaginary big top. "I swear it on my painting,"[86] he would exclaim when a friend doubted something he said. His religion was freedom, according to the new virtue expressed by André Gide: "Remaining available for all possibilities."[87] In *The Fruits of the Earth*, Bérard had found, like so many other young people, the source of a liberating momentum: "Get out of anywhere, your city, your family, your room, your thoughts."[88]

Dior enjoyed himself, Bérard painted

1923. Marthe, Christian Bérard's mother, died when the soldier of the Rhine was only twenty-one. He had gone to Italy with his painter friend Léonide Berman and wanted to share everything that enchanted him there with her. Rome, the Scrovegni Chapel painted

by Giotto in Padua, and the frescoes of Piero della Francesca in the San Francesco Basilica in Arezzo would have a crucial influence on him. *Constantine's Dream* functioned as a vision that would enlighten his self-portraits. Below a curtain of light, the reclining emperor would inspire the young painter to make his *Enfants* in 1925. Here he is with cherubic features and dark curls; one of the guardians has become his double in a white polo. "Our room is about as big as the studio in the villa, with red damask curtains, doors with pink marble frames, a huge and wonderful Venetian chandelier, and a balcony opening onto an admirable little canal. The weather is splendid, and it is nice to live in the midst of such beauty."[89] This letter, the last one he wrote to Marthe, shows his ability to become one with the landscape, to enter a setting and forget himself. Bérard, the painter of "those faces that stare at you, with his own anxiety in their eyes,"[90] found in the light of the Grand Tour an inspiring initiation. But the grace of this trip to Italy would soon fade behind an experience that was radical in a quite different way: the army.

After World War I ended, French troops occupied part of German territory. That was where Bérard performed his military service. He was alone; far away, there was his father, whom he constantly asked for things, as if these packages could by themselves make up for an absence: "I'm ashamed of my letters, which are nothing but endless requests, but I hope that you read between the lines and see all the affection I have for you."[91] He was already encumbered by this body that he would later drape, letting it float in dressing gowns that looked like palettes. His "infected teeth" that set his "head on fire" only increase the discomfort of the soldier's life, under the yoke of a leadership that was "nitpicky and obsessive," with its demands, "orders always followed by counter-orders." The adolescent with the "energetic griping"[92] was already the character whose thicker outlines he sketched: "I have a devouring appetite, in the evening I eat two or three bowls of soup, three or four servings of potatoes, I'm an ogre."[93] But nothing sustained him as much as books: "Your son is so annoying, but, my dear Papa, it's my only vice and as soon as I know a book is out, when I like the author, it's so sad not to have it, so I'm asking now for two books, *Plain-Chant*

by Cocteau, and the history of the Ballets Russes by Michel G. Michel."[94] More than anything, Cocteau's words intoxicated him:

> I do not like to sleep when your face resides,
> At night, against my neck
> For I think of death, which can quickly glide
> To send us off to sleep.[95]

With a butter-yellow tie and a golf-green sport jacket, Dior cultivated his dandy look. His mother saw him already as a diplomat. He was nineteen and, with no particular vocation, managed to get into Sciences-Po, "which committed me to nothing. It was a hypocritical way to keep on leading the life that pleased me."[96] His style was out of place, and supposedly one professor did not allow him to register because of his travel clothes. He kept his shirt collars in a little honey-colored Moroccan leather box with his initials engraved in gold. His divorce with the academic world was finalized. In a letter to his friend Edmond Lainé, a native of Beauvais who wanted to attend the school, he complained about his "damned law exams": "They're far from brilliant […]. Some went all right, others were bad."[97] After two years studying public finance, the results were crushing: he did not complete his course of study and did not graduate. And the friend he wrote to died of tuberculosis later that year.

As invasive as they were distant, his parents were impassive before the whims of a son who was at best a dilettante and whom they considered ungrateful. This is what separated him from Bérard, who never concealed his ambition: "I cause you worry, but have confidence. I want so much to be a great painter and to make something beautiful."[98] The latter revealed himself both "skillful and awkward":[99] his lines were precise but his gestures and actions were sometimes clumsy, knocking a wine glass onto the tablecloth, or stepping on open tubes of paint. The hand that he used to express himself was also his first agony: "I had a bad infection on my finger that got inflamed. I must have gotten paint and dirt in there. They gave it a good lancing and now it's healed."[100] The first symptom of

the dirt that henceforth would serve him as armor. Back in Paris, it would always remain embedded in this body which he often barely washed in the morning at his sink.

A true provincial, Dior acted like an English gentleman in the city, and, with distance, his property seemed to him a grand estate. He was obsessed with the garden in Granville. Gertrude Jekyll's mixed borders fascinated him much more than the Versailles Conference. He had seen his mother fight the rocky soil to create an English garden with extravagantly decorated flower beds. Encounters and friendships substituted for the kind of career that he was not allowed to imagine. For the Dior family, bohemian life meant drifting, failure, shipwreck on the horizon. Even before Christian was born, Maurice Dior had signed a draconian regulation concerning drinking establishments in Granville. "Monsieur Maurice Dior says that he sees this regulation as a way to prevent vice. What must be avoided is contact with women who may contaminate young men and give them germs that can be transmitted to their descendants."[101]

From the Cirque Médrano where Cocteau and Picasso were regulars, to the Tip Top on Rue Tronchet, where people imitated English lords and a German singer performed Wagner, the Paris of the Roaring Twenties was a scene that Dior stepped into as quietly as a cat. Of course, he would never give up his roots, his taste for mantelpieces and vases overflowing with Gynerium plumes, those Belle Époque feather dusters that his mother adored. But after growing up on the Granville property "as if on an island,"[102] he discovered at this age that there existed a different life on the other side of the beaded shades, the porcelain candy dishes, and the white-gloved servants of Rue Louis-David. "In exchange for giving up Sciences Po, I had obtained from my parents, not without difficulty, permission to learn musical composition. I soon developed a passion for the reaction that was beginning under the impulse of Satie and Stravinsky with the group Les Six, then the Arcueil School. We spent unusual evenings in our family's apartment. Seated on the floor almost in darkness – as was the custom at the time – they played modern

Elective affinities

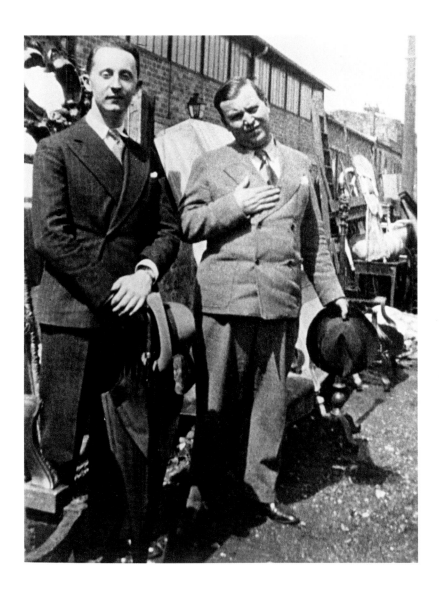

Anonymous, Christian Dior and Christian Bérard
at the flea market in Saint-Ouen, circa 1930.

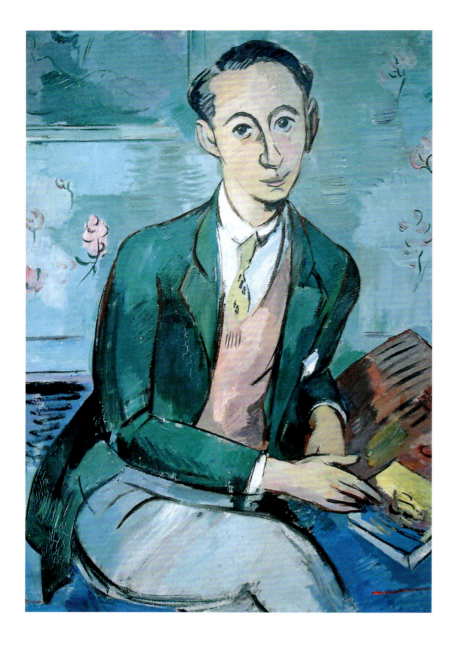

Paul Strecker, Christian Dior, circa 1928.
Oil on canvas. Paris, Dior Héritage.

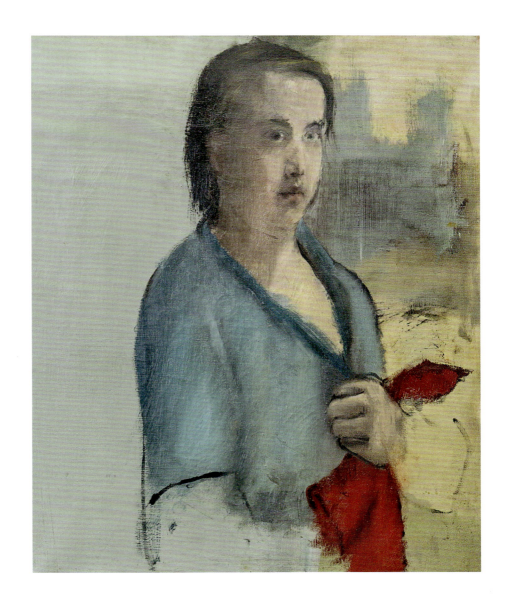

Christian Bérard, *Autoportrait au foulard rouge*
[Self-portrait with red scarf], 1930s. Oil on canvas.
Private collection.

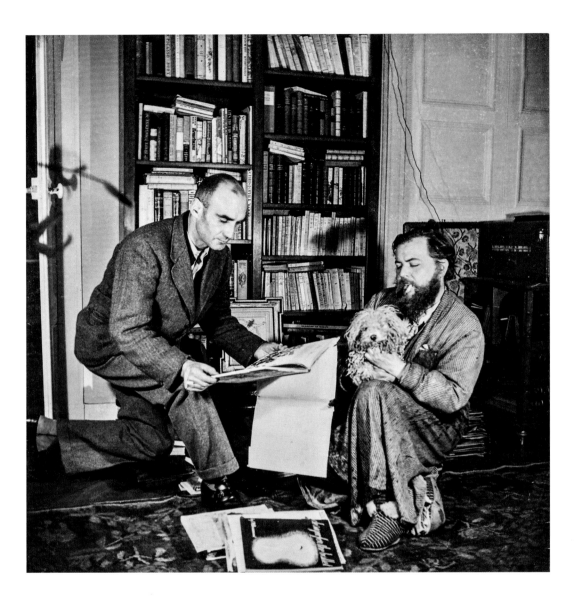

Anonymous, Christian Bérard, Boris Kochno, and their dog, Jacinthe, in their Paris apartment, circa 1945.

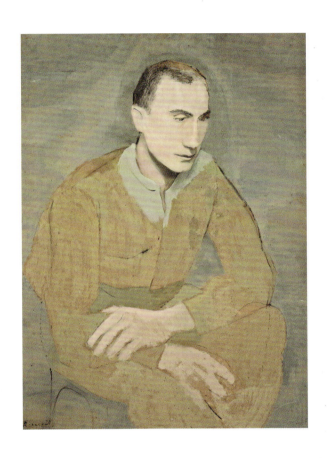

Christian Bérard, Boris Kochno, 1930. Oil on cardboard.
Private collection.

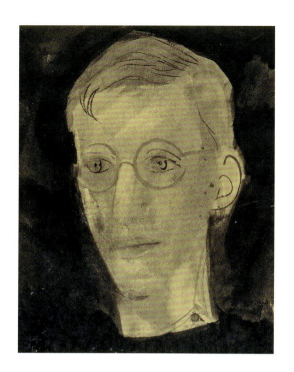

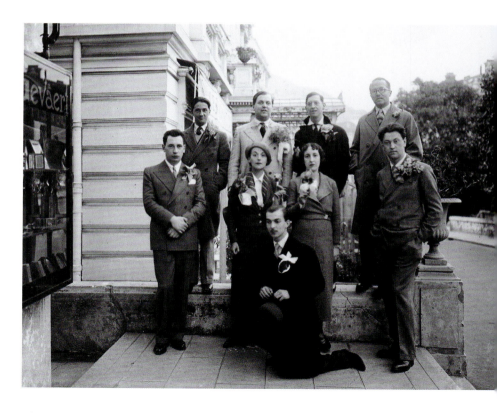

Christian Bérard, *Henri Sauguet*, 1927. Ink and wash.
Paris, Bibliothèque nationale de France.

Anonymous, Roger Désormière, Christian Bérard,
Henri Sauguet, Charles de Noailles, Pierre Colle,
Nora Auric, Marie Laure de Noailles, Nicolas Nabokov,
and Igor Markevitch, in Monte-Carlo, 1932.

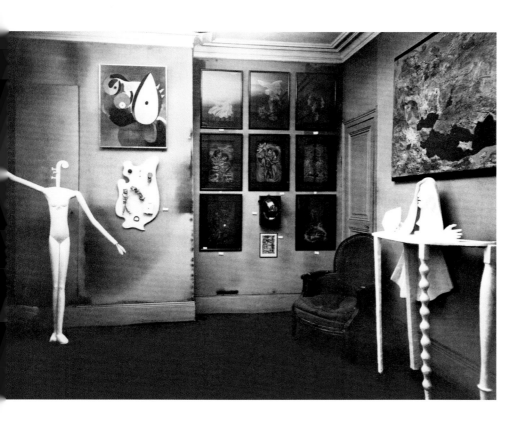

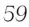

Man Ray, "Exposition surréaliste, sculptures, objets, peintures, dessins" [Surrealist exhibition, sculptures, objects, paintings, drawings], Paris, Galerie Pierre Colle, June 7-18, 1933.

Anonymous, Maurice Sachs, Pierre Colle, Max Jacob, and Jacques Bonjean, 1927-1928.

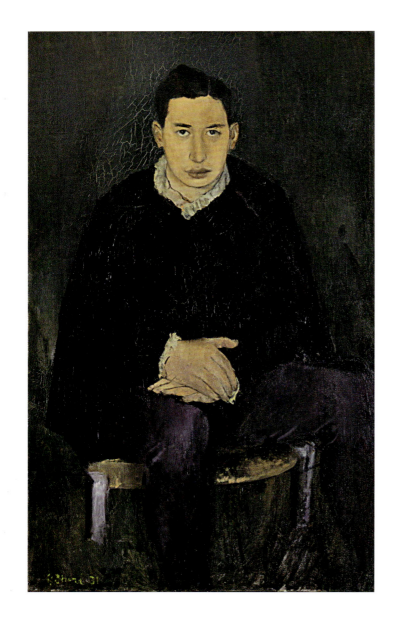

Christian Bérard, *Pierre Colle*, 1931. Oil on canvas. Private collection.

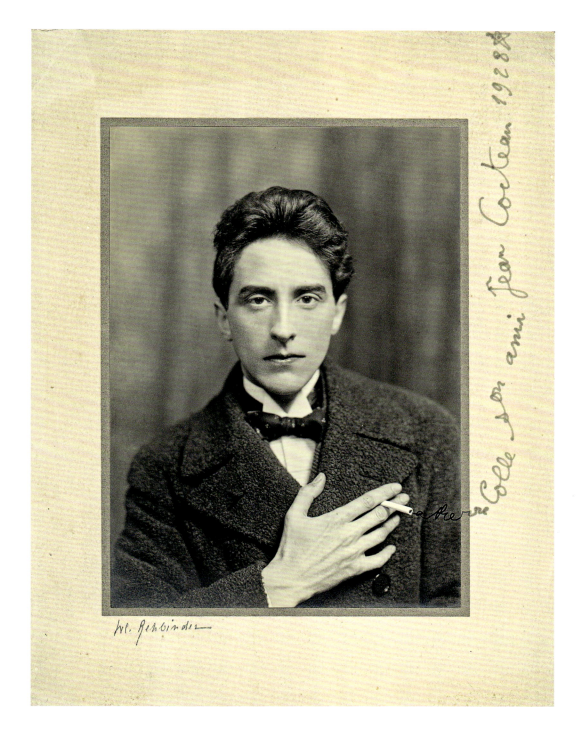

Wladimir Rehbinder, *Jean Cocteau*, circa 1915. Private collection.
The print is dedicated by Jean Cocteau to his friend
Pierre Colle.

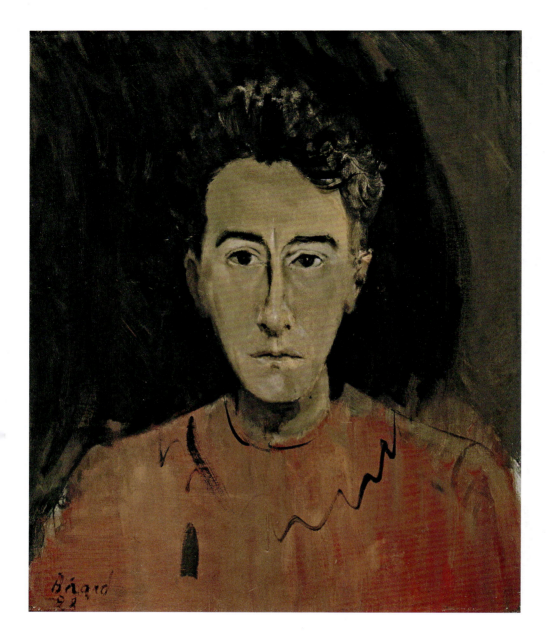

Christian Bérard, *Jean Cocteau*, 1928. Oil on canvas.
New York, Museum of Modern Art, Abby Aldrich
Rockefeller Fund. Former Christian Dior collection.

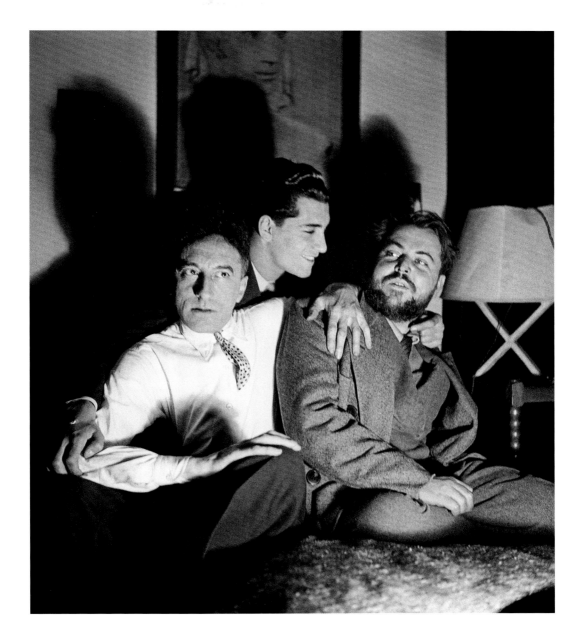

Boris Lipnitzki, Jean Cocteau, Marcel Khill, and Christian Bérard, Paris, 1938.

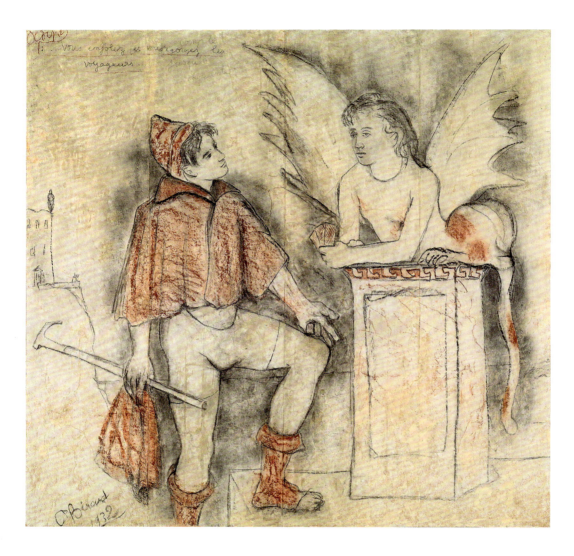

Christian Bérard, *Œdipe et le Sphinx jouant aux cartes*
[Oedipus and the Sphinx playing cards], 1932.
Graphite and pastel drawing mounted on canvas, fresco
for Jean Cocteau's apartment in the Palais-Royal, Paris.
Paris, Centre Pompidou, Musée National d'Art Moderne.

music, the kind that would make our elders' skin crawl with horror. On those evenings, my appalled father and mother would lock themselves away in their rooms. At one of these performances, a young Dutch musician, who has since become a diplomat, brought Henri Sauguet to me. His eyes sparkling with mischief behind his glasses, his tremendously expressive face, the intelligence and humor of what he said – everything that was Latin and lively in this Girondin from Coutras astonished the slow, quiet Norman that I am. He had already had some success, but he seemed very famous to me."[103]

Henri Sauguet, born Poupard, was a musician who was taught by the organist of the Church of Sainte-Eulalie in Bordeaux. There was nothing about him to frighten the bourgeois. He, like others, became part of the network that Christian Dior was establishing, this constellation of homosexual friends making art under the auspices of Christian faith. Among them was Max Jacob. From a non-practicing Jewish family, he had converted to Christianity in 1909, and soon unmasked the young man from the provinces:

> The dandy being
> An art-loving type,
> Bœuf and company,
> School is paid no heed.[104]

A former organist, Sauguet had just founded the Arcueil School as an homage to Satie. "Hadn't there just been a concert at the Théâtre des Champs-Élysées where his pieces had been applauded? That evening he played his *Françaises* on the piano and his music abolished all our differences. It was the kind I would have dreamed of writing if heaven had granted me the gift of truly being a musician. From his very first pieces, Henri Sauguet promised to be the reformer of the spontaneous, loving, anti-academic style. We soon became friends, and it was through him – one of the best composers of his generation – that I soon met someone who would become one of the leading painters of the time."[105] This little circle also included Pierre Gaxotte, who had an advanced history degree and counter-revolutionary beliefs. After having been

the "nighttime secretary"[106] of Charles Maurras, he began praising radical nationalism in the new weekly *Candide*, which he began editing in 1924.

From the lower middle class of the provinces, Dior's friends shared many taboos. Although France had decriminalized sodomy in 1791 – which, along with "procuring," "scandalous co-habitation," and "bestiality" had once been considered a moral offense – they grew up in the fear of getting locked up for a sex crime, given the other charges that judges could impose, such as "offense to modesty."[107] The second family of the "taciturn Norman" indulged in the pleasures of the mind and the body with the same fervor as they worshiped God. Considering that it was not until 2019 that the journal of gay Catholic writer Julien Green was published in its entirety, we can understand the silences of this generation that was socially gagged, living a double life known to all. Dior preferred to offer a cleaned-up vision of the Roaring Twenties, with memories that could have been lifted from a postcard sent home by a teenager: "How did I get to know my friends? […] according to those mysterious laws that Goethe called elective affinities. […] We simply met, all these painters, writers, musicians, and decorators, under the aegis of Jean Cocteau and Max Jacob."[108]

What wouldn't he have done to avoid shocking his family? A regular at Le Bœuf sur le Toit, he forgot his regret at flunking out of college, to the amusement of Max Jacob, who wrote a parody of Mallarmé in Christian's honor:

> Sadly sleeps
> Christian Dior
> With his empty musical core[109]

Buttoned up in his proper education, Dior measured the distance between the world of his parents and the city he was immersed in, as a novice, a witness of the extravagances of the avant-garde: "At the sound of the gramophone, Max, remaining the youngest of all, took off his shoes and danced in his red socks, miming an entire ballet

company to Chopin's preludes. Sauguet and Bérard, in a transformation of amazing speed, became, by extensive use of lampshades, bedspreads, and curtains, all the characters of History."[110]

A sudden transformation? Racing toward anything new, "inventive, cosmopolitan, smart Paris overflows with truly new novelties."[111] Dior enjoyed himself, Bérard painted. The Paris School, which gathered painters from all over Europe, was a sign of this cosmopolitan influence that dominated Montparnasse. On dark backgrounds, angular faces resembling those of the models of Amedeo Modigliani, Chaïm Soutine, or Kees Van Dongen were found in the paintings of this very promising young artist: in December 1925, Galerie Pierre, which had been opened by Pierre Loeb one year earlier at 13 Rue Bonaparte in Saint-Germain-des-Prés, offered him his first exhibition, just after the group show of Surrealist painting that featured Jean Arp, Giorgio De Chirico, Max Ernst, Pablo Picasso, André Masson, and others. The first to show the Surrealists' work, and the first to make Balthus known, Pierre Loeb thus anointed an artist whose existential torments none suspected, except for his father and, of course, his companion Boris Kochno. Gertrude Stein was the first to purchase a painting by Bérard in May 1928 for the price of 1,200 francs, a relatively modest sum judging by the 3,000 francs spent by the Noailles that same month for a Miró, the Picasso that was billed for the same price to the quiet American Eyre de Lanux by Galerie Pierre, or the Matisse sold for ten times more at Galerie Bernheim-Jeune.[112]

But by September, Bérard's prices had almost tripled, and he would find himself several times alongside prestigious names such as Braque, Soutine, Rouault, or Utrillo, with Derain being the most popular painter at that time, according to the gallery's sales records. All the same, Picasso, jealous of the support that Gertrude Stein gave to Bérard, did not hide his aversion to this unknown artist, whose work was not unanimously loved. "Haven't you ever been guilty, as I have, of finding Frenchmen silent or cold, hard at times, when the enthusiasm of the English and Americans is so natural and wonderful?"[113] In this city where nothing was forbidden, English and

American women were always the first to give their all-consuming admiration to their protégés.

> Eating is her subject.
> While eating is her subject.
> Where eating is her subject[114]

Thus poeticized the American patroness of the arts, who shared with Bérard a serious inclination toward stoutness, as well as the nickname "Baby" from her companion Alice B. Toklas. It was the young "*Béward*" whom she chose to sketch her as one of her *Dix portraits*. In this famous series, Bérard's signature rubs shoulders with those of Pablo Picasso, Eugène Berman, and Pavel Tchelitchew. A talented Russian painter, Tchelitchew would soon take a dislike to his former classmate at the academy, whom he would caricature with the features of a bearded monster in *Phenomena*. "When you think of how high Bérard's prices have gotten,"[115] he would moan.

In the fall of 1925, Christian Bérard became friends with Jean Cocteau. Villefranche-sur-Mer would seal this intoxicating union. "Cocteau entertains me incredibly. Listening to him, I enjoy myself and laugh out loud like a child. He knows little about painting, and speaks about it superficially but brilliantly. He does not say as much as I would expect about my own paintings either."[116] In between opium-smoking sessions, Bérard wrote to his father asking for money. "Tired, nervous, without a penny, everybody makes a ruckus! And I'm bringing back four big boxes over 1.4 meters, two busts of acrobats, and two studies of sailors – it's impossible to roll them up, they're hard, and it's impossible to just pack them because they'll get broken, so I have to make a big crate that will also accommodate my large painting that won't be dry yet. This will all cost a lot. The only thing that calms me down is the joy at having worked like never before."[117] The "most sacred"[118] thing to him was his painting.

While Bérard was a truthful liar, Dior kept on hedging. "From one deferment to the next, like all students my age, I had avoided military service. But in 1927, the excitement of the 1925 exhibition

having died down, I had to resign myself to becoming an enlisted man. Taking advantage of my family's established comfort, I professed both anarchy and anti-militarism and I had naturally refused to apply for the commandment of any platoon. So I did my time as a second-class engineer in the 5th engineering regiment of Versailles, which had the advantage of allowing me to stay near Paris."[119]

Cocteau had debauched Picasso by "dragging him" to the theater to make the curtain for *Parade*. Ten years later, he still accepted somewhat uneasily his role as a "prospector of the new."[120] Therefore it was a rough blow when, in *L'Intransigeant*, Cocteau angrily discovered an interview, originally published by *La Publicidad* and translated from the Catalan, in which Picasso mocked him, calling him a "thinking machine." "If he could sell his talent, we could go for our whole lives to the pharmacy to buy Cocteau pills without ever running out of his talent."[121]

A team of friendship

Reclining on their bamboo mats, Cocteau and Bérard savored their burgeoning alliance: he had become "Bébé," a transitional love object replacing Radiguet, who had died of typhoid fever in December 1923. The poet, with whom Cocteau had founded the magazine *Le Coq*, "wrote his poems on old crumpled paper. He smoothed them out with his hand so they could be read. Obviously, we did not know that he would become an extraordinary novelist and that he would die and leave behind *Le Diable au corps* and *Le Comte d'Orgel* but we had seen right away, in his gaze, in his way of being, in this wounded bird's bouncing walk on the edge of the sidewalk, we had guessed that he was someone out of the ordinary,"[122] the poet wrote in sorrow. The capture of Bérard, whom he met through Georges Hugnet, a friend of Max Jacob, increased his reputation as talent spotter: "It wasn't drama that he loved, that he sought out, that he created, but an atmosphere of extreme tension, without which he would lose interest in things and disappear into a cloud."[123] By knighting the young artist, Cocteau confirmed his destiny as a

shooting star: a body whose particles heat up and gleam as they pass through the air, before disappearing into space, in the history of modern art. For Jean Cocteau, Christian Bérard was also the artist-alibi whose success could be contrasted with that of the Surrealists. It legitimized his swipes at André Breton, the man who led this fanatical group with an iron hand. And then Cocteau, who often accused his contemporaries of "walking on their hands," could only be conquered by this young man who shamelessly mocked the avant-garde orthodoxy. "I could never get interested in the fate of a guitar cut into four pieces,"[124] Bérard commented ironically.

Future leader of the neo-humanist generation, he was already keen to return to studying and expressing human sensitivity, which he would depict in spaces with metaphysical contours, between land, sky, and sea. "I enjoyed that a young painter (Christian Bérard) painted someone sleeping instead of following the fashion and painting a dream. The man who sleeps and does not dream or who sleeps too deeply to remember his dreams moves me very much,"[125] Jean Cocteau wrote in *Le Mystère laïc*, a defense of De Chirico and an attack on the Surrealists and their automatic writing. Around Dior and Bérard, a network of influences and friendships was taking shape. The first one to praise *Le Mystère laïc* was none other than Jacques Bonjean, who would co-edit Cocteau's text, as well as *Visions des souffrances et de la mort de Jésus fils de Dieu* by Max Jacob, with Maurice Sachs. Dior described him as "devoured by the desire to become a writer and already an adventurer in spite of himself."[126] Together they shared "a wonderful atmosphere of uncontrollable laughter and pranks."[127]

Bérard rejected everything the Surrealists advocated, and Dior, so smartly dressed with his bowler hat, was even more reserved: "Bérard illustrated scores for Sauguet's opéras-comiques based on librettos by Max Jacob, and invented costumes that Dior would have made for characters that Salou, among others, would have played."[128]

An introvert, Dior grew wings within a "team of friendship."[129] Bérard, as secretive as he was extroverted, was the only child seeking an

70

audience. But at night he was alone with his canvases, "painting quickly, with a skillful brush, sometimes rubbing the canvas with his little fingers, erasing, correcting, never satisfied."[130] He had absorbed the lessons of his masters, who included Vermeer and Piero della Francesca first of all, surely, but also Le Nain, some portraits by Rembrandt, Tiepolo, and twenty others."[131] Bérard brought these neo-classical lines to a world that was both strange and familiar — neither part of the "return to order" movement nor the realm of dream-like debauchery. And everything that Dior felt, critic and essayist Waldemar-George, born Jerzy Waldemar Jarocinski, would express in words in *Formes*, the artistic journal for which he was the creative director, a true manifesto of humanist painting. Waldemar-George evoked with emotion "a new state of intelligence, a new affective attitude, a new psychological attitude of the artist, on the one hand, and of the viewer, on the other, before the painted canvas. […] Bérard belongs to a generation that has stopped believing in the necessity of creating, imposing, or spreading a formal repertory that would correspond, at least in appearance, to the spirit of the time."[132]

Instead of fragments, sketches, and geometrical figures, Bérard has substituted the art of expressing "all the beatings of the heart and all occult dreams."[133] If he belonged to a caste, it was that of the untamable dreamers who had nothing to do with manifestos and the avant-garde. In "the seriousness of his white Pierrots" as "in the derision of a fallen clown" and of all these "beings on the margin,"[134] Christian Bérard transmitted at once "the taste of grace and the fear of death": "The body swells, expands, becomes obscene in the garb of successive garments that claimed to make it forgotten on the stage; the head becomes even bigger, placed like a ball on the torso of a child; the body reappears in its fatality and its impoverishment."[135]

By distancing himself from an abstract interpretation of faces, by returning to study, he willingly reaffirms influences at a "time when any portrait is called 'a horror' by the groups that are in fashion,"[136] as Lucien Daudet emphasized. Crushed by the fame of his writer father, and having failed to achieve success, this student of the painter Whistler was all too aware of the artistic dead end in

which painters found themselves. "I believe that the 'portrait by Renoir' of 1876 was rather the equivalent of what is today 'the portrait by Christian Bérard,'" *La Revue hebdomadaire* pointed out.[137]

And then Christian Bérard, the "poignant cross-dresser who is constantly projected outside himself"[138] embodied what the homophobia of someone like André Breton could not tolerate, since the back-and-forth between the two banks and the graces allotted by the aristocrats and the upper-middle-class to these oddballs all seemed like betrayal to the Surrealist clan, which functioned like a political party. "No more descriptions from nature, no more studies of manners. Silence, so that I may go where none has yet gone, silence!"[139] The Surrealists had drawn their line in the sand. Having stayed in the "inn of smoke,"[140] Bérard did not care. He was resolutely elsewhere, "on that other slope of life that was slowly smoldering away, or in that port filled with sailors with impatient bodies."[141] Cocteau gladly drew him into one of those cafés where people danced "to music full of little curls and spit curls [...], their bodies welded by sex."[142] At the Clos Mayol, in Toulon, Bérard became fond of "Pas de Chance" or "No Luck" – his real name was Marcel Servais – who would later become his servant. Cocteau described him as "a timid animal," whose nose had been broken by a carafe during a brawl and who had a shaved head. Why was "No Luck" tattooed on his chest? After a mutiny on board the *Ernest Renan*, he had landed in the maritime prison in Calvi. Ever since, he had kept his head completely shaved. The cap worn low over his forehead read "Tapageuse" ["Wild Girl"] in gold letters. "Pas de Chance" wore flared pants "which in the past sailors could roll up over their thighs and which current regulations forbid on the grounds that they symbolize pimps." Cocteau gave him his chain, and crossed out the tattoo with his "writing implement," drawing a heart and a star below it. He made the first move. He even drew on him in ink, emphasizing the raised areas of this figure with "muscles of iron," quite the opposite of Bérard's collapsed bodies.

Other locations, like the Bar de la Rade, the Jacky, and the Zanzi-Vermouth, in Toulon, acquired scandalous reputations as brothels

I could never get interested in the fate of a guitar cut into four pieces.

Christian Bérard

Christian Bérard painted faces consumed by an ember gaze, in reaction against Cubism.

Christian Dior

and sites of orgies. On the Mediterranean shore, the relationship between Cocteau and Bérard seemed closer than ever: they shared this taste for light and danger, which they would illustrate by drawing together, each enjoying imitating the other.

At the Welcome Hôtel in Villefranche-sur-Mer, Bérard and Cocteau sealed their union with opium, sunshine, and cross-dressing. "Cocteau carnally loved these human seals that had washed up on the beaches, to whom Bérard lent his aged child's corpulence."[143] His presence was a spectacle. In the thick air, here he was already changing, "fat, shining, and majestic,"[144] "his little hand, round, pearly, dirty,"[145] as if his body rejected any kind of constraint, pulling him along in its deformity. Like a chameleon, Bérard strutted around as a dowager or a showgirl and resisted no obscenity. Did Dior voluntarily erase all excesses?

"Hello from Bayonne," Dior wrote chastely to Bérard on the back of a postcard of the Basque city sent in August 1927.[146] He chose the white marble statue in the Jardin Léon-Bonnat, a man's head on a nude woman's body. Named *Fleur d'ajonc*, it displayed the languid curves that evoked the Pictorialist Arcadia of the early twentieth century and transmitted a breath of sensuality to this generation that was electrified by imagines of ephebes, homoerotic figures borrowed from ancient Greece. The publication of *Sodome et Gomorrhe* (Proust, 1921-1922), along with that of *Corydon* by André Gide in 1924, did not weaken the requirement for self-censorship. The hermaphrodites that Dior would not stop reproducing, particularly in designing his fountain of La Colle Noire with the features of a nymph, are quite removed from the outrageous exhibitions of his friend whose figure had become a Parisian curiosity while the lewdest rumors circulated about him, including one recounted by Tchelitchew that, one evening, Bérard, having lost at cards to "some thugs and a few friends," "gave himself not only to the lucky winner but to the entire party."[147] Invited to lunch at Cocteau's house, he "speaks, laughs, tells little stories in an amusing way, and clearly says things he does not think."[148] At the table, he was noticed. "Stout, big appetite."[149]

Life was a circus, and Paris was a stage for stars. Bérard dined there with the transvestite trapeze artist Barbette, made little veils

out of fishing nets, and bargain-hunted for trinkets to play showgirl. He went out in his dressing gown splashed with paint and kissed his Scottish terrier Biribi on the muzzle. His greatest fear was to disappoint. "Despite this ridiculous physique," he exuded "some kind of air of majesty."[150] Like Béby the clown dressing up as a bride to marry himself, it seemed he was always acting. Around that time, his body began to overflow; the boundaries between day and night, outside and inside were dissolved. A body performer before his time, Bérard took his "half-complimentary, half-murderous sense of humor"[151] too far. And it was of course in Villefranche-sur-Mer, an addition to Toulon, "this charming Sodom where fire falls from the sky without striking in the form of affectionate sunshine,"[152] that he experienced the first signs of this transformation. Taking on the role of the beast, when, all around him, handsome young men were turning into beauties. "Enticing nighttime transforms the most violent jailbird, the roughest Breton, the fiercest Corsican, into these tall girls with plunging necklines, swaying hips, and flowers in their hair, who love to dance and lead their partner, without the least embarrassment, into the shady hotels by the port."[153]

Bérard and Cocteau would contribute to establishing the gay imagery of "this vertigo of sweat," which would be found in Yves Saint Laurent and Jean Paul Gaultier, in Jean Genet and in *Querelle* by Rainer Werner Fassbinder: this story of a sailor mixed up in opium trafficking who drops anchor at La Feria, a bar and brothel, found its source in this white-hot South, the polar opposite of Paris's stiff sixteenth arrondissement. In Hyères, the locals called the famous wintering villa built by Robert Mallet-Stevens for Charles and Marie Laure de Noailles "the house of the nitwits." Palm trees versus cypresses, cheerful bay laurels versus wild rock-roses and sage, everything contrasted the Mediterranean South of Christian Bérard and that of Christian Dior. Dior's chosen Provençal land would be a rocky region with winters that were so cold that it was nicknamed "Little Siberia." While Bérard was crazy about soaking in rays of sunshine that warmed him up, Dior the pale-skinned Norman fled the bright sun that "wrapped around you, grabbed you, knocked you over."[154]

Dior's roots protected him from this open-air debauchery; he sought shade, secret passages, and the lost paradises of childhood. There emanated from him a rusticity which his fashion, "anchored to reeds, gripping the shores, and, like cement, armed inside with a thousand blades of grass,"[155] would reflect. His silences would become dresses named *Cachotteries* ["Enigmas"] or *Petites Filles modèles* ["Model young girls"]. Reading his words recalls the innocent letters Jean Cocteau wrote to his mother from Jean Hugo's farmhouse: "Our life in Fourques is like a children's book. We're five years old — we chase insects, lizards, and grass snakes. I read and reread — and time passes in the midst of a garden that the false May of September in Languedoc covers with flowers and new grass."[156]

The attraction of opposites

Nature was perceived differently by Bérard and Dior. With giant paper flowers and artificial fruit, Bérard, along with Jean-Michel Frank and Boris Kochno, would decorate the "Country Ball" given in 1931 by Baron Nicolas de Gunzburg, with help from Elsa Maxwell, in the Bois de Boulogne. That day, the guests arrived in carriages, and baskets filled with vegetables towered above carts and bales of hay. For Bérard, nature was a diorama, one of many entertaining trips in the country of illusion and *festeggiamento*. A festival of painters along the Seine, a seemingly improvised moment with paper tablecloths, straw hats, and crooked tables. For Dior, nature was a rustic refuge, but for Bérard it was a composition. An occasion to "go from hell to heaven and from heaven to earth," on the traces of Faust:

> Thus spare me not machines or sets,
> From all my storehouses, steal their treasures,
> Sow generously the moon, the stars,
> The trees, the ocean, and the rocks of canvas[157]

A lover of cottage gardens, Dior was interested only in real flowers. He knew their resilience, their courage, their ability to recover after storms in the icy wind of Granville.

Quite the opposite, Bérard's friends had little attraction to gardening, which was a synonym for "enslavement of the land and plants,"[158] with its "traced paths"[159] and "learned lawns."[160] They constantly caricatured it, following René Crevel, in *Babylone*, which Bérard illustrated in 1927: "A gardener with his sleeves rolled up and an old lady with fingerless gloves, with a spray bottle in one hand and shears in the other, persecute this land and these plants, one brutally, the other with the petty wickedness of a hypocritical nursemaid."[161] In the chapter titled "Resuscitating the Wind," we can almost glimpse the figure of Madeleine Dior, her false pitch pines enhanced with bamboo framing, her shades with their jingling beads, the silk fabrics embroidered with fantastical flowers and birds in the family's living room: "Until her death, she would remain faithful to the dear horizon that is so artistically marked off by a hodgepodge of villas, pavilions, trellises, overelaborate trees, etc. 'What a magnificent lawn, what splendid baskets, what a pretty countryside,' she raves. A lorgnette plays the role of scepter and designates the wonders of the landscape."[162] Mocked also by Luis Buñuel in *L'Âge d'or*, the taste for gardens was the favored domain of aristocrats with wheelbarrows who had the illusion of being artists, starting with Étienne de Beaumont and his horticultural screens.

Since their tastes were so different, what mysterious force attracted Dior to Bérard? A magician of the countryside, Christian Dior was drawn to ways of seeing that let him explore his inner landscape. The voice of the brother whom he was never willing to listen to surely reached him through Bérard's paintings. The voice of Raymond Dior, the jealous older brother who had become a damaged survivor: "When we were young, they aged us into old men."[163] This was a cry from deep inside a man who had been broken by the horrors of war. After nine hospital stays, his body contained no more shrapnel, his dysentery was cured, his mustard-gassed lungs had healed, but his anger was unabated. "This is why I can't

set a course," he finally realized. "I should have asked for a pension, but it's too late now and no one cares about these things anymore."[164]

In *La Rencontre* (or *Le Béquillard*), a painting by Bérard in 1928, two figures face each other, one holding up the other, who is missing a leg. Dior saw in it what he usually preferred to ignore by focusing on his relationship with flowers: harrowing accounts of marches describing the hell of these soldiers, who wore themselves out digging tunnels for mines, blew up the trenches of the "Krauts," and struggled through water and mud. A life of burrowing and bombs, with whole battalions decimated in a siege war that everyone once thought would be over quickly.

Later, artificially rediscovered opulence would eclipse the tumult of war, but the wounds would never heal. There was one glimmer of a silver lining: Raymond Dior introduced his brother Christian to a friend from his regiment named Jacques Bonjean, "a buddy from the ambush at the old fort of Vincennes."[165] A new damaged veteran appeared on the scene. This time it was one of the painters who inspired Bérard: Roger de La Fresnaye, the portraitist of *L'Homme souffrant* (1922) and *Vaincu*, drawings he did in his bed, depicting the illness that laid him low. Evacuated after contracting pneumonia in the army, he later died of tuberculosis in Grasse. It was a tragic fate for another lover of the Quattrocento whose curves embraced the melancholy of a generation that had lost its bearings — the generation of Christian Dior and Christian Bérard, the young painter who was the first to "distance himself from an abstract interpretation of faces" to "return to study, analysis, to an effort for an expression of the soul."[166] Julien Green, who collected his work, chose a Louis XVI frame for one of his portraits; in *Épaves*, a novel published in 1932, we find the same existential anguish in this great observer of the human soul, an enlightened art lover and daily visitor to the Louvre: "This evening, by the water, he felt keenly all that might be inaccessible in the depths of his own heart. How could he hope not to be alone if he himself remained a stranger to himself?"[167] René Crevel's brush sketched their buried youth: "A salon opened onto the motionless blue night. Glances in the shadows of mauve eyelids, hair in a tur-

ban, diadems, slim legs glimpsed in the secretiveness of long pleats, arms abandoned to the gentle curves of the furniture, for eternity, these creatures had their smiles, their ambitions, their happiness. What could the people of today guess of this?"[168]

Bérard! The magnetism of this chubby-cheeked charmer instantly worked on young Dior, who had been born almost two-and-a-half years later and was still searching for his identity. Bérard was a neighbor in whom he recognized himself before even being introduced to him. Like Marie Laure de Noailles and Jean-Michel Frank, or Drieu La Rochelle and Mireille Havet, they both had the profile of the northern sixteenth arrondissement where they grew up, among isbas, German nannies, and the noise of wooden shoes clicking on wood paving stones. An arrondissement? It was more like a village where privileged sons often remained until their death. They lived in the family residence, and their estate was their bedroom. No one bothered them; everyone knew they were there, spotted on a park bench or walking their dogs along Square Lamartine. Some of these aging heirs could be aggressive, hitting a car with their cane if it ran a yellow light, while others blended into the background. The neighborhood of La Muette (or "Mute") was well-named. Here, the crystal gathered dust behind the glass-paned sideboards, as the hallways from the kitchen to the reception rooms seemed to grow longer with each generation. Those who were born there would die there. In 1930, on Rue Bénouville, a ninety-year-old named Eugène Mollier tied an Indian scarf around his neck and rode horseback around the track of his private circus. Scented with *Ambre de Delhi*, the program was signed "Baron Jadis."

Formed of villages that had for a long time been separate from Paris, the sixteenth arrondissement had rituals that seemed to be engraved in stone, including navy blue, glass cloches, religious schools, and secular offspring. Bérard had grown up indifferent to the furniture: when he moved, he broke things – and got noticed. Christian Dior, on the other hand, frightened by all the trinkets that he could damage, was so reserved that he seemed almost transparent, on the cusp of a destiny that still could not be imagined. He had not yet made a name for himself, and had to share his first name

Two thwarted destinies

Christian Bérard, Dress in sea-green rayon jersey; asymmetrical draped bodice completely revealing shoulders, in *Quinze robes de Paris dessinées par Christian Bérard* [Fifteen Paris dresses designed by Christian Bérard], circa 1937. Brochure. Patrick Mauriès collection.

Christian Bérard, *Les Deux Modistes au chapeau*
[The two modists with hats], undated. Ink drawing.
Private collection.

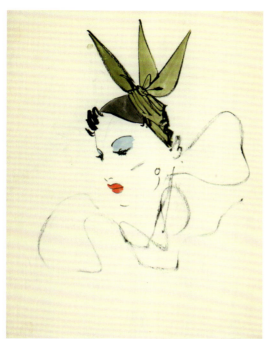
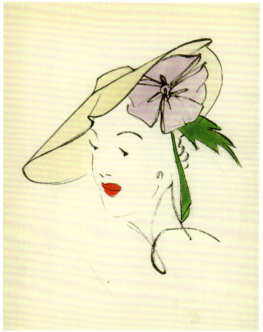
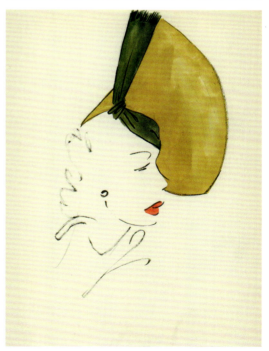

Christian Dior, Hats for Claude Saint-Cyr, 1936.
Ink and watercolor on paper. Paris, Dior Héritage (left).
Amandine Labrune and Myrtille Ronteix collection (right).

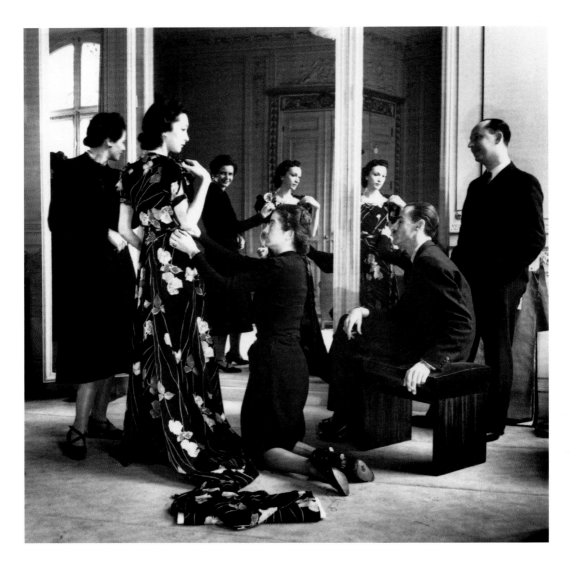

Willy Maywald, Fitting session in the salons of the Robert Piguet couture house at 3 Rond-Point des Champs-Élysées, Paris, in the presence of Robert Piguet and Christian Dior, circa 1939.

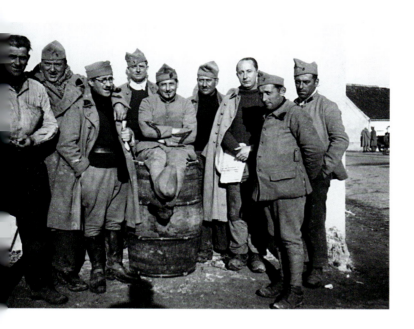

Anonymous, Christian Dior (third soldier from right) during mobilization with the 47th Engineering Company, Mehun-sur-Yèvre, circa 1940.

Christian Dior, Menu designed during his mobilization for the New Year celebrations for 1940, here reproduced as a bookmark in the posthumous book *La Cuisine cousu-main* (Christian Dior, 1972). Paris, Dior Héritage.

Christian Dior, Evening sets for Lucien Lelong,
circa 1944. Black pencil sketch. Paris, Dior Héritage.

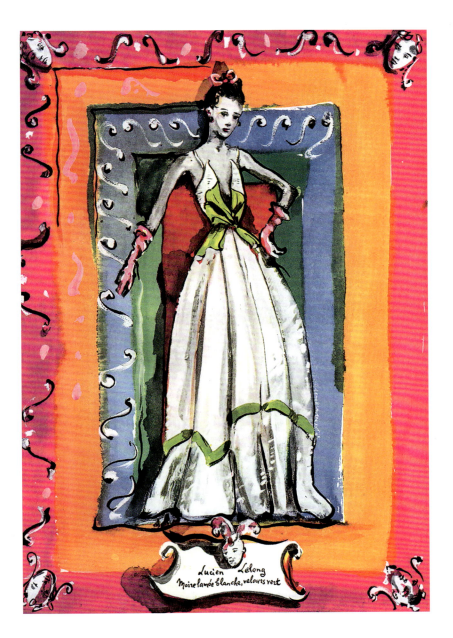

Christian Bérard, Evening dress for Lucien Lelong, white washed moire, green velvet, 1938. India ink and watercolor. Private collection.

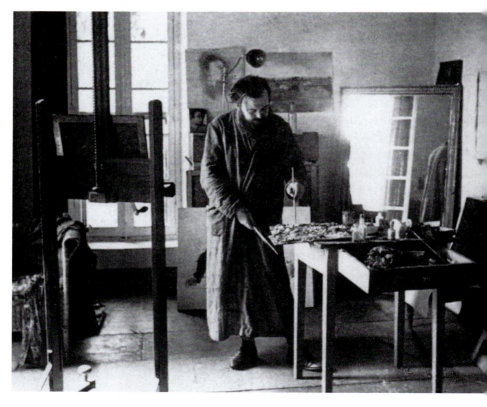

Christian Bérard, *Le Nain d'après Vélasquez* [The dwarf after Velázquez], circa 1940. Oil on canvas. Montauroux, Château de La Colle Noire, Christian Dior Parfums. Former Christian Dior collection.

Georgette Chadourne, Christian Bérard in the disused silkworm nursery converted into a studio at Jean Hugo's farmhouse in Fourques, Hérault, 1940.
In the background, *Le Nain d'après Vélasquez*, by Christian Bérard, once owned by Christian Dior.

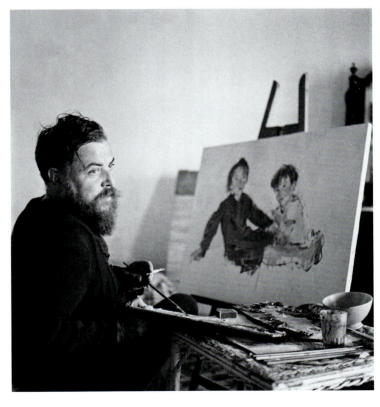

Christian Bérard, *Les Enfants des Goudes* [The children from Les Goudes], 1941. Oil on canvas. Private collection. The couturier Robert Piguet acquired this painting, which he later hung in the salons of his couture house.

André Ostier, Christian Bérard painting *Les Enfants des Goudes*, 1941.

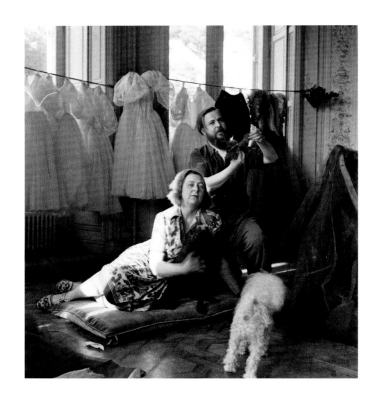
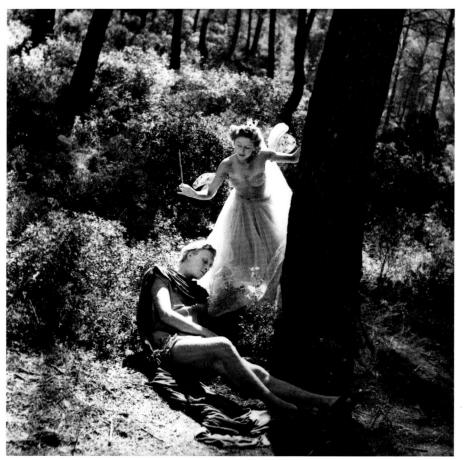

90

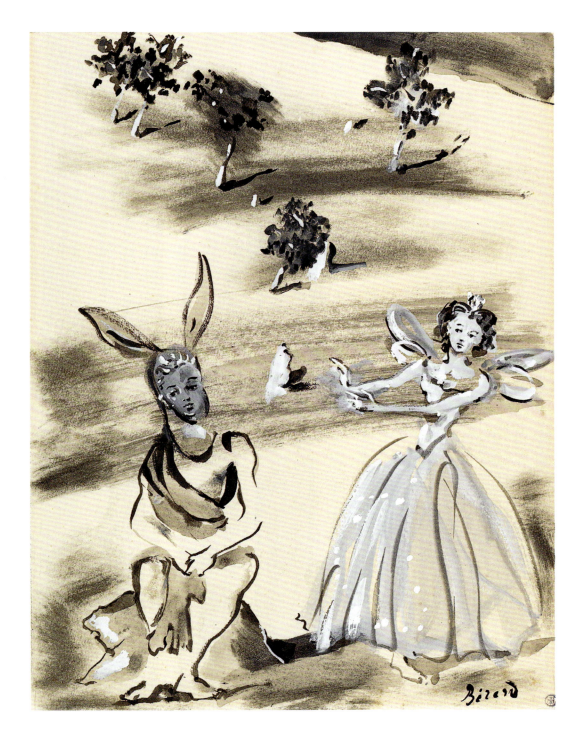

Victor Grandpierre, Costume design by Christian Bérard for the play *A Midsummer Night's Dream*, directed by Jean Wall and Boris Kochno, at the Parc de Montredon in Marseille, 1942.

Victor Grandpierre, Liliane Valois and Georges Jongejans as Titania and Bottom in *A Midsummer Night's Dream*, performed in the Parc de Montredon, Marseille, July 1942.

Christian Bérard, Costume project for *A Midsummer Night's Dream*, 1942. Ink wash and gouache on paper. Marseille, Musée Cantini.

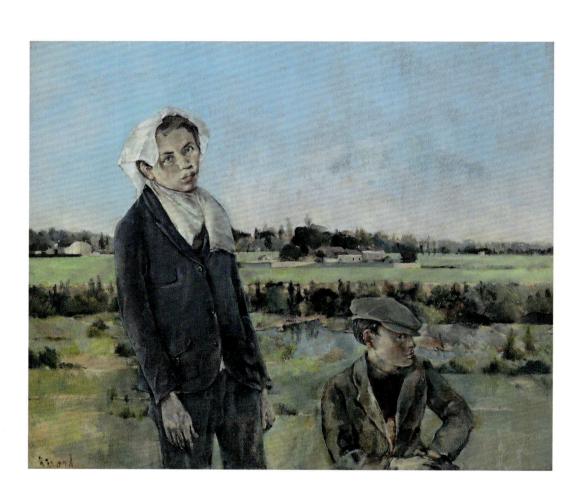

Christian Bérard, *Garçons à Fourques* [Boys at Fourques, young Louis Jouvet], 1943-1945. Oil on canvas. Peter Doig collection.

with Bérard, who shredded ridiculous people by imitating them, from the height of his already portly stature as an artist: "Bérard the magnificent, as always, crushing everyone as he goes."[169]

Dior was subjugated: Bérard the ringmaster pulled him along. Here he was in the front boxes of the room that would be his theater, his life. The date of the meeting is not specified, but it had the significance of aesthetic love at first sight: "He was a blond, clean-shaven, slim young man, whose huge blue eyes had already glimpsed that the human face, the life of human beings, deserved more attention and honor than the simplified still lifes of the Cubists or the geometrical figures of the abstract artists. His name was Christian Bérard. Each of his drawings was a lesson in how to see, to transfigure daily life into an intense, nostalgic fairyland. I bought everything I could of his inspired sketches and panels and I covered the walls of my room with them,"[170] Christian Dior wrote in 1956 about meeting the painter.

In reality, the more Bérard creased the pages of the book on Piero della Francesca on his bedside table, the more he sank into the fascinating monstrosity of the character he was composing: this other self watched him paint vastness in shadow. For Dior, it was a revelation. A gigantic wave submerged him, and he was rolling in the foam of his memories. The child who was yesterday perched on his cliff now gave himself over to the discovered secrets of the lower city, the one that he embraced again in *La Ramasseuse de palourdes*, a small painting by Léonide Berman that he purchased around the same time. These skies soaked in gray clouds sent him back to Granville: there, they had always covered sadness with songs, masks, costumes, and music. Fishermen of the open sea set sail for Newfoundland or Saint-Pierre-et-Miquelon without knowing if they would ever come back. The cod fishing boats would disappear in the distance, leaving women in tears and children dazed, shaking their pennants on the jetty of dry stones. No one here had forgotten the tyranny of the sire of Préfort, who hadn't hesitated to put women and children in the dungeon and who had charged a hated toll called "the right of the wicket gate" to those passing through the city gates.

Because of this royal commander, the fishermen who had once dried their nets on the Esplanade du Roc had to put them away, and the children were forbidden from running there, under punishment of death. Granville had also maintained the memory of those narrow huts built on the side of the rock. During nighttime storms, frightening stories were told: Pierre le Maçon used a stick to fend off his neighbor Thomas le Boussy; he even killed him, for which his nose was cut off and he was imprisoned. In medieval tales, there was also a story of stones thrown at women's heads to "fell them to the ground."

In Bérard's art, Dior seemed to discover a different Granville, with paths called "les Nervages" or "Noires-Vaches," the one that led from the church and the city to the gate of the Dead. Granville and its practically naked children, whipped by the wind, their shirts sticking to their backs under their antiquated roof beams. When a poor housewife put out straw mats to dry, the king's soldiers tossed them into the waves, laughing. Granville after the French Revolution, its great ships disarmed, their hulls green with algae, while disaster struck the land: drought, an icy winter, and little food — just bread, butter, and fish. Christian Dior was from that place, a city where, in the late eighteenth century, when Paris wasn't yet dancing the *La Carmagnole*, beggars who came to seek help perished of the cold. Their bodies would be found frozen on the road. During the Revolution, in Granville, some danced at the bishop's palace while others marched through the streets carrying straw aristocrats that they threw into the moat. These are the people we seem to glimpse in the features of Bérard's solitary bathers. His figures have the sadness of those worn-out bodies, those bodies filled with air and grief that the sea seems to have abandoned when it withdrew. Buffet would paint these sad postwar clowns, emptying them of their flesh, and Bérard filled them with absence.

Modest and reserved, Dior was surely astonished by Bérard's spectacular deviations. His personality was as cheerful as his art was melancholy. With his smudged face that resembled a mask, this painter was a carnival all to himself. His nickname, "Bébé," was

inspired by an ad for Cadum soap – a funny moniker for someone who washed himself so infrequently. In his disorderly appearance, all the stories of Granville returned, starting with the châteaux where the rich children "showed off their dresses and pulled out the angels' hair."[171] Even though Bérard sprayed himself with *Jicky* by Guerlain along with the "blinding light" of Piero della Francesca – the painter of *La Résurrection*, who died completely blind – he also found his visions of the absolute in ponds, reflections of armor, sails of boats, and shadowy caves. In Bérard's spectral art, Dior rediscovered the beaches of his Norman childhood, its blue clouds and gray storms, but also its harlequins, clowns, and carnival puppets.

In Bérard's *Autoportrait au châle* (1933), the shirt has taken on the color of moonwater. It recalls the "light rain" that "removes the starch of crepe fabric and passes through my coat"[172] as described by their friend René Crevel in *Détours*, one of the first books illustrated by Bérard (1924). Jean Hugo invited Bérard to stay in his house Ker-Dros, near Le Pouldu, a small port in the Finistère department where Émile Bernard, Paul Gauguin, and Paul Sérusier were frequent visitors. The gray sheen of the cliffs striped with "kelp fangs" bled onto his canvases. "It's a little château with a bistro and fishermen's houses right nearby."[173] In these outlandish seaside settings, Bérard forgot the Rolls-Royces, the English servants, and the "magical life" of the Côte d'Azur and slipped away toward himself, a disheveled street performer leading through his caravanserai all the souls of the children who cry at the circus.

In August 1930, the strange death of his friend Christopher Wood – an opium-smoking painter like himself and a friend of Cocteau and Crevel – surprised Bérard in this mystical quest: "I don't know how to write, I feel so awkward. How I'd like to express the wonder and shock that I felt looking at Christopher Wood's last paintings. He had just brought them back from Brittany. He was cutting the cords, he marred them and abruptly turned around landscapes of such purity, such gentleness, that right away the room became dark and the walls pulled away in a fog,"[174] he wrote about "Kit"; "shortly before death, in painters' work… as if they were leaving

us already, the colors, the values become strange, coming from another world."[175] Kit limped. It was said that he threw himself from a locomotive in a train station in England. For a long time, he had been hearing voices.

Christian Dior was even more receptive to Bérard's paintings when, on the threshold of the 1930s and a terrible economic crisis, "another world"[176] was about to come crashing down onto him. Storms were accumulating above his family. It was a bit like summer in Brittany, at that precise moment when the gold and blue light fades, leaving a gloomy mist to cover the still-sleeping sea. One morning, you wake up, and autumn is there, the beach is empty, the rocks have bled onto the sand, clouds have swallowed the sun, the horizon stretches out. In the solitude of his studio, Bérard found "that white, that gray, that solitude, a life as monotonous as the landscape,"[177] as described by his father. But it was as if he had transfigured seasons and places. Those stretches of sand usually associated with happiness and holidays he made into the theater of desolation and boredom. Time and space expanded to make figures with closed eyes appear from nothingness – a self-portrait in a shawl, a fanciful Pierrot, a metaphysical clown – who seemed ready to fall back into nothingness at any moment.

World War I had laid everything to waste. "Sadness, despair, awful uncertainty. These young men and these young women have no peace inside. They suffer in silence, waiting for who knows what."[178] This atmosphere of waiting seemed to have taken over Christian Dior, who was unable to see himself in the diplomat's career that his mother had laid out for him. Everything Bérard expressed spoke to Dior of his own uncertainty: "[His] pessimism is even more flagrant because he clearly has nothing that is desired, nothing prepared. He is the color of time, of a time that no longer believes in much, except for its impending ruin."[179] With Bérard's brush, the dove became a hybrid figure, half human, half animal. By illuminating what should have stayed in darkness, Bérard shed light on the disillusions of youth. Although he painted with the shutters closed, light, like the halo of Rembrandt's *The Night Watch*, was his

revenge, his salvation. Bérard drowned his own face in a moving frame, a stage curtain ready to close over him. He had converted a room in the stately house Villa Spontini into his studio. It was a "cursed place"[180] where his family did not enter.

Evoked by Julien Green, this "solitary game" was certainly what spontaneously mesmerized Christian Dior – who was described as "Bonjean's associate" – when he went to visit the writer. Regarding Dior, Green wrote: "I had offered, in fact, to show him my Bérards. He thinks that the portrait of the young man with his face propped in his hand is one of the best portraits by Bérard that he has seen. White, gray, and black are the only colors in this painting – if these are even colors."[181] "Few painters can paint in gray. But the great ones like to base their palette on this color that isn't a color, but which is like the consumption, fine and powdery, of all colors at once."[182] At age thirty, he had already found his spectral light. Christian Bérard was convinced of his vocation, which did not stop him from constantly doubting. "He took a keen interest in his neighbor, in whoever was before him; he tried to please this person, flattering him greatly, encouraging him to say things that would complete the image he had of him."[183]

Sentinels of dreams

In the gazes surrounding him, Christian Bérard sought that recognition with which neither love nor friendship could compete. He hid in order to prepare to pounce, like that "monstrous animal"[184] that would be described by Giorgio De Chirico, who showed around twenty paintings at Galerie Bonjean. De Chirico, "the inventor of certain archeological peculiarities about which the Surrealists made a big to-do,"[185] also painted absence. In a wonderful text, "On Silence," the artist evoked a "kind of islet with a swan's neck and a parrot's head" that "came out of the water to enter onto land, into mysterious forests and deep into damp valleys." He continued: "In sublime poses of fatigue and sleep, warriors now repose in their final resting place while there, behind the dark cliffs with their profiles of Gothic

apostles, a moon of boreal pallor rises in great silence; gently its rays light the faces of the dead."[186] This torpor that for Dior simply meant a seaside resort emptied of its vacationers was filled with an evil presence by Bérard. For Bérard knew all the secrets of a silence that De Chirico compared to "sleep's younger brother."[187] A silence that would later become one of Dior's great allies, "ensconced in his armchair, on the lookout," ready, during the first fittings, to see the dress "live": "What surrounded me disappears. The design is *alone*."[188]

What Bérard offered Dior was the promise of shadows, another way that the Borniol heir transmitted his family tradition by warping it. If cinematographers soundproofed a room with a "borniol" so that the sound would be muted, Bérard papered his backgrounds with art. A setting could become dark or so light that each figure stood out in a spectral manner and the ground that his ancestors constantly dug suddenly disappeared, letting the figures float in a series of artistic dreams. They seemed to be ghosts shaped in a void. The presence of these figures looking "spectral and with the gaze of visionaries, intense and harrowing"[189] generated as much fascination as unease.

No bones, no thinness, no use of "coded language," nothing to provoke pity. The tragedy was elsewhere: it took place in dispossession, the condition of a man who could be all others. It calls to mind the doves discovered by Reynaldo Hahn and Marcel Proust in the Jardin d'Acclimatation: "Reynaldo points out that "with their red wound as if still hot," the stabbed doves looked like nymphs that had killed themselves for love and had been turned into birds by a god. "That day, Proust contemplated them for a long time, and he loved them more and more deeply."[190] "La colombe poignardée et le jet d'eau" was first a poem written by Apollinaire in 1918 in *Calligrammes*, a collection subtitled *Poems of Peace and War*:

All the memories of before
O my friends gone to war
Gush toward the firmament
And your sight in still water
Dies in melancholy[191]

For Bérard, these pains were all the more incurable because they remained invisible. He showed them, without nostalgia, spreading out the dateless present in a sort of cloistered vastness, on the border of the end and the beginning. According to Boris Kochno, Bérard with his "flushed face" and "irresistible laughter" was only truly comfortable at costume balls, where, by dressing up, he felt "outside of time, immunized against the critical eye of society people."[192] This Russo-Ukrainian dandy, who was Diaghilev's secretary, met Christian Bérard during a visit to his studio arranged by Henri Sauguet. From then on, they were inseparable. Bébé gave *Les Enfants* to Kochno, a painting with this dedication on the back: "To Boris, all his youth."

Dior had learned never to show anything; he never let loose. As the years passed, Bérard, an "unwilling precursor of the miserabilist manner,"[193] in his jacket or blue smock spotted with paint, displayed more and more the signs of alcohol, drugs, and lack of sleep. As if the melancholy of his wakeful sleepers, those whom Jean Cocteau would call the "great sentinels of dreams,"[194] had bled onto him. He had turned his room/studio into a dump, with his little dog around his neck, like a living fur stole above his dressing gown splashed with all the colors of the rainbow. From their very first meeting, Kochno witnessed his transformation. "When it was my turn to leave Bérard, I suddenly noticed that his clothes were in an indescribable disarray. In the half-hour that we had spent together, they seemed to have deteriorated on his body. Nicely arranged when we arrived, Bérard, when we left, had hair that was completely uncombed, with blond strands falling in his eyes, his tie was crooked, his shirt was open on his chest, a button was missing on his jacket, and his socks had slumped over his shoes, whose untied laces dragged on the floor. It looked like he had just been in a fight or an accident."[195] What demon had possessed him so that he had nothing else to offer in society except for his "anguished gaze, his crazed smile, and his forehead dripping with sweat"?[196]

While Tian's family shone by its taboos, Cri's family established itself by its inability to communicate love to him except in the form of slightly annoyed judgments. The affection of his father, André, always suffered from management problems connected to

the disorderliness in which, like Diogenes in his barrel, Cri had made his nest. And, after the death of his mother, Marthe, his father got remarried to his secretary. According to Boris Kochno, she was a calculating, pragmatic person. He added, perhaps because of jealousy, that Bérard hated his stepmother. The only relative who understood Cri was apparently his aunt, probably because she was the crazy one in the family. Bérard soon left the family residence to live with his lover Boris. He would always fear being judged by his father, whom he didn't really have the time to get to know: "What are you doing, my dear Papa, I'm thinking of you and your solitude."[197] The isolation that his father ended up enjoying was ultimately the most valuable thing he transmitted to Christian: "You know, I'm still just as uncivilized, and nothing makes me as happy as a day by myself and dinner alone with a book."[198]

Dior had not cut ties. But both Cri and Tian were marked by the lack of understanding that families at the time often showed to their homosexual offspring. These two young men were confusedly searching for guides, spiritual fathers. While Cocteau had made Bérard his new Radiguet, Dior found a mentor in Jacques Bonjean, who had become an art dealer. Like him, Bonjean had suffered from a puritanical education: "For a long time, I had imagined that eyes that upheld the law were watching behind his glasses. They spied on me. They saw my sins."[199] Friends or lovers? The glances they shared indicated the extent of a closeness that went beyond professional collaboration. In *Les Mains pleines*,[200] his first (and only) novel, Jacques Bonjean concealed himself behind a female character. Married to the heiress of Lip watches, he found in Dior a convenient replacement for Maurice Sachs, who had converted to Catholicism and then been expelled from the seminary because of his sexual orientation. The Sachs-Bonjean pair had still had time to publish, in 1927, *Le Livre blanc*, whose first printing, in a limited number (thirty-one copies), did not mention the name of the author, Jean Cocteau. Jacques Bonjean and Christian Dior had grown up in the fear of sin, but still kept from their childhood the enchanted memory of those embroidered, sequined frills "stuffed with camphor" in their storage

boxes. "I would have liked Maman to lend me her outfits so that I could wear them as costumes. But she was jealous and careful with them. She wouldn't let hands other than hers unfold them when she wanted to check on their condition, and then she would put them back herself in the box, with gentle movements the way one puts a sick child to bed."[201] It's always behind a mask that we have to persuade ourselves to exist. His gesticulations to assert himself annoyed many: "Fed up with the Jacob comedy at the Bonjeans, worse than the Verdurins," notes René Crevel.[202]

Tian had been religious by duty since his earliest childhood. He carefully followed what his parents had taught him, respecting the commandments of the religion of Jesus Christ. He did not wish to disturb anything or overstep in any way, simply trying to hold his head high and not to disappoint. "Dior is a gentle, pink young man. [_] Extremely proper and reserved. He is not handsome and seems to be of rather modest intelligence, but he has the thin-skinned sensitivity of a lady, and his love of painting is sincere," Julien Green remarked.[203]

The young man from Normandy with the pink complexion took on the color of the bouquets of his childhood: a light incarnadine like the rosebushes known as "Maiden's Blush." This Belle Époque sensibility cut him off from the immediate present, and Dior did not hide his aversion to the apostles of the avant-garde: "Modern art still had the feeling of a black mass."[204] Obsessed with the urgency of setting up the new order, the enemies-in-chief of decorative arts wanted to eradicate all traces of a past that moved him: "Bonnard, Vuillard, Ravel, Debussy, seemed too vague, a bit out of style."[205] The "taciturn Norman" could not embrace this aesthetic of demolition, rationalism, reinforced cement, raw wood, this "poverty for billionaires" that would be seen in the skillful styles of Gabrielle Chanel, the head architect of the "robot woman":[206] "The woman of 1925, wearing a hat pulled down over her eyes, belonged to the silhouette of machines, which were at the time idols reigning over both music and furnishings."[207]

The first one to dress society women as maids severely clothed in black dresses with three holes, Gabrielle Chanel had drawn

Christian Bérard into her net. They posed together in Deauville like twins, in pants and white tops. In Paris, the Amazon gave herself over to tenderness, her head on his shoulder. A rare moment. He sketched her in charcoal. And it was during a reception that the designer gave in honor of the Ballets Russes that he met Kochno for the second time, in June 1929, in front of little carafes of vodka and casks of caviar where they both dipped their soup spoons. Like Cocteau, Chanel – who put up a white and gold tent to receive eighty guests – was able to skillfully bring society people and artists together. With little taste for society gatherings, Dior anticipated, twenty years in advance, that Chanel would become his greatest rival.

As for Bérard, who had grown up among death announcements and eulogy bills, he had spent too much time around men of the Church to allow them to preach to him. Too many crosses, too many coffins of polished oak with panels, lead, or pine, too many interior satin linings, too many funeral processions. So he caricatured his burial by drawing a funeral procession, with a van in the shape of a black canopy bed. Although he fled the family background, it came back to him like a bad dream. In the "huge blue eyes"[208] that Christian Dior spotted upon their first meeting, there was always an annoyed azure gaze, like the sky whose torments and hopes his father had expressed to him from afar, during the First World War, on French blue writing paper.

One painting after another seemed to be a delayed transcription of his father's fear: "All of Europe is aflame. The human race is struck with madness. We call them Krauts and they call us pigs. The Bulgarians want to crush the Serbs who want to crush the Turks. This madness is contagious and the beautiful years, the sweet hours move on, we will never get them back."[209]

From these tragic visions, Christian made textures that he extended frenetically: with him, "red once again resembled blood, becoming a color at once primitive and refined."[210] And this famous Bérard red, either scarlet or ruby, soaked in light or darkness, was primarily a theatrical color: the slit-throat red of draped velvet, surely

I had become a designer who no longer waited in the antechambers, but whose visits were expected.

Christian Dior

Now I demand to be considered a painter and require people to have some measure of respect for me.

Christian Bérard

that of a jeweler's window, in front of which there passes, her coat just sketched in pencil, her head delicately haloed with black butterflies, a certain "Madame de _." In this watercolor from 1930, titled *Élégante*, could the red color spreading in a dark puddle be the blood of Marthe, who was found motionless in her white dressing gown? Her "bad blood"? Marthe, his dead mother, standing for always. Marthe had signed her love letters to her future husband "the little white mouse." Often, Cri seemed to invoke her presence: she lived in the final *d* of his signature, a heart bristling with a little tail.

Dior had dared to talk about architecture; he was rebuffed by his family. And why did he let people think or make them believe he was married? Was this a mistake by Green? Dior led them down the garden path. Ultimately, what future plans did he have in mind? His connection with Jacques Bonjean gave him the strength to deploy a newfound boldness. "Since my new life was more austere and allowed for meditation, I reflected on the profession that I would need to pursue upon my liberation. I decided for the wisest one, that is, the one that could only seem the craziest to my parents: operating an art gallery!"[211] Who could say that he wouldn't become the equal of Daniel Henry Kahnweiler or David David-Weill and other dealers who were making Paris the capital of modern art? In fact, his gallery was just steps away from Paul Rosenberg's! He set up shop with Jacques Bonjean at 34 Rue La-Boétie, in the eighth arrondissement. While Bérard strolled around freely in "the dark, run-down, nameless streets of the working-class neighborhoods,"[212] dropping his luggage and easel at the Marquis Hôtel at Place Pigalle, Dior, for his part, never ventured far from the beautiful streets of the west side of Paris. However, according to Madeleine and Maurice Dior, their last name was too valuable to be compromised in an unworthy venture: they forbade him to use it. The axe fell: "my name could never appear in the name of the business."[213]

"Dior ham." With Bonjean and Colle, Dior faced jeers and criticism without batting an eye: "Our ambition was to show, alongside our favorite leading painters, Picasso, Braque, Matisse, and Dufy, painters we knew personally and already valued a great deal:

Christian Bérard, Salvador Dalí, Max Jacob, the Berman brothers."[214] Their competitors could have been worried. But they just welcomed them with relative indifference. A dangerous revolutionary in his family's eyes, Dior looked like a mere novice to these art lovers, who were barely bothered in their negotiations by this pair of over-eager intermediaries: "Yesterday, spent an hour with the painter Tchelitchew, who lives in a little apartment on the sixth floor of a modern house in Grenelle. I knew him already, but not very well. *Unfortunately* Bonjean and Dior are there too buying paintings *for a very low price*... Since my presence bothered them while talking business, the three of them left me for a moment to go talk in the anteroom while a fat young American (Tchelitchew's lover) chatted with me so I couldn't hear what they were saying."[215]

Did Dior inherit his father's business sense? In any case, he was much more aware of the value of Bérard's paintings than the artist himself was, since he usually gave away his artworks out of "kindness" instead of selling them. At the First Hôtel on Rue Cambronne, a two-bedroom apartment that would become his home/studio for ten years, drawings were scattered on the floor. Some people picked them up, or they might serve as wrapping paper for pieces that, according to the artist, deserved to be given as presents. "He made me a gift of an admirable little painting (portrait of a young man seated at a table) that he himself admired very much as he gave it to me, but his lack of modesty is so natural and there is something so childlike about it that it amuses me instead of displeasing me,"[216] wrote Julien Green, who was judgmental and touched at the same time.

Decoy gallery

When he painted, Christian Bérard was like a man possessed. He seemed to struggle with an outside force, a Horla from whom he would protect himself, entrenched behind his bushy elf's beard and his repugnant dirtiness. "I felt I was no longer alone with Bérard,"[217] Kochno recalled, describing his first sitting. "It seemed that an

occult being was helping him in his work, guiding his left hand that handled the brush, or holding it back halfway when it moved toward the canvas. Bérard seemed to follow the advice of someone who was behind him speaking in his ear, for, at times, he stopped working, turned around as if to listen to what he was saying, and then exclaimed, stomped his foot, and started painting furiously once more."[218]

Christian Bérard described his paintings as his "children." In this way, collectors' interest in them showed a kind of understanding: "I am deeply moved… You know how much I value your judgment and how I can be proud of the affection that you have for my paintings,"[219] he responded to Julien Green. Alas, at Galerie Bonjean, the profits from the sales of his artworks did not seem very encouraging. Bérard was more agitated than ever. He was poor and in debt, but he refused to let himself be restricted: "The portrait that Emilio Terry commissioned from me will earn me money but it annoys me very much to ask him for an advance on this commission or to bind myself to dealers by asking them for money," he admitted to his father. "I owe almost 2,000 francs and you are my only hope."[220]

In this way, after the snare of drugs, he would become caught in another trap: private commissions emanating from the "upper crust" that his friends mocked so much. "I'd really like to see the frescoes in the Polignacs' dining room! But without setting foot in the home of that lady whom I hate. What can I do?" Jean Desbordes asked him, showering his "little Bébé" with compliments that came too late: "I never dared to write 'genius' about you, something that no one writes anywhere."[221] And, while he no longer inspired the admiration of art critics, Bérard found consolation in high society through commissions and the money they provided to him. He did a fresco for the Noailles in Hyères and a portrait of Jean de Polignac – a portrait which would in fact cause him some problems: "I had started a portrait where he was white and pink and then he came here looking like a Negro because he had gotten so tanned on his boat and I would have had a lot of trouble making it match,"[222] he complained to his father. "I need money for the train, packing the canvases, and the hotel bill, which is not completely paid. I need

3,000 francs. Try to send me the money here. You would get me out of a temporarily tough spot. I've been very serious and very economical, dear Papa. And think of your son who is fond of you and who is ashamed to cause you this trouble again."[223]

As at the end of his letters to Boris Kochno, Bérard seemed to always be saying "farewell and see you soon."[224] His ease in the upper crust was, however, only one mask among so many. His drafts of postcards to Marie Laure de Noailles written in the artificially spontaneous tone that society people assumed are sufficient proof of his discomfort. Between evenings at the Villa Blanche with the Bourdets and his daily opium pipes, Bérard bubbled, radiated, exulted, lamented, and made Cocteau's definition his own: "Opium is yourself, but better."[225] He was at once the eternal child full of wonder who wrote to Kochno that "the only beautiful thing is light"[226] and the man broken by solitude and the "torment of work."[227] His insatiable appetite and his addiction to smoking the little brown balls wore him out more and more every day, torn as he was between making models for the Ballets de Monte-Carlo and producing paintings, high society and silence, the scenes that Cocteau caused about his "selfishness." Bérard always felt hunted, in withdrawal. He said that he was afraid to go into the Musée du Jeu de Paume, "because you have to cross a big open space all alone."[228]

Bérard arranged his fears himself. He was a man of wonderment followed by abandonment. The painter of an impossible time that lasted because it hadn't begun, shot through with instants that he caught in flight, an inspired predator of dawn and fiery twilights. "The landscape becomes more and more beautiful – with all the colors, it decomposes as if it were going to be sick with fever – and evening falls quickly."[229] In reality, he did not manage to fulfill his commissions. He never found the right time to get started on them, so he disappeared, still waiting for the moment of grace when, with his mind free, he would be rid of the demons that had always gripped him. Naturally, these demons were "this very troublesome insomnia" and the "dark thoughts"[230] that he had dared to tell his father about ten years earlier. And when he had time, he preferred to use it for

other things; he received plentiful invitations, which diverted him from himself.

Dior and Bonjean displayed it 34 Rue La-Boétie "at the bottom of a dreadful cul-de-sac."[231] Bérard disoriented the experts but touched sensitive souls. "Real or unreal, his figures impose their presence on the viewer, who is like a seer. They take part in his life. They communicate with those around them."[232] That is why some people kept their eyes open for him. Marie Laure de Noailles played this role. In return, Bérard was able to reveal her sensitivity without using artifice. His piercing eye saw the lovestruck woman doubly betrayed by Jean Cocteau (who nicknamed her "nez Bischoffsheim," meaning "Bischoffsheim nose," a pun on "née Bischoffsheim"), from whom she had commissioned *Le Sang d'un poète*, and the deceived wife and unwilling mother. Unlike Balthus who would depict her as a pauper in front of a modest kitchen table, or Dali, who would bamboozle her with paranoid-Surrealist accessories, Bérard painted the extremely wealthy heiress with bare arms in a sky-colored dress, as if innocently flying over this world that judged and condemned her. Indeed, *L'Âge d'or* – the film by Luis Buñuel that she produced with her husband, Charles de Noailles – had caused a major scandal. Considered "blasphemous" and "Judeo-Bolshevik" by French conservatives – *Le Figaro* called it "l'âge d'ordure" – it was banned from the theater by the prefect Chiappe. Marie Laure was "Marie-l'or" ("Marie-Gold") with dark curls, both angel and demon of the Parisian upper crust, whose "plaintive eyebrows"[233] Bérard painted.

Nicknamed "Vicomtesse Medusa" by Cocteau, she was a predator with filaments so transparent that they were invisible. That worked out perfectly: "Bérard's figures look inside. These animated puppets have a heart, a brain. Without even realizing it, they communicate to us the contents of the collective soul. They connect us to their illegal life, to their murky existence of specters, shadows, ghosts who have taken on a physical appearance without ceasing to be themselves."[234] This time, however, neither Marie Laure nor her daughter Nathalie, her head tilted in space, looked at the painter straight on. What dominates in the painting are the planes of color, this burnt-red canvas, on which Bérard created a

shimmering presence wearing a sleeveless dress that was sky blue blended with the sea. The skin is so delicate, so silky, that it lights up everything. This radiant starkness echoed the sanded wood of Jean-Michel Frank, who decorated the grand salon and the smoking room of the Noailles mansion at 11 Place des États-Unis. He skillfully made the material stand out, without decoration, rendering the walls invisible by covering them in parchment. "The silent but profound revolution that someone like Bérard accomplishes includes no explosions, no breaking of glass, no manifestos, no mottoes, no attacks on government security. It's a revolution that goes unnoticed by the most skillful sleuths of painting," Waldemar-George had predicted.[235] In the grand salon, the portrait of Marie Laure presided above the gypsum mantel; and it was as if Bérard had painted the memory of Laure de Chevigné, Marie Laure's grandmother and the descendent of the Marquis de Sade, Proust's "bird of paradise" and the model for Oriane de Guermantes, who had already been sketched out in *Le Banquet*: "You think of a dreaming bird on a thin, elegant leg."[236] In Marie Laure's dress, shadows moved in the wind. Bérard, the "beautiful sea animal of the Seine," in the words of his female friend, played with his models. We see him in an ink wash drawing: his eyes stare at us, motionless, next to Marie Laure, who is also seated, but this time without a face. Who is who?

In the immaculate paradise of ghosts, truth converses with lies. Together in a quartet of plastered sheets, Jean-Michel Frank, Boris Kochno, Marie Laure de Noailles, and Christian Bérard dressed up as statues for Comtesse Pecci-Blunt's White Ball in June 1930. Here they are, Cocteau's beloved circus performers. In Man Ray's lens, they recognized themselves in these games of concealment, white as the rooms of Jean-Michel Frank, like the "lost islands"[237] where "Bérard places shipwrecked figures on the sand."[238]

With Frank, blocks of rose quartz had replaced andirons, the mineral luxury of near-nothingness had outmoded opulence as much as metal tubing. Silence was light, dissolving the space where a dozen Corots, a Delacroix bather and a Courbet landscape glowed in majesty. The emptiness might have been these antique

gold snuffboxes, this cigarette holder decorated by Bérard for Marie Laure, present on the table one evening and absent the next, stolen during the night. Gone, like good taste, principles and all the rest. Dior wasn't invited, why should he have been? The world dreamed of enchanters, not salesmen or assigned attendants, like Kochno, "who are mistaken for flunkies."[239] Besides, at the time, Dior didn't exist to disguise itself outside its circle of friends.

Far off, a wave was coming. The end of the 1920s brought upheaval, and the family secrets that the Belle Époque had concealed in its feathered hats and multicolored enamel exploded without warning. Among all those lonely recluses raised behind invisible prison bars, there was one whom Christian Dior had grown up with: the fourth child in the family, his brother Bernard, who was five years younger. Described as an "unusual and endearing child"[240] by Madame Lebrun, one of the housekeepers, he could have been one of Bérard's spectral figures. Bernard was there; Bernard was gone. Bernard floated, failed his baccalaureate exam, and had multiple crises, ranging from agitation to listlessness. "In December 1930, while his brother went skiing in Saint-Moritz, Bernard left for Megève. He came back three days later, having abandoned his sporting equipment and asking his father for money to go to Switzerland,"[241] observed Dr. Marcel Montassut, who had been treating him since 1927. "When his father refused, Bernard became uncommunicative. Since then, alternating periods of excitement (with ideas of persecution, grandeur, and influence), depression (ideas of influence, self-accusations, ideas of suicide, muteness), and mysticism."[242] Day after day, week after week, month after month, his condition only became worse. In the medical file of L'Estran hospital, it was noted that Bernard Dior was homosexual. The fear was there, amplified by the feeling of being different within the society in which he grew up, another source of shame. A homosexual caught by an unmentionable family defect. Christian watched this decline powerlessly. It was as if his own mother, unable to resist the tide, was drowning, entangled in her long black dress. Sometimes, he was overwhelmed. It was only a nightmare, a bad dream. Thus ended the carefree years, taking with

them Magic City and its flying woman. The reality of the world was spread out before him and began to fall apart, like a painting by Bérard, an artist who came under fire by critics.

Although Dior continued to defend it, the art of Bérard, "a chubby baby with puffy eyes, swollen cheeks, an ungainly boy who lets his arms hang down like columns,"[243] provoked a degree of scorn from others: "There is a certain impoverishment and pity in his work. I like him less in the scenes of the past and ancient times. He shows the influence of Picasso, but that has to end. His harlequins are inferior to those of the Spaniard, more theatrical, less painful and agitated."[244] "Poupard" meant a chubby baby. That was the real last name of Henri Sauguet, Dior's friend who had first mentioned Bérard's name to Diaghilev. Salvador Dali would be the first to criticize the "lamentable state of obesity of today's phantoms," calling immobility an "exhibitionist collapse."[245] Was this an attack on Bérard, who "talks about Dali's wonderful instinct, as mad and complete as intelligence," while still believing him "mad"[246] and envying him?

The references to Poussin and the masters of the Italian Renaissance no longer seduced. Painters were some of his leading critics. In addition to Picasso and Tchelitchew, there was Alice Halicka, a Polish artist who, like Bérard, studied at Académie Ranson, back when he was "slim, pink, and clean-shaven."[247] She first perceived him as someone who painted "strange and morbid psychological portraits, but who likes drawing dresses a lot."[248] For a while, she was an adherent of Cubism, but ultimately rejected it. She illustrated *Enfantines* by Valéry Larbaud and began making little figurative paintings using pieces of fabric and cardboard, which were similar to three-dimensional Art Nouveau postcards of the seaside. These naive depictions were quite different from the work of Bérard, who attempted to find "in the human face, in the interpretation of a neck, an arm, or a hand, all the painful mystery that nature can put into our muscles."[249]

The axe fell. "He tells me that he only goes into society to see his paintings again and to find houses for them where they'll be warm, where people will love them. He has managed to win over a

wide circle of society people. His punishment, if there is one, is that this circle will close over him like a prison."[250] Named deputy conservator in the department of paintings at the Musée du Louvre in 1930, René Huyghe vehemently criticized the trend of "salty arid dunes where the stooped figures of Léonide [Berman] pass by" and "the anguish of the interior void of all these figures leaning on their elbows, tired and pensive, with their vague or dilated eyes, the most terrifying examples being *Damia* by Bérard and *L'Hiver* by Gruber."[251] Even flattering comparisons were a burden: "In Bérard's portraits, the desire to express interior life recalls the portraits of Degas. They have the same heavy eyes, the same pouting mouths, the same indecisive and melancholy expression of worried questioning."[252]

When Bérard sank his teeth into you, he didn't let go. For it was the same René Huyghe who had sponsored Christian Bérard (as one of five painters) for the Grand Prize in Painting held at Galerie Georges Bernheim, "in order to highlight the best artists who have just begun to be known recently."[253] This group was made up of Aujame, Chapelain-Midy, Holy, Brianchon, and Bérard. But Bérard, "whom he had first indicated, withdrew, judging with humility that it was too soon for him to come out of the silence in which he wishes to work."[254] Bérard's intransigence toward Cubist formalism continued to make things hard for him. But he didn't give in. "What is his secret? It is not the haunting mystery, the obsession of the madman who flees his shadow. It is the latent anguish of the wise man who asks questions."[255]

Opium and demons

Dior had become an art dealer in spite of himself. The suits he wore and his neat haircut had still not given him the confidence he hoped for. He lacked assurance and experience; he had neither the physique of the red-blooded young men and pretty boys who fascinated his set, nor the gift of gab required when attending posh affairs. He had nothing: no aristocratic name, no eccentricity, no sign of success, except for his good manners, which sometimes made him look

like a sad young man. As for Bérard, he had already given himself over to the theater of his own destruction: "I saw Bébé last night. Very nice, but his work is going nowhere,"[256] wrote his cousin Jean Ozenne to Henri Sauguet. "Tell Bébé he's a bastard. I wrote him two postcards. He didn't write back. I'm crushed."[257] His attitude worried those around him: "Bébé went to the South to work. [...] I still don't have any news from him."[258] "Saw Bébé who is working pretty hard and made two nice paintings. Boris Kochno still has grandiose but vague expectations."[259]

The year 1930 had begun in the twilight atmosphere of *La Voix humaine*, Bérard's first theatrical collaboration with Cocteau, followed by his first choreographic experience produced with Kochno: a "pursuit of the impossible" animated by "the melancholy poetry" of a setting without joy. "Bérard has created the anguished atmosphere of his paintings. The run-down street of the setting seemed to belong to an abandoned city where the dancers, in rags, looked like phantoms materializing from the fog."[260] The reviews were poor. Plus, Dior witnessed a quarrel between Bérard and Sauguet, who felt humiliated to have seen his role as composer overshadowed by *La Nuit*, the performance in London that gave Bébé top billing in March.

Élysées 57-20: the telephone at Galerie Bonjean began to ring less and less. The death of Diaghilev on August 19, 1929, the death of Jacques Doucet on October 30, and the crash of Wall Street tolled the end of many illusions: "1930. Coming back from vacation, one sign affected me more than the stock market crash. In the empty house, a mirror had come unattached on its own and smashed on the parquet in a thousand pieces."[261] The time for bartering had begun: on July 29, 1930, Galerie Bonjean traded three paintings by Bérard and a drawing by La Fresnaye for *Ruelle des Gobelins à Paris* by Utrillo, a painter of the Paris School who had just been awarded the Croix de la Légion d'Honneur by the French government. Something that would keep its value during an uncertain time? The estimated sum of the transaction was 18,000 francs.[262] It was the beginning of the end. But Dior didn't want to give up. He associated himself with a young poet whom he met at an exhibition by Max Jacob, the disciple

of the author of *Cornet à dés* who had just moved from the countryside: Pierre Colle, whose portrait as a cross-dresser Bérard painted. "He would soon have to give up poetry for art dealing. His flair, his intelligence, and his business sense brought him remarkable success, which was, alas!, shattered too soon by an early death. We quickly became very close."[263]

So now Dior was engaged in a new adventure, alongside the man whose brilliant rise was chronicled by Jean Hugo, a newcomer to his "stable": "[Pierre Colle] had come from Nantes to Paris with a few gouaches that Max Jacob had given him. He picked up the phone book and started asking for numbers at random. If someone answered, he would say: 'I'm twenty years old, I'm a poet, and I'm selling paintings.' Fifty or a hundred times, people would hang up, with or without swearing at him. The one hundred and first time, someone answered: 'Well, come and see me on this day at this time...' It was M. Doucet. [...] Pierre Colle's fortune was made."[264] How could Dior resist the charm of someone who believed in chance just as he did? This time, hope was lodged at one end of a dead-end street off Rue Cambacérès, while Galerie Bonjean scraped by "with losses, then seizures, while still continuing to hold shows of Surrealist or abstract art that scared off the last art lovers."[265]

For Bérard, the year that ended with the death of Kit, an opium addict like him, announced other trials. The upper crust fascinated him: "He describes an apartment whose dining room he is decorating on Avenue du Bois. The living room is all white, with bronze doors that have the reflectiveness of the armor of Giorgione."[266] Despite all that, Bérard would have liked to be left alone. For he already knew that he was gripped by a demon, torn between the desire of being invited, recognized, paid to support his daily addiction, and the impossibility of devoting himself to his painting. "Already in extremely difficult conditions, I did my best. Now I demand to be considered a painter and require people to have some measure of respect for me."[267]

Frank wrote letters to Bérard complaining about his delays. Meanwhile, Dior was too concerned with his own dramas: "Misfortune was entering our happy, protected family. My brother was struck by

an incurable nervous disease. My mother, whom I adored, suffered privately and died of grief."[268] All too soon, Marie Madeleine Juliette Martin, the girl from Anjou with the sad look in her eyes, who was raised alone by her mother, was gone forever. The woman who had dressed her eldest son up as a girl and dreamed to see her Tian speak with powerful people. Christian Dior's hell was beginning. But this hell would save him by forcing him to be born again, i.e., to emerge from himself: "if he hadn't been ruined in his youth, Christian would have been a dilettante and a patron of the arts whose name would never have been spoken."[269]

Dior plunged into an abyss that the world of Bérard, who was like a hero "deafened by the icy grasshoppers of drugs," seemed to have foretold: "Was that the ideal atmosphere for a delicate mother who feared germs and drafts?"[270] Madeleine Dior, his mother, was gone. For a long time, Tian would keep like a relic the very straight dress that she had bought in Paris from the couturier Perrault. Can one keep vigil over a dress as one does over a body? Whatever the case, May 4, 1931, was a dark day, in a painful context, which was marked one year later, on May 20, 1932, by another death, that of Lucien Dior, his father's cousin. One tragedy following another, the Dior family seemed to have been swallowed up into a painting by Bérard "with strange, melancholy figures painted on a background of gloomy skies or dilapidated walls."[271] Christian's younger brother Bernard sank into depression. Sent to England, Switzerland, and finally to Schaerbeek, Belgium, he was committed to an insane asylum called the "maison de santé de Maeek" to be treated for the strange illness that was consuming him. "An affected attitude, strange, incoherent facial expressions, negativism, refuses obstinately to answer even the simplest questions, yet obeys orders commanding him to do the most ordinary actions."[272] The Dior family was in a morass, as if sucked into the white backgrounds of Bérard, which cause so much unease, because they display human beings in all their solitude. His "strange apparitions of half-disembodied living beings, sometimes in costumes but with their faces showing, beset by demons,"[273] offered every viewer an awareness of his own deprivation.

Coup de grâce

With his real estate investments reeling from the financial crisis and "Black Thursday" on Wall Street, Maurice Dior was ruined. He could no longer pay the large loan that the insurance company La Séquanaise had given him to build four apartment buildings in Neuilly: over nine million in payments. His stocks were not even worth the paper they were printed on. This time, it was bankruptcy. Clocks, sideboards, chandeliers, the inventory of the estate of Madeleine dated August 13, 1931, exposed the family's belongings. Like a Belle Époque landscape painting, it was an entire life that went askew and shattered on the floor. The broken mirror in the living room was indeed a premonition. Christian Dior kept a Christ under glass, English china with flowers, two medallions featuring Eugénie, the wife of Napoléon III. He still had the fawn-colored velvet dress that he would keep for a long time like a relic. And the bridal bouquet with its delicate white silk flowers.

For this privileged son used to wood-paneled living rooms, it was the beginning of his Parisian wanderings, with humble lodgings in an attic room in Passy. Among artists, Bérard was not the most cooperative. "Bérard's feelings for himself in front of his paintings were dominated by humility and modesty,"[274] Boris Kochno recalled. "Instead of showing his paintings, he hid them the way one hides his nudity. The sound of footsteps, a hand knocking on the door of the place where he was working – which was never a studio, but his bedroom or a hotel room – were an alarm signal: the canvases were turned to the wall. No one was allowed to see them, and they weren't allowed to see anyone. Bérard shrouded in secrecy his encounter with the melancholy and infirmity of the world, which he painted like a conversation of lovers taking place in low voices."[275]

Although he exulted in public, Bérard was often difficult with those who came too close. For instance, he refused to illustrate *Mont-Cinère* by Julien Green: "I'd be happy to make drawings of *Mont-Cinère*, portraits of Emily, to stain and smudge them, but to arrange all that the right way bibliographically speaking, to engrave them,

that would become dead, lifeless, and you wouldn't have liked it at all ‗ I admire you and ‗ I'm sad that I can't control my nerves anymore, or be neater and more assiduous ‗ ." This did not keep him from profusely apologizing and feeling guilty. "The portrait had some mishaps, but, thank God, they've been fixed. In my hovel, I knocked over a pot of sepia and I had to remove the spots and harmonize everything… that's why it's late."[276]

For Dior and for Bérard, money problems were multiplying. On May 9, 1931, a new Bérard exhibition opened at Galerie Pierre Colle. "Opening tonight. High society wriggles around within our walls. Bébé flits around, friendly and smiling. Jacques-Émile Blanche appears, who for a long time held the scepter of upper-crust success. Bébé abruptly leaves Marie Laure de Noailles to greet this illustrious predecessor. 'Who is this fat lady?' Blanche asks in front of a painting. Bérard almost chokes – it's a self-portrait painted when he had shaved his beard."[277] Julien Green admired him: "Splendid. Bérard is there, a seasoned veteran, with the most touching courtesy."[278] During the opening, people noticed the presence of a man wearing a cassock, Abbé Morel, an evangelizing painter introduced by Max Jacob (whom the priest would describe as a "penitent in a pink shirt"[279]) into the bohemian Parisian scene. At the time, the Vatican saw its missionaries as a chance to reconnect with intellectual circles. With a broad forehead, a delicate mouth, and a square head, Maurice Morel stood out, with his reassuring physique, amidst all the thinness of the time. Dior had often seen this priest, painter, and art critic, following the Church's orders to win back souls in need of asceticism, at Hôtel Nollet, the Parisian meetingplace chosen by Jacob, the poet of Quimper, "Christian by rite and parish," outside his retreat of Saint-Benoît-sur-Loire.

For Abbé Morel, it wasn't so much to prosperity that Dior bid farewell. It was above all to the excitement of the 1920s, with its music and especially Le Bœuf sur le Toit, "which was neither a bar, nor a restaurant, nor a cabaret, but – which was – our youth, a stopping place, a prestigious amalgamation of forces and wonders, one of those saloons where gold prospectors gather. The gold I'm talking

about was the gold of the mind."[280] And, indeed, "the enchanting voice of Cocteau, which reverberated above the tables"[281] had been silenced. The author of *Les Enfants terribles* had just been laid low by typhoid fever, the same illness that had carried off Radiguet, the Cadum soap baby of literature, seven years earlier. He would not delay lighting up his little balls of opium once more and returning to the Villa Blanche – where, alas, the noose was tightening, as the police had already charged him once with "violation of the laws on poisonous substances."

Cocteau owed Bérard for having introduced him to the Bourgoint family, whose children inspired him to write *Les Enfants terribles*. In his descriptions, we find the influence of Bérard fading into a freeze-frame: "The soul of luxury crossed the stones, made itself visible, became the velvet that shrank the city, furnished it, enchanted it, transformed it into a ghostly salon."[282] Jeanne Bourgoint had killed herself. Bérard would seem to always be seeking these two children, whom he would find again, quite changed, in Les Goudes ten years later." You, Bébé, [Cocteau told him], the Surrealists say you paint ectoplasms, but it's not true."[283] Cocteau, "with his prophetic intuition," had sensed that Bérard was the "great painter of the human face."[284] But, in public, he sometimes defended his friend's talent awkwardly: "It proclaims him a true painter, like Delacroix."[285] The police were not there to decide. They had too much to do with law-breakers. Bérard knew he was spied on and watched. He and Kochno "are said to have been investigated."[286] In September 1931, his name would appear in a police report connected to the Clos Mayol. This was an awful ordeal for the artist "with the little green teeth."[287]

During this time, Christian Dior was plunged into another drama. His brother Bernard's condition became increasingly worse. In July 1931, Bernard stopped in every church to pray. He wanted to print a manifesto to the French people encouraging them to follow their religion more faithfully. The printer refused, causing him an emotional shock. He then would stay up all night praying, kneeling at the foot of his

bed. "Recently he suffers from evident auditory hallucinations, in which he is called to become the emperor of France or the new Christ. One day he completely shaves his head and lets his beard grow."[288]

In 1932, it was in the company of Bérard that Cocteau would produce his first fresco in the Villa Blanche of the Bourdet family, in Tamaris, in the neighborhood of La Seyne-sur-Mer, for an Art Nouveau ball. He painted himself "costumed as a granny, a terrible granny who looks as if she ate the wolf."[289] What was he hiding behind these trappings? Wasn't it the painter's body that he concealed while dressing him as a woman? You could not forgive the genius you have discovered for betraying his calling. In Paris, Gertrude Stein judged the defrocked painter harshly: "Bérard has the charm of his breed, and it may be that endlessly hesitating between the beautiful and the fashionable, he will finally choose the beautiful, but he is in danger of falling into the fashionable and staying there."[290] With her hand thrust "into the thick white fur of her poodle,"[291] she looked "strong and calm as a menhir: she could be ten centuries old, in other words, she has the serenity and youth of a mountain."[292]

In Tamaris, Bérard couldn't keep still. "By working day and night, I've got to finish the paintings." He ordered Kochno to go see Chanel: "Have her wait for us on a particular day for some work and have her give us some money, a little bit will do, you know how poor I am, but except for the train, enough for me to get back."[293] They both raced around independently, and Bérard sent a telegram: "Keep Chanel friendship and be careful during Jean's negotiations."[294] Bérard would officially be responsible for the staging of the wax mannequins for the "Diamond Jewelry" exhibition organized by Gabrielle Chanel. The fashion designer and patron had a sense for useful friendships. Ten years earlier, she had made the costumes for Antigone by Sophocles, adapted by Jean Cocteau — Mademoiselle's first immersion in art. Picasso had done the sets. In the midst of the Depression, Chanel wanted to "cover women in constellations."[295] Through her first collection of diamond jewelry, she established her forceful lines, full of motion. "If I have chosen the diamond, it is because it represents the greatest value in the

smallest volume. And I have used my taste for what gleams to try to reconcile, through jewelry, elegance, and fashion."[296] For his part, Bérard chose to place the jewelry on mannequins instead of in jewel boxes. Transformable pieces, with the center stones off-kilter and invisible clasps, these stars sparkled freely. Held to benefit the Société de la Charité Maternelle in Paris and private social aid for the middle class, this exhibition and sale in Chanel's mansion at 29 Rue du Faubourg-Saint-Honoré brought together forty-seven unique pieces made from gems provided by the International Diamond Guild. "47," a number that Dior would also make famous with the New Look (1947). On that same street, on April 18, 1946, he would also find a star, which would become one of his talismans. Having come detached from the wheel of a horse carriage, it was a little star without light, but full of promises. In June 1932, at the Théâtre des Champs-Elysées, Bérard triumphed with the sets and costumes he produced for *Cotillon*, a ballet by George Balanchine to excerpts of works by Chabrier, whose mysterious poetry the public applauded. Two protagonists, a man in a tuxedo and a woman in a tulle skirt "with bats' wings"[297] danced wearing black domino masks in front of the painted screen of the "Hands of Destiny." "At the end, they dragged Bérard onto the stage. He struggled a little and fled."[298] Somber omens?

For young Dior, the planets were misaligned. His ruined father watched as everything he had believed to be solid fell apart. A house of cards had collapsed. Christian, with his artists, had an uncertain future. Raymond was unstable. Bernard had become "irritable, impudent, and violent with those around him. He presents the classic signs of schizophrenia and refuses to eat."[299]

 The two friends then experienced a strange time. "Bérard has become enormous, his face shines."[300] It was a bad time for this because the body had never been so emphasized in fashion magazines. "July with a golden key opens all the doors to the city. People flee toward the beaches, toward the sea."[301] Traveling to Greece was popular again, and the Neptos company even took out a page of advertising in the magazine *Minotaure*. Draped in Roman crepe or

peau d'ange satin jersey, the women rediscovered the aura of the muses. "We have cherished you, frills, organdy, flounces, and ruches that wrapped us up delightfully. Let's say goodbye before it's too late."[302]

With his smooth, powdery sand, his shell dust similar to the white ash of the ages, Bérard had discovered, well before the fashion world took hold of them, these "surges of stars" and other "floating splendors," "this desire for sand and water" that *Vogue* would evoke in July 1933. But the artist whose "figures are arranged in empty space, the depth of space, like projections of dreams, like ghosts,"[303] was far from receiving universal acclaim. His "mental work," his "puppets that connect us to their illegal life,"[304] were intensely appreciated by Christian Dior. Surely he felt understood by these "strange, melancholy characters, painted on backgrounds of gloomy skies or dilapidated walls."[305] Kochno noted that they all had "a spectral appearance and the gaze of visionaries, intense and anguished."[306] Perhaps what Dior saw in *La Rencontre* was absence itself. Two barefoot children stand on the deserted beach. When Dior looked at the painting, he had the impression that Bérard made him turn his head slightly to the right. It seemed one could glimpse tombs: wasn't that the cemetery that can be seen from the terrace of Les Rhumbs? Christian Dior could not return to Granville without hearing the silence of the invisible. "Let the dead rise up," Bérard seemed to whisper. It was this devastated setting that allowed for the decisive encounter: his encounter with himself. Bérard confronted Dior with his truth.

From his scruffy body, Bérard had the gift of making clowns appear, his street artist doubles. This can be seen in his paintings *Carnaval* (1927) and *Jeune Acrobate* (1930). Under his gaze, his friends were changed into circus entertainers, like Cocteau wearing an orange ruff; or this portrait of Boris Kochno for which he had rented a yellow satin jacket in a theater costume shop; or René Crevel, his gaze sparkling with gouache tears. One of the first paintings that Christian Dior purchased showed, in fact, a young acrobat with black eyes: his athletic build contrasted with the gentleness of his clothing, the pale green jersey and tights, and the

small handkerchief that he held in his hands. It was as if, in a gaze, he had found, intact, the magic world of his childhood, sleeping inside himself like a princess.

In Granville, one world escaped boredom. It was that of the rag merchants and sailors about to set sail who became Pierrots or harlequins for a day. Ladies in finery, leaping puppets, dominos, troubadours, mandarins, anarchists, aristocrats, and witches and wizards set forth from the grain market toward Le Roc. The street children bombarded the carnival aristocrats with pig bladders filled with dried peas. On that day, Granville looked like a little Venice. The birth of Christian Dior had coincided with the revival of the parade and the brief reign of His Majesty Carnival III, Prince of Charenton, King of the Fools.

The lost kingdom of Magic City

The future absconded. While a dark curtain was falling onto Europe, Paris reinvented itself as Epidaurus. Neoclassicism was in the air. Dresses were rolled around the naturally deified body. The little wooden soldier no longer existed. The robot had turned into Mélusine. "The female body has abruptly given up the boyish aesthetic and turned toward delicacy. It has lengthened, melted, reclined without seeming sickly, for it has shapes that the eye had forgotten and discovers again with pleasure."[307] Prosperity had offered itself houses that could be taken apart and certainties of steel. Now luxury indulged in fleeing to an ancient imaginary world. Paris was barely flustered by the "Four-Power Pact" and the Reichstag fire, and mythology soon turned women into goddesses and the bas-reliefs of the Louvre into themes of inspiration. From Madame Grès to Madeleine Vionnet, the magicians of the bias cut revealed female androgyny, with ephebe-like shoulders, tanned legs, and softly crimped short hair. The transition was there. The female body had lost its flatness and dryness. Collars, flared coattails, soft rolling shoulders: Bérard followed these new broken lines, and his horizons seemed to endlessly escape, lighting his silhouettes with a ray

of moonlight or sunlight. His specters had become vestal virgins, their hair curled by Antoine, in living rooms of zenithal whiteness. On paper, his abandoned angels regained the liveliness that the canvas had absorbed. Bérard dropped painting for watercolor, ballet, and theater. His distant places had become illusions on the stage, which he turned into a palace, a park, a house, made entirely of trompe-l'œil fashioned by sensitivity. "Being true, whatever the cost, by any means, hitting the bull's eye, aiming at the heart, that is our only method, what Baudelaire called 'coming back to find asylum in impeccable naïveté,'"[308] *Vogue* wrote in May 1934.

Did Bérard find this sincerity in the Surrealist exhibition that Dior put on in June 1933 at Galerie Pierre Colle? Surely not. How could he recognize himself in *Tête couverte de trois objets désagréables: une mouche, une mandoline et une paire de moustaches* by Jean Arp, *Chaise atmosphérique* and *Planche d'associations démentielles* by Salvador Dali, *Pharmacie* by Marcel Duchamp, *Objet basé sur la perversion des oreilles* by Paul Éluard, *Saucisse-artifice* and *Rideau diaphane* by Man Ray? *Le Ruban des excès* by Yves Tanguy, which Marie Laure de Noailles purchased, appeared here in a nice spot next to three sculptures by Picasso. The gallery would soon close because of a lack of clients. Pierre Colle would partner with another dealer to open Galerie Renou & Colle at 164 Rue du Faubourg-Saint-Honoré.

Despite appearances, Dior never gave up his passion for figurative art, especially for the way that some artists painted not just nature, but their love of nature. He remained faithful to Bérard, Bérard the ambassador of a weightless country of chimeras and entertainment, who spread his celestial brilliance beyond his paintings, through his costumes and sets. In June, Bérard took flight again at the Théâtre des Champs-Élysées when George Balanchine and Boris Kochno founded Les Ballets 1933, a company financed by Edward James, Cole Porter, and Gabrielle Chanel, who was always ahead of the crowd. "A blue and yellow tutu and a purple maid, a mauve and gray character with a little black pillbox hat decorated with a red flame, and Toumanova's black sparkly outfit with a glowing touch of violet in her hair were all successfu."[309] The crème de la crème of

124

A taste for wonder

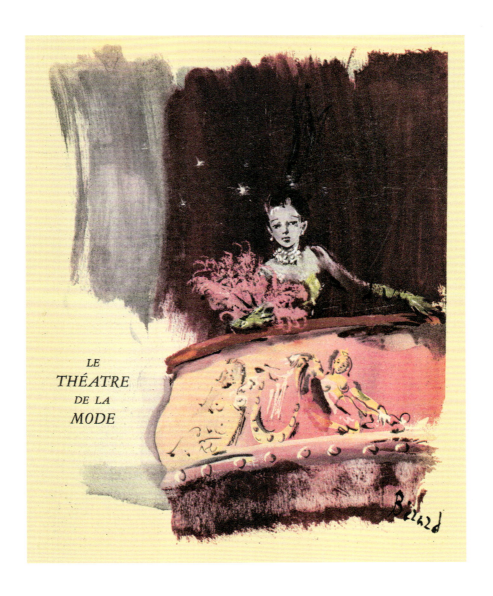

Christian Bérard, Cover of the program for the exhibition "Le Théâtre de la Mode" [Theater of Fashion] organized by the Chambre Syndicale de la Haute Couture [the trade association for haute couture] at the Musée des Arts décoratifs, Pavillon de Marsan, March 28 – April 29, 1945. Collection Catherine Houard.

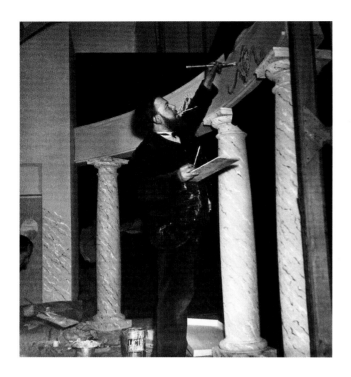

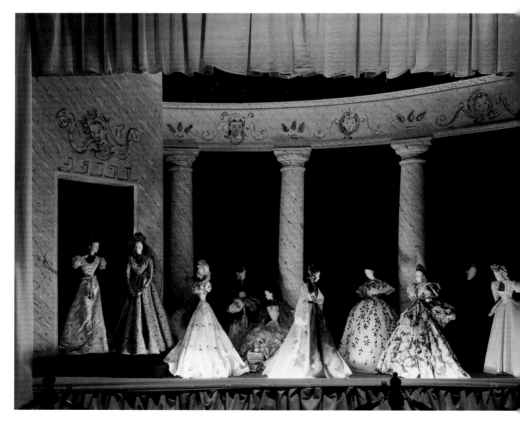

Robert Doisneau, Christian Bérard painting the sets for the exhibition "Le Théâtre de la Mode," 1945.

Roger Schall, One of the sets for the exhibition "Le Théâtre de la Mode," designed by Christian Bérard, 1945.

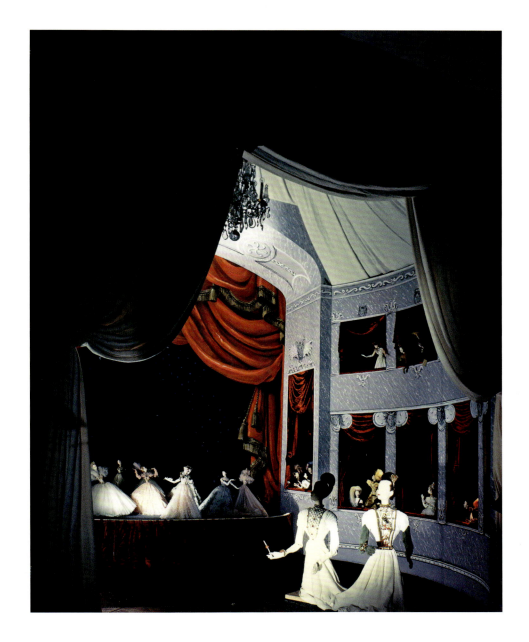

Horst P. Horst, One of the sets for the exhibition
"Le Théâtre de la Mode," designed by Christian Bérard,
published in *Vogue* Paris, 1946.

128

Anonymous, Christian Dior disguised as the King of Animals at the Kings and Queens Ball given by Count Étienne de Beaumont and his wife Édith, in Paris, March 1949.

Christian Bérard, Fireplace set for the film *Beauty and the Beast* by Jean Cocteau, 1946. Gouache and pastel on paper. Madison Cox collection.

Christian Bérard, *La Bête* [The Beast], 1946. India ink. Paris, Centre Pompidou, Musée National d'Art Moderne.

Christian Dior, Costume of the Brigand for the ballet *Treize danses* [Thirteen dances] by Roland Petit, 1947. Black pencil drawing. Granville, Musée Christian Dior.

Christian Dior, Costume of Death for the ballet *Treize danses* by Roland Petit, 1947. Black pencil drawing. Granville, Musée Christian Dior.

Christian Dior, Costume of Death for the ballet
Treize danses by Roland Petit, 1947.
Black pencil drawing. Paris, Dior Héritage.

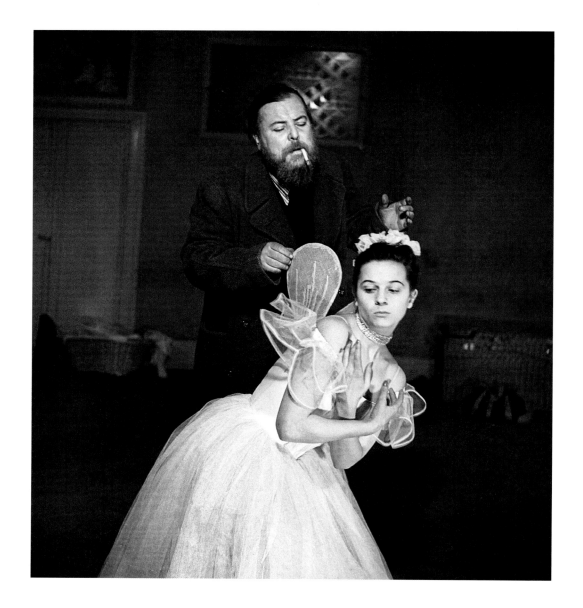

Boris Lipnitzki, Christian Bérard adjusting Hélène Sadowska's costume for the ballet *Treize danses* by Roland Petit, performed at the Théâtre des Champs-Élysées, Paris, November 12, 1947.

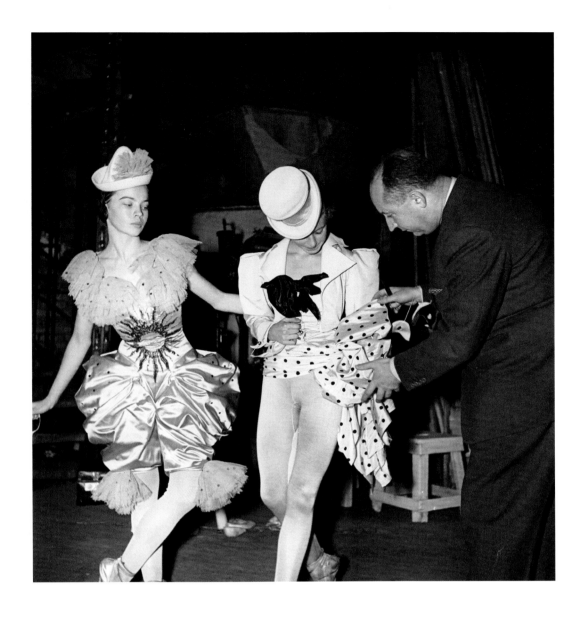

Roger Berson, Christian Dior adjusting the costumes
of Leslie Caron and Nelly Guillerm for the ballet *Treize danses*
by Roland Petit, performed at the Théâtre des Champs-Élysées,
Paris, November 12, 1947.

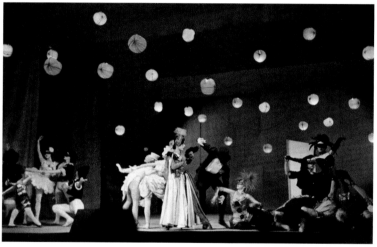
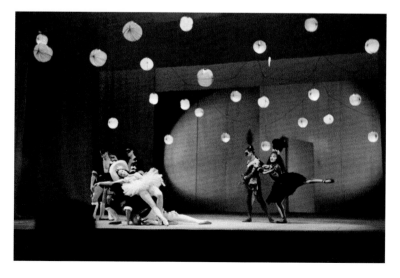

Frank Scherschel, Scenes from the ballet *Treize danses* by Roland Petit, performed at the Théâtre des Champs-Élysées, Paris, November 12, 1947.

134

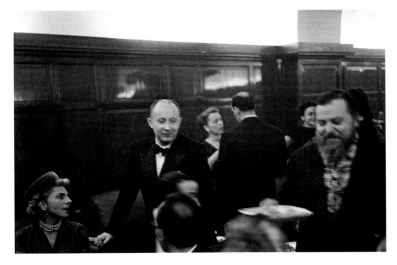

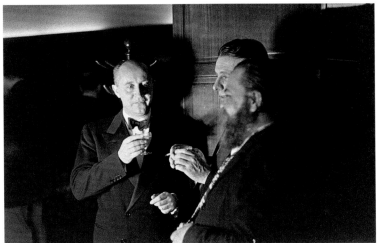

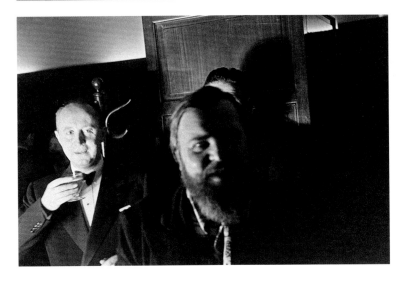

Frank Scherschel, Christian Dior and Christian Bérard after
the performance of the ballet *Treize danses* by Roland Petit,
at the Théâtre des Champs-Élysées, Paris, November 12, 1947.

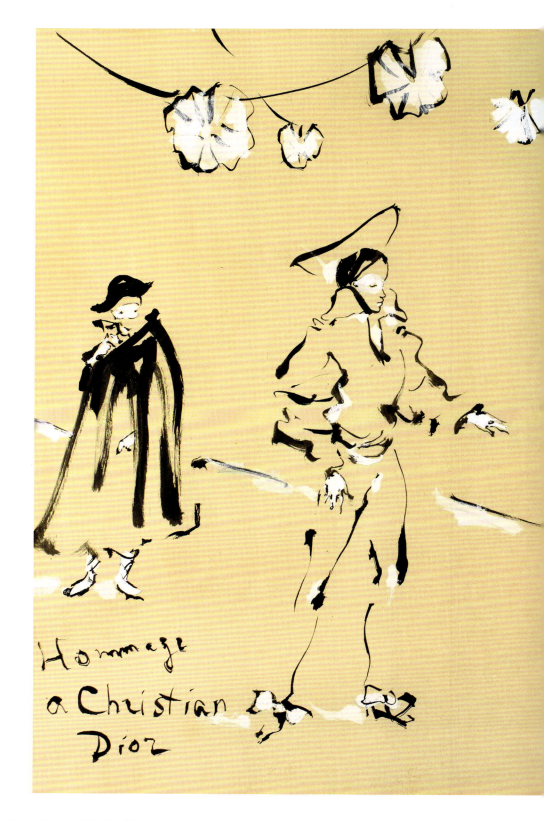

Christian Bérard, *Hommage à Christian Dior*
[Tribute to Christian Dior], November 12, 1947.
Gouache and India ink on paper. Paris, Christian Dior
Parfums. Former Christian Dior collection.

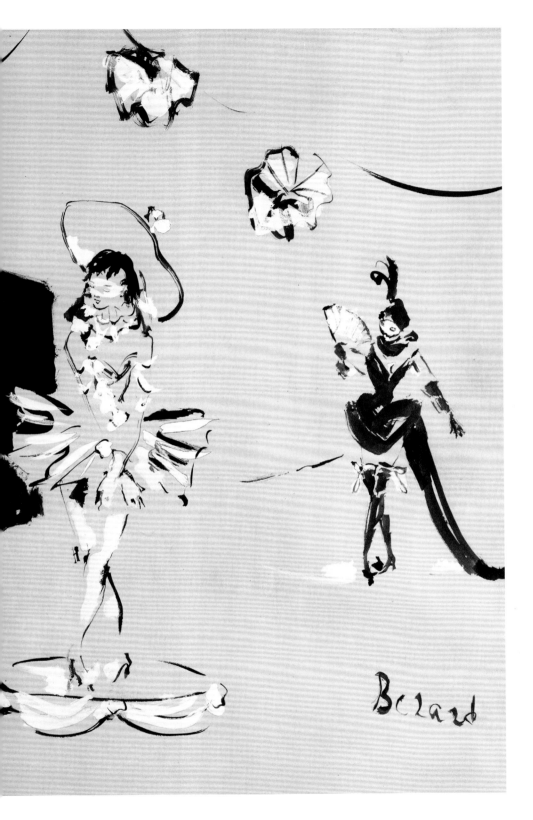

This drawing, reproduced in the center of the program for the ballet *Treize danses* by Roland Petit, in a printed version in black and white with gouache highlights in pink, represents the set and costumes designed by Christian Dior. It later belonged to Anne-Marie Muñoz, niece of Henri Sauguet, who made her debut with Christian Dior before becoming studio director at Yves Saint Laurent's haute couture house.

Brassaï, Christian Bérard at a costume ball, June 28, 1946.

Christian Bérard, Headdresses for *Vogue*, May 1937.
Ink wash. Private collection.

Christian Bérard, Disguises for a costume ball, undated. Gouache. Private collection.

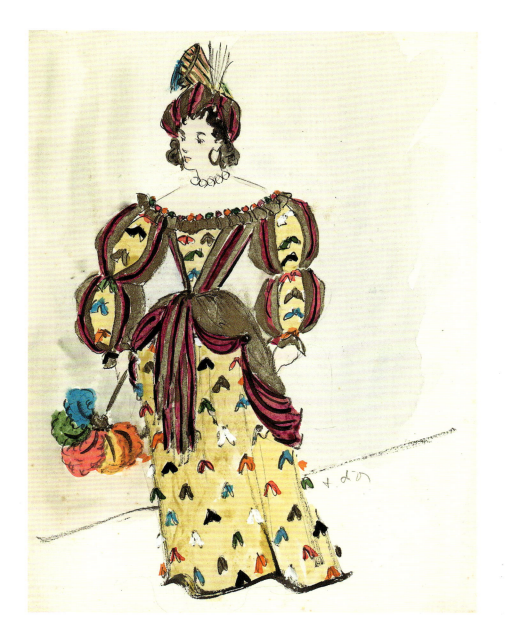

Christian Dior, Woman's costume project for the theater, circa 1945. Gouache. Paris, Dior Héritage.

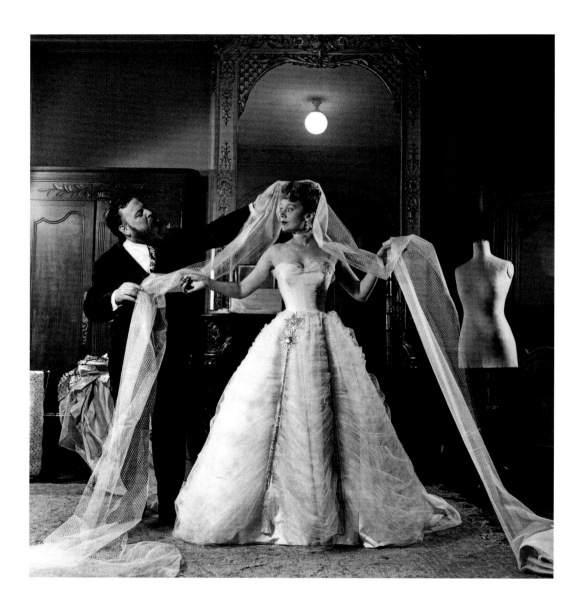

Willy Maywald, Edwige Feuillère at a fitting, dress designed by Christian Bérard for *L'Aigle à deux têtes* [The eagle with two heads] by Jean Cocteau, 1946.

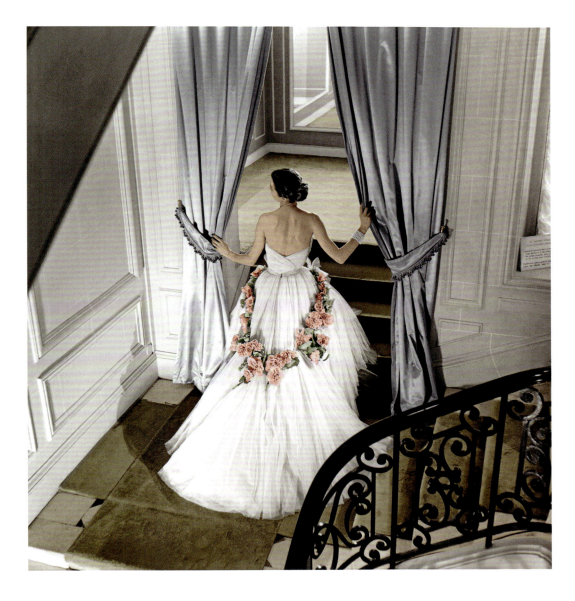

Willy Maywald, Grand gala dress *Tableau final*, at 30 Avenue Montaigne, in Paris. Christian Dior, spring-summer 1951 haute couture collection, *Naturelle* line.

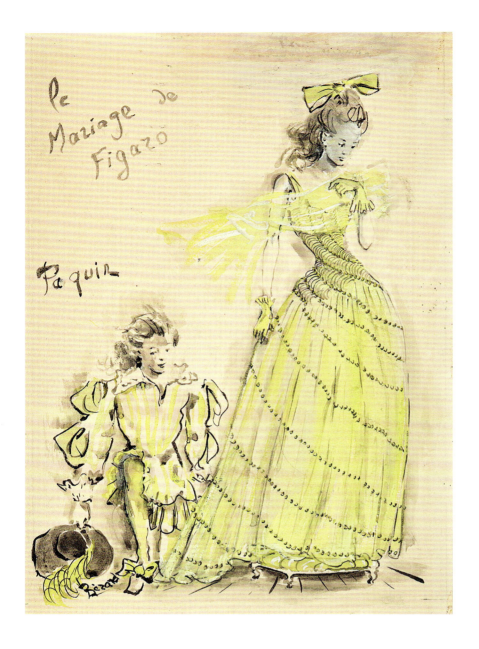

Christian Bérard, Dress for *Ce Soir on joue...*
Le Mariage de Figaro [Tonight we play... The Marriage
of Figaro] by the Jeanne Paquin couture house, 1944.
Gouache. Private collection.

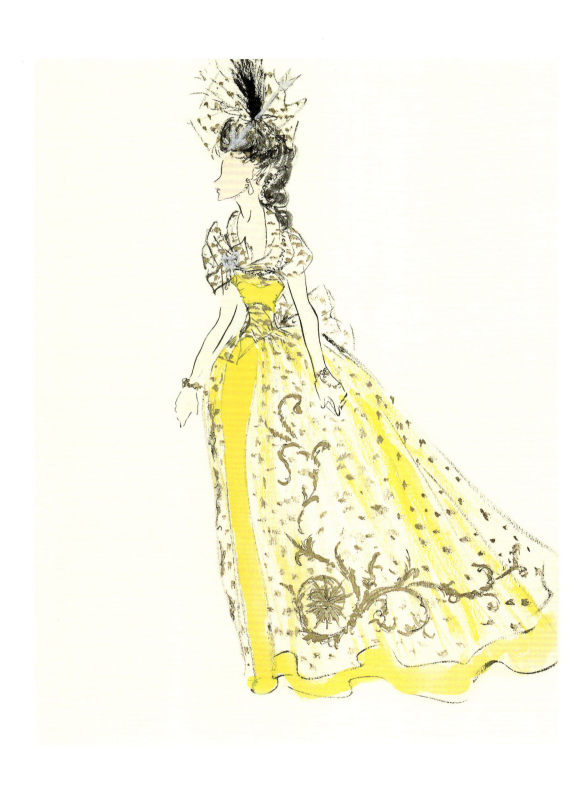

Christian Dior, Woman's costume project for the theater, circa 1945. Gouache. Paris, Dior Héritage.

146

Christian Dior, Unidentified theater model project, circa 1945. Gouache. Paris, Dior Héritage.

Christian Bérard, Set design project for *La Folle de Chaillot* [The madwoman of Chaillot] by Jean Giraudoux, Théâtre de l'Athénée, 1945. Gouache. Paris, Bibliothèque nationale de France.

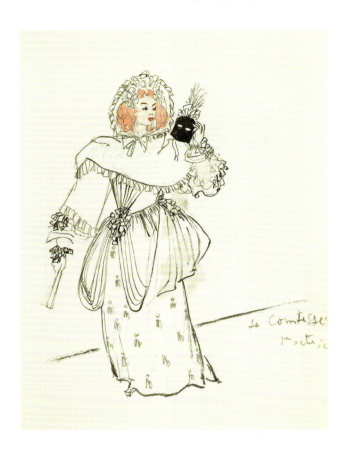

Christian Dior, Countess costume project for the theater, circa 1945. Gouache. Paris, Dior Héritage.

Christian Bérard, Illustrated cover of *La Folle de Chaillot* by Jean Giraudoux, Paris, Grasset, 1947. Gouache. Paris, Dior Héritage.

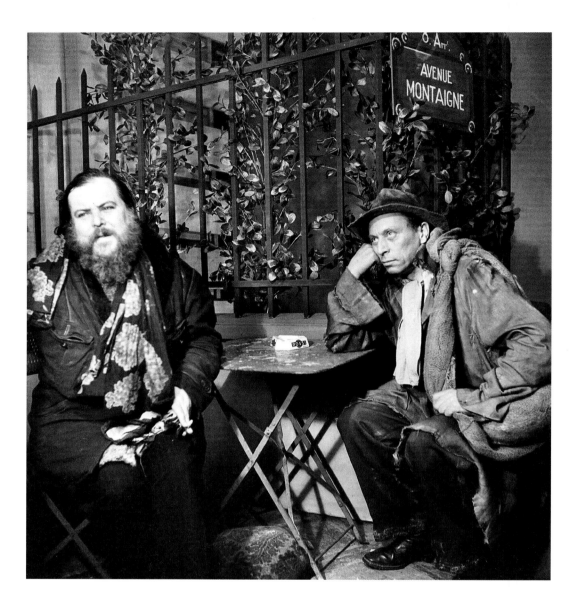

Boris Lipnitzki, Christian Bérard and Louis Jouvet
on the set of *La Folle de Chaillot*, 1945.

Paris "enjoyed the gray stones, the immense pale sky framed with a few spots of greenery,"[310] *Vogue* raved in a review of *Mozartiana*. Yet a few shadows could be perceived on the image. Harsh criticism came from scholars. André Levinson, a dance critic who was an expert in the history of the Ballets Russes, found the set "neutral and quite pallid."[311] He would only live for a few more months. The acid remarks were discordant, always carrying the hatred of old hostilities, starting with Tchelitchew who was never short on barbs: "Great painting is serious. French people do not understand this; they like what is pretty – Corot, Bérard,"[312] he stated at the beginning of the decade. For the Russian painter, *Mozartiana* was primarily "a fiasco. Everyone mocked the costumes, which are in the style of the Magic City homo balls."[313] This was a spiteful allusion to those years of costume parties, when Bérard dressed up as Victor Hugo, and Dior as Barbey d'Aurevilly, the Catholic and royalist writer, born like him in a town in La Manche, in Normandy: "Just tell me where this mania comes from to never appear as what one is?"[314] Magic City was a ball at mid-Lent, and "the cream of Parisian inverts was to meet there, without distinction as to class, race, or age. And every type came, faggots, cruisers, chickens, old queens, famous antique dealers and young butcher boys, hairdressers and elevator boys, well-known dress designers, and drag queens."[315]

The lights of the night were dimmed. Le Bœuf sur le Toit had become "a refuge for vagrants."[316] Dior lived in a little room on the seventh floor on Rue Benjamin-Franklin, where everything leaked, "the roof, the water, the electricity, and especially the money."[317] Their friendship lasted even though Dior had to sell many paintings. However, his Bérards continued to live with him, a reminder of "this elegance of the soul and the liveliness with which he transforms ugliness into splendor."[318]

Dior and Jacques Bonjean had divided their roles: "I don't like high society, and I feel awkward in it. Why should I force myself? Christian spares me this trouble, because it is no trouble for him. I admire his ease. I trust his gift of pleasing others with no effort," Jacques Bonjean wrote in his unpublished journal.[319] Pleasing others

with no effort? But Dior had to hide everything. René Crevel made no secret of his irritation. And his partner's methods did not seem to please everyone. Bonjean "would sell candles and dried apricots better than Bermans. His shiny and crude pleasure-seeking face displeases me greatly."[320] Raised in the school of secrecy, Dior had learned to live as the clandestine passenger of his life. In Granville, didn't they say that the Scissy forest had been swallowed up hundreds of years ago by the sea? Now it was the past that Dior had to conceal, at least in part, to avoid the bailiffs. On July 17, 1931, his father, called to the attorney's office, had to listen for five hours while Louis Ferrand listed the inventory of the estate of the deceased Madeleine. "Christian had the prudent idea of moving some furniture, paintings, and other valuable objects from their Paris apartment before they were seized and to store them at the home of the father of his friend and associate Jacques Bonjean."[321]

In 1934, Christian Dior was approached by the Galerie de Paris to lend an artwork for an exhibition of contemporary portraiture. Of course, he chose the portrait of Jean Cocteau by Christian Bérard, a small oil painting from 1928. Part of his personal collection, it depicted the poet in a fiery red harlequin costume. "Why are we still so attached to old portraits?"[322] Jacques-Émile Blanche asked in the preface to the catalogue. "Isn't it because they tell us about a milieu, a society, a civilization?"[323] But a page had been turned. Dior would leave this profession as he had entered it, as discreet in the daytime as he was whimsical at nighttime, dressed up with a friend "as God knows what, trotting from side door to side door to go on foot, without being noticed, to some costume ball."[324] He had never been so physically weak. As for Pierre Colle, he partnered with the dealer Maurice Renou, a great admirer of the Impressionists. Thus their names became attached, and at "Renou & Colle," visitors would admire Dalí, Hélion, Hugo, Balthus, and Bérard, the painter of those "strange doors that display their baroque excess or their classical severity in the poverty of idealized faubourgs, imagined in their human indigence. We are no longer in the city, we're nomads who pass by, we live in the ruins. Or is the city dead?"[325]

The pleasant trend for ancient styles during the early 1930s was only a dream. The financial crisis that plunged Europe into a slump, Hitler's rise to power following the humiliation of the reparations of the Treaty of Versailles, and Mussolini's Italy all contributed to nationalistic tensions. "Daladier is leading us around like a herd to people like Blum, Kaiserstein, Schweinkopf, and Zyromski, whose very French names say it all," attacked a poster for Solidarité Française:

> Here are your masters, patriots!
> Here is the dictatorship that waits for you, people of France!
> Your parliament is rotten.
> Your politicians are compromised.

Far-right Catholic organizations exploited the Stavisky Affair and the financial scandals, lending their voices to Maurras in *L'Action française* or Henri Béraud in *Gringoire*. Bérard witnessed the tottering Republic. "Young people walk around with bandages on, very proud to have been beaten, and there are rolling kitchens set up for soldiers on the Champs-Élysées."[326] The expedition of December 3, 1930, against the "foreigners" of *L'Âge d'or* had only been a prelude. Something was broken, and on February 6, 1934, there was a protest of unusual violence in front of the National Assembly. On the same day, Magic City was definitively closed by order of the Prefecture.

Why was Dior limping? What violence caused this injury? How did he reconcile his friendship for Marie Laure de Noailles, who wore a silk dressing gown patterned with hammers and sickles, and his connection to Pierre Gaxotte, the editor of the right-wing publications *Candide* and *Je suis partout*? This weekly magazine, founded in 1930, supported Mussolini and the Spanish fascist group Falange Española. And now Gaxotte, Dior's friend, was at war against the "strongholds of revolutionary unrest."[327] In 1936, *Je suis partout* would publish an anti-Semitic caricature of Léon Blum as a eunuch handing France over to the communists.[328] And Pierre Gaxotte would write about him two years later: "First of all, he his ugly, with the sad head

of a Palestinian mare. [...] He embodies everything that revolts our blood and makes our skin crawl. He is evil. He is death."[329]

Dior shared his last name with a brother whose resentment against "the two hundred families" had become professionalized. In September 1936, Raymond Dior published a special issue of *Crapouillot* devoted to the Jews.[330] In any case, the name of Dior, which once shone on advertising posters and in the halls of power, had lost its aura. When people spoke of Dior, they no longer talked about fertilizer or official inaugurations, but of debts, decline, and personal bankruptcy over bad real estate deals. Raymond, the eldest, who was very wound up against the downward spiral of capitalism, would take an ironic approach, referring to this situation as if it were a manuscript titled *Family Crisis*. It was a tale that was very much in the current style: the subtle agony of his family squeezed by the banks. "A high society story, to some extent."[331]

As for Christian, he was shut away in his secrets that critical success could not console. Hadn't Galerie Bonjean been the first to anoint the discovery of Léonor Fini, an "Italian Marie Laurencin," according to Waldemar-George, and the first to bring together Salvador Dalí, René Crevel, Yves Tanguy, Man Ray, Tristan Tzara, and Marcel Duchamp, and to dare to exhibit "elements of prophetic dreams," "perversions of ears," and "atmospheric spoons"?[332] "Do you remember when painting was considered an end in itself! We have gone past the time of individual exercises":[333] that was the manifesto written on the invitation to the Surrealist exhibition held in June 1933. And yet, it was these individual exercises that shaped Dior's work, Bérard's, whom he admired so much: "Christian Bérard painted faces devoured by an ember gaze, in reaction against Cubism, whose fiery manifesto –the new Koran– forbade the reproduction of a human figure for twenty years."[334]

Dior was still just as reserved. The economic crisis had only widened the gulf between the Granville native who kept his feelings quiet, never saying anything that would compromise him, and the liberated painter, unable to hide what he felt: "It's awful, it's awful what you're telling me," Bérard replied to Edmonde Charles-Roux,

when she told him that Italy, which he had visited in the early 1920s, "no longer existed, that another one had come about, wearing black shirts, a traitorous and detestable Italy."[335]

Through Dior and Bérard, two worlds were henceforth opposed. A Catholic, traditionalist, anti-Bolshevik Faubourg Saint-Germain versus a "Right Bank" Paris that went from the Plaine Monceau to the Faubourg Saint-Honoré. Indeed, this neighborhood was very cosmopolitan: the Galerie Bernheim-Jeune had moved to 83 Rue du Faubourg-Saint-Honoré in 1925, establishing itself as the meeting place of the European avant-garde; upstairs, Madame Grès opened Alix, her maison de couture, in 1934, while at number 140, in 1935, Jean-Michel Frank opened the gallery for which Bérard made a triptych and designed the invitation. Frank would call on Bérard several times, whether for producing wall paintings for the dining room of the Polignacs or for the Guerlain beauty salon in spring 1939. "In the most restful setting imaginable, designed by Jean-Michel Frank and Christian Bérard, very gentle light, walls of a bluish white [...]. The marble itself becomes tender [...] and miraculously becomes matte and warm to the touch like very delicate skin."[336]

But Christian Dior was not moved by Frank, who was hostile to Belle Époque decorative moldings and all the "Marie-Antoinette Art Nouveau" style that his mother Madeleine had passed down to him in the apartment on Rue Louis-David. "I'm speaking, in fact, of the neo-Louis-XVI style, white paneling, white-lacquered furniture, gray wall hangings, glass doors with beveled panes, bronze wall lights with little shades, that dominated the 'new' apartment buildings in Passy."[337] It was those very alcoves, those wall lights with little shades, and those medallion chairs that Dior wanted to put back on display in all his interiors. Plus, it was through the memory of his own mother and the passion of the French bourgeoisie for Versailles that Dior would celebrate the French eighteenth century, all curves and arabesques. One could imagine no more clearer contrast with Jean-Michel Frank, the designer who stripped furniture of its varnish to highlight material and function in their opulent nudity. Frank, whom Waldemar-George considered a "man of the laboratory," had

an aversion for the "aesthete in the garden" style, upholstered padding, Pompadour clothing design, and any kind of "decorated atmosphere"[338] – which was exactly what Dior cherished! Frank replaced lampshades with white plaster lamps by Alberto Giacometti, offered the wealthy the modernist luxury of his azure grottoes, broke the moldings to hang his marquetry with straw, and preferred okoume to violetwood. These were indeed two worlds confronting each other, the style conflicts expressing very personal positions.

Anti-Semitic propaganda extended the hygienic metaphors that were dear to Drumont and began associating Léon Blum with "human garbage."[339] It denounced "Neapolitan filth," "dealers in women and cocaine" who rushed over "preceded by their odor and escorted by their hussies."[340] In the violence of these words, Bérard anticipated the hatred that would soon target him when he became the whipping boy of the ferocious Alain Laubreaux, the theater critic of *Je suis partout*.

Inventing follies

"Banish worries by inventing follies."[341] Hadn't that always been the motto of this Granville native, and that of a whole generation enveloped in shadows from whom the French army had hidden all horrors? After World War I, with one-and-a-half million Frenchmen dead and six hundred thousand widows, Dior was one of those who thought the troubles were over. And now they were back, on the ruins of a crisis that was, however, less painful than in Germany, which was more industrialized. No jobs, no money, no future. "The country of Despair," as Dior described it, using a capital D, was worthy of a set by Bérard. "The run-down street seemed to belong to an abandoned city where the dancers, in rags, looked like phantoms materializing from the fog."[342]

Dior had his phonograph and his friends. Bérard had his solitude, his colors, and especially his opium balls. "I don't want to make you sad." In the letters he wrote to his father, where he called

Dear painting! What I'm looking for is to create unease.

Christian Bérard

himself a "neglectful son," "ashamed," "unhappy," and "at fault,"[343] he seemed always to want to make up for his wrongs: "Right now I see no one. I'm working as hard as ever. I'll have lunch with you Monday. Don't receive me with a look that's too harsh. Your respectful son who loves you, Christian."[344] But Bérard was pulled into the other world promised by Cocteau in *Opium*, published in December 1930: "Opium, which slightly loosens the tight folds that make us think we're living long, minute-by-minute, episode-by-episode, takes away our memory in the first place."[345] Dior's friends were willing traditionalists, starting with Pierre Gaxotte, who, in *La Révolution française* (his first book), had sketched an idyllic portrait of Ancien Régime France and its "douceur de vivre" that was already dear to Talleyrand.[346] A golden age which he contrasted to the time "of riots and massacres" due to revolutionary propaganda, which he treated as a specter in order to rail against the danger of his own era, "communist Terror," devoting an entire chapter to it. The book was a success, especially since it coincided with the terrible famines of 1931-1933 in the Soviet Union, which are estimated to have killed over six million people. How could Dior have contradicted him, when, faced with "absolute ruin," he had gone on a "flight to the East," joining "a group of architects leaving for a study trip in the USSR" in 1931 from which he returned horrified? He would describe it as "a voyage that was rich in surprises and wonders" concerning the past, but full "of disappointments at a horrible present": "I must mention the sigh of relief that we all let out once our passports had been turned in and the boat was out of Soviet waters, at the thought of returning to our Western world, even in the midst of the crisis, even if, for me, it was darkened with cruel grief and worry."[347]

Facing adversity, Bérard's friends had always been definitively subversive, animated by the desire to attack the bourgeois hypocrisy they had inherited. Leading the way, René Crevel, the archangel with the sulfurous words whom Bérard painted, published that year *Le Clavecin de Diderot*: "We know your schools, your high schools, your places of pleasure and suffering. If anyone there had any momentum, they would just end up breaking their necks against these mosaics of damned petty interests, which were the ground, walls, and

ceiling of your public buildings and private residences."[348] With them, Death was a character to dress up as at a costume ball, a kind of daily, inspiring companion, like Cynthia, the heroine of the novel *Babylone*, by René Crevel, which Bérard illustrated in 1927 for Simon Kra, the first publisher of the *Surrealist Manifesto* by André Breton. "Cynthia will be our ray of sunshine [...]. What joy, the day of her arrival. She brought nice gifts for everyone and, with her red hair, green dress, and eyes gray like clouds, we guessed right away that she had been born in a country where you will never go. We had given her the prettiest room, and she could have stayed there for years and years, but, one fine day, there was no more Cynthia. She had run off without saying anything. Like a thief. When she left, she took papa."[349]

Dior never treated death so ironically; it was a forbidden subject for him. However, beyond the rifts due to their respective groups of friends, Bérard and Dior were united by strong affinities. What one saw, what the other imagined, was the liquid gray-blue of those endless beaches, the rays of illumination, the "contrasts of shadows and light"[350] for Bérard, "the nostalgia for stormy nights and the foghorn"[351] for Dior. These inclinations were shared by Léonide Berman, a former classmate of Bérard at Académie Ranson, who was also haunted by the shores of the northern sea, by the skies full of swallows of this agricultural region of France, where Bérard and Hugo chose to paint "in a new light."[352] There where the women scattering hay to dry appeared to them like "fairies who had slipped out of the deep woods and were surprised to be seen in the sun."[353]

 With Waldemar-George and Jacques Bonjean, Dior was one of the first to have grasped the rupture that Bérard stood for: "The era functions. It works at full capacity. Nothing suggests it is moving toward the abyss. Do Bérard, Eugène Berman, and Pavel Tchelitchew usher in an era? Are they its true pioneers?" the critic asked again in 1934, speaking of these "isolated artists who have avoided the collective hold." "But their defense was ineffective. Their static attitude doomed them to failure. The mediocre and the indifferent could only confront the mystique of the avant-garde schools with vain eloquence and sterile logic. [..] Ageless, they could not regenerate a

language that was condemned to die or to live on mirages." "Bérard's first portraits" were "immobile masks in shock." Later, becoming more intimate, more meditative, they nevertheless kept "this spectral type, this mournful air, this neurotic aspect, this tragic fixedness."[354] The tragedy was now too real to be found in the features of these failed characters: "Unlike Surrealism or Magic Realism, it is not a question of phantasmagoria or the fantastic: the pebble beach is an abandoned stage for a final parade in front of a deserted theater."[355] Bérard's portraits all referred to "the hyperbolic and harrowing image of the condition of the modern artist."[356]

So they had to live on commissions and mirages. While Dior felt at home in the open air, it was in the shadows that Bérard traced his red and gold path. As the world was turned upside down, here he was slipping inside that magic box called illusion. Uninclined to let themselves be dragged into the sanctification of Romanness by Waldemar-George – who met Mussolini in 1933 – the neo-humanists discovered in theater both a spectacle and a refuge. The curtain rose on their deserted landscapes shaped by color and perspective. Léonide Berman imagined a set in the form of an Italian square with doors opening onto the sea, and Christian Bérard designed an immaculate canvas for *La Machine infernale* by Jean Cocteau. With trompe-l'œil effects, the real characters moved about among figures that looked like Madonnas and Florentine gentlemen. "Only architecture could serve the word," observed *Art et Décoration*, evoking "the absolute palace of useless glories where in desired splendor the mathematical obliteration of a mortal was completed. A steady, cold, gloomy light, a surgical light without shadows or life, bathed these three acts almost the entire time, which constituted one of the finest intellectual spectacles that contemporary theater has produced."[357] However, the curtain would close on the neo-humanist painters, their deserted rooms peopled with faces with absent, weary gazes. Their art had not opened "the new paths that it promised. It takes fright at the disproportion between results and ambitions; it worries about its own fate […]. Art is a forest devastated by a fire. The capital on which one intended to live finds

itself consumed in a single blow. The ungrateful hour of reforestation and wise planting has come."[358]

Picasso had already abandoned the sad figures of his Blue Period for quite some time. In 1932, he painted his sensual figures; he had understood that making art was a "way of keeping a diary."[359] Bérard's diary was nothing more than his social calendar. While Picasso was now too expensive for Gertrude Stein, Bérard was losing value without even attaining artistic glory. His last solo shows would take place not in France, but in New York, at Julien Levy. Thus ends the first act. Christian Dior, who wrote to a German collector to ask him for a check for Salvador Dalí – whom he had to visit at home in order to pick up the artwork – offered to give his client a small drawing by Bérard: "I know that you don't care for this painter, but I like him personally, and I would like this drawing to be a little jest to remind you now and then of my existence and my friendship. Your devoted Christian."[360]

The fracture that was splitting Dior's world from Bérard's would never threaten their friendship. Especially since it was thanks to Bérard's cousin, Jean Ozenne, that Dior would heal, and even find meaning in his life. Here's the story. In 1934, the house in Granville was sold to the municipality, with one thousand bottles of wine still in the cellar. Christian Dior had lost everything. Except for his body, which now played a nasty trick on him. "There happened to me what had to happen after so many missed meals and so much anxiety. I became ill. Seriously ill. I had to leave for the mountains without delay."[361] He never complained, due to the sense of duty from his upbringing. To Abbé Morel, he described only a "slight bout of tuberculosis"[362] and added, disillusioned: "I don't know if 'slight' has a positive meaning for me, given the circumstances of my life. I don't dare ask myself if I might have preferred it if my illness had ended the way that so many people fear."[363] At that time, tuberculosis was, with syphilis and alcoholism, one of the three major health scourges in France. It was estimated to have caused the death of eighty-five thousand people in 1920.[364] After years struggling against this terrible respiratory illness, René Crevel turned on the gas: he committed

suicide on June 18, 1935. Death had never lurked so near. Suffering from Koch's bacillus, Dior was not only contagious, but he was poor and did not have the means to isolate himself to heal from this illness that was still called "the white plague." His friends, including Jean Ozenne and Henri Sauguet, paid for his stay in the heliotherapy sanatorium in Font-Romeu and then on the Spanish island of Mallorca, as shown by a postcard he sent from the port of Alcudia.[365] At L'Espérance clinic, the therapy consisted in lying down facing the sun, which this pale-skinned Norman had always avoided. "First we stopped to say hello to Christian Dior in Font-Romeu. He is better [...], but he is only starting to walk, still limps considerably, and a little half-hour stroll still gave him a fever of 99.5°F the next morning. The poor fellow still isn't able to return to normal life yet,"[366] Jean Ozenne wrote to Henri Sauguet. A thinner Christian Dior seemed to float in his dressing gown, his gaze empty. Naked before his destiny, he wrote to Abbé Morel: "I pray to God that this may be the last trial He has in store for me. If I have to face new struggles and new disappointments, I fear I will no longer have the courage. Your encouragements have helped me not to lose confidence. But what good is my useless life, even to me?"[367]

The apprentice couturier and the wizard

For both Dior and Bérard, 1934 was a turning point, a revelation. It would be mystical for the former and chromatic for the latter. Loneliness, fatigue, despair. Christian Dior had never plunged so deeply inside himself. His brother was in a straitjacket, and his father had lost all self-esteem: he looked like an old man. It was now Marthe, called "Ma," the faithful housekeeper, who had taken control of his existence. Whether appointed by Maurice or acting on her own initiative, she purchased a small house called "Les Nayssès" in Callian, in the Var department in the South of France – "with a plot of land that can be irrigated and farmed, grapevines, olive trees, and fruit trees."[368] She moved there with Christian's father and his younger sister, Catherine.

160

As for Christian, he was quite alone. He suffered from being only what he was. Not that he felt "more different or worse" than "normal men."[369] But he resembled a bit the washed-up figures of Bérard, whose only setting was the immensity of the void and who breathed "only on the seashore at low tide."[370] Alarmed by his distress, Maurice Dior decided to commit his son to the hospital in Pontorson, in the Manche department, near Granville. Does having affected mannerisms mean being crazy? Does a person become crazy because there is no room in this world for those who have affected mannerisms? During a correspondence of rare intensity, Tian designated Abbé Morel as his true confessor: "I haven't been able to fulfill any of my religious duties and have not gone to Easter services. I do not know any priests here and I don't dare to go to confession for fear of being misunderstood. Every night, I pray that God will absolve me […]."[371]

For Bérard, 1934 was also the setting of an important transformation. Had he gone through the looking glass? His specters had transformed into sylphs. Like the undulating branches of Corot's trees, they took possession of the frame, enchanted the page. He had just produced his first fashion illustrations for *Harper's Bazaar*. Under the leadership of editor-in-chief Carmel Snow, the magazine had become the bible of new talents, such as Martin Munkácsi, who had just produced a series of photos of women in bathing suits in Palm Beach. At the same time, Christian Dior proclaimed in a "rambling" letter that he had lost all faith in the future. In 1934, in his white room, he had waited, almost as if for death, to "receive the sacraments" from his dear Abbé Morel. "I certainly know all my flaws and I know that there are even some against which I have little or no desire to struggle. Must one sacrifice all material happiness to obtain a few mercies from heaven? Forgive me for telling you all this."[372] His sadness was all the greater when, in June 1935, he heard the news of the suicide of René Crevel, himself a victim of tuberculosis. The writer had chosen to put an end to the boredom that had marked his stays in sanatoria: "the days are so terribly monotonous that the day before merges with the day after, and you no longer know where you are in time."[373]

All that remains of a youth is the foam of memories, a slightly lunar fog, between uncertainty and halos. In his *Double Autoportrait sur la plage* (1935), it is as if Bérard had painted his Dior, wearing a jacket and straw hat. The silhouette is not like the one on the right, which is stockier, in brownish-red and gray. Was this painting based on a photo taken at the "flea market," as it was then called? In any case, we can recognize Dior's rounded forehead under the hat. He holds his cane the way he would hold his couturier's walking stick ten years later. In this painting, he is satisfied with posing, a bit worried and rumpled, while Bérard smiles. Behind the two motionless walkers, there is a vast cloudless sky and the sand stretching out like a beige canvas under their feet. They are in the light, but it casts no shadow. They are together, but each on his own side, like two close friends each playing solitaire on his own. During his treatment in the fresh air and sunshine, and from the depths of his sadness, Christian Dior mentioned his friend Bérard; in fact, he was the only friend he brought up in his letters to Abbé Morel: "If I haven't gotten in touch with you since my return, it's because it was impossible for me to arrange this meeting with Bérard that I promised you."[374]

Hope was not far off. It was like the calm after the storm, when, through the torment of destruction, the survivors feel the unspeakable joy of still being alive. "For me, luck seems to want to save me," Christian Dior wrote to Abbé Morel on September 28, 1935. "I thank God for it every day: for the first time in over four years, what I am working on is successful. What joy and what encouragement. Friends suggested that I use my free time to do fashion drawings. I gave it a try and sold them so successfully that I've decided to do this professionally. In addition to earning a good living, it is a pleasant career that lets me take care of my health."[375]

Jean Ozenne was living with Max Kenna, a young American who worked for the fashion designer Edward Molyneux, a former captain in the British infantry who dressed European royalty, as well as the divine Greta Garbo, Marlene Dietrich, and Vivien Leigh. He was especially keen to help Christian Dior because he himself had had a checkered career, having abandoned law school for dressmaking. During the winter of 1935-1936, the Ozenne-Kenna couple

let Christian Dior live with them in their apartment on Quai Henri-IV. Tian did not seem bothered by their liberated way of life. Jean Ozenne wrote to Henri Sauguet that many young men were "relatively abundant game of quite wild and pleasant quality."[376] The free tone of these letters clashes with Dior's discretion about his sexuality. Regarding Barcelona, Ozenne wrote to Sauguet: "The slums are sublime. The crazy Spanish women in the special cabarets are mad, inspired artists; it's the capital of sex [...]. The little music halls, which are like sexy versions of the Bobino theater, are packed and marvelous. I saw sublime dancers and singers and will see them again when I go back."[377]

 The fortuitous couple of Jean Ozenne and Max Kenna would change Christian Dior's life. For the first time, he finally felt that he could rely on his own talent. Of course, he didn't have the ease of Bérard: "Christian Dior started over again and again. In his room, the floor was littered with papers, some tossed in piles, others torn up in discouragement, and others crumpled up into balls."[378] His very labored-over line contrasted with the approach of Bérard, who was like a wild animal in his room, not concerned with reproducing what he saw but suggesting silhouettes that he made appear out of nothing. But, through hard work and determination, a miracle happened. "One night, Jean Ozenne came home in triumph: he had sold drawings by me for 120 francs (20 francs apiece). The first money I had really earned by the work of my hands! I was amazed. These 120 francs brought by considerate and faithful friendship were like the first sunshine at the end of a long night; they determined my future, and they still sparkle in my life."[379]

 At the urging of James de Coquet, his first sketches, signed "Tian," appeared in *Le Figaro illustré* in June 1936: "I had known him at age eighteen in Granville, his hometown, on his family's property. He was the head gardener. He also composed imaginary dresses with sea foam, clouds, and trees. [...] He drew, and he had a sense of fashion; I asked him to do a page of imaginary hats inspired by the Colonial Exhibition for *Le Figaro illustré*. That was his first contact with fashion. He later made a living selling 'dress ideas' to designers and illustrating fashion articles in *Le Figaro*."[380]

Dior composed an almanac of floating pages, each one corresponding to a month of the year: May, "memory of Brittany"; June, "tricentennial of the Antilles"; July, "Renoir retrospective." As if life, to become desirable again, had to be arranged in a series of appointments. For January, there was even "premiere of Margot": a nod to his friend? Indeed, the previous year, Bérard – who had started collaborating with *Vogue* in March 1936 and illustrated Parisian fashion collections – had a triumphant success with the costumes for *Margot*, directed by Édouard Bourdet and performed for the first time at the Théâtre Marigny on November 26, 1935. Produced by Lanvin, his women's costumes attracted special attention from *Vogue*: "It is easy to see that fashion will borrow more than one silhouette here, more than one effect, more than one detail."[381] With his doublets and cloaks, Bérard announced a new romanticism, which borrowed the virtuosity of the style of Delacroix illustrating *Hamlet*. Puffed-up, bumpy, and quilted, the sleeves wiggled, resembling paper lanterns and horns; the collars stood up straight; the bodies were held tight in black and mauve-violet velvet. Christian Dior saw these costumes close up. Especially those worn by Yvonne Printemps: a dress of black tulle, crisscrossed with sequins colored like stained-glass windows, and another, of immaculate Ducharne silk, with pink false slashed sleeves. *Vogue* praised this "prophetic fashion statement." The hats decorated with feathers, the jewels on the forehead like a fringe, the high-heeled, openwork shoes – not to mention the ornaments that were invisible from the theater – showed Christian Bérard's love for women's clothing and the crucial influence he had on Dior. Although neglecting his own appearance, he was uncompromising when it came to the appearance of the dancers, of whom he spoke with the informed eye of an aesthete. "I haven't attended a single rehearsal. It's going to be a disaster. They don't even know how to do their hair."[382] The next day, everything was taken care of, and nothing was out of place. Even if, in the eyes of the art critics, Bérard did not fulfill his promise; he gave up his destiny for glory that was too artificial. They did not forgive those whom they felt they had expelled into another field. The Surrealists excluded Alberto Giacometti

from their group because of his "useful" objects designed for Jean-Michel Frank and his involvement with figuration. Alberto Giacometti liked to talk about how "this new concern for the human head"[383] did not suit the taste of the partisans of inventiveness, of constant reinterpretation, and found objects. And those who had always defended Bérard now expressed stinging criticism: "Bérard brings into Frank's studio his prestigious colorist's genius, his sense of arrangement, his effeminate taste, his morbid romanticism, and his perversity,"[384] Waldemar-George tersely observed.

Both on stage and on the town, Bérard recorded movement like a virtuoso. In his portrait of Gabrielle Chanel at the Ritz, we notice the position, the black turtleneck, the cheap long necklaces, the hands in the pockets of a skirt rolled up simply like a blanket. Was the skirt really red? Surely not. But, with him, the power of evocation took precedence over verisimilitude. Thus, he added colonnades to a dress of smoky lace and added ribbons to a mirror reflecting, from behind, a dreamlike silhouette. This recalls the effect that Balzac sets up in *Le Lys de la vallée*, when the appearance of Madame de Mortsauf is preceded by a "golden voice": "her complexion, comparable to the fabric of white camellias, reddened her cheeks with pretty pink tones. […] Her body had the greenness that we admire in newly unfolded leaves."[385] Bérard, even when he described a fashion design, wanted to give it the feeling of a character. "Lucien Lelong, white lamé shot silk, green velvet," was written under the watercolor, on a white panel topped with an angel wearing a feather.[386] The series of orange frames, the first garlands, the white arabesques danced on the sky-blue borders. Traced in India ink, the silhouette fluttered, similar to Balzac's visions: like the "effect of sun on the prairie," "clouds in a gray sky, the misty hills, or the trembling of the moon in the jewels of the river."[387] Bérard's evening gowns had the gentleness of summer nights; his coats caressed shivering skin. His line expressed a gesture, a position.

Indeed, his chromatic exuberance clashed with the designs that Christian Dior drew, still subjected to constraints that he would make his salvation: a dress or a coat is first embodied by lines. More

freely sketched, the little watercolor heads of Bérard invited him to join the dance, rather than to design some kind of prototype. Dior spoke to a client, while Bérard spoke to the public that he was losing, or to the one he was winning, as a painter of feelings. Dior was still convalescing: he applied himself, he wanted to succeed. But Bérard was an inspired wizard. The result was that, every day, illustration took him further from himself. "His friends told him constantly that he was prostituting his talent, and when he spent several months without painting anything, he accused *Vogue* of having hijacked his career."[388] "Lazy not by weakness, but because he had so much difficulty managing in life, Bérard was also capable of 'working to the limit of his strength.'"[389]

Crazy about Rimbaud, Apollinaire, and Balzac – his library contained two thousand books – Christian Bérard was a reader before anything else. He revealed characters instead of describing them by their clothes. This sense of apparition would make his reputation in 1936, with *L'École des femmes* by Molière, directed by Louis Jouvet, whose costumes and sets he designed. For Jouvet, he would become this "wandering rainbow."[390] When he worked for the theater, Bérard obeyed no rules, and the same intelligence guided him in his fashion efforts. He reproduced nothing, but merged with the material, the style, the attitude implied by the dress. Dipping his brush in the spring water of color, Bérard became the illuminator of *Vogue*: "Here is Christian Bérard, renowned designer of sets and costumes, whose taste and originality influence the major couturiers more than anything else today."[391]

 For Cri as for Tian, nothing was yet definite, alas. Bérard was too much of an artist. Before signing a contract with *Vogue*, he had to deal with the reproaches of Edna Woolman Chase, who worked in the New York office of *Harper's Bazaar* and disagreed with Carmel Snow: "Bérard's drawings are extremely decorative, which is a plus for the magazine, but we need more realism. Women want to know exactly what the clothes look like."[392] The overly artistic style did not meet the expectations of the press. Jean Hugo, who had been recommended by Bérard to *Harper's Bazaar*, had his sketches rejected: "Despite their exaggerated legs and their tiny heads, my silhouettes

do not attain elegance. They sent the drawings back to me and I had to start over."[393]

When it came to accuracy, on the contrary, Christian Dior was as flawless as his sense of proportion. He had stopped approaching insurance companies, banks, and offices to ask for employment. He would have accepted to be a paper pusher, an accountant, or just about anything, if fate had not opened up another path for him. His first clients were named Rose Valois, Nina Ricci, Elsa Schiaparelli, Jeanne Paquin, Cristóbal Balenciaga, Jean Patou, and Edward Molyneux, who had just designed the wedding gown of Princess Marina of Greece, the bride of the Duke of Kent. With sketch after sketch, he launched his career in a world that he did not know, but whose secrets he was familiar with. He had not benefited, like Bérard, from the support of Jean Cocteau, a Pygmalion who was, it just so happens, very preoccupied by his encounter with Jean Marais (1937). At age thirty, Dior was a new man: "I was going to start my real existence."[394] He drew day and night. "The hat designs found buyers, but the dresses, which were decidedly less fortunate, were not very persuasive."[395]

After all, Dior was still an unknown. On the contrary, Bérard had an entire court of female admirers. From Comtesse Jean de Polignac to Princesse d'Arenberg, the queens of Paris were influenced by his effects of light, and the "dazzling power of his two pallet-hands, whose slightest imprint spontaneously created a living thing, a periwinkle, a gaze, or a butterfly"[396] on the back of a restaurant menu, on the plaster of a wall, on the side of a vase, in the folds of a veil. But Dior, reassured by his first earnings, pursued his tireless efforts in the shadows. "Scraping by on sketches sold one by one by means of endless waits in anterooms and store rooms, I worked relentlessly. But this stalling around – which lasted for two years – was infinitely less difficult for me than all the running around for dreary jobs that had preceded it. Here, I was defending myself on much more attractive terrain."[397]

Dior stated that he became an illustrator in 1937. Fashion designers "now expect[ed] [his] visits": "I earned a good enough living to recover the only benefit I care about: being at home."[398]

Reassured, he seemed to rediscover those lighthearted times; present at his side, his younger sister Catherine inspired in him once again an urge for parties. "Sometimes it's amazing what he comes up with: a Neptune outfit for his sister, with a shell corsage and a raffia skirt, the effect of which is astonishing. And when he can't find a piece of tartan to make the skirt for a bagpiper's costume, he hand-paints the tartan pattern himself."[399]

After living in a small hotel on the Rue de Bourgogne, the brother and sister rented an apartment on Rue Royale and rediscovered, after years of suffering, the joyful closeness of their childhood. It was quite natural that in the little stalls at Porte de Saint-Ouen Christian found once more the past that he had been forced to give up. From the Vernaison market to the Biron market – both started in the 1920s – the Paris of the rag-and-bone merchants, the dealers in second-hand goods, and the dreamers overflowed with treasures sold at auction: torch sconces, medallion chairs, glass globes, and stopped clocks.

On Sundays, Bérard and Dior liked to go poke around the flea market together, attracted, like Emilio Terry and Jean-Michel Frank, to the styles that the sober designs of the 1920s had put in the trash heap. This humanistic style included the rediscovery of eighteenth-century utopian architect Nicolas Ledoux, who was himself inspired by the temples of Paestum and the villas of Palladio. In the rediscovered imaginary world of orange groves and water lilies, trompe-l'œil colonnades and neoclassical domes, Dior, still seeking an ideal, witnessed with unfeigned emotion the announced return of decorative arts, arches, niches, false staircases, and other alcoves, these effects of illusions that he would constantly multiply, from dresses to interiors. In 1933, Galerie Bonjean exhibited Emilio Terry's sketches including the spiral house that Dali would go on to include in his portrait of the aesthete, and which New York's MoMA would present in 1936 as part of the "Fantastic Art, Dada, and Surrealism" exhibition. In the eyes of that most Parisian of Chileans, "the stone treated like a fabric, the draperies frozen in marble but maintaining an energetic design, an emphatic symmetry, a rhythm

of curves, all this brings us an architectural renewal in the direction of the rococo."[400]

In his living room, Dior hung on the wall the portrait that had not left him, Bérard's acrobat in the pale green jersey: a force of nature ready to leap. And Dior found within himself the colors of such exciting close calls. Just like the time when "he also composed imaginary dresses with sea foam, clouds, and trees. [...] He drew, and he had a sense of fashion."[401] At the same time, in *L'Illusion comique* directed by Louis Jouvet at the Comédie-Française, Christian Bérard reconnected with pure imagination. These "five wandering acts"[402] would become his. "The arrival of Isabelle on her blue chariot, in a mauve apparition, preceded by white and black musicians is an absolute pleasure for artistic appreciation."[403] Yes, it was indeed to him that Corneille seemed to whisper in his dedication: "Here is a strange monster that I dedicate to you. The first act is only a prologue; the three following ones make an imperfect comedy, the last is a tragedy: and all that, sewn together, makes a comedy. One may name this bizarre, extravagant invention however one likes; it is new."[404]

Louis Jouvet was the first to be won over: "I do not know what reception the public will give to this production, but I can say with certainty that Corneille's play, through the collaboration of Christian Bérard (the designer), will surely find for the first time ever the true elements of magic that it calls for, made of wit, grace, youth, and freshness. It is thanks to his designs that I have understood its rather fantastic, extravagant, fanciful poetry."[405] Like the powerful magician Alcandre, who makes "speaking specters" appear and "[evokes] new ghosts," Christian Bérard was once again anointed the enchanter of Paris: "Hasn't he been each time the inspirer and instrument of such powerful feeling? Outside of the theater, don't his paintings also offer us 'this shock' of importance?"[406]

In July 1936, at Covent Garden in London, *La Symphonie fantastique*, for which Bérard designed the costumes and sets, was also a pure triumph. The English did not hesitate to "place our compatriot along with Berlioz, Goya, and Offenbach."[407] Nevertheless, *L'Illusion*

comique, this "story of a son who has escaped the tyrannical surveillance of his father,"[408] marked his true apotheosis: "Of all I have done, the presentation of *L'Illusion* is what has excited me the most [...]. Jouvet and I worked, explored, and discovered a great deal: we enjoyed ourselves greatly. My sets and costumes – there are about fifty of them – may not please everyone. The magician's cave and the final spectacle, designed as a carnival, may surprise."[409] In this spectacle, the prison was suggested by a little cage hanging from a wire, a traveling basket carried Alcandre and Pridamant into the air: some saw this, perhaps correctly, as "a cable car or the swings of the Fête du Trône."[410] Brought to the stage, this "extravagantly delicate elegance" astounded the public. "Set free, Christian Bérard painted a clearing of fables, dresses in the color of time, and costumes made of sunshine."[411] It could even be called a resurrection. The resurrection of both Corneille and Bérard, and this plot seemed to concern him so directly: "A father, despairing over the departure of his son, whom he has expelled from his home, questions a magician. The magician will make the magnificent clothes that the son is wearing in his new condition appear. Is he a great lord, a military leader, a prince of the Church? None of the above. He is an actor."[412]

The enchantment of color

All suns crackled in him. Bérard warmed himself in the sun of the extreme. In the performance of actors who risked their lives every night, these acrobats in doublets, he found something like a reflection of his own life and also a release. And, yet, there already bubbled inside him the desire to leave all this and go back to his easel. "After *L'Illusion comique*, he planned on devoting himself to his painting once more, to go to the South, close himself up in his hotel room, cover his face and hands with madder red and liquid white as he can't help but do."[413]

Bérard, who dreamed of returning to painting, was always caught by his own demons. He was jubilant when he had to depict the cave of the magician Alcandre. Wasn't this illusionist now his

double? "The arched lip of rocks rises up, secreting human shadows and swallowing them up,"[414] wrote Maurice Martin du Gard. "They are ghosts with neither faces nor hands, but Bérard's enchanting spirit endows them with the essentials of a fairy tale: golden gowns, brays of glitter and mother-of-pearl, hats, and panache."[415] It's all Bérard, between "absolute black" and "pale, soft sky brightened by some magical, purple glow."[416] Piercing the original obscurity, ghosts reappeared in the features of heroic, determined characters. In "a noble building, standing like a dream in the center of total darkness,"[417] the writer Maurice Martin du Gard found the substance of a metaphysical landscape. "These bone and salt whites, these blacks where all appearance of color is definitively immersed, resuscitate in our memory and in our gratitude, along with the name of Christian Bérard, the names of Cocteau, of Jean-Michel Frank."[418] Appearing under this "pale, gentle sky, brightened by a purplish light"[419] Bérard's ghosts now had golden dresses.

In a certain way, color was also what saved Dior. He succeeded, thanks to Max Kenna, in selling one of the fourteen paintings by Raoul Dufy that Paul Poiret had commissioned to decorate his barges named *Amours*, *Délices*, and *Orgues*. Its title was *Plan de Paris*, and Dior had bought it from the same Poiret – then bankrupt – in 1925. A surprising reversal. How could he have imagined finding himself in the same situation, assigned to what he would call a "vain quest from office to office"?[420] "Earlier, his family having known great misfortune following the crisis of 1930, he had eked out a living by drawing," James de Coquet relates. "He came to see me at *Le Figaro*. I had the idea of commissioning fashion drawings from him. Not on existing fashion, but imaginary fashion, which he would design himself. In 1938, I published a page by him. I was criticized for giving so much space to an unknown."[421] For this occasion, the young Dior had designed – in scholarly fashion – a "parade of styles," drawing silhouettes inspired by Watteau, Goya, Manet, Renoir, Velázquez, Chardin, and Winterhalter. It constituted a veritable encyclopedia of painting, seen in the light of fashion tempted by nostalgic withdrawal. Morning cloak, afternoon cloak, early evening cloak: Christian Dior's line did not venture beyond the shape

of a piece of clothing. He said only what he showed, and showed only what he should show. His line spoke volumes about this apprentice couturier, who was careful to practice, to understand that a piece of clothing cannot be constructed without foundations. Quite the opposite of Christian Bérard, who, at the same time, knew everything that theater craftspeople could do to create effects: spangles and braids embroidered by the meter, trimmings painted with a stencil – nothing was impossible in the kingdom of artifice. What his own body refused him, he obtained by drawing, moving from the languid curves of Chanel to the tours de force of Schiaparelli – he shared with the latter a sense of "Della Robbia blue" and the commedia dell'arte. With this result: "Being approved, admired, or sometimes loved by Bébé meant achieving recognition in the artistic, intellectual, and social circles of Paris."[422]

"Bébé" and "Schiap" were the living heirs of the Ballets Russes, and particularly of Léon Bakst, the designer of sets and costumes for several masterpieces – *Shéhérazade*, *Le Spectre de la rose*, *L'Après-Midi d'un faune*. He made society women give up corsets to wear feathers and Persian tunics. It was as if the "magician of colors,"[423] as Gabriele D'Annunzio called him, had found a spiritual heir in Bérard. Bérard seized pinks and yellows roses as Bakst did "triumphant" and "murderous" reds, along with "Saint Madeleine" and "Messaline" blues.[424] Between Bérard and Elsa ("the Italian woman who makes dresses," as Chanel called her), color became close to a language of fire. The daughter of an orientalist and a descendant of the Medici, the niece of an astronomer who was the first to map Mars, this woman from Rome was a chip off the old block. She had fled the convent where her family had sent her, after the discovery of erotic poems. Everything burned in her. It was a visit to Paul Poiret that convinced Elsa Schiaparelli to invent a life in fashion. Christian Bérard was not from the South, but he had filled himself with its light. In Rome, he wrote to his mother: "Yellow and ink tones of Corot on a blue sky, white roses bloom in the midst of the ruins, circuses, triumphal arches. I went up on the Palatine Hill, centuries-old paths, always with the wonderful sound of fountains […]. The tones of the setting sun became mad with life, wonderful colors

and tones of ancient painting, without the nauseating purples and burning greens of modern painting. I towered over Rome."[425]

1938. Hitler annexed Austria. The fascist intellectual Lucien Rebatet deemed Vienna "to be lighter and cleaner. You could see it in the streets, reclaimed by young girls in little flowered skirts and Gretchens' gorgerettes, and fresh, athletic boys proud of their new uniforms."[426] The Holocaust had not yet dishonored anti-Semitism, and Pierre Gaxotte espoused such a position loud and clear: "There are three-and-a-half million foreigners in France, most of whom have come as refugees from Fascism. We have seen these very belligerent men march with their fists in the air, shouting insults against Hitler. A truly exceptional occasion to combat this Fascism they hate through more direct means may perhaps be on the verge of presenting itself to them. Naturally, we are counting on these gentlemen with names ending in *ski*, *vitch*, *o*, *of*, and *ez* to take advantage of it. The first soldier killed in 1914 was Corporal Peugeot. We are counting that the first soldier killed at the front in 1938 will be named Rabinovitch or Rosenfeld."[427] Gaxotte wrote a preface for *The Pink Terror*, a violently anti-Front Populaire diatribe by Alain Laubreaux; this preliminary text was incidentally very appreciated by his colleague Lucien Rebatet. One year later, this same Rebatet, a great admirer of Hitler, would praise *Trifles for a Massacre*, Céline's anti-Semitic screed, before writing another one of his own invention: *The Ruins* (1942), in which he repeated his admiration for Pierre Gaxotte, "the brilliant anti-republican historian from Revigny."[428]

Having fallen in love in 1941 with the young Jacques Homberg, ten years his junior and from a Jewish family in Mainz – which had converted and obtained French nationality – Christian Dior found an additional reason to be discreet. To live happy, it was best to live in secret. New discriminatory measures established by the Vichy government penalized acts considered "indecent and against nature with people under age twenty-one."[429] Homosexuals were targeted by the police. Hunted or not, Dior was still the young man who dreaded gossip, having been brought up as a good Norman in the

173

Each of his drawings was a lesson in how to see, to transfigure daily life into an intense, nostalgic fairyland.

Christian Dior

spirit of wooded hedges, those windbreaks that allowed gardens to grow away from prying eyes. These unfortunate circumstances offered him the ability to be liberated, to tend to his love for this young man who would keep their relationship relatively secret until the very end.[430] What could Tian be afraid of now? Due to lack of funds, Maurice Dior had definitively left the sixteenth arrondissement and now lived in the Marais, a neighborhood where his son hardly ever ventured. Yet fear was still there, clinging to him.

As if he felt the rising danger, Bérard overplayed his own character, the monster with one thousand and one colors. It was as if his palette burst into flames. In 1938, with his "moving clusters of raw red cadets," his Roxane as captivating in pink as in black, his Comte de Guiche splendidly adorned, he dazzled the set of the play *Cyrano de Bergerac*, a real success in Paris, as Edmond Rostand's play (1897) entered the Comédie-Française repertory and was performed ninety times. "The play retains the youth and freshness of the evening of its birth."[431] Louis Aragon noted: "There's no doubt that a skillful director and the exquisite colors of costume and set designer Christian Bérard had a lot to do with this infatuation with a mediocre play."[432] The press was full of praise, evoking, in the words of Edmond Sée, "exquisite evocative magic," "skilfully measured luminosity."[433] In reality, there was extreme tension. Bérard could not keep up with everything he had been hired to do. When people looked for him, he disappeared. Thad Lovett, Jean-Michel Frank's lover, gently prodded him. Others did things more by the book: "Cher Monsieur, may I ask how far along you are with your design work for the performers' room in the Théâtre de l'Odéon?"[434] Where was he? Where was he hiding? Bérard didn't answer the phone and was sought in vain. Incendiary yellows, acid greens, blacks brought out with a dot of silver white sprang forth from his hovel. There were new insults from *Candide*, which had panned his *Illusion comique* a year earlier in these terms: "It is time to stop this abuse. If the Comédie-Française is managed this way, it will soon turn into a circus. Next they will announce the name of the supplier of the hats and gloves."[435]

This circus was exactly what Bérard was crazy about – even if Bébé's appearances shouting "Blum Blum" instead of "boom boom"

175

rubbed people the wrong way. Plus, he wasn't the only one: the circus had won over haute couture, inspiring handbags as big as clown hats or balls. It was the theme of Schiaparelli's summer 1938 collection, which the couturière would describe as "the most tumultuous" and "the most audacious."[436] In July 1938, she dared to arrive at Lady Mendl's party at the Villa Trianon at Versailles in a white embroidered Directoire-style dress, with a long "Shocking" pink silk scarf and a mane of hair in the Etruscan style. As the rivalry between Coco and Elsa reached its peak, Bérard had lunch with Schiaparelli, whose apartment decorated by Jean-Michel Frank – naturally – had horrified Chanel. Bérard enjoyed the compliments paid to him by this jolie laide: "I also want to tell you that I infinitely love your ballet and I have never seen more beautiful colors. It was a real pleasure. Affectionately."[437] However, did this mean that he concurred with Schiaparelli's frenetic provocations? After all, he had been around when all these Surrealist transformations that the fashion world had rediscovered had been invented fifteen years earlier. "Madame Schiaparelli, whose talent is well known, managed to push the boundaries of elegance to the limits of the bizarre. Perhaps she went too far."[438]

Appearances and disguises

Meanwhile, Christian Dior had assembled a much more discreet club: the circle of couturiers who were attentive to defending a line and arranging shapes with architectural precision. Impeccably buttoned up in their suits, they protected their privacy, although everyone knew about their lives. Aesthetes who looked like bankers, they defended beauty in glamour and truth in construction. Balenciaga is the most brilliant example. Having opened his Paris company in 1937, this son of a humble fisherman in Getaria renewed a desire for grandeur. "A disdain for embellishment and a love of pomp. Austerity of manners and voluptuousness. These extremes of the Spanish soul can be found in every Balenciaga collection."[439] Dior could only approve: "Mainbocher, Robert Piguet, where I was a pattern maker, started the return to a more classical style."[440]

Dior and Bérard were two loners with lots of friends. In 1938, Bérard introduced his friend to Marie-Louise Bousquet, whose Thursday afternoon gatherings at the Place du Palais-Bourbon were all the rage. At Piguet, Dior was only one of many pattern makers, but he was the one responsible for *Café anglais*, "A houndstooth dress with a visible linen underlap, inspired by the *Petites Filles modèles*, which had made a big impression that season."[441] But while Dior felt a "love of quiet and anonymity,"[442] Bérard – praised for his "modesty and humility" as a painter by Boris Kochno and for his modesty as a designer by Jouvet – hungered for social appearances and costume parties: Paris was his theater, and the only reason to live there was because it was to die for. He continued to design for the stage, from the ballet *La Septième Symphonie* to *Cyrano de Bergerac*. Dior was a bit suspicious of that kind of thing, since he "didn't like shows much."[443] "The chaos of backstage requires improvisation and approximation, a sacrifice to the overall effect that does not suit my personality."[444] In 1939, Marcel Herrand asked him to design the costumes for *The School for Scandal* by Sheridan, an experience that he would repeat, "but never with pleasure."[445] Dior met Carmel Snow – thanks to Marie-Louise Bousquet, so also through Bérard. He commented ironically: "I was starting to think I had arrived. What actually did arrive was the fateful year of 1939."[446]

Four years earlier, during his "retreat far from Paris"[447] in Font-Romeu, Dior had learned about upholstery, feeling "the need to do something with [his] hands."[448] The war would offer him a role he had not anticipated: "one year in wooden shoes, in the company of farmers from the Berry region of France."[449] He explained: "In 1939, the war turned me into a recruit." And it was in Nayssès that he found refuge after the armistice, "in a property that my sister and I owned near Grasse, where we lived from the fruits of the earth."[450] There, he pulled up flowers and rosebushes to sow green beans and peas that he sold at the market. "A farm? That's saying a lot. It would be more accurate to say that for two years, I played the country boy digging in the dirt. In fact, I love working with the soil."[451] Dior left Callian at five o'clock in the morning to go eleven miles on foot because he didn't

177

know how to ride a bicycle. "He went to Grasse where he could get a bus for Cannes. Since it was at least twenty-two miles in all, he sometimes slept on the way."[452] Christian Dior must have walked a great deal during this time, for, according to Alice Chavane, James de Coquet's companion and a journalist for *Le Figaro*, he was in the habit of coming to see her every Thursday to bring her his drawings. "All done by candlelight."[453] According to various recollections, "he would arrive with no coat," "starving."[454] She would serve him rabbit – which, at that time, was an extraordinary find – or "radishes and zucchini [...] and a dessert made of apricots from the garden."[455]

Bernard Dior, the "poor little sick boy," as described by his father, Maurice, was still in the asylum; he would stay there until his death in 1960. As for the head of the family with the broad, powerful stature, he was now a man worn down by hardship. A widower, isolated from the world, he owed his survival to the kindly Ma, a saint wrapped in her long peasant smock dress, who was glimpsed in her hat on Sundays at mass. Raymond was imprisoned in a stalag and would return even more bitter. As for Christian Dior, who thought he could resume his position as a pattern maker at Piguet, he learned that he had been replaced. It was not until October 1941 that he was hired by Lucien Lelong: a couturier whose first fashion show had been planned for August 4, 1914, but had been canceled by World War I. He reigned over Paris with the firm intention to yield to no pressure and to give up nothing. After being seriously wounded as a reserve second lieutenant and spending almost a year in the hospital, he made his company a cosmopolitan meeting place where Babe Paley and Marlene Dietrich, who admired his strict, energetic lines, would drop by. In silhouettes by Lelong drawn by Bérard – from designs that were surely by Dior – one could already see the signs of a "tailored" spirit. But the figures that Dior sketched on "16 Avenue Matignon" letterhead had become more supple, surely under Chanel's influence, but also from spending time with the seamstresses in the workshops and attending fittings.

A sketch by Dior, *Or en barre* (summer 1939), displayed a black sweater embellished with lines of gold sequins over a wool evening skirt, also in black. From Piguet, he had learned that "elegance lies

only in simplicity."[456] His line now revealed a look that was both languid and determined. Dior embraced curves and suggested, as in *Éventail* or *Palmes*, the new confidence embodied by these women with their hair piled high on their heads, models without mouths or eyes, but with a proud stance. We can sense that he was looking at American fashion magazines and had understood how accessories could define a silhouette, tracing with the same precision the squares of a *Mylord* Scottish coat as its matching cap, the belt buckle, the pair of earrings, and these legs delicately perched on a pair of pumps. He also knew that color was a trap, and while he was working for Piguet, the bungling of a green coat designed for the model Billy Bikkiboff, the daughter of a Russian general, got him kicked out of the studio for three days by the "blasé Oriental."[457] The young woman had told the couturier that she felt "ugly as a caterpillar"[458] in the coat.

Bérard, whose work Piguet appreciated (*Les Enfants des Goudes* was presented in the salon of his couture house), was more fanciful. His watercolor illustrations for *Vogue* make this clear. Moreover, he embellished these silhouettes with friezes and cherubs, bringing together red taffeta and "white satin painted" with arabesques. Their eyes clouded with gray, the Dior women looked at their clothing, but Bérard's women stared at the viewer and trembled. It was indeed about life, and for Dior these women were clients, before being mythical beings. They moved, they were alive, they were no longer just lines on white paper. The neoclassical world designed by Frank for Lelong – whose couture house he decorated – put Dior at ease. The fitting rooms of natural oak created a soothing atmosphere: "the white draperies seem to flow from the ceiling all the way to the floor," *Vogue* observed, praising this "decor of total white that is surreal and dreamlike."[459] The tensions with Jean Cocteau, who had stolen away the couturier's wife, Nathalie Paley, whom he had married in 1927, had settled; his divorce from the beautiful, diaphanous Russian woman took place in 1937. All the circumstances were in place to give Dior the confidence he was still lacking. Lelong was first of all "an excellent design school": "A solid tradition of crafts-

179

manship continued there thanks to the presence of remarkable seamstresses."[460] As president of the Chambre Syndicale (the trade association for haute couture), Lucien Lelong worked to prevent the Parisian workshops from moving to Berlin. For the young pattern maker, he was a master, a model, a "champion" – a name given by Lelong to a sweater in 1928. His practical sense – he had launched his *Robes d'édition* in 1934 – did not exclude a taste for ornamentation and transformation, season after season: "Fashion, a changing mask, renews women with a thousand different looks," a Maison Lelong invitation read in July 1941. "Dresses, coats, skirt suits, furs, lingerie, sport": the Lelong collection described here – which offended Schiaparelli – heralded all the licensing deals that Christian Dior would sign after opening his own couture house.

As a farmer couturier, a designer in the fields, Dior had acquired a "passion for [the countryside], for the slow and difficult labor of the fields, the cycle of the seasons, and the eternally renewed mysteries of germination."[461] It was as a country gentleman that he would regain his name and restore the family reputation, taking on his role as head of the family after receiving 1,000 dollars from the sale of "five or six paintings"[462] that he still had from his defunct gallery.

As for Bérard, costumed as the grand vizier at the Beaumonts' ball (1938), then as Little Red Riding Hood at the Bal de la Forêt (1939), he had started to look like a hunted Pantalone. In 1939, during a stint in rehab, he had to give up making the sets and costumes that Jouvet had hired him to produce. Out of desperation, the director replaced him with Tchelitchew – his old rival. Balzac had indeed noted that, in some men, poverty acts as a "tonic," and in others as a "solvent." At the hospital, Bérard presented "nervous disorders characterized by vertigo, insomnia, and speech problems,"[463] as detailed in his medical report. The peak of humiliation was the letter he received at the recovery facility of Saint-Mandé requesting that he pay for the cleaning of a taxi. The legal department of the taxi drivers' association reminded him of a debt of 170 francs, a "law enforcement officer having certified that the cushions of [the] car were stained by you."[464]

30 Avenue Montaigne

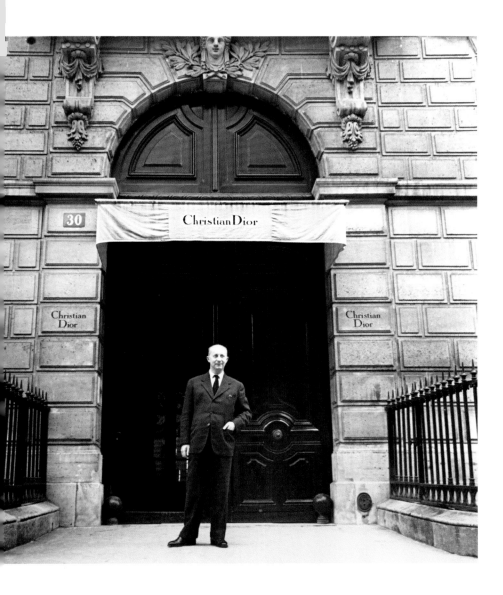

Willy Maywald, Christian Dior in front of his haute couture house at 30 Avenue Montaigne, Paris, 1948.

Jean Moral, Mademoiselle Blanchard wearing
the *Colette* evening gown in Christian Bérard's studio,
in *Town & Country*, May 1947. Christian Dior,
spring-summer 1947 haute couture collection, *Corolle* line.

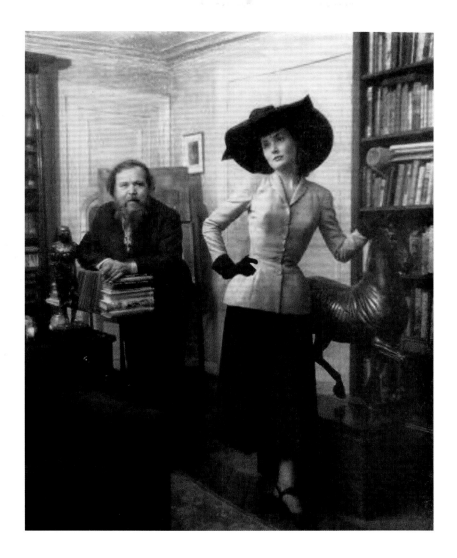

Jean Moral, Christian Bérard in his studio with
Mademoiselle Blanchard wearing the *Bar* suit, in *Town & Country*,
May 1947. Christian Dior, spring-summer 1947 haute couture
collection, *Corolle* line.

Eugene Kammerman, Mizza Bricard in the models' cabin for the first Christian Dior haute couture show, February 12, 1947.

Loomis Dean, The models' cabin, 1955.
At the center of the beehive, Christian Dior and, in the background, on the right, the young Yves Mathieu-Saint-Laurent, who joined the designer's studio that same year as an assistant model. To his right stands Marguerite Carré, the studio's technical director.

Eugene Kammerman, Christian Bérard in the models' cabin with Marie-Thérèse, on the occasion of the first Christian Dior haute couture show, February 12, 1947.

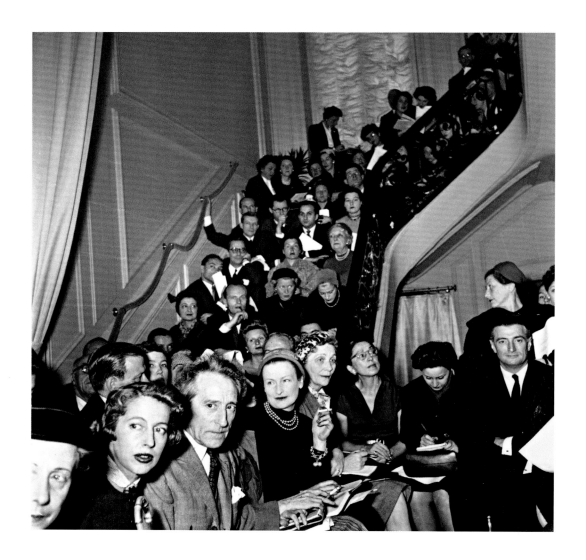

186

Willy Maywald, Jean Cocteau with his friend and patron Francine Weisweiller at a Christian Dior haute couture show, at the foot of the grand staircase at 30 Avenue Montaigne, circa 1950.

Seated on the right, Serge Heftler-Louiche, Christian Dior's childhood friend and founding president of Parfums Christian Dior.

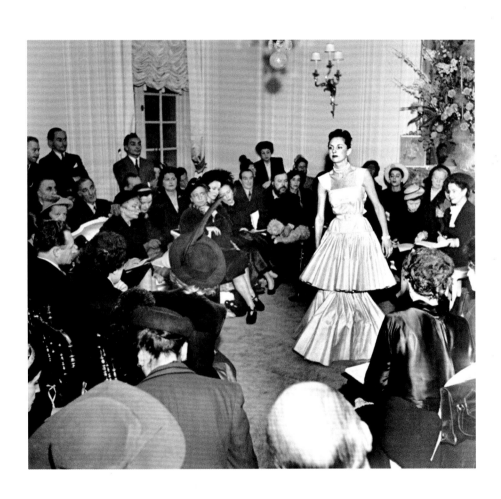

Pat English, Presentation of the *Songe* evening dress in a salon, February 12, 1947. Christian Dior, spring-summer 1947 haute couture collection, *En huit* line.
Behind model Tania, Christian Bérard is seated in the front row.

Eugene Kammerman, Presentation of the *Ariette* dress, worn by model Renée. Christian Dior, spring-summer 1955 haute couture collection, line *A*.

On the left, photographer Louise Dahl-Wolfe with Carmel Snow and Marie-Louise Bousquet, editors for the American and French editions of *Harper's Bazaar*. On the right, smoking, Michel de Brunhoff, then editor-in-chief of *Vogue* Paris.

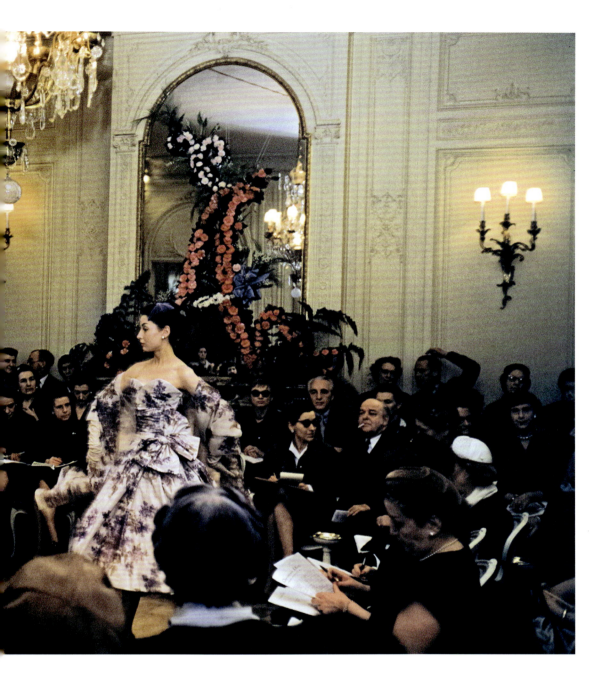

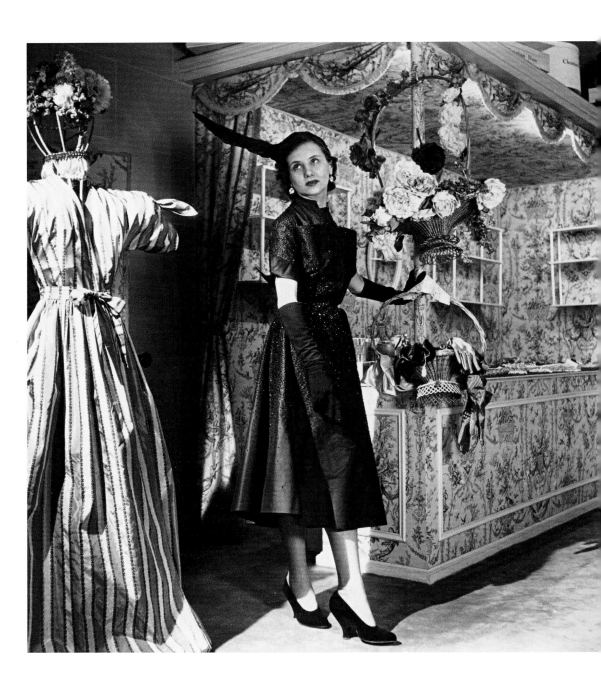

Willy Maywald, The Colifichets boutique at 30 Avenue Montaigne, with its toile de Jouy décor designed by Christian Bérard, 1949.

Model Hélène de Korniloff wears the short *Rive gauche* dinner dress. Christian Dior, spring-summer 1949 haute couture collection, *Trompe-l'Œil* line.

Serge Lido, Christian Dior in the Colifichets boutique with its toile de Jouy décor designed by Christian Bérard, 1947.

Willy Maywald, The perfume area of the Colifichets boutique, 1949.
Carmen Colle, in the foreground, was the manager.

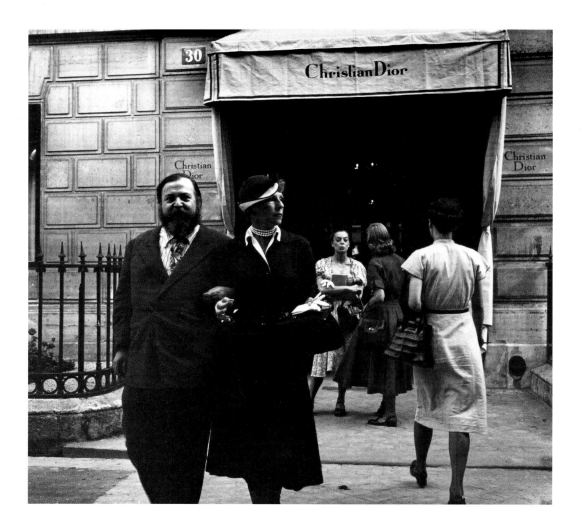

Willy Maywald, Christian Bérard exiting
30 Avenue Montaigne, circa 1948.

As if wrathfully haunted by the demons of the time, his colors became increasingly electric. With Jean-Michel Frank, he had just completed the interior design of Institut Guerlain, a new temple of Parisian beauty at 68 Avenue des Champs-Élysées: "And we cannot say what we admire the most in the immense lobby with its splendid marble surfaces and luminous niches, where a red rug edged with a black arabesque adds a warm note of color; or in the charming loggia based on a model by Christian Bérard, where, on a background of yellow fur, there is a trompe-l'œil decor made of gray, black, and white cut-out braiding featuring console tables painted by Bérard; or in the grand salon with its pared-down woodwork, where the pale yellow rug plays off the black curtains with mauve, pale blue, and beige fringe."[465] Bérard sketched gas masks for American *Vogue*; he displayed the obliviousness of condemned men while finding himself on the edge of an "abyss of catastrophes."[466] "Undisciplined, without the least sense of hygiene,"[467] he had the cruel attitude of a mocking child whom his father lectures in vain: "You are the one responsible for the leaks occurring on the lead terrace of the apartment."[468] He had other reasons to roar with laughter, or simply to roar. His joy was acidic. Written up on July 12, 1940 – one month after the Germans arrived in Paris – the identification card of his dog Cola, "a.k.a. the Naughty Girl," a "Maltese" with a "pink" back, a "dirty" complexion, and an "ugly" face, indicated her profession as "licker."[469] First thing in the morning, Bérard drank "glassfuls of brandy," which he supplemented with all kinds of pills and drops. "The extreme refinement of his taste" contrasted with the "careless state of neglect of his person."[470] Certainly, he had started earning money, but, with the badly combed red beard that he would keep from now on, he looked like a "high-end homeless person."[471] When he couldn't handle anything anymore, he would go to bed in his clothes and fall asleep with his shoes on. The suit he had made by a tailor was tattered.

Cola's eyes were "red." And on the stage of *Monstres sacrés* by Cocteau, for which Bérard designed the sets and costumes, the reds multiplied hypnotically. Bérard's eyes were injected with poison. Called to military service, he got sent back to the hospital in

Saint-Mandé before even being demobilized: "Hospitalized for anxiety, impulsiveness, lethargy. These problems are continuing due to withdrawal, despite apparently good general condition."[472] In November 1940, he was definitively discharged.

Dark nights

After the "drôle de guerre," there was the debacle. Around Bérard and Dior, their friends scattered to the wind. Jean-Michel Frank suddenly left Paris for Bordeaux, then Lisbon, before a long period of wandering that would ultimately end with his suicide in March 1941 in New York. A victim of the anti-Jewish laws of October 1940 and June 1941, Pierre Loeb fled to Cuba. The Propagandastaffel kept up a steady stream of orders, which were received docilely. Waldemar-George, stripped of French nationality and become Jerzy Waldemar Jarocinski once again, the "gallery-browsing yid,"[473] had to give up the exhibition that he was to organize at the Salon d'automne. "After this visit, our friends of the Jewish race were excluded for political reasons."[474] He had to flee, beginning a life of secrecy that would break him. At a time when works of art were being despoiled and Jewish gallery owners had to hand over their businesses to the "Aryans", the Galerie Renou & Colle, which had been closed during Pierre Colle's mobilization, reopened in 1941 and continued to do business during the Occupation.[475] As for Pierre Gaxotte, whose ultranationalist writings characterized "the golden age of invective,"[476] he was so hostile to collaboration that he became a target for Vichy. Fleeing the Gestapo, he found himself in the company of the composer Mitty Goldin (Goldenberg) in Varennes-sur-Allier, a small village south of the demarcation line, on the Paris-Vichy railroad. The mayor supported refugees, providing false papers and ration cards, and warning Resistance members and Jews of coming round-ups. He would be named one of the Righteous Among the Nations. In danger, Pierre Gaxotte stopped signing his articles in *Candide* starting in 1940.

Dior-Bérard. Cri-Tian. Between them, there was what was kept quiet, World War I and the Roaring Twenties that overshadowed its violence, bitterness, and humiliations, then World War II, which hurtled onto the scene like an old enemy. No, France was not divided between Resistance members and collaborators; the majority was simply concerned with survival. Getting by. Like a motto embroidered in white letters on a straw hat: "Be silent." The murderous madness of some was strengthened by the complicity of others, who were unfamiliar with the feigned rebelliousness of the masses. For, in the chaos, people wanted to believe that continued celebration would be the best response. The women who repaired their dresses with their own hands, lacking seamstresses, imagined that they were defying the Nazis, and all saw themselves as peaceful resisters. Bérard found his own refuges. When he went to Beistegui's home at the château de Groussay, it was with "his suitcase of dirty laundry that a well-trained and rather disgusted staff" handled and returned to him "laundered and mended."[477] In his rumpled Hilditch & Key shirts, he had never worked as much as during these war years, rather like Cocteau seen by Jünger: "Nice, and at the same time tormented, like a man staying in a personal but comfortable hell."[478]

The dreadful Nazi death machine was at work. The older brother and youngest sister of Max Jacob were gassed at Auschwitz. And soon it was his turn to be arrested. "I am outside the world, I can only suffer martyrdom,"[479] he had written in 1939. Through letters and petitions, friends including Pierre Colle and Henri Sauguet tried to save him. Despite Cocteau's pleas to Otto Abetz, Max Jacob died of pneumonia in the camp in Drancy. The anti-Semitic press that systematically panned Bérard's sets and costumes had a venomous response to the poet's death: "Jewish by race, Breton by birth, Roman Catholic by religion, and a sodomite in his habits, this individual was the most characteristic kind of Parisian one can imagine, from this Paris of rot and decadence whose most visible disciple, Jean Cocteau, remains an equally symbolic example."[480] On March 26, 1944, before a grave in the cemetery in Ivry, Abbé Morel blessed the memory of Max Jacob in the presence of a few friends, including Pierre Colle and Henri Sauguet.[481] Dior and Bérard would be present

at the mass at the church of Saint-Roch that brought together many they knew, from Coco Chanel to Paul Éluard, from Roger Lannes to Pablo Picasso.

Bérard's social success made him a target for informers and collaborators, who raved against Jews, Bolsheviks, and "fag brothels."[482] This fury went so far that on June 12, 1941, the actor Jean Marais slapped the collaborationist critic Alain Laubreaux who, skewering the play he was performing in (*La Machine à écrire*), had called him "the man with Cocteau between his teeth," a play on the word *couteau* ("knife"). One month earlier, Lucien Rebatet (alias François Vinneuil) had published a piece called "Marais et marécage" ("Marais and the swamp") in *Je suis partout*: "Cocteau is responsible for everything he has broken and sullied, for the parade of worldly fools, fags, and excited widows who come giggling along behind him [...]."[483]

Bérard could tell he would be the next scapegoat. He got into the habit of cutting out all the reviews, which he piled into a cigar box and pinned above his bed, but did he even have the August 25, 1941, issue in which Alain Laubreaux criticized his "absurd décor" for *L'École des femmes*?[484] So he left Paris for the South, toward the light and sun he desired so much. Jean Ozenne picked up his mail: he wrote to his friend that he had found "newspaper clippings of little interest," a gas bill, and another from the art and antiquities gallery À la Vieille Russie in New York. In a letter to Bérard, Jean Ozenne expressed empathy, awkwardly hiding the concern he felt for this cousin whom he did not want to offend, since Bérard was so far away, flighty, and fragile. He wrote that he was "very glad" that the exhibition in Zurich "went so well."[485] He described how pleased he was: "From concurring reports, it truly seems you are working, how wonderful!"[486] Ozenne ended with a tone full of hope, with very confused phrasing: "Now I'm even happy that you didn't come, despite how much I would have liked it, but if this wait of a few weeks could fulfill the hope of these recent years!"[487]

Indeed, it had been years since Bérard had exhibited his work. It is apparently during this period that Dior acquired a painting by Bérard, *Nain, d'après Vélasquez*, an anxious figure with a revolted

mouth and dark hair falling above a thick slash of eyebrows. This torment could also be perceived in 1942 when Bérard painted *Le Fils de Victoria* during his time in the South of France. The line became messy and the expression grew heavy with his fear of losing the subject whose light he had been able to capture ten years earlier. His last paintings showed figures close up; the background had disappeared. And when he tried landscapes (*Le Potager du mas de Fourques*), his style was unrecognizable. Like a man who had deserted his country, the painter tried to relearn how to see what the landscape now refused to tell him. "I hope that the excitement of the theater will not make you forget for too long that you are also a great painter,"[488] Lily Pastré tried to reassure him. She hosted him in Montredon, on a lovely estate just outside Marseille.

Occupied Paris was busy with the black market, looting Jewish property, rationing, and collaborating, with varying degrees of zealousness. Yet every evening on the theater stages, the lights went up as if nothing had happened. Bérard projected onto the set of *Renaud et Armide* an iridescent shine, his admirable talent consisting in "revealing the unknown as a natural world."[489] He stimulated vocations. "Jean Cocteau, Charles Trenet, Christian Bérard were for me like heavenly bodies, and the satellites gravitating around them formed a constellation that lit up the dark night of the Occupation,"[490] Pierre Barillet wrote. Bérard revealed Gérard Philipe as an angel, had lunch with Cocteau and Genet at the Hôtel du Louvre, and dinner at Maxim's where an alarm made him leave;[491] one night, he got into Comtesse Olinska's Rolls-Royce, and, as he was getting out, she poked him in the eye with the rose she offered him. Another time, he was attacked at the Invalides as he got out of the Métro with Paul "Boulos" Ristelhueber and Misia Sert. She said she owed her life to Bébé, who "fought like a little lion."[492] At the time, he was living at Hôtel Beaujolais, very close to Cocteau: "Bérard was my right hand, and since he was left-handed, I had a right hand that was surprising, skillful, graceful, light, a fairy's hand."[493]

In the Free Zone, people still hoped, still dreamed. "Pour Que l'Esprit Vive" ["So that the Spirit May Live"] was the name of the association

started by Lily Pastré in November 1940 on her Provençal property. It wasn't for nothing that this heiress and music aficionado was born on Rue Paradis in Marseille. On July 27, 1942, having been abandoned by a flighty husband, she put on *A Midsummer Night's Dream*. "Fairies, spread the springtime dew everywhere," Shakespeare wrote. Why *A Midsummer Night's Dream*? Perhaps simply for the summer night that was beginning. The music was by Jacques Ibert, the sets by Jean Wall, and the orchestra was conducted by composer Manuel Rosenthal, who had joined the Resistance after having been imprisoned and then liberated by the Germans. Around him were many Jewish musicians, including Clara Haskil. The costumes were by Christian Bérard, with the artistic collaboration of his dear Boris Kochno. This dream was more than a dream. It was a boundless challenge to the night, to all the shadows that were threatening. It was also a beautiful homage by Bérard to his master, comrade, and friend, Louis Jouvet, after missing his last chance to work with him: "In the art of the theater, where everything that is material is destructible and corruptible, it is the immaterial that commands and defines."[494]

Ultimately, it was an ode to life. In Bérard's *Dream*, the tulle fabric floated, eerily lit by the full moon. The watercolors seemed to evaporate among the olive trees. The fairies and sprites played with danger as if it was just another "jest of love" announced by Shakespeare. The playwright had even imagined a character who is a tailor named "Starveling." Colliding together, the centuries highlighted the fantastic grace of a "sweet secret." "But earthlier happy is the rose distill'd than that which, withering on the virgin thorn, grows, lives, and dies in single blessedness," Shakespeare wrote. While the performance lasted, imaginary beings took form, before the costumes were destroyed at dawn. "Montredon is very quiet and full of melancholy hanging about the lawns and entering through the windows," Lily Pastré would write to Bérard in 1943. "It is like a large ship abandoned to the storm while springtime has still come to us with all its flowers and scents."[495]

Edmonde Charles-Roux, whose mother was a friend of Lily Pastré, played a sylph. Bérard took down the curtains to make the

dresses: the curtain rings became bracelets for Peaseblossom, Cobweb, Moth, and Mustardseed. "Bérard managed to dig up velvet for the hats, woolen cloth for the pants, silky lawn, soft chiffon, and puffy taffeta for the sleeves of the dresses. And, my goodness! Bottom's angel face of papier mâché! He draws each character in India ink wash."[496] Whimsy blossomed in the hands of the wardrobe mistress Ira Belline, Stravinsky's niece and Louis Jouvet's collaborator at the Athénée theater. There were cloaks, doublets, breeches, veils of misty gauze. It was as if Bérard had rediscovered his Italian masters; his silhouettes seemed to be formed from a transparent dream. Costume designer or couturier? To the grace of his drawings, Bérard added a technician's precision. "This hand seized labor like prey. It could cut fabric, hold a hammer, hammer a nail, cut the framework for a set. When, with the tip of a brush, this hand placed a dot of color onto a watercolor, we would shout with pleasure as the rose, or the lip, or the breast bloomed before our eyes."[497]

An eye was there to photograph this fairy-tale all-nighter: it was that of Victor Grandpierre, who photographed Bérard at work and the actors, who seemed to be sketches of flesh and blood. His black-and-white photos show an enchanted interlude, the trace of an intense time of work and happiness. This detail might seem unimportant: Victor Grandpierre, having fled to Cannes, had just met Christian Dior, with whom he became "very close." Montredon had seen the start of not just a friendship, but of a promise that gave hope. Dior saw himself in Victor Grandpierre. "He had told me about his desire to become a decorator," he would say of him. It happened that Grandpierre, like Bérard, was the son of an architect: at the turn of the century, his father, Henri Grandpierre, had built the mansion of Winnaretta Singer (who became the Princesse de Polignac). In Dior's opinion, Victor understood "good tradition":[498] "Our tastes aligned perfectly in our shared search for our childhood paradises."[499] For the first time, Christian Dior realized that he was not alone with this nostalgia whose delights he could reconstruct, without feeling ashamed. "You must throw it out!" Eugenia Errázuriz, Jean-Michel Frank's muse, would shout, the

woman whose "penitent's cowl came from Chanel."[500] Jean Hugo enjoyed imitating her Spanish accent – "No treenkets!"[501] – and related: "There was nothing left in the apartments except for a dark rug covering the entire floor, a big sofa, a few deep armchairs with light-colored covers, and an electric photographer's projector."[502] Like a starving man composing his menus, Dior imagined everything that he had left in the attic of his own history, as he was enamored of "this cursed style [and] colors," the neo-Louis XVI of his childhood, whose "invisible elegance survived in the salons of the Ritz or Plaza hotels."[503] The past he shared with Grandpierre was a score to set to music. It meant a watering can was in its place in the garden, not in a vestibule under a statue of the Virgin. It was the aesthetic revenge of a few inconsolable souls who had to suffer, for almost fifteen years, purifying calls to order:

> We don't want trinkets anymore!
> Take the furniture out the door.
> All these things are superfluous,
> Toss everything, it's so cumbrous![504]

Montredon marked a turning point. In a single night, Bérard had expressed its frivolity – twenty years earlier, during his military service at Koblenz, wasn't he already "the organizer of the splendors of the barracks, in charge of the sets and lighting"?[505] And the photos taken by Grandpierre captured this mood for always. "SOS Bébé, save me," wrote the young Edmonde Charles-Roux: "My sister the princess who is still living it up writes to me from Rome to ask me for four sketches of spring evening gowns and four sketches of simple dresses. Coming from her this request flatters me but I am desperate. After a year living in Marseille, I'm unable to write to her and even less to draw the trends of Paris fashion for her. With a few touches of your pencil, show her how beautiful the dresses in France still are. They will fight over your sketches and that will be some nice propaganda. With or without color, on any old scrap of paper. Keep in mind that she is blond, with slim hips, a catlike face with green eyes, and she looks good in frills, pleats, and simplicity. I know

you're terribly busy. If you think I have much too much nerve, say no, and I'll certainly understand. Otherwise I'll tell Cyprienne to be patient while waiting for your inspiration."[506] This letter from Edmonde surely remains one of the best homages he ever received.

However, at Montredon, Lily Pastré found Bérard "nervous, anxious, agitated."[507] Like Hamlet, he seemed to say: "I have that within me which passes show. These but the trappings and the suits of woe." Bérard and Dior each personified a French garden in his own way, and, behind the well-trimmed hedges, secrets grew in the midst of the brambles. In Paris, people were still looking for Bérard. "Bérard hasn't replied to any postcards. Will he collaborate on your work? When can he come to Paris?"[508] Jean-Louis Vaudoyer wondered. As for Giraudoux, he refused any other designer. Bérard was *"the only one."*[509]

In 1943, Jean Cocteau wrote to Christian Bérard to ask for morphine for his poor dying mother: "This is why I'm asking you, calling on your old friendship, like twenty years ago, when you ran over to Jean Guérin's place for me, I'm asking you to look carefully in your closest, in your clutter, to find whatever rags, little bits, and discards you can give me, for I don't have any anymore and I realize that without 'that' I won't be able to handle it. Be helpful my Bébé and send me whatever you find right away. You understand, it's a question of hanging in there physically for two or three weeks, maybe less, and then, you can be sure, I won't care. Sorry to bother you my Bébé, I'll be able to make it up to you once I'm alone. With all my affection. Don't make me wait. Jean."[510]

This Parisian force of nature lit up his difficult nights with visions found in the abyss. In *Renaud et Armide*, a tragedy in three acts by Jean Cocteau, "a chameleon in bourgeois society," "whatever his transformations, he keeps a simian gait. He's always imitating someone."[511] Christian Bérard's set, "with its transformable garden, gives the performance an extremely graceful lightness,"[512] commented the *Cahiers franco-allemands*, in November 1940, about *L'École des femmes*, staged once again at the Comédie-Française. Critics were no longer as indulgent, and Laubreaux, who dreamed of running the theater, led the slingshot: "Christian Bérard's sets are

of quite bad taste."[513] Hatred was unbridled, with critics referring to a "show that veers into caricature," a "parodic play," a "kind of transvestite Tasse."[514] In October 1943, Bérard created the costumes and sets for *Sodome et Gomorrhe*, a play by Jean Giraudoux performed at the Théâtre Hébertot. Here, the bodies had no more mouths, no more eyes. They were like ghosts, or angels with jet-black wings: "Their bodies are their alibis. They are never there. They have nothing more than their bodies to simulate their absence," Lia complained. The 2,028 stitches required by the costumes were concrete evidence of the colorful dream of the head rag-picker, but he had still not gotten over his withdrawal symptoms and would suddenly begin sweating or shivering. Now, this bugbear would be his salvation and his daily suffering in the bitter garden of opium. He was commissioned to make illustrations, but did not deliver them, forgot, fled. Edwige Feuillère insisted that he show up to the appointments she made, but he eluded her for over six months; the actress, who did things by the book, complained. But, two years later, during a dinner with Louis Jouvet, he ended up designing the costumes for *La Folle de Chaillot* on the tablecloth of Le Berkeley restaurant. His chubby little hand with its dirty nails flew here and there, and his pencil was just "the sooty point of an extinguished match." With these tools, he created "clouds, trees, faces full of feeling, emotion, humor, poetry."[515]

Dressed by Bérard, Edwige Feuillère sported a coat of ash and a headdress of dead birds. Her hair was red, her complexion covered with Spanish white, and the lines "j'adore la vie, j'adore la mort" by Irma Lambert already revealed a world that had vanished in smoke. Bérard seemed now to reside in "this life of succor, where one learns to escape from the conditions of reality before coming back to it and taking it prisoner."[516] With everything rationed, the dresses were made from old clothing, for it was impossible to find the necessary stylish fabrics to make turn-of-the-century corsets and blouses. The director took out an ad in *Le Figaro* and received a hundred bundles of clothing, which Bérard rummaged through. He knew his power, his way of conveying wonder as well as discomfort. "Bérard only likes mess and the fire of arguments. He lights that fire and feeds it with

Christian Dior will revolutionize the world of fashion.

Christian Bérard

I can certainly say that my most passionate and exciting affairs are my dresses. I'm obsessed with them.

Christian Dior

twigs. His entrance into public places. His beard, his lace hat, his rags. Stupefaction."[517] Certainly, Bérard's world rustled with stories, with bursts of color, boxes of gold and thousand-dollar bills he pulled out of his rags. "People think it's theft".[518] For Jean Cocteau, "Bérard is always right and his greatness always contrasts with what the weak expect [...]. Bérard brings me the burning bush of his beard and his dreamlike sketches."[519] In an empty Paris, unreal under the snow, Cocteau said: "This city in the moonlight is the statue of the Commander."[520] Could his madness rival the hatred spread by the press? If Jean Cocteau wrote in the program of "Dürer's black sun" illuminating Armide's gardens "mysteriously,"[521] Alain Laubreaux vented his bile on the show: "Chiffon, mists, clouds, dull forest vibration. I do not want to be unfair, but it seems to me that this astonishing artist did not succeed in giving us, in these curves, the equivalent of that fresh style that attracted us so much in the past, in *L'École des femmes*, for example."[522] The newspaper unleashed its fury: "Armide's bewildering grotto causes us a certain unease."[523] *L'Action française* too: "*Sodome et Gomorrhe* may have been performed. As for us, we can ignore the literary value of this play. We just can't get over our disgust."[524]

Meanwhile, Christian Dior was facing a harrowing experience. Hell had opened up underneath him. Ginette Marie Catherine Dior, his cherished younger sister, had been tortured by the Milice, at a site where French torturers and crooks hired by the Gestapo practiced shooting at a sewing mannequin while Bach and Mozart covered the screams. Christian Dior's sister was one of the three hundred Resistance members who were tortured from May to August 1944 by "the Rue de la Pompe gang" led by the German Friedrich Berger.[525] The sixteenth arrondissement of the Dior children darkened with this encounter with horror. Beatings did not make her reveal the name of her lover, Hervé des Charbonneries, or those of the other members of her Resistance network, such as Liliane Dietlin Crespelle. Unlike the writer Jean Desbordes, Cocteau's former secretary and lover, who was tortured and died without having talked, this "extraordinary young patriot" survived. But on October 9, 1944, she was in one of the

last trains headed for Ravensbrück. Then she was transferred: "At Aberoda, the working conditions are unlivable. The female workers sleep in the workshop where they work, on the cement floor, with no toilets. The rations are minimal, a clear soup, sometimes with a bit of stale bread; the shifts alternate every twelve hours and they toil away under the blows of SS guards who enforce the pace. Anyone who refuses to work is immediately shot."[526]

Christian Dior had become a different man. "I was wearing myself out seeking traces of her. But the work was there, absorbing, demanding, like the only remedy I had."[527] After being imprisoned in Fresnes, she crossed France and Germany in a lead train car, becoming a number, with a white cross painted on the back of a man's coat for the female prisoners. "My dear Papa, we must be brave. [...] How long will it be until we can see our dearest again?"[528] Christian wrote to his father on April 19, 1945. As he was writing this desperate letter, the death march had begun. When she returned in late May of 1945, Catherine was just a shadow. Besides all the beatings and abuse, had she been raped by her torturers Rue de la Pompe?[529] According to accounts, ice was placed in her belly.[530] She would never have children. On her face, which no longer smiled, silence had turned to stone. "My beloved dearest Catherine, I cannot find the words to express to you the immense and heartfelt joy I feel upon learning of your resurrection."[531] In her room, Catherine would always keep the portrait of her brother as a dandy by the German artist Paul Strecker in the 1920s. Tian was wearing a green jacket, a pink sweater, and a fresh butter-colored tie. She scratched out the artist's signature because she could not tolerate, whether near or far, the trace of a Germanic presence in her home, or, additionally, the "German vice" by which this young artist, she believed, had perverted her older brother. The Resistance member of the F2 network had the dignity of those who had lost everything except their honor. On July 1, 1945, she found the courage to write to the head of the agency for deported Resistance members to ask for an advance of twenty thousand francs on her government payment. At that time, it was said that she was "in a very difficult financial situation."[532]

When the war ended, the shame of four years of occupation, roundups, and deportations gave way to popular celebrations. Catherine Dior would bury her secrets in the earth, in her dear Provence, at Les Nayssès, this family home where, having married Hervé des Charbonneries, she would cultivate her garden and become a flower merchant. In this rocky country with its black mulberry trees, the winters were harsh, the summers dry, and there was no running water or electricity. "I am currently on recuperation leave in Provence. I am benefiting from the sunshine and quiet of this beautiful area,"[533] she wrote to the military authorities. "Ma" watched over Catherine and over Maurice Dior with the devotion of a saint.

Newfound sensations

The economic crisis had given Christian Dior a faith from the beyond. This man deeply struck in his flesh knew that he could no longer go back. His dresses would no longer be lines; they would grow in him like flowers, and he would be the absolute master of his garden. He would place in his designs, as if in an imaginary trunk, his joys, torments, desires, and memories. Raised in constraint and modesty, Christian Dior only ever perceived the body from the perspective of arabesques, swirls, and allegories. Concerned with creating "'constructed' dresses on the curves of the female body whose form they would stylize,"[534] Christian Dior found in Belle Époque decoration the essence of himself. On his intimate flaws, he would build the scaffolding of his dreams, the experience of what "carries to the theater."[535] Dior would make the "architecture of situations"[536] that was dear to Bérard serve his own story, or rather the stories that he would tell to women. Inside his memories, he found the scent of a mysterious countess in the staircase of the Rue Louis-David, a drawer of lingerie, a rose pinned in the sky of Granville, and he turned this into the soul of a style made to "renew the feeling of being in love."[537] And of this he created his own kind of fashion. The Dior spirit proceeded from these infinite layers of rediscovered sensations. Life

was a theater of emotions with a set designed by Bérard: "Where will the characters enter, and where will they meet each other, and where will they part?"[538] He would no longer be the illustrator for *Le Figaro* or the pattern maker for Piguet or Lelong. He would be Dior, and he would find in this name the courage he had been lacking, as he put together the most extraordinary bouquet in the world: "It is a mistake to believe that there is nothing but vanity in hats and frivolity in the folds of a dress."[539]

Flowers, reeds, and stems would be the foundation of his stylistic vocabulary, defined in 1947 by the famous *Bar* suit of the *Corolle* line. A silhouette that had been found in Bérard's work starting in 1938, particularly in the costumes for the ballet dancers of the *La Septième Symphonie*, a ballet set to music by Beethoven that was performed in Monte-Carlo in 1939. Slim waist, full skirt, the ink drawings expressed pure grace, winning him heartfelt compliments from his father: "I can only tell you how proud I felt upon seeing what you have done, you and your friends, and in thinking of the big part you played in this magnificent, poignant thing."[540] Color had disappointed; black and white were arranged in an absolute lesson in harmony. Dior would be the guardian of this dream that Bérard had sketched once more in *A Midsummer Night's Dream*, this life that was so fragile, like Catherine's heart, which had somehow managed to keep beating. "My temperament is reactionary, which is not the same thing as looking backwards. We had barely left behind an impoverished, frugal era, obsessed with tickets and stitches. So my dream naturally took the shape of a reaction against this poverty."[541] Haute couture would be for him "one of the last refuges of wonder."[542] Didn't his psychic predict that Catherine would come back? "Accept!" she ordered me. "Accept! You must create the Maison Dior! […] Before such clear certainty, I gave in, or, rather, I resigned myself."[543] Tian still feared not being up to the task. His family was there, gleaming in its invading absence: "How would my parents have recognized me – I can hardly recognize myself – when the adventure of Christian Dior began, in late 1945?"[544]

His brother Raymond published a "short, private chronicle" under the title *Les Vaches (1918-1935)*. By doing this, he publicly

Exercises in style

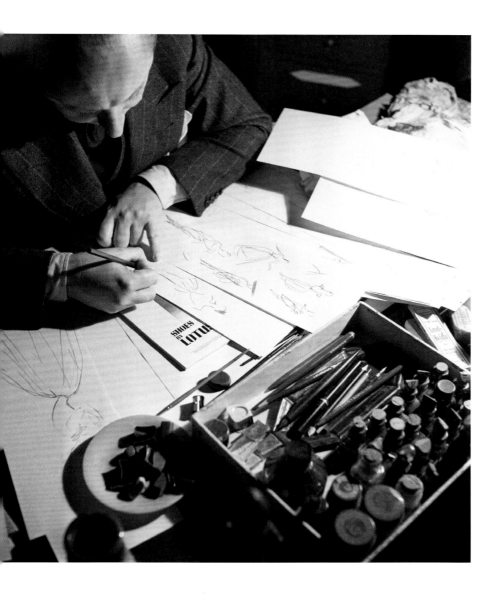

Émile Savitry, Christian Dior drawing at his desk, Paris, 1947.

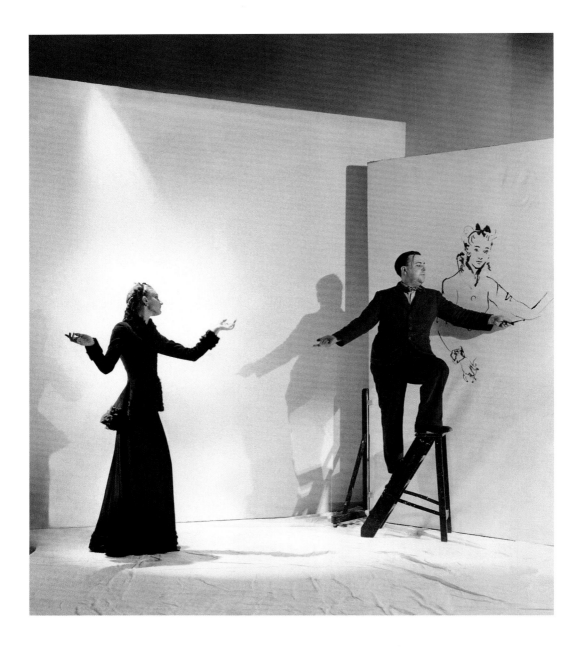

Cecil Beaton, Christian Bérard painting a model of the Mainbocher haute couture house, 1936.

Willy Maywald, Christian Dior holding his sketch sheets, circa 1950.

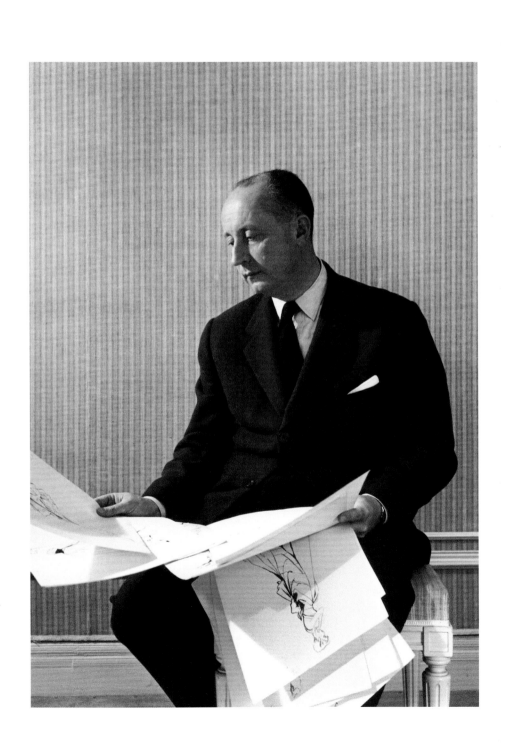

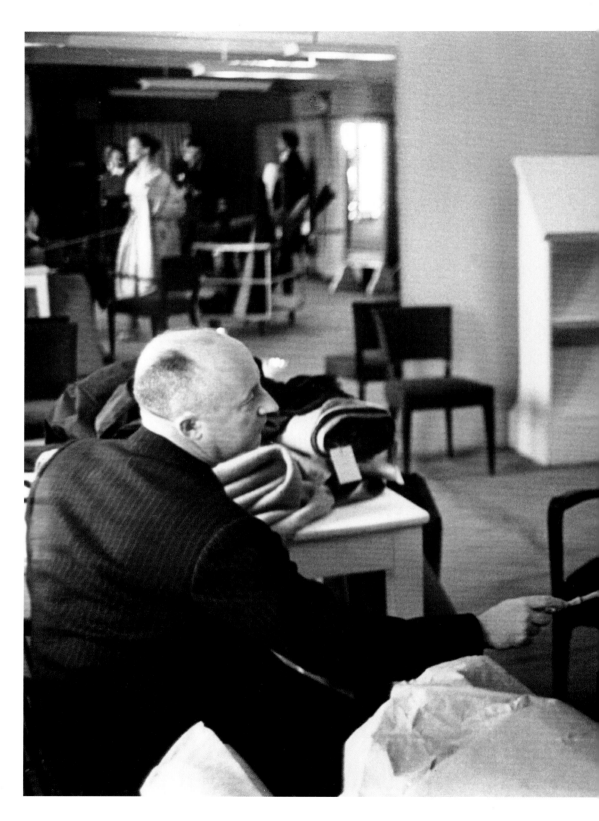

Roger Wood, Christian Dior examining in his studio, with his badine, the *Tournesol* ensemble consisting of an afternoon dress and a coat, worn by the model Lucky. Christian Dior, spring-summer 1952 haute couture collection, *Sinueuse* line.

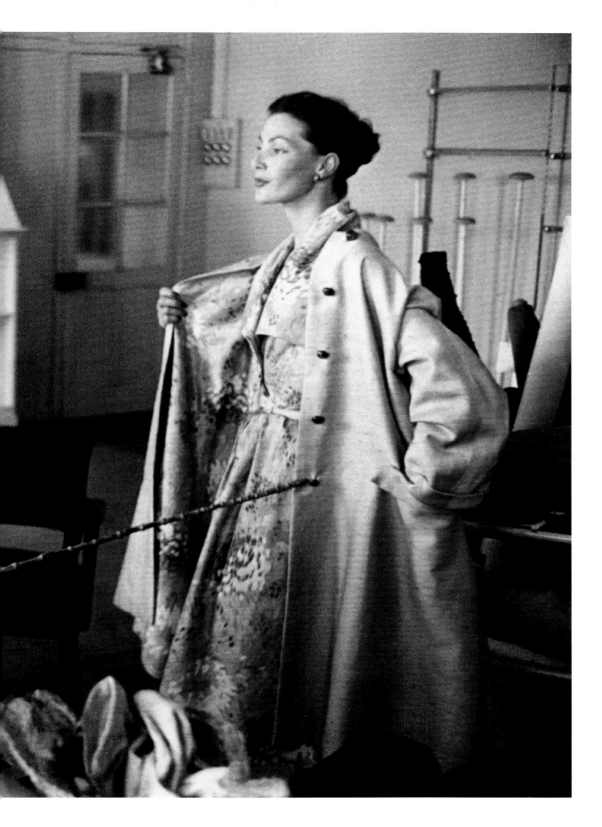

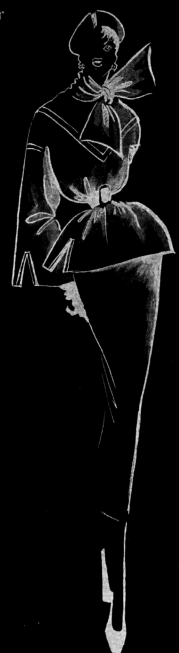

Press sketch of the *Christian Bérard* model, two-piece dressed in "Dior red" velvet. Christian Dior, autumn-winter 1949 haute couture collection, *Milieu du siècle* line.
Paris, Dior Héritage.

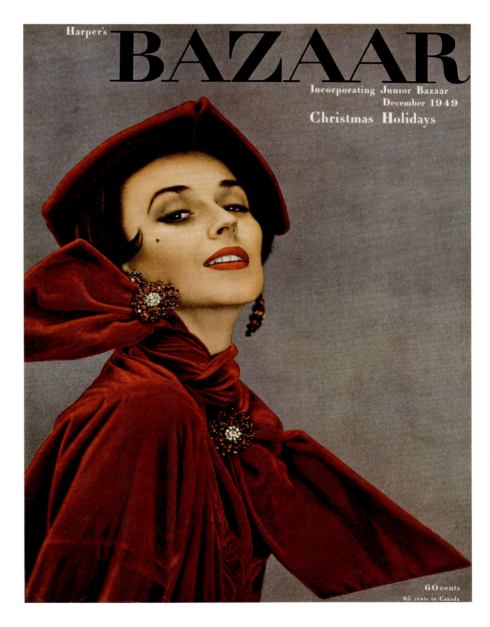

On the front cover of *Harper's Bazaar* (no. 2856, December 1949), model *Christian Bérard*, photographed by Richard Avedon. Christian Dior, autumn-winter 1949 haute couture collection, *Milieu du siècle* line.

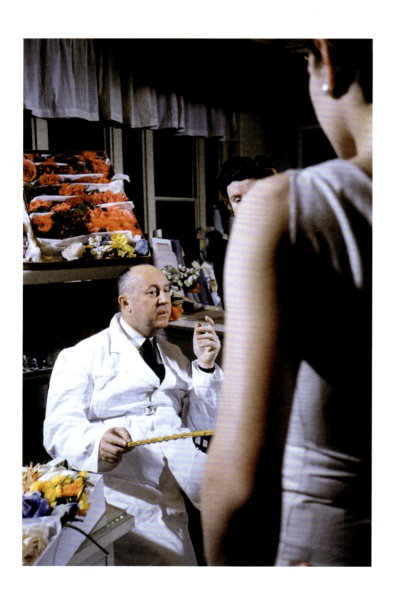

Eugene Kammerman, Christian Dior in his studio, July 1953.

216

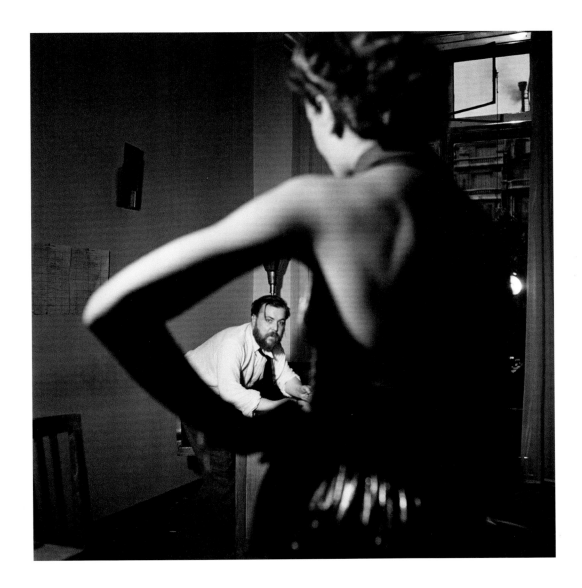

217

Roger Schall, Christian Bérard drawing a model in the *Vogue* Paris office, 1937.

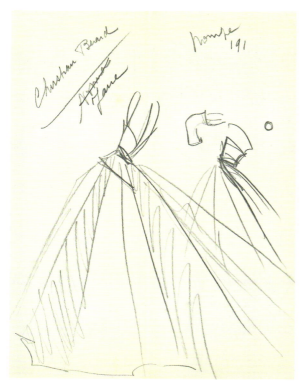

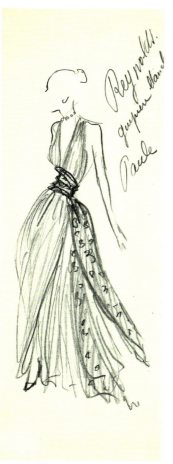

Christian Dior, Long evening dress *Christian Bérard*, autumn-winter 1949 haute couture collection, *Milieu du siècle* line. Black pencil sketch. Paris, Dior Héritage.

Christian Dior, Evening dress *Reynolds* in muslin, spring-summer 1947 haute couture collection, *En huit* line. Black pencil sketch. Paris, Dior Héritage.

Christian Dior, *Les Lilas* daytime suit, spring-summer 1949 haute couture collection, *Trompe-l'Œil* line. Black pencil sketch. Paris, Dior Héritage.

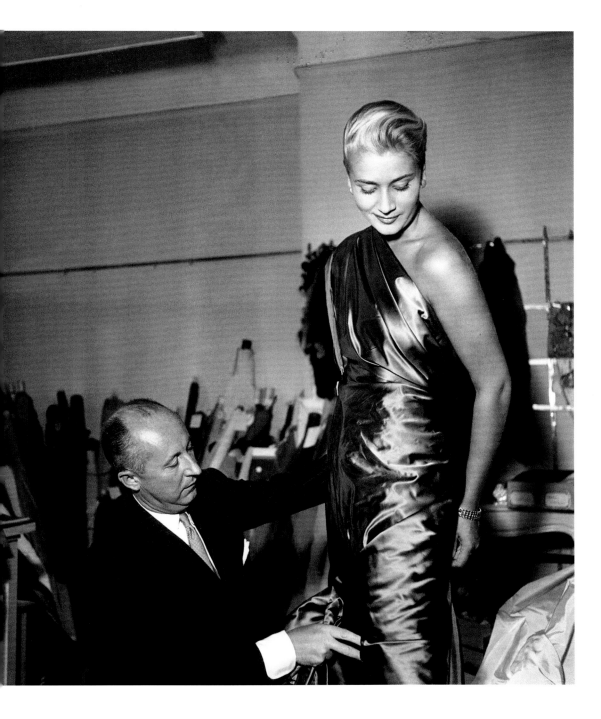

Georges Dudognon, Christian Dior fitting a dress on the model France, 1949.

Charter page for the Christian Dior autumn-winter 1947 haute couture collection, including the *Offrande* model in the russet color named "Barbe de Bébé" in the program. Paris, Dior Héritage.

The collection included six other models in this color (*Châtaigne, Fauve, Perdreaux, Ploërmel, Tirésias, Vénitienne*).

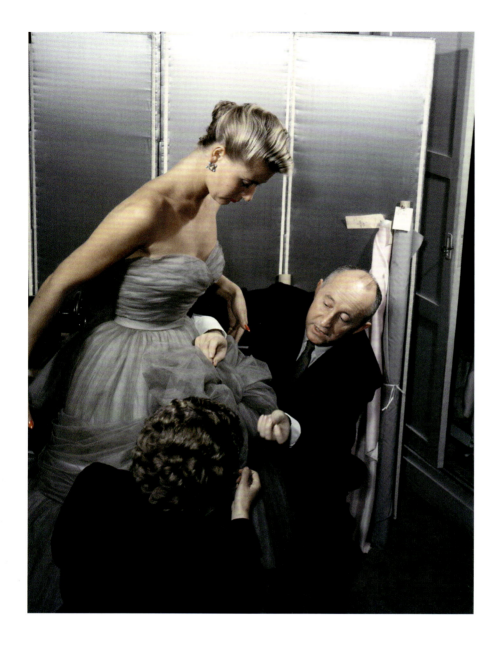

Eugene Kammerman, Christian Dior adjusting a dress on model France, 1953.

Anonymous, Christian Bérard designing the summer dress *Vincennes*, February 11, 1949, published in *Paris Match*, March 25, 1949. Christian Dior, spring-summer 1949 haute couture collection, *Trompe-l'Œil* line.

This photograph of Christian Bérard, reproduced in the first issue of *Paris Match*, was taken the day before of his death.

Richard Avedon, Christian Bérard and Jacinthe with
a model wearing a Christian Dior design, August 1947,
for *Harper's Bazaar* magazine, October 1947.
Christian Dior, autumn-winter 1947 haute couture collection,
Corolle line.

chipped the pretty decorations of Madame Madeleine Dior. It was as if he had slashed the silk shades of his mother, or broken her Venetian glassware. "In my youth, I was provided with carefully fashioned blinders. Thus equipped, I could follow the quiet path to which I was entitled due to my status as a Frenchman, my good education, the labor of my ancestors, and my first communion."[545] The tone is searing when the narrator describes his character, "Jean," who can be clearly recognized as Raymond: "His mother, upright and friendly, opened her lace-edged parasol and responded with a haughty smile to the waves of passersby. But revisiting the past froze his heart, and Jean tried to dispel it from his memory. All he had left from that straitlaced, tender era were maternal memories that stirred him too much and the good manners that astonished his occasional girlfriends; with all his strength he dispelled the calls of his youth, the toys he had had, the nannies who had dressed him."[546]

The eldest son's ferocious jealousy had never faded. It became even stronger in its bitterness, as "too many old scores never get settled."[547] Christian was in the Free Zone when Raymond, mobilized as a corporal, was captured in the Vendée in June 1940, then sent to Stalag X-B in Sandbostel near Bremen.[548] Liberated one year later, he never got over his double experience of war. He was not able to have a child. The adoptive father of Françoise Dior, who would later become a royalist and then a neo-Nazi,[549] Raymond Dior was aware of "the secret defect that will awaken."[550] He mocked the bourgeoisie for "desperately clinging to what was its strength: […] eighteenth-century furniture,"[551] and denounced the "new generations conceived under the sign of the *franc papier* and homosexuality."[552]

On the contrary, Christian Dior wanted to believe that 1945 was the year of a new beginning. He had found meaning in a battle that he had never waged: yes, he would oppose a style that he hated, which featured women's hats that were "inflated like ottomans, skirts that were too short, jackets that were too long, and soles that were too thick," and, to top it off, "horrible shocks of hair sticking up Fontanges-style on their foreheads and spreading like manes down the backs of Parisian women."[553] Destiny would "persist," and from

lucky stars to providential encounters, he would become engaged in an "adventure," like a soldier in the army of a country that is new and familiar at the same time. This bon vivant consumed by grief knew quite well that fashion design is not a static composition, but first of all a sketch: "for a dress to be successful, you must have an idea of what it will be like in the movement of life."[554] In choosing this career, he wanted to make hearts beat.

At the same time, something different animated Bérard. "He invents with every image, and his surprising inventions never require the least luxury. This is the supreme luxury, that of the mind."[555] For *Les Forains*, "with four poles and four old Turkey-red curtains found at the flea market," "Bérard achieved splendor."[556] In 1945, he wrote his last will and testament. "Accuse no one of my death. Despite the devotion and reproaches of Boris, I let myself go along this bad slide. I leave to Boris Kochno, in addition to my furniture and my books, everything I own in the apartment,"[557] he scribbled in pencil on a crumpled bit of paper. An invalid will that he would have to start again, as if to remind himself that now he no longer feared anything. He made the figure in *La Douleur (Sainte Thérèse)*, which he had painted in 1927, a personal emblem. "Here Bérard, a clumsy buffoon, undergoes his last transformation, turns into a fanciful Pierrot, a metaphysical clown, appearing out of nothingness and at every instant ready to return to it."[558] He no longer looked at his reflection. His mirror was his pad of paper, on which he wrote in black pencil: "My dear Papa, I am dying of my deadly habit, which you will discover. Boris has been an angel to me, trying to free me from this poison, but, alas, without succeeding."[559]

For everyone else, 1945 had the colors of a ball overflowing with jubilation. "One month ago, Hitler killed himself, and the Wehrmacht capitulated. That night was the first grand ballet performance at the Sarah Bernhardt Theater since the war. Liberated Paris was pulling itself together. We were emerging from a long four-year period of darkness and that night was a festival of refound freedom."[560] Collaborators, traitors, and Resistance members were side by side on the velvet seats. Paris had to move on, and no one wanted

to hear about those who had survived the death camps, and even less about those who, forced to live in secrecy, returned to find their homes looted, like Waldemar-George. At the offices of *Beaux-Arts*,[561] he discovered in September 1944 that the portrait of Maréchal Pétain was still hanging up.[562] He smashed it to bits. The man who observed Paris high society noted: "A big opening. A big exhibition. A peacetime mood. This crowd, this assault of true or false versions of elegance. This police presence at the entrance of a gallery that looks like a noble mansion takes us back to the time when life was a useless game. Is this good or bad? I don't know. But I am sure that if a deported person who had escaped from some German prison had suddenly appeared in the midst of this Parisian crowd, whose display was a cheerful spectacle, he would have been seen as a killjoy."[563] Before the war, Louis Jouvet quoting *L'Illusion comique* by Corneille – "The betrayer and the betrayed, the dead and the living find themselves friends once more," – concluded, in visionary fashion: "To my taste, one cannot imagine a prettier way of life."[564]

It was in this atmosphere overflowing with hope that the Theater of Fashion was launched. Jean Cocteau designed the poster and Bérard came up with the name. All the greatest couture houses participated in their own celebration through fashion dolls in a tribute to Parisian savoir-faire, under the elite patronage of Lucien Lelong, who was then president of the Chambre Syndicale de la Haute Couture: "Elegance and Paris are inseparable! All of Paris is present in the Theater of Fashion! Its cheerfulness, nerve, spirit, charm, and eternal soul, with all its constant renewals. […] It's also Paris with its precision, its delicacy, and its style decorating the era with an unexpected jewel full of grace and exquisiteness, and which, in the ephemeral history of fashion, marks the spirit of consistency and continuation that characterizes our sense of construction."[565]

We recall that Bérard had lit up Paris with his acrobats, his sailors, his portraits of young men. In the 1930s, his palette set the tone for fashion: we think of the black mask of Queen Margot (*Margot*, 1935) or the gouache rainbow of a black skirt for *La Symphonie fantastique* (1936). The chalk candelabras of *La Belle et la Bête* plunged Paris

227

into the endless black of Bébé's fantastical spirit. The set with its painted starry sky, along with the program that he illustrated, now represented to Christian Bérard the reawakening of hope, and of this revival of Paris: one hundred thousand visitors would head to the Marsan pavilion to admire the one hundred eighty wire dolls decorated by forty Parisian couture houses, while the hairdos and shoes stimulated rediscovered elegance, despite the restrictions that were still present. Henri Sauguet wrote the music. For Dior, the Theater of Fashion was like the sketch of a developing dream. With its façades of trompe-l'œil Parisian stone, the set was in place. The miniature silhouettes were displayed the length of a true artificial avenue drawn freehand. You only had to dream of Paris for Paris to become a dream again. Everything, from the energy invested by the seamstresses to the excitement caused by the event, announced the ambition of the couturier-architect: to create his own couture house.

Bérard, "the fantastic monster with his heart in his head,"[566] was tacitly considered a mentor. From the height of his celebrity, he was the absolute, dreaded eye: "He walked his beard and his dog around to every corner of the building site. With beating hearts, we awaited his verdict. He gave his approval, and even suggested a few details,"[567] Christian Dior recounted. The couturier recognized in his dear Bébé an "infallible taste."[568] Bérard's judgment of others was to be feared. "Every time Picasso tries to approach the human, he falls into conformity, conventionalism, the style of Spanish chromolithographs. He only finds himself in his grimoires. There, he reigns with an almost infernal artistic sense. His drawings. His pen that spits, spots, and tears the paper. His signature is always his best drawing."[569] Between the two artists, there was extreme tension. And it was because of Picasso that trouble occurred. Bérard, who, "as was his habit," complained "of having torn the seat of his pants,"[570] said he could not go order another pair. How could he go to the tailor with his derrière exposed? Pierre Colle, who was the executor of Max Jacob's will, gave him a pair of corduroy pants and a pair of shoes that had belonged to the poet. For him, "it's a pair of pants like any other. Max hated fetishism."[571] A bad idea. When Bérard showed up at

Denise Tual's home in October 1944 wearing these pants, whose knees had been worn out through prayer, Picasso turned white as a sheet. "This is the height of disrespect." Colle went to see Picasso, who threw him out. "These pants became the pretext for a communist development, a criminal act, the symbol of repulsive frivolity (a Spanish sacrilege)."[572] Paris certainly never lacked for these little personal enmities that the war had not dissipated.

One can understand even better the doubts that Christian Dior was experiencing. "Won't they expect too much from me?"[573] the young couturier wondered. The man who founded his couture house on December 16, 1946, had just lost his father. One could object that he had already replaced him by becoming the savior of his own family. And now he was running a company, one that was still small yet already big because his name would become the most coveted brand in the world. Hesitation was only natural. "It was the first time that I was facing journalists and professional buyers. At Piguet or Lelong, where I was only a pattern maker, I disappeared after my dresses were designed. [...] Now it was different. I had to take advantage of a dazzling 'takeoff' with overwhelming consequences."[574]

By making flower women bloom, Dior would germinate the whole earth with "all the colors of fields and gardens,"[575] lily of the valley white, lawn green, buttercup yellow, peony pink, over which he showered millions of sequins and beads placed individually by nimble fingers. Bérard brought out "naked beauty from the void where it was hiding."[576] As for Dior, he would dress it, or rather decorate it, as if it were nature turned into a woman. He would transplant his lost garden from Villa Les Rhumbs, delicately removing stems to root them anew, on the cusp of spring-summer 1947 and the New Look, in the fullness of the *Corolle* line. Balzac was the novelist of women; Dior would be the landscape artist of desire. In his inaugural collection, he offered "discreet shades" (including "Earth of Paris") and "a few bright tones," such as "Longchamp" green. He would let his "stem-women" blossom, in a greenhouse dominated by "zinnia" red and "vertigo" green.[577] It was as if he had reopened the treasure box described by his friend Bonjean. Haunted by his nostalgia for the

Belle Époque, he would reconnect with the feminine ideal of fake bosoms and bustles, thin waists and round hips. And in this rediscovered charm, it was indeed love that he celebrated, a bit like André Bérard writing to his future wife early in the century: "I was also thinking that you were mine, and that I was yours, that we would have only a single soul, and that we would be only one person. [...] It seemed to me that this dream was the image of our life, and that the mysterious country where we walked so naturally was nothing more than the representation of the long years of love that were waiting for us."[578]

Christian Dior wrote his own "love letters" not to a single woman, but to all those who would rediscover, through him, a reason to be beautiful, happy, and loved. Women like the flowers in a garden of light, in which all his emotions took root. Moments whose wonder he would resuscitate by capturing, in his dresses and fragrances, the memory of the Plat-Gousset promenade, strolls past the roses in Granville, or the first lilacs at the florist Orève in Passy. A fairy godmother was looking out for the couturier. Dior-Bérard was a friendship that canceled another one. Mademoiselle loved Bérard to the point of scribbling on the back of a postcard with a photograph of two lovers inside a clock: "Come give me a kiss or I won't make a collection. Votre Coco."[579] Her collaborationist past had caught up with her. "Chanel had had a German lover during the Occupation and she was now disgraced."[580] Condemned to a golden exile in Switzerland, where she was bored, Chanel did not reopen her couture house until 1954. The field was open.

Bar suit, Bérard suit? The leading design of the collection was a manifesto to rounded hips executed by Pierre Cardin – one of the first employees hired by Monsieur Dior and a pattern maker in the *atelier tailleur* (the workshop for tailored designs) at the time – made of strips of absorbent cotton bought at the pharmacy on Avenue Montaigne. He found the iron at a hardware store on Rue François-1er. "Christian Dior was very bourgeois physically. He liked what was already accepted. But he was an artist. He was very literary. He stayed seated at his desk. [...] 'My dear Pierre, I'd like to see

this suit a little bit longer.' I went to lengthen it in the workshop. I came back; 'My dear Pierre, it needs to be shorter.' I cut it; 'My dear Pierre, no, I liked it better before.' But it was too late; I didn't have any fabric left."[581] Cardin's description of Bérard was quite different, of course: "When you saw him, you saw Cocteau, and Cocteau was very sharp and refined. Bérard had designed the costumes for *La Belle et la Bête*. I made them, working for Paquin. I even wore them. His studio was indescribably dirty. He slept there, with his little dog. But as soon as he picked up a pen, fantastic things appeared. His drawing was untouchable."[582]

Dior-Bérard, Bérard-Dior. Two children of the century, from the French bourgeoisie: "Are we optimistic, quixotic, utopian?"[583] the couturier wondered. Like anyone, they experienced this tension between recognition and celebrity, balls and solitude, doubts and certainties, stolen moments and renunciation. "After all, doesn't one work in order to succeed?"[584] Christian Dior asked himself. He was no longer a man who designed dresses; dresses designed his life. "He was a very fearful being. He had confidence in himself because he was an artist, but he was still quite jittery. He was always a little afraid. He never knew if it was good. He realized afterwards, and when we said, 'Yes, that's right,' he was happy, but he always had his doubts."[585] They had seized him, these bewitching presences presided by Marguerite Carré, Raymonde Zehnacker, Suzanne Luling (a friend who was also from Granville), Mizza Bricard, "a general staff of great class."[586] Now, he "sketched everywhere, in bed, in the bathtub, at the table, in the car, on foot, in the sun, by a lamp, during the day, at night."[587] He would give up everything for these dresses. His joy, when he sketched, was precisely that he no longer felt his own body. "I can certainly say that my most passionate and exciting affairs are my dresses. I'm obsessed with them."[588]

And that was quite different from Bérard, whose body had become a magnetic phenomenon. As the general staff of the Maison Dior took shape, Bérard took on the role of prophet, an unofficial and whimsical advisor to this general who was invading the fashion realm at over forty years old. Paris would sizzle under the magic wand of Dior and Bérard, its two enchanters. "This first success

We refuse to accept decline. Are we optimistic, quixotic, utopian? Maybe.

Christian Dior

could not have any more appropriate confirmation than the one it received from Christian Bérard during a dinner with Michel de Brunhoff, Boris Kochno, and a few others, hosted by Marie-Louise Bousquet. Bébé gave me a pastel depicting the façade on Avenue Montaigne, which I then reproduced on everything: scarves, Christmas cards, collection programs, etc. Then he improvised a kind of toast where all his penetrating understanding of life was expressed. He had never known anything but success, and he was warning me. At the time, I didn't realize it. Success was still a poison that was too new, too unknown to me. The immediate future would prove to me that Bérard, once again, had been a good prophet:"[589] "Christian Dior will revolutionize the world of fashion,"[590] Bérard had predicted to *Vogue*.

Sketched by Bérard, the *Bar* suit like a bird on a rocky cliff. Between them, the sea was always there. Speaking of Dior, Bérard stated: "He made big skirts like those worn by the wives of fishermen in Marseille back in the day, down to there, with narrow tops and little hats."[591] Christian Bérard was born in a summer when violent storms tore up trees, and cool temperatures in France set a record: it was 59°F in Paris. Christian Dior came into the world on the day of the anniversary of the death of Louis XVI, during one of the most frigid months France had ever experienced. These two brothers of the cold never stopped putting on weight. But their volume protected them. Their bodies were two life preservers to confront the swells and shallows. "There are three kinds of men: the living, the dead, and those who go to sea."[592] Dior and Bérard sailed from island to island seeking treasure. Bérard's "method" consisted in "panicking, becoming demoralized, drifting, sweating with anxiety, as soon as he was no longer in direct contact with technique. He drew strength from it and stirred up waves that were useful to him when his mood became calm again."[593] He now embodied the "drowned man." This is how he defined himself in an acrostic scribbled on a piece of paper:

 Childish Brilliant
 Human Energetic

Ruthless Repressed
Instructive Adoring
Snobby Reclusive
Theatrical Drowned
Imaginative
Anguished
Neglectful[594]

Already portly and bald, Dior was preparing to become the captain of a drunken boat of celebrations, the leader of a traveling band of musicians, entertainers, seamstresses, and female friends and clients wearing Vagabond hats, as if echoing the *Forains* set to music by their friend Sauguet in 1945.

With Dior and Bérard, Paris would once more be a stage made up with illusions, a palette of sentiments. When Bérard gave a dinner at the Grand Véfour for the British Embassy, the electricity went out and they had to use candelabras. Every time, the supernatural came on stage. There, Dior gray, sea gray, gravel gray of the Villa Les Rhumbs, Trianon gray, pearl gray of the haute couture salons at 30 Avenue Montaigne, "early morning" gray and "morning" beige, flannel gray, tailored gray, solid, structured, dense wool, burlap, stitched fabrics, linen thread, darts, ribbing, deep pleats and thick manes, "rampart" gray, rocks in the drizzle of Normandy. Here, Bérard gray, the shadow of the tall plane trees at Lycée Janson-de-Sailly, the rustling of tulle, palaces of painted canvas, queens crowned with ash, the gray atmosphere of dusk, watercolor charms. Fashion was like theater, an art of converting chaos into enchantment, and tumult into freshness. "While he speaks, the room sparkles. He has just discovered it", wrote Louis Jouvet[595] about him. Routine was dressed in the new clothes of renewal.

Maison Dior with its "tamed chimeras" would become a paradise for the seventh art, from Grace Kelly to Sophia Loren. Dior's dresses were films; they whirled in a rustling of taffeta faille and Cigale stockings. Hats of straw, umbrellas with parakeet heads, natural shoulders and "unimportant" sleeves. The waists were slim, the obsession quite clear: to create a "beautiful and dazzling" look.[596]

In contrast, Bérard's paintings held the plaintive murmurs of beyond the grave. On their dark or swollen background, the figures stood out, displaying an inability to communicate. *Les Enfants des Goudes*, which was painted between 1942 and 1943, most likely at the farmhouse Les Fourques, expresses the certainty of hope in the twilight of this landscape nicknamed "Marseille's middle of nowhere."

Back in Paris, Bérard couldn't sit still, and his studio moved around with him. For now, it was urgent to meet the sphinxes backstage, to dress Genet's *Les Bonnes* at the Athénée and *Thérèse Raquin* at the Théâtre du Gymnase, without falling in the sea off this drunken boat of parties and balls. Cocteau observed: "Bérard's method consists in panicking, demoralizing, dispersing himself, sweating with anguish, as soon as he is no longer in direct touch with the technique. He draws strength from it, and stirs up waves which he can then use when he regains his composure".[597]

Glory and reprieve

Bérard surfaced, while Dior rediscovered the soul of a tall-ship captain. It was inside his couture house that Dior found his own divine light. Catherine, Saint Catherine. This miracle sister appeared like a lucky charm in the couture house, where they took care, from the very first fashion show, to spray *Miss Dior*, the perfume that she inspired. "Look, it's Miss Dior," people said in Granville. Coincidentally, Catherine is the patron saint of seamstresses. She was celebrated every November 25 in all the workshops: at Dior, the tradition began starting in 1947. "It's on Saint Catherine's day that one must see 30 Avenue Montaigne. In our craft, this feast day has maintained great importance. For me, it means a great deal. I go to every department and, in the little rhyme that I address to each workshop, I can express the sincere and loving affection that links me to all those who unite – in a large or small way – their efforts to mine for the success of our company. It's also the day when, in the way I am welcomed, the decorations of the rooms, and the inventiveness of the staging and the costumes, I feel the heart of the maison beat.

Nothing is more touching than Saint Catherine's Day. Nothing is more joyful either. Each workshop has its orchestra and in all the buildings there is just a great ball."[598]

While burying the horror that she survived, did Catherine Dior also conceal the compromising traces of her brother's homosexuality? During the Occupation, the apartment at 10 Rue Royale that Catherine shared with her older brother had become the liaison office of her Resistance group. What happened to all the memories, all the letters? Bérard let his father inspect his apartment, which "served as his dwelling."[599] "A calm and steady country boy," Christian Dior "intends to remain single."[600] He would not only block access to his private life, but reinforce and protect everything, hang white curtains to protect the designs from copiers before the collections came out, line all the fabric with percale or taffeta, and lengthen the dresses, giving the name "Chérie" to a dress that required eighty-seven yards of white faille.

The style of a design, the equilibrium of its proportions had to do with the extraordinary work that preceded putting it together: this "test garment decked with pins and alterations" that would express the line, the volume. Bérard "puts on a show" with fabrics, improvising silhouettes with the assurance of a "wizard."[601] He was always cited, along with La Fresnaye, "as one of the favorite painters" of Christian Dior, this "old young designer," a "contemplative torn from his vocation by success."[602] Deep inside, Dior knew that his true mission consisted in reconstructing – over forty years later! – a lost paradise, glimpsed during childhood.

For Dior, "becoming one's own master" meant, by designing dresses and everything they made possible (stockings, scarves, perfumes), "succeeding at any price." What was originally a challenge became an obsession whose consequences he did not measure, defining himself at first as a "couturier in spite of [himself]."[603] The man who dreamed of walking incognito on the streets of Chicago would expand the business named after him into fifteen countries, employing almost two thousand people, only eleven years after his company's founding. On its own, Dior would represent over half of French

couture exports. Along with Brigitte Bardot and Charles de Gaulle, he would be one of the three most famous figures of the postwar period. The businessman Marcel Boussac naturally played a big role in this success. But, as *L'Intransigeant* would recall, "all the money of an investor would not shower Christian Dior with talent [_]. Success came. Why? Christian Dior does not know, or, at least, that's what he says. He is modest."[604] Bérard hardly painted at all anymore. Without trying to, Dior had confiscated his identity. Dior was the painter of fashion. "A couturier is someone who has horrible doubts about his work and himself. That is one of the authentic characteristics of the artist."[605]

Dior, panicked by the talk of his "sudden popularity," would become a "conspicuous person."[606] And Bérard dazzled by creating an atmosphere for Parisian Café Society, which wanted to forget about the war and move on. In his sets, as in his costumes, he was better than anyone else at giving the color red its "splendidly dramatic" look, just as he had previously mastered the "greenish yellows, sulfurous colors" that were ideal for "expressing an atmosphere of unease."[607] In contrast, his purples had disappeared, blown away by the pinks and ashy grays of his fluttering watercolors.

Like Ladon guarding the golden apples of the Garden of the Hesperides, Bérard and Dior had one hundred heads, each speaking a different language that everyone understood. Dior would call his dresses his "children."[608] Prim and proper ones, ready to cut loose. He would name them *Partie fine*, *Cachottier*, *Précieuse*. He contrasted their sensuality with the sky blue linen of the *Alliance* dress or the pink satin of the long *Angélique* dress. All of his fashion was organized around this hide-and-seek between appearance and desire, the virgin and the mistress, the white satin of the *Fidélité* pinafore-dress, evoking sunny afternoons at Le Plat-Gousset, versus the flash of "Satan" red.

No matter how much time passed, Dior would never mention the eggshells stuck in Bérard's beard or the dirtiness he had made into his insignia. Others would take care of that. He would always be

"Bébé," his fellow traveler, a big beast who was affectionate and very fragile, generous with his talent, "selfless," able to sacrifice "precious time serving many different people, to the detriment of his own work."[609] Bérard, with whom he had leisurely games of canasta at the Colles' house in Fleury-en-Bière on a Sunday afternoon. In the photos taken by Louise Dahl-Wolfe, Tian and Cri, sitting next to each other, looked at these playing cards the way others look at themselves in the mirror. Quite different from the Bébé who only loved "disorder and the fire of arguments."[610] On those days, Bérard did not wear costumes or rags, and Dior, in shirtsleeves, seemed as calm as he would later be at the old mill that he would buy in Milly-la-Forêt, "protected from any neighbors," with a view only of his flowers, canals, and "little pond."[611] It made him happy to sit and listen to the bells of the villages in Île-de-France. Canon Letellier passed by; God, how badly dressed he was! Dior offered to make him a new cassock. Denise, the cook, was at the stove. A few close friends would come by, starting with the women who worked closely with him, such as Raymonde Zehnacker and Mizza Bricard. With his suit vest unbuttoned, the couturier in the fields kept his cards close to his chest; he seemed to have left all his worries behind in Paris. There was no doorbell. A gravel path led to the residence, which was surrounded by a garden where the couturier smelled his aromatic and medicinal plants. In the living room, a wooden Virgin dominated the grand piano. Here, he was calm.

A magician of the silhouette, Dior knew how much some lies are necessary. He erased the flaws of his friends, the same way he reinforced a design from the inside to slim the waist or straighten the back by eliminating what overflowed. The era lengthened its dresses but shortened its memory. They needed to forget. Some people disappeared, but they would come back and start over again. Gaxotte made a grand re-entrance. In 1953, he was elected to seat number 36 of the Académie Française. Three years earlier, in the laundry room of Clairvaux Prison, two collaborators had recalled his important influence: "If I became a fascist, I owe it most of all to the teachings of Pierre Gaxotte."[612]

Dior knew he was doomed. His belated success had chained him to something more painful than everything he had known before: addiction to glory, being judged, applauded, and always wondering "how long will this last?" There were licensing contracts, and he was like the character in *Mr. Perrichon's Holiday* as he traveled to New York and Tokyo. Women everywhere claimed him, while he, the creator of Rouge Dior, launched successfully in 1953, knew that he would never again see his beloved sister's smile. He had stopped looking at himself in the mirror; instead, he held out a mirror to women, to their desire to be beautiful. Dior's first dresses were called *Amour, Tendresse, Corolle, Bonheur*: "The birth of the Dior label benefited from that wave of optimism and from the return of mentalities to an ideal of civilized happiness [...]. Women, with their very reliable instinct, must have understood that I dreamed of making them not only more beautiful, but happier. Their favor was my reward."[613]

Like Bérard, Dior, "whose apparent placidity belies an innate nervousnes,"[614] got revenge on himself, building his own enclosure inside this body that isolated and protected him as much as it buried him.[615] Pompadour poached eggs, partridge with Dom Pérignon, hare à la royale, veal escalope stuffed à la maréchale, chocolate tambourin cake: his insatiable appetite made his table an Epicurean temple that he shared with his guests, who were usually his friends. He was one of the few Parisians to have a personal chef. In the fluffy omelettes and porridge with toasted cheese made by Monsieur Lhuillier, he also found the rustic, creamy pleasures of his childhood in Normandy. No one else knew how to combine a shepherd's houppelande and a school blouse called *Le Grand Meaulnes*, "uranium"[616] gray and "happiness" pink, windbreaker collars and evening necklines. In Passy, he settled in a mansion on Boulevard Jules-Sandeau, not far from his childhood street: "I recognized the balcony with columns that had filled me with wonder as a child. As soon as the door opened, I felt immediately and against all good taste that this was indisputably 'my house.'"[617] The winter garden immediately made him think of the Kentia palms and phoenix palms of Granville.

"Without waiting, without even consulting my architect, I gave my agreement."[618]

Christian Dior used to talk to his dresses, naming them after flowers, artists, feelings and impressions. He set the tone. "Dior wants no visible red on the cheeks and no smoky eyes. Spring, he says, is a young girl".[619] Bérard chatted a lot, but he didn't put anything down on paper. He had no time; all these women wanted him. As repulsive as he was adored, he was nevertheless rejected by the art world. They associated him with the elite, a label that could not be removed, for the Left Bank was unforgiving. The bearded aesthete who invented Zizi Jeanmaire's short bob was "the organizer of great Parisian parties, where he took pride of place".[620] Parisian society saw him as "a bearded, ragged entertainer, an inspirer of frivolity".[621]

And therein lay the difference with the earthbound Christian Dior. The couturier "loves the patient work of the man who draws plans, shapes slender stone sprays that are cathedrals, heavy lace stretched against the sky."[622] With him, the lengthwise grain of the fabric and the bias cut intertwined in a special way. Like no other, he knew how to make the best use of brocades and the most sumptuous brochés, how to manipulate and bend "these gilded fabrics glazed with reflections, to give them a youthfulness, an incredible casualness. No longer did anyone want to think about the sad majesty of chasubles and the imprisonment of Velasquez's farthingale hoop; this was the twentieth century, the time of rocket cars, of record-breaking airplanes, in full motion, in full life!"[623] Bébé-Dior, two shy exuberants? Dior-Bérard, two masters of illusion? If Bérard, "dazzled every day," hid beneath his apparent laziness the art of seizing labor "like a prey,"[624] Dior was the artificer in chief. "Christian Dior never crumples a dress, he builds it." [625] In the workshops, the tailored touch meant a hand that could attach and turn linings and shape skirts to the roundness of the hips. The framework was placed afterwards. The tailored touch pressed and "subdued." The workers had the name of Dior engraved on their silver thimbles; their fingers, their eyes, everything contributed to align the fabric on a foundation of organza, to make it roll, "and so on and so forth." "Clean, clear

Refuges of illusions

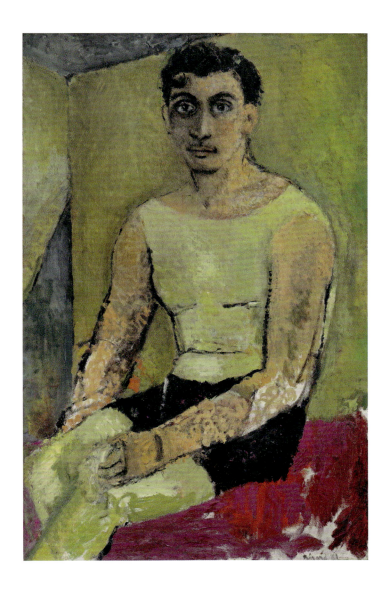

241

Christian Bérard, *Acrobate au repos* [Acrobat at rest],
circa 1925-1927. Oil on canvas. Peter Doig collection.
Former Christian Dior collection.

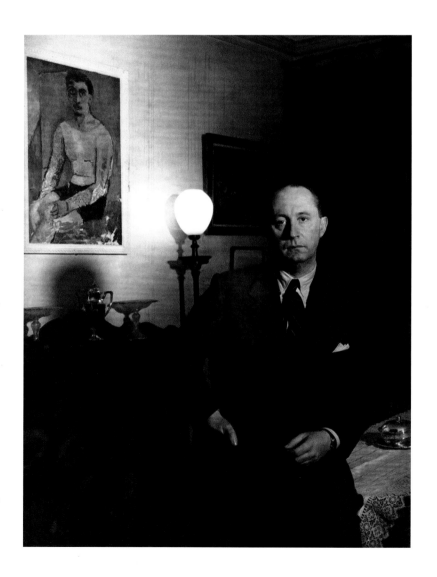

Brassaï, Christian Dior photographed in his apartment at 10 Rue Royale, Paris, circa 1947.

242

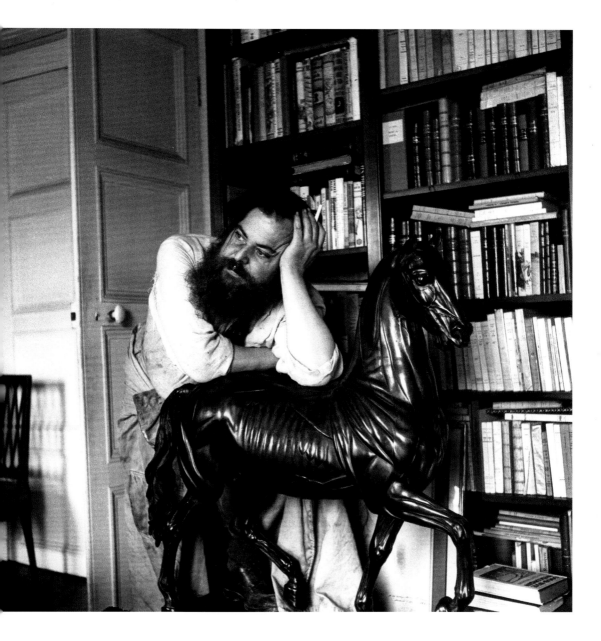

Lee Miller, Christian Bérard in his apartment at 2 Rue Casimir-Delavigne, Paris, 1944.

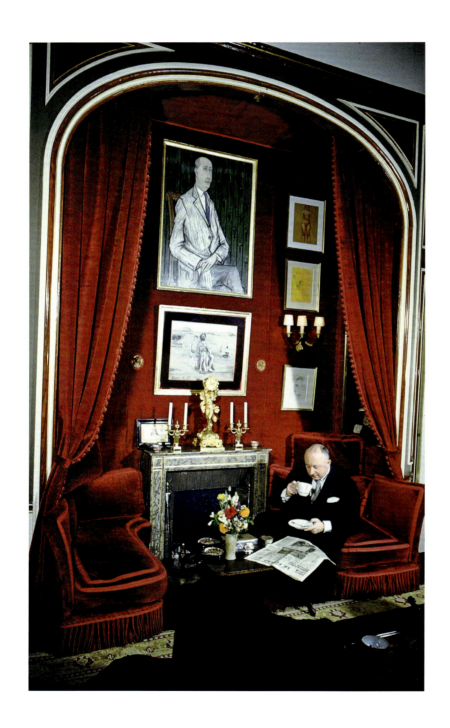

Loomis Dean, Christian Dior in his apartment
at 7 Boulevard Jules-Sandeau, Paris, 1957.

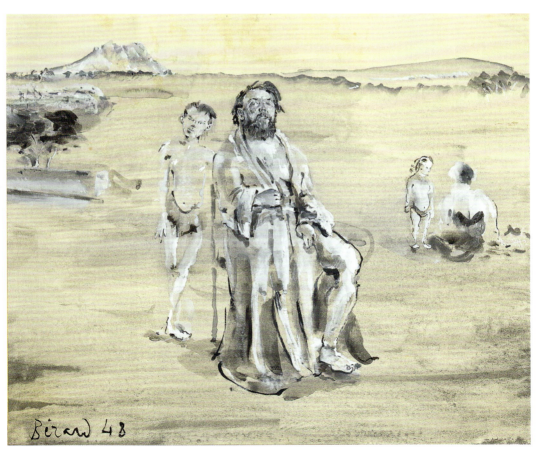

Christian Bérard, *Jeune femme à la prière* [Young woman at prayer], undated. Watercolor. Private collection. Former Christian Dior collection.

Christian Bérard, *Triple Portrait*, 1948. Oil on canvas. Private collection. Former Christian Dior collection.

Cecil Beaton, Christian Dior in his apartment at 7 Boulevard Jules-Sandeau, Paris, 1953.

Cecil Beaton, Christian Bérard, 1930.

Dora Maar, Christian Bérard, circa 1935.

248

Willy Maywald, The Château de La Colle Noire, 1957. Christian Dior loved to relax and entertain friends in this Provencal residence, acquired in 1950.

Léonide Berman, *La Ramasseuse de palourdes* [The clam digger], undated. Oil on canvas. Montauroux, Château de La Colle Noire, Christian Dior Parfums. Former Christian Dior collection.

Frank Scherschel, Christian Dior in the salon
of his apartment at 10 Rue Royale, Paris, February 1947.

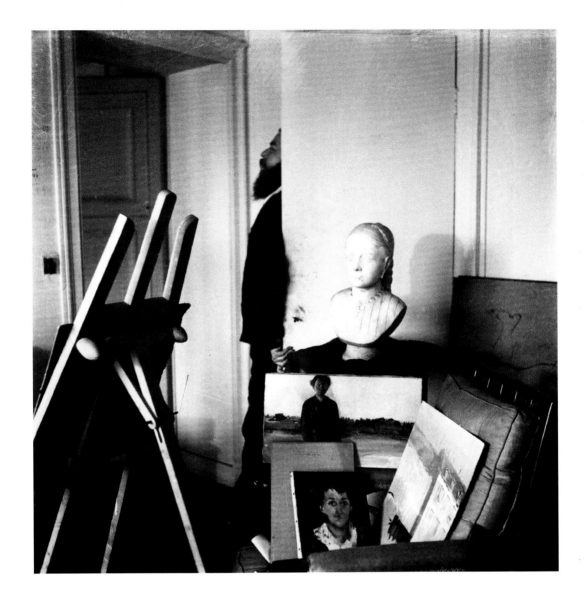

Cecil Beaton, Christian Bérard in his studio at 2 Rue Casimir-Delavigne, Paris, 1944.

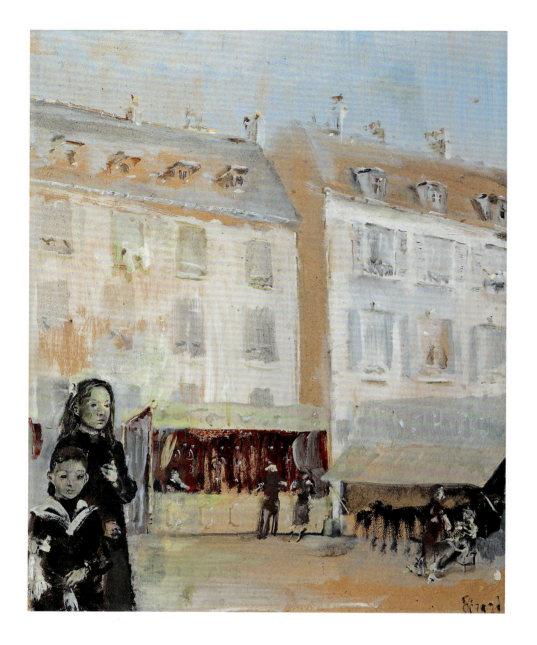

Christian Bérard, *Les Forains* [The showmen], undated.
Oil on canvas. Private collection.

craftsmanship." One line per season for one, thousands of dabbed sheets for the other, Bérard, whose body thickened and became deformed, now similar to an empty lot invaded by the "fiery fern of his beard."[626] Dior constructed: his dresses were built on structures that shaped a silhouette, corsets, boning, shoulders, everything held together. Bérard removed, evaded, erased any trace of framework. While others added wigs and powder, Bérard dusted off and dismantled, opposing lines to curves and replacing machinery with the movable simplicity of a painted set. That was his signature style. In 1936, it had impressed in the staging of *L'École des femmes* at the Théâtre de l'Athénée: "I removed in order to leave only the essential." Or: "What I recommend above all in the theater is the void. From this, one can make a general rule; I tell young set designers: Don't clutter the stage. People always tend to add too much".[627]

Omens and talismans

In Paris, Christian Dior traced his lines with the same energy as his mother fought the rocks, and he brought the same vigor to conquering the swamps in Milly-la-Forêt, to "domesticate the river and tame the forest surrounding it."[628] In vain. The house turned out to be too damp and he had to leave it. Every season was a challenge to a new torment that obsessed him. Escaping, living only to project himself into a season, a line, that would replace the previous one through good-luck signs and symbols (8, his magical number) and stick letters branding the lines Y, A, H. But Christian Bérard needed to set life on fire to invoke its mystery. Mystery: that was one of his key words, according to Marie Laure de Noailles: "He rolled it around in his sentences, crushed it in ink, under his brush, dressed women in it, the streets of Paris, the stage, the fighters of Arezzo, the flowing hair of Giorgione, wise men, madmen, filmmakers, and French classics."[629] In contrast, mystery was the enemy of Christian Dior, who loved above all to feel protected and safe.

On February 12, 1947, Dior became the most famous designer in the world. He was gentleman; he was a businessman. His body

encumbered him. He built other ones; every season, there were new bodies. And at this company where fifty thousand people a year were received, he constantly had to escape his fame. After every collection, Dior, the superstitious epicurean, never missed one of the rituals that his stomach demanded: steak frites and baba au rhum. His figure grew thick, and superstition ate away at him. He did nothing without consulting his psychic, Madame Delahaye.

A photo shows him on Boulevard Suchet, in his alcove hung with ruby velvet: he poses with a big cup of coffee in his hand and *Le Figaro* spread out between a vase of flowers and silver ashtrays. It was the morning and he was about to leave; his chauffeur was waiting for him, the scent of cologne floated in the air. Above him, there is another of him, the neophyte seeking his destiny, the scattered man, almost naked on the edge of the sea, in this set that wasn't a set, whose sparseness clashed so much with the gilded bronze wall lamps that now lighted his way: this was a sketch by Bérard from the 1920s, the first one that Dior purchased. This was indeed the proof that the sea was always there, in him, with the rhythm of the high tides of the dock at Hacqueville and the pebble beach of Hérel. Those lights that always took him back to that phantom island, of which Bérard was the lighthouse.

Granville entered the scene once again through the personality of Dior's old friend, Serge Heftler-Louiche. Heftler-Louiche had long experience in the perfume business: at the age of twenty-seven, he had headed the Parfums Coty company. Even before the couture house opened, he suggested to Christian Dior that they should work together to create the company Parfums Christian Dior, of which he would become president. The first fragrance was *Miss Dior*, a very green scent enveloped by the memory of the soliflores of the Belle Époque and by *Chypre*, with its vivid notes of oakmoss and patchouli, which Coty had launched in 1917. Other Granvillais joined Christian Dior's network, starting with Suzanne Luling, who was promoted to director of sales, exhibitions and communications.

This "paradise of childhood"[630] rediscovered would have the colors of a neo-Louis XVI interior by Victor Grandpierre, the friend whom Dior

met in Cannes during World War II. Not satisfied to re-armor the female body, Dior built his own château: "know who to surround yourself with"[631] would become his motto. Victor Grandpierre, who decked the Helleu salon of 30 Avenue Montaigne in delicate shades of gray, also designed Colifichets, the Dior boutique that was inspired by an eighteenth-century bauble and accessory shop. Bérard applied his touch of magic to the shop: a cream toile de Jouy fabric with sepia patterns was hung on the walls, the counters, and even the ladder for the shelves where the gift boxes were placed. To run this boutique, Dior chose another friend, the flamboyant Carmen Colle, who was the wife of his former collaborator Pierre Colle, who had died in 1948. The Mexican aristocrat would make this spot a wonderful meeting place, where all the clients would come to forage in the shop full of knickknacks to get themselves "trinkets." "And come on, Carmen, give me a good blow of Popocatépet in there!"[632] urged the couturier.

Dior was busy. Bérard was more courted: wasn't he the only Parisian who was invited to dinner with his dog? The carefree times had returned, recalling the charmed era when the head of the railway company of La Manche was named Georges Bonheur, and the dry cleaner on the Rue des Juifs, Monsieur Dieu. The postwar period was a new series of pleasures. It had the feel of excursions on board the steam yacht *Ondine* and the taste of the pink lollipops sold in the grotto under the Normandy Hôtel. In 1947, Granville had rediscovered its carnival. In June, one hundred twenty days after Dior's first fashion show, Bérard held a "Bal du Panache" at the Maison de l'Amérique Latine. On watercolors drawn for the occasion, the background was powdered with "sigh rose," the feathers flew, and the tiaras were bejeweled clouds. "It was the year of our Lord 1947,"[633] Dior wrote. "1937 had danced in feathered headbands and pouf hats by Schiaparelli on a growling volcano. Ten years later, we hoped to dance wearing the New Look on a volcano that was definitively extinguished. This new postwar period started with balls. Christian Bérard organized the Panache ball where all kinds of bird-of-paradise, ostrich, and egret feathers were gathered on the prettiest heads in the world. Then came the Ball of the Birds. Masks with feathers added extra mystery to the women's faces."[634]

They both knew how to transfigure appearances. One with his spots of dreams, and the other with his lines that made every collection a true dramatic twist: "After the astonishing presentation, the whole city is abuzz."[635] Where was the truth? Was it hiding in the lies that had liberated them from their solitude? There was water, earth, air, and fire, and there was this joy, this invisible movement that joins two beings, attracts them, pulls them in, reveals them, the miracle of a line on the page, sketch, shape, architecture, manifestation of the soul made dress, the Everything in a little thing, a little pot turned into a hat, brush and black ink wash on paper, fairy sanctuaries, houndstooth and bows, trinkets, wonders of an eternal French spring.

Now nothing more could separate Bérard the "fancy hobo,"[636] "favorite of high society women and actresses"[637] and Dior, the bourgeois from Passy comfortably settled in his neo-Louis XVI lair. They no longer needed to talk to each other; they knew each other through their gestures, that "terrible professional look"[638] mentioned by Dior, which Bérard never managed to "still."[639] They shared everything, united for life and death by these secrets, down to the millimeter. While one constructed bodies and disciplined structures, with his walking stick in his hand, and invented spiral chignons, the other left cigarette burns on the chiffon. While one, with a stick in his hand, scaffolds bodies and disciplines structures, the other, "the dirty Silenus,"[640] leaves cigarette burn marks on muslin. "With his filthy fingernails and his worn-out shoes, his dressing gown palettes and his bottled-up body, Bérard embodied the whimsy of the era in monstrous form."[641] Their memories and dreams mingled, yesterday's joy became a ritual, a craft, a ball of apparitions, colors, and masks. Soon, people would be talking about "gooseflesh golden gauze," "tweedor," "breasts in champagne cups," and the "billionaire velvets" of Dior, the inventor of the "décolleté on the book cover."[642] Between the *Coup de Trafalgar* dresses and the pretenses of the postwar period, celebrating became a national duty: everything could be started anew. The more his face was lined with fatigue, the more Christian Dior was enthralled by his models – they didn't wear the dresses; they acted them out. "It's as if they have a secret. In a few

hours, they can revive every cell in their bodies and become as beautiful as queens."[643]

By redefining himself, Dior reconstructed his own family. "I realize that in my own way, I reacted like the other members of our team of friends: Christian Bérard painted faces devoured by a smoldering look as a reaction against Cubism [...]. Francis Poulenc and Henri Sauguet countered pedantic composition with music of the heart. Pierre Gaxotte's sincere *Histoire des Français* opposed the versions of history that had plagued our country since Michelet. In my own sphere, with my means, I was also a reactionary: I fought against everything that seemed to me to triumph ill-advisedly. Fashion is a means of expression like any other and it was with my dresses that I tried, for my part, to establish a taste and a temperament."[644]

Earrings, eyeliner, spangles, pins… they bustled around in front of the mirror. Each dresser had two models. The changing room was a hive. Bérard and Dior were the only men admitted. Two ogres who breathed heavily, while everything else there trembled. The bald one and the bearded one: they were sexless, ageless. The women put on makeup: a stroke of make-up pencil, a mouth that was always red. Among the devils, they became angels again. In this Holy Family, where the queens traded their husbands' male lovers for the right to have fun at work, those who created the atmosphere were gods.

Like people who know true anxiety, Dior and Bérard believed in everything because they feared nothing more than their intuition. If a bad card was turned over, it was a tragedy. Finding a lost good-luck charm, encountering someone beautiful in the street, the emotion of a test garment in front of the mirror, and the sun rose again. They were both in full apotheosis. With Dior, "the baptism of a dress is still a kind of small sacrament."[645] The *Saintes-Nitouches* designs were called *Frontine*, *Boutonnette*, and the mother superiors were Raymonde Zehnacker – alias "Madame Raymonde," Dior's right-hand woman in the studio ("reason in whimsy, order in imagination"[646]) – and Marguerite Carré, the technical director, alias "Dame Couture." ("The world could come tumbling down, and sitting in front of her dress she wouldn't notice a thing,"[647] Dior said of Marguerite Carré.)

One had found himself; the other was losing himself. Christian Bérard lived in an apartment on Rue Casimir-Delavigne that was "arranged with supreme elegance, without any apparent concern for decoration, totally without the least affectation."[648] It featured "period English furniture, of mahogany, with very clean, spare lines, and a few objects whose unique beauty made them rare. A bronze horse, an unfinished Degas, first editions of Pushkin."[649] He seemed to be at the peak of a glory that prevented him from devoting himself to painting, while still distracting him from his anxieties. Drunk with transformations and more overworked than ever, he went from the hairstyles of *Le Bal de la nuit des masques* to the costumes of *L'Aigle à deux têtes*, giving up *Les Mamelles de Tirésias*, by his friend Poulenc. Women were constantly calling him to ask for just one more piece of advice. "It's Edwige. It's Marie Laure." Her action, "combined with that of Christian Dior and Pierre Colle,"[650] enabled Edmonde Charles-Roux to leave *Elle*, joining *Vogue* in 1945. "From then on, I saw it practically every week."[651] Since Dior often sought refuge in his "office of dreams," it sometimes seemed that Bérard was the couturier. For Bébé was seen everywhere at Dior, posing with the models or photographed in front of 30 Avenue Montaigne. He was also the one immortalized by the American photographer Richard Avedon reclining on a vehicle in a working-class street in Paris. He danced with Carmen Colle, "the queen of baubles,"[652] chatted with Marie-Louise Bousquet, kissed the hair of a dresser, and wandered like a disheveled prince before the lens of Willy Maywald. It seemed he never stopped moving so he could forget that he had rejected painting and the malaise that inspired it. Yet there were some new canvases, such as a portrait of Nathalie de Noailles, the daughter of Marie Laure and Charles (one of his few commissions) or the anonymous figures of lovers, onlookers, a young man, and a group in Saint-Mandé, which the artist overloaded with paint, as if to reassure himself that he hadn't lost anything.

Dior and Bérard made Cocteau's "ink of light"[653] shine to the point of blinding their own public, of dissolving in the shower of bravos. "Dior is to couture what Diaghilev was to ballet, Christian Bérard to theater sets, and René Clair to filmmaking."[654] In this part

of the world, where a millimeter was a matter of life or death, one tore a frill, slashed a sleeve, massacred a parasol, while the other grazed the fabric with his walking stick with its gold knob. Dior traced, reinforced. Bérard suggested. His silhouettes floated like colorful shades before becoming animated on the puffy vellum. It was as if they contained a magic spell. A fan looked like a cloud; a stem of feathers evoked rosé champagne. The queen was no longer of flesh and blood; she was an apparition, a blurry body held up by highlights of white gouache, white on white, mixed media, a signature that was always recognizable, even when it wasn't there.

Dior's workshops continued to expand. Christian Bérard, the lighter of stars, did not make models of his set designs. He would leave no archives other than his artworks, photos, letters spread across the four corners of the world. One day, when his friend Froska came into his studio, she stepped on a painting hidden under some newspapers and tore it: it was a Degas that Bérard had purchased at the Drouot auction house. "It's nothing… anything can be repaired," he reportedly said in a miffed tone. Surveilled and soon identified as a "drug user" by the narcotics bureau, he was approaching the title role of his life: that of the incurable eccentric Bébé. In 1948, when Bérard painted himself with a boy next to him, it was once again as a sailor washed up somewhere in the middle of nowhere. The day he had dreaded for so long finally arrived: he was arrested for drug use. The only solution was another treatment at Saint-Mandé.

Deprived of his bearded muse, Tian invariably assumed the role of the uncontested master of elegance. Although he hated being center stage, he had to agree to interviews and photo shoots. Stuffed into his gray suit, he smiled sadly. And he repeated: "You can never take too much care in selecting shoes. Too many women think that because they are low clown, shoes do not matter, but it is by her feet that you can judge whether a woman is elegant or not."[655]

Already in 1931, Kochno had spoken of Bérard's "greatness," which was "expressed by scorn for success and love of glory, the complete sacrifice of what is pretty to what is beautiful […]." He concluded: "For this social butterfly disdains fashion because he

creates it."[656] Bérard used to dread showing his paintings, and now his papers flew off here and there. He had no official job at Dior, but, together, they shared a whirlwind of muslins, patterns, and pins; was there any life outside of fall-winter and spring-summer? When the curtain fell, they capsized. Bérard gripped the bars of his bed as if they were those of a prison. Dior, a high-strung teddy bear, emphasized in his decor the "overall softness that suits [his] pudgy person."[657] Tian had become as dependent on food and the predictions of his psychic as Bébé was on drugs and alcohol. The long taffeta train that Bérard had designed for Edwige Feuillère in *L'Aigle à deux têtes* by Cocteau (Théâtre Hébertot, December 1946) caused "the roar of waves on a turbulent sea."[658]

In the theater, superstition was part of the acting life. Theater people knocked on wood to avoid bad luck, and there were forbidden words, such as "flop" and "success." Stagehands would not say "rope." And, at the theater as in fashion, green, the color of changeable minds, was a taboo. At Dior, chance had become a dragon that had to be constantly tamed. In order to banish his doubts, the couturier would discreetly visit his psychic: perched above the Seine, she had a little apartment on Rue de Boulainvilliers instead of a caravan tent.

Bébé was suffocating from having gone astray, as alone among the flowers and feathers as the Comtesse de Castiglione – an eccentric whom he admired – when she hung black fabric over the mirrors in her apartment on Place Vendôme so she would not see herself getting old. The more he deformed himself, the more he appeared in his sorcerer's role and embodied the beast among the beauties in his fashionable Paris set. He was the creature from whom the prince appeared. He knew how to flip reality inside-out like a glove; everything collapsed, but his Jocastas and Antigones defied gravity, and his walls of Thebes, like his sleeping beauty clouded in tulle with gold stars, all floated above the void, with no need for framework or artificial limbs. In Le Pouldu, in Brittany, Bérard adored "the continual variations of the sky, the water, the sands,"[659] but in Paris, he made the shadows his accomplices.

On his nightstand with its lamp constantly lit, there was always a deck of cards. As if he could not fall asleep without having

aligned his rows of kings, queens, and jacks. He played solitaire the way people today mechanically tap on their phone screens. Like Tian's life, Bébé's existence seemed to be in the grip of a taste for illusion and chance. You must believe in fairies for them to appear. "Dear Christian, you should completely savor this *unique* time of happiness in your career,"[660] Bérard had warned him: "It will never be given to you again to enjoy it as fully as today. Tomorrow there will be the anxiety of having to equal yourself, and, if possible, to surpass yourself."[661] Dior could not forget these words. They haunted him. But Dior had good-luck charms to help him. "Of course, I always have on me a little piece of wood in my pocket, which I touch when necessary!"[662] he ventured to confide to an American journalist. "You know, Mr. Murrow, I'm very superstitious. Do you want to see all the good-luck charms I have on me?"[663]

"It's such a New Look!"

Carmel Snow's word echoed in his mind like a refrain. They indicated both joy and penitence. For Dior experienced both, without ever being able to separate them: "as long as this double is there, I will be able to keep, in his shadow, and for myself, Christian, the better part. The one that, from the idea to the dress, gives my life its reason: my work."[664] In between collections, Dior would have tarot readings but never on an odd-numbered day. At age fourteen, dressed up as a gypsy, he had sold the good-luck charms of a palm reader. He came from a region where sailors avoided weighing anchor on a Friday, where the ships, nets, dredgers, and cupboards were blessed by the priest before a bottle of cider was broken against the hull. The words "rope" or "rabbit" were never spoken on the boats, and whistling on board was taboo.

Dior had awaited the death of his beloved mother before finding his vocation: fashion design. He had dreamed of being an architect, and he was a soldier and a farmer before entering fashion quite late. His father died on December 9, 1946, and he officially founded his couture

house on December 16, as if to promise to be worthy of what he had passed down. On that day, it was from Christian Bérard, the sorcerer whose pupils had been shrunken by opium, that Christian Dior received a life lesson. It sometimes happens that condemned men have the disturbing wisdom of soothsayers. For Bérard, illusion weighed nothing; it was freedom itself. Dior expressed charm through his fragrances and dresses, and Bérard transmitted it as a virtuoso of the ephemeral: "It is one of those sets just like those Bérard has always made for us; where there is nothing, and there is everything. Everything is empty, and everything is filled; everything is light, everything is suspended in the air, and everything sits on the ground: everything that sits on the ground seems to be flying off. The set is pearl gray, the gray of a pearl, it's day, evening, morning, and night at the same time, a pink sky and the sea, and the steps of a seaport, which resemble the steps of Montmartre; that is, a set that looks like all the places we have lived in with Bérard, all our vacations, all our lives."[665]

Tian and Cri shared this sense of other people, this way of emphasizing emotion over codes, seduction over shock. But while Bérard exhibited his distress by allowing himself to be photographed in his grimy hotel rooms, Dior fled the camera and sought refuge in his profession. When his friends seemed to catch him in happy moments, he continued to fool them, hiding behind his name. "The public Dior,"[666] he said.

If there was someone who knew them better than anyone, it was Cocteau, the word-juggler with the unreal physique of an ageless young man whose diamond glance scratched others without ever breaking. It was a long time ago when, dressed by Poiret, he became an ambulance driver for a Red Cross medical convoy. Thirty years later, he still had the suppleness acquired from his exploits during World War I. This figure, thin and sharp as a wire, leapt from one bank to the other, from art to fashion, stage to cinema, words to drawing, with an agility that irritated his critics. Jean Cocteau, the frivolous prince. "I have great hopes in him as a painter and in certain young people around him, whose minds are being instructed under a favorable star,"[667] he had written of Bérard in 1925.

You should completely savor this unique time of happiness in your career. Tomorrow there will be the anxiety of having to equal yourself, and, if possible, to surpass yourself...

Christian Bérard

The anxiety that Bérard had foreseen overwhelmed me. But instead of paralyzing me, it pushed me to the limits.

Christian Dior

In between stints in rehab at the hospital in Saint-Mandé – the same one where Adèle Hugo was swallowed alive in 1872 – Bérard wandered. He knew that he had to free himself from opium: "He tossed and turned in his bed as if in a river, escaped the line, caught beauty in flight."[668] After each psychiatric treatment, he returned heavier, more damaged. To transform his malaise, a touch of Bébé pink and silk fluttered down, his bed turning into a flying carpet, the printed flowers blending with the spots of paint. With Bérard, silhouettes are candlesticks of wind. "To express happiness, there is only sky blue, the blue of the sky in spring,"[669] he declared. This blue had the color of an ideal; it was the horizon emptied of all clouds, it was the set that needed no decoration, it was the dawn of the world. "For in order to arrive at this nothing, one must not start from nothing. You must start by putting in everything. And remove it bit by bit."[670]

In 1948, Bérard painted by Lucian Freud like a dying man on his pillow had become a ravaged shadow of himself. What happened to the "young blond man"[671] discovered by Dior? The heavier he became, the more his color palette shone and expanded, caressing the figures with his brushes of light. Dior was the couturier of the return; Bérard bore in himself these "dews of blood" dear to Hamlet, which made the figures tremble. Could he feel that death was stalking him? He advised Jean Cocteau on the costumes for Maria Casarès in his *Orphée*: "Death must be very elegant, because she is only concerned with herself."[672] Jean Cocteau would pay him the most beautiful homage in this film where he sought to "combine myths and intertwine them," convinced that "mirrors are the doors by which death enters."[673]

The effects of the drug were colors brightened as if by a rain shower, revelations that vanished upon awakening, a vibration of love and gentleness, similar to Dior's feelings when thinking about his childhood. But the couturier's nostalgia did not have the same effects as Bérard's withdrawal from opium: sweats, fever, aches and pains, intestinal problems, a feeling of decline and abandonment that took endless days to disappear. At the end of his night, he ringed the collar of a cloak with an azure ribbon, his face was haloed with a

domino mask of ink, a hood became a pumpkin with a pair of half-moons holding it, a celestial jewel. It was as if Bérard brought Crevel's visions to life by drawing them: here a 'wind scarf', here one of his "aquatic tea-gowns."[674] Every costume had the taste of an offering: "Cynthia, red-headed goddess, from your fingers there depart bundles of light."[675] The difference was still there: where Dior was eaten away by his ideal of perfection and this ideal of regained time, Bérard seized time in flight: it was the grace of the present. "Birds of the watery sky, what aurora in the depths of the seas has painted these acrobats of mother-of-pearl. On their swimsuits the unknown suns have left such rays that to look at them, Cynthia, you've become radiant for life."[676]

The silhouettes became cloudy, and even thought the line dissolved, it still retained everything. In the hands of others, the cross-hatching would have hindered the scene, but with him, it brought it to life. The dancer didn't wear a skirt; the artist's line just suggested the air that moved around him, and he spun, took flight. Opposite was the shadow, the stained Other. It was as if Bérard had always spoken familiarly to the sky before joining it. Color crackled under his black fingers, his brush worked, every face was a halo. With his bear paws, he lit up the puffy vellum with suspended presences, "sun all of sulfur and love,"[677] "intimate undergrowth,"[678] "drifting icebergs,"[679] his friend René Crevel, whose portrait he sketched, reportedly said. Colette, for whom he illustrated an edition of Gigi, mentioned his "boldness of line and inspiration" and his "fire of colors."[680] On Rue Casimir-Delavigne, in his room with its dirty sheets, the Fabergé boxes sparkled like lost stars. The stage was his kingdom, where the madwoman of Chaillot appeared for Bérard as if in a kind of inhabited nowhere. It was as if everything he had placed there – the chestnut trees, the façade of Chez Francis – was still there, even when he had eliminated everything. His line became stronger when blurred, he removed the walls, and seeing these windows hanging in the void, we wonder: what if the end of the world were simply a set by Bérard? A lake in which vanished creatures are reflected?

"Don't be fooled by the impression of laziness and craftiness he may create; it's a state of mind, an attitude."[681] Around him, no one

was fooled, and no one judged him. "He slept, drew, and spent most of his time on a litter of fashion magazines, photos, detective novels, cigarette ash, and opium residue."[682] Life was a constant playground, where "Bérard in pajamas, Bérard in his bathrobe, Bérard enchanted every day"[683] made a game of everything – and of himself most of all. Did Dior, his soul twin, sense that the wind was shifting? In January 1949, his *Trompe-l'Œil* line emphasized a silhouette that was "clearly shifted, moving, shortened"[684] and made lighter by droguet, a very lightweight taffeta faille fabric. The colors took flight in a rippling country bouquet: forget-me-not and larkspur blue, the straw color of ripe wheat. The busts became suppler, the jackets had the "naturalness and style of a carnival worker's jacket that is hastily slipped on," the shoes were inspired by "sea bathing."[685]

The last dance

On February 12, 1949, it was at the Théâtre Marigny, in front of Madeleine Renaud and Jean-Louis Barrault, that Bérard received death while defying it, like Octave in *Les Fourberies de Scapin*: "I am murdered by this cursed return." "Oh! I like this because it's theater for dogs!" exclaimed Bérard from an orchestra seat, with Jacinthe, his Bichon Tenerife on his lap, a little Bichon Frisé like the one that Goya painted at the feet of the Duchess of Alba and Fragonard depicted in his *Billet doux*, a dog for street performers and organ grinders. A few minutes passed, in this red silence, and Bérard suddenly clapped his hands and collapsed from a stroke. People thought it was a joke, but he had crumbled for real. He was not taken to the hospital. Madeleine Renaud and Louis Jouvet took him home, as if he were just a bit drunk. He was a walking dead man when he crossed the threshold of his apartment on Rue Casimir-Delavigne. A larger-than-life ending, just like the man himself. "He died from giving everything,"[686] Jean-Louis Barrault wrote. Thus, on February 12, two years to the day after the first Dior fashion show, Bébé was no more. "And we, his friends, his Harlequins, his Columbines, we cried, we laughed, we had our magician, our Pandora's box, our costumes, our

ribbons, our stage constructions."[687] His death, a final tip of the hat from Cri to his friend Tian? That very night the full dress rehearsal took place. The curtain broke. They repaired it, and the memories surged forth. Bérard's death resembled one of his sets. Paris was a mouth of shadow haloed by a pale winter sky. "Dear Christian, how we will miss the flash of your eyes. No one can replace you." I thank you for our profession. The interest that you took in it gave it a new status and a deeper human resonance,"[688] Dior wrote to his double on a white card slipped into a basket. The mourners included Boris Kochno, Louis Jouvet, Jean-Louis Barrault, Jean Cocteau, Marcel Achard, Madeleine Renaud and the deceased's three nephews. In the nave, Dior was there, and not far from him were Madame Grès, Marie Laure de Noailles, Jean Babilée, Marcel Herrand, director of *Captain Smith* at the Rideau de Paris, for which Christian Dior had designed the costumes and sets ten years earlier: "Bright walls and sunlight coming in through the windows, flowery dresses, comical costumes without being buffoonish."[689]

The Borniol company took care of everything, from the wreath of hyacinths sent by Antonio del Castillo – who had stolen Dior's pattern maker job at Piguet – to the calling cards of Roland Petit and Leonor Fini. There was a profusion of arum lilies and dark roses. And then hyacinths, the name of his little dog (*Jacinthe* in French), for whom he had ordered a Texas saddle and a collar with fake gems. She preferred to stay like him, uncombed, unwashed. Who were the two old ladies wrapped in black who crossed the nave standing stiffly, with an expression of profound disapproval? Christian Bérard's aunts, the sisters of Marthe de Borniol. They looked like the two nannies sketched in his first notebook. Half a century later, a coffin had replaced the carriage. The picture of Bérard floated, already blurred, as if the sea had swallowed him. "And I see him sitting again, his heavy head amid a flood of fabrics, a scum of old newspapers."[690] In the catalogue for the exhibition in homage to Bérard at the Musée National d'Art Moderne in 1950, Christian Dior is featured as a lender, and yet he did not write a tribute. Did he not have the time? Did he refuse? Did he think that a couturier would be out of place here?

Before leaving, Bérard had wanted to make introductions, dragging his friend to a ball of needles and skeletons. When Dior emerged exhausted from his first collection, Bérard had encouraged him to design costumes for the theater. This experience remained painful for him, even disastrous. "Gray shirt, yellowish white gold, black velvet bodice, navy ostrich tutu on black tulle, black sequins. Sequined tulle drapery and scarf. Black velvet gloves. Diamond crown and jewels. Death." Christian Dior wrote in 1947 on the back of one of the sketches for *Treize danses*. "A nightmare," the designer stated, paralyzed by this audience that came to judge him, in front of whom he introduced himself, without his seamstresses as bodyguards. The costumes were produced by Barbara Karinska, a close friend of Bérard. It was a different school: it was a world whose writing Dior could not master, with its finds, its masquerade of formulas that were quite different from the whispered secrets that were so dear to his workshops, the hours spent aligning a test garment, fixing a sleeve, checking the proportion of a collar, all to make sure that "a well-cut dress is a dress with few cuts."[691] Instead of this, on the theater stages, anything was possible: a modest fabric could suggest a brocade or a gold-tasseled belt, and red velvet could be the entrance to a castle. In this mythical kingdom, effects were not about centimeters but about illusions. Bérard, who walked his dog in the palaces with a string around her neck, was quite different: he thrived on these vast discrepancies. He was a flea-market alchemist, and everything he touched became a bonfire. "The wretched setting of an apartment that's been lived in for twenty years, with old gas appliances and old bathrooms; basically, it's really fun to do this for a change from splendor, you see; old dressing gowns, dresses with holes, there's nothing by designers, it's completely awful, but it will be very funny."[692]

Dior, who still had "the taste for solid, tested constructions, dear to Normans"[693] always reserved costumes for private life. The night of the premiere, it seemed that the Parisian high society that acclaimed the couturier had come to murder the costume designer. Elsa Schiaparelli was seated in a box. We still wonder how this frail figure, helped by Marie-Louise Bousquet, was able to

prevent Bérard from committing the crime that would have brought him to trial: in 1948, furious at Kochno for his spiteful remarks, hadn't he set out to kill him?[694] As indestructible as her Etruscan-style horsehair hat, this close friend of Bébé had certainly lost her aura, but not her eye, which was still to be feared. The newcomers of the postwar period could not understand her sense of fashion, fueled by high standards and extravagance. "I like throwing punches around," she stated. And she proved it by saying indirectly to the unfortunate Dior, the couturier of oddball special designs created by the studio: "I hate useless things, easy details, easy flowers, an 'embroidered flower' that adds nothing."[695] Dior did not receive only praise: "*Treize danses*, set to old music by Grétry, plays around with all the artifice of fashion, with the most excessively decorated Parisian look. Women with horses' manes, masks of Italian theater, death crowned and spangled with stars under a sky of orange paper lanterns – all this could certainly have unleashed a frivolous, nocturnal, mysterious carnival, if the choreography had been able to fill the stage the way youth and freedom enter a sky by Tiepolo, but, on the contrary, if I may say so, it plugs away in vain and laboriously struggles as if to tame a wild animal, instead of enchanting."[696] Was Dior an awkward imitator of Bérard in spite of himself? As always, Cocteau had the final word: "Christian Bérard is a 'Seems-dead,' for never does an artist die; he merely slumbers." He continued: "His magnificent imaginings, his lines, his spots of color perpetuate him. Bérard toiled on napkins and menus, the way nature is tasked with decorating, anywhere, plants and animals. It is surely to this privilege of participating in the mysteries of the universe that he owes a kind of forgetful ingratitude from men. What he created was like what grows, not what is invented. Beauty emerged from his person with the bizarre and monstrous ease of the animal and plant kingdoms. Bérard was a demiurge and demiurges are immortal."[697] And so it was with the art of theatrical illusion, with which fashion was no match, so much so that the "smiling dead" dominated his audience: "The purest Christian Bérard style, where mold and dust on the great walls resemble gray, grated velvet, and flea-market

objects, mysterious as tramps adorned with ostrich feathers, find a new youth that may never leave them."[698]

Bérard was triumphing when Dior was still a mere collaborator whose name appeared in italics at the bottom of sketches drawn for *Le Figaro*.[699] Time had passed, but friendship had not. This was in 1956, during a lecture, when he recalled, regarding the names of his dresses: "there can be a connection between the dress and its name – I'm thinking of the design dressed in red velvet, which we called *Christian Bérard* in 1949, because our friend would have loved, I think, its color and shape."[700] The day of his death, in February 1949, before going to the Théâtre Marigny, Bérard passed by Avenue Montaigne: Dior was always on his path. And even after his death, he still remained an enchanter for Dior. Life was held together by the thread of beauty, which he summoned through his sources of inspiration — scissors, windmills, Diane's crescents — not forgetting the "painters who came to the rescue,"[701] which of course included, besides Picasso, Braque and Dalí, Derain and Bérard, who had inspired him for the autumn-winter 1949 haute couture collection with two twin sets of "Dior red" velvet. For it was the painter's own touch that he was expressing, in this seamless jacket, loosely tied with a collar "mounted to match," in this skirt both constructed and moving. The spirit was "tailor," but the style was "flou". Number 49 in the program of the Dior fall-winter haute couture collection of 1949, *Cri de Paris*, a "semi-evening" gown in black velvet, revealed a presence that would be added to with the "veteran travel coat," the "end of day" dresses, and the "Barbe de Bébé" satin-lined dancing dresses.[702]

In 1950, Dior purchased a country getaway, La Colle Noire, an old post house in Provence where he would recharge his batteries, far from the whirlwind of Paris fashion, and where he strove to create the impression that this building had always been lived in. He was like Marie-Antoinette playing shepherdess at the Petit Trianon at Versailles: "Here, I am not a queen; I am myself," she said. Dior put in larger windows on the ground floor, lowered the second-floor windows, and dug a pool. Nothing was unthinkable for this reinventor

What I recommend above all in the theater is the void. From this, one can make a general rule.

Christian Bérard

of traces. He even changed the access to the site, designing a tree-lined road to create an entrance that would be worthy of a château. He kept the old oak trees and planted fourteen cypresses with the precision of a landscape artist. His lucky number 8 – which was identified with one of the two New Look lines – was obsessively found in the octagonal entrance hall, with the sea star of Les Rhumbs in the paving stone. Matching the legendary Dior motif, white peacocks and black chickens drank in the long pool whose proportions were inspired by those of the pergola in Granville. With Dior, everything was a sign, everything was an omen, and on this estate of 125 acres there resided the promise of a new beginning. This house was located "in Montauroux, near Callian, where a lucky star had allowed [him] to find peace and quiet and to start a new existence."[703] Dior caught white butterflies, Dior concocted a raspberry liqueur, and summer had the fragrance of the perfect life, a lunch prepared by his chef whom he met with every morning, a concert of cicadas under the plane trees, a game of solitaire in the "cool room." Before his close friends, Dior improvised a striptease. Taking off his jacket, his pants, and standing there in his underwear, he laughed, he was happy. A breath of life, a Bérard moment on the wings of time. With Bérard gone, Dior dug, supervised the workers who were astonished to be asked to place the floor tiles in the large salon upside down.

At Callian, Dior acted the part of a rich uncle, letting the entire village benefit from the electricity he installed and producing wine and olive oil, an epicurean beaming among the almond trees with the sweet name of "lookouts." He would never finish the projects he started. In his office, he had hung up the little dwarf painted by Bérard, the famous "Piéral," the pseudonym of Pierre Aleyrangues, who was four feet tall. Hired by the Bouglione brothers, he began his career in *Les Visiteurs du soir* by Marcel Carné in 1941 and then performed in *L'Éternel Retour* by Jean Delannoy. Having lost his virginity to a prostitute in a brothel, Piéral the bisexual dwarf had, as seen in Bérard's portrait, a look of suffering borrowed from Goya's monsters. This presence exchanged invisible

connections with all the good-luck charms arranged in Dior's little room: the card table and its little notebook with the boxes marked "we," "they," "and "dealer"; a drawing by Marcoussis; a burgundy-colored leather briefcase where he kept his sketches, in that summer of 1957, his last.

At La Colle Noire, as at Versailles, some doors led to secret rooms. Bérard was omnipresent among the ghosts. The modest ticking hung in one of the rooms, called the "siesta" room – adjoining Christian Dior's office – recalled by its simplicity Christian Bérard's apartment on Rue Casimir-Delavigne. It was certainly the most pared-down room in the entire château, the most personal and friendly of this Petit Trianon on the Fayence plain. It was as if the dust of time had bleached the striped raspberry fabric, leaving Dior to thoughts that were increasingly mystical: "the maintenance of fashion is a manifestation of faith."[704] "Christian Bérard is dead, which does not stop anyone from working under his direction,"[705] Jean Cocteau promised. Writing his memoirs in this place, Tian spoke of himself as if of another person: "Dior and me." Very discreet, he never came out as gay to the press, even if, seven years earlier, *L'Intransigeant* had pointed out his preference for "the company of men."[706] There were other omissions as well: the madness of Bernard, his brother who was institutionalized, and the virtual non-existence of his other brother, Raymond, and his bitter defeat. Didn't he have the habit, when he looked in the mirror, of first establishing the shapes, a line? And then the pink shadow of Bébé, the friend with "sensitivity as fine as a child's skin,"[707] lurked, without warning. "Those who were still alive, how bored they would be without him. The very heart of Parisian taste had stopped beating. Where would the new ideas come from, who would revive the old ones, who would make the choice?"[708] The dead man's eye was invasive. "I got back to work enthusiastically. The anxiety that Bérard had foreseen overwhelmed me. But instead of paralyzing me, it pushed me to the limits."[709] What Dior felt in 1946, he would continue to feel during a decade of creativity that he would not survive. The Grim Reaper never stopped haunting him. She crept into all his collections, because

each one buried the one that preceded it. Death slipped into his doubts and memories. "I applied a great deal of prudence to making progress in fashion — a mirror destination that is of rare fragility. If I wanted to cross this frozen river safely, the thin frosty layer had to hold."[710] Despite all the money earned and spent on opium, in suits that all became stained, Bérard survived his glory, but lived in visible poverty, being better suited to squandering money than earning it. Dior, for his part, survived poverty, but glory did not faze him; sometimes it seemed to weigh him down. "The atmosphere in the house is dignified and courteous. Christian Dior doesn't show himself there any more than he does at cocktail parties or general meetings."[711]

The social circus

Bérard made visible the sadness of a lost generation. In 1927, Georges Hugnet was among the first, along with Christian Dior, to recognize the talent of a peer. "Bérard understood the danger of painting in our time. He understood that it was dying of starvation. Now we're looking for the ultimate, the art of placing a point and a curve on a surface. [...] Everything in his painting is a protest against painting. [...] Bérard has benefited from the lessons of Picasso, that admirable master. But he has also managed to free himself from the processes that still plague many painters, and which make painting a vast undertaking. [...] He knows how to see the faces around him. [...] He paints what he wants to paint, seduced as he is by the lighting of fairground circuses, by the tragedy of articulated waxworks at fairs."[712] As it happened, twenty years and counting later, so many snobs had worshipped him that the faux-pures were intractable. And so it was that Frank Elgar, whose real name was Roger Lesbats, journalist and art critic, killed him a second time, as in the theater: «His portraits reveal no original or powerful personality. A skilful but banal draughtsman, he has confined himself to serving an exhausted tradition, dressing it up in shimmering finery to make it seem more amiable [...]. Dashing, frilly, adorably false, neither sensual nor

dreamy, fluid and elusive, his gouaches are more like illustrations for women's magazines. [...] We find their modern-style coquetry distasteful.[713]

Wasn't what was criticized about Bérard reminiscent of Dior? In the chorus of funeral eulogies, dissonant voices were heard, showing just how vulnerable the much-exposed artist proved to be after his death. Bérard, then, "the transvestite man who makes an impression, a cad dressed in lace and satin who parades,"[714] would freeze into his own ragged caricature. A signal for Dior? Over time, the wounded couturier retreated into seclusion, surrounded by his fox terrier Bobby, his boxer Winnie and his alley cat Minouchette. He arraigned his wound, padlocked it under his gray suits. Bébé's shaggy ghost prowled the Drap d'or, with its imperial decor, violinists and champagne served in silver goblets. Occasionally, Christian Dior would be spotted at Carrère, where crepes Suzette were flambéed on checkered tablecloths to the sound of Aimé Barelli's orchestra, velvet trumpet. Deep inside him, musette tunes, memories of the Cirque Médrano and the days when juggler Rastelli, tightrope walker Colleano —a virtuoso at somersaulting on wire— and Barbette, half man half woman, lit up the capital. A Paris of *tableaux vivants*, roughnecks and funfairs, in the days when "*carat*" meant "a year", "*agrafer*" meant "to be caught", and "*repasser*" meant "to be robbed at gambling". Dior might have found an accomplice in another man of few words, but the great Spaniard was the opposite. You wore Dior to be pretty, charming, to seduce; you wore Balenciaga to remain straight, always. Balenciaga refused to dress actresses. "Balenciaga is elegance in all its rigor. Women are hangers on which he hangs dresses that never go out of style because they make no concessions to fashion".[715]

Christian Dior said he hated advertising as much as women wanted his designs, whispering "How do I miss Dior?" In 1948, just one year after the creation of the New Look, he was imposing his "impenetrable filtering"[716] with more than three screenings, so much so that some had seen appropriate to ask ministers for invitations. The more his creations softened, the more he stiffened, the more he doubted. Let nothing show: that was the Faustian bargain he had

made with glory. One day, having accepted to attend Count Étienne de Beaumont's 1800-1900 costume ball, he asked the Comédie-Française for permission to borrow a costume. He sent his secretary to Suzanne Lalique, director of the couture workshops at Molière's house. "She tried on a frock coat from Musset, breeches from Hernani, a leotard from Alceste" _ "No, on second thought," she said, "Monsieur Dior will make his own costume." The press wondered: "So Christian Dior went unnoticed?"[717]

"My nerves are in very bad shape, I only have dark thoughts and cannot enjoy at all the beauty that surrounds me," Christian Dior wrote to Jacques Benita on August 21, 1957. With brown hair and the olive skin of the East, Jacques,[718] born Isaac, was twenty-five years younger than the couturier. He looked like an exact replica of the acrobat in the pale green jersey painted by Bérard. He resembled the young man that Julien Green had spotted at the Cirque Médrano, with his "innocent, disdainful face and his splendid body [...]. With his dark eyes, he seems to promise us 'yes.'" But where Julien Green had seen a quarry – "his thick, vigorous calf shone in its silk sheath,"[719] – Bérard saw a man, a man like any other, handsome and lonely enough to die for. Jacques Benita, whose real name was "Ben Itah," was born in Oujda, Morocco, and moved to Paris on a whim after the war, giving up his original vocation – the clarinet – to try his hand in supporting roles in film. Dior met him in 1955. They went to Italy in the summer of 1956, running into Dalí there. Jacques was his last lover. Did Dior fall in love with a painting before meeting its likeness two decades later? In Saint-Tropez, he gave Jacques a little red scarf, a token of love that would be a farewell gift.

Before leaving for Italy, Dior went to Jacques' show for the last time, at the cabaret of Suzy Solidor, whom Bérard had painted in her ugly helmet of yellow hair. After the Liberation, she had been tried for collaboration, but the Madonna of the sailors had just reopened her Parisian nightspot. "Change nothing," he wrote to his young friend. It was as if, despite his death, Bérard was still there, always there, commenting on the funeral ceremony, stifling his laughter in his wild beard. There was no way in the world that Tian would miss

an appointment with his youth. On October 8, 1957, he went to the tribute that was held at Père-Lachaise cemetery in honor of Pavel Tchelitchew, who had died on July 31. Surely his burdensome good upbringing had overcome his judgment. "More energy in the line and clarity in the concepts, but an emotion that is less deep and not the least trace of that mystery that makes Bérard inimitable in my view."[720] This was the last official outing for Dior, the inconsolable, lifelong friend. Didn't he call on Pierre Gaxotte, who, like him, had also suffered from tuberculosis, to write a preface for the autobiography he was preparing to publish? On October 12, 1957, the day before he left for Italy, where he was planning a weight-loss treatment, Dior went to see his psychic, Madame Delahaye. "Don't go!" his faithful advisor ordered. But the sign of Aquarius is rebellious and headstrong. "On the skin of my heart there are wrinkles. [_] Must we leave each other already? [_] Don't shock me. I am full of tears," Henri Calet had written two days before his death, in his diary, published after his death with the title *Peau d'ours*. The last name that Tian had scribbled in his calendar was that of "Madame D."

Dior/Bérard. Bérard/Dior, each in their own way, reassembled the Paris décor piece by piece, caught up in the whirlwind that devoured them: they could not be reduced to the gotha in which they were the sorcerer's apprentices. They transformed the allure of the Parisian woman, erecting her silhouette like that of a capital city. Unlike Chanel [Coco], Louise de Vilmorin [Loulou] and Bérard [Bébé], Dior never had a nickname. Insiders and outsiders devoted admiration to him. That same admiration that the artist of the "expiatory gouaches"[721] let burn away. "So many passions, enthusiasm, illusions and kindness, follies, excitement, love, weakness and energy, made of this fat, selfless man a strange object of luxury who made everything he touched, even life itself, luxurious and beautiful".[722] Dior undoubtedly understood better that one must know how to "live posthumously and protect oneself against the outside world."[723] Is there a better barrage than passion? Which of them has best survived all the defeats? Bérard, in love with sailors and deserted beaches, or Dior, who "let his dreams wander in the fog that shrouds legends, cities and Nordic landscapes?"[724] Journalist Marie Wahl

wrote: "In other times, he might have been a privateer. In the twentieth century, he became a couturier because he loves this special art (mixing drawing and sculpture), which consists of dressing a woman's body, but he continues his incessant voyages, constantly discovering new galleons laden with booty and bringing them back to port carried by favorable winds."[725] His greatest booty, however, was not so much his own life as the name he turned into a treasure in less than ten years: DIOR. "After Bérard's death, it was said that Dior would not be able to go on without him. Dior, of course, has since demonstrated his personal talent a thousand times over, but it was Bérard's sincere enthusiasm that had earned him his dazzling start,"[726] wrote Cecil Beaton.

The image of Bébé's beard has faded, as have Antonio's hairdresser's hands, Cocteau's cuffs, all those signs that seemed so essential to Paris. Dior kept a watchful eye on things, with his prelate's hands, "stingy with gestures," his "slow, calm, plain voice," his "eyes so lively and yet veiled in dreams".[727] He knew the thousand and one nuances of the earth and the seasons so well, he had counted the days and minutes leading up to each of his shows, that time held no secrets for him. Whether he sewed pockets, cut out shark wings, turned lapels into French fry cones, screwed on overcoats or transformed overcoats into pea coats, one wondered how Dior could "design like Dior while renewing himself".[728] His spring-summer 1957 haute couture collection was a tribute to freedom. It was more than a color (for stockings), it was a "Cri". Didn't Bérard similarly dream of "an immense empty room"[729]? "I can't stand this apartment any longer, where it's impossible to move without bumping into the furniture that clutters the house and without banging into useless objects."[730]

On October 24, 1957, Christian Dior suffered a heart attack and died at Montecatini Terme, Italy. Until the very end, his friend's artworks had accompanied him. Among them, a portrait of a young man seated on a red cushion, which he had hung in his apartment on Rue Royale. Red like the handkerchief that Bérard held to his heart, "Macaw" red, the red of Proust's stabbed dove, which almost

became the title of *À Recherche du temps perdu*. Red, which could be flamboyant red, "Scream" red, "Ember" red, "Madder" red, red-headed like the "Barbe de Bébé" design by Dior, like burnt red, "this tanned color that in the past kings adopted for their attire and which concealed the purple of power under the brown of sorrow."[730]

Epilogue

What if they went through their lives masked? Each one wearing a costume, revealing himself as the double of the other? Dior, the theater actor, dressed as a couturier, the one who made each new season into a plot twist. "I set the catwalk for my models, a bit like placing characters on a music-hall stage, considering the harmony of silhouettes and tones... I saw it all in me.... And then..."[731] Bérard, the trendsetter disguised as a set-designing ogre. Bérard painted sorrow, and Dior spent his life camouflaging it, hiding his fears with good-luck charms, a hammered cast-iron star with a pierced design, a dried sprig of lily of the valley, a four-leaf clover, a piece of wood and a chunk of gold. This kit of amulets was always with him. Any compromising letters he may have written disappeared; his lover chose silence, and even changed his name, becoming "Tony Sandro," surely to escape the past that had abandoned him and left him alone under the scornful gaze of all these women in black upon leaving the cemetery in Callian.

Who drove back with Jacques Benita that day in his Jaguar? A certain Pierre Bergé, who was then in a relationship with the painter Bernard Buffet, Dior's neighbors at the Château de l'Arc in Furveau. In three months' time everything would shift, but, really, it was as if destiny had already taken hold of things much earlier. Bergé would leave Buffet for Yves Mathieu-Saint-Laurent, who became, at age twenty-one, in November 1957, Dior's successor. The dice of chance seemed to have been thrown by a familiar hand that remained invisible. It just so happens that Yves Mathieu-Saint-Laurent's first overwhelming aesthetic experience had been a performance of *L'École des femmes*, directed by Louis Jouvet in Oran – his hometown – in 1950. When he was only fourteen years old, Yves had done sketches in the style of the costumes of *La Belle et la Bête*, his favorite film, and found inspiration in Dior's collections. This child of the Mediterranean found his lines, his colors, the meaning of his life, in fashion and theater, muses and solitude, identifications and addictions. Dior-Bérard, a pair of larger-than-life inspirations for this son of glory and destruction. This Leo would fight back at double

strength, as if to avenge "the cynical, bearded, dirty fags, with their hair in grimy buns, their gnawed-on fingernails, their green teeth,"[732] who were vilified in a homophobic attack by Paul Morand, in *L'Allure de Chanel*. "How many young women I have seen die under the subtle, intoxicating influence of the 'horrible queer.'"[733] Didn't the young Yves see himself in this fight from the beginning? Even if Dior, playing on words, predicted that he would have "a rosy [...] future in this profession [...] like the flyleaves" of his autobiography *Christian Dior et moi*, which he signed for Yves in 1956.[734]

Bérard is perhaps one of the few to have grasped the mystery of Dior, "the Watteau of couturiers, bursting with nuances,"[735] "with his teasing and vaguely melancholic smile".[736] Bérard was perhaps one of the only people to have understood his mystery. Through his enigmatic self-portraits, Bérard held out a piece of the broken mirror from Granville to the dilettante who was fleeing his own image. He allowed Christian Dior to see himself differently and to seek in the depths of his solitude the essence of a providential third man: himself. What is a man who has not yet trembled?

Fashion is a means of expression like any other and it was with my dresses that I tried, for my part, to establish a taste and a temperament.

Christian Dior

Footnotes

1. Marcel Jouhandeau, "Le peintre," *Labyrinthe*, February 1950, special issue on Christian Bérard. "The mark of his genius, whether he dresses it in flamboyant rags or shows it to us completely naked, is Anxiety. For me, Christian Bérard is the painter of Anxiety."
2. Françoise Giroud, "P.S.," in *Carrefour*, February 16, 1949.
3. Ibid.
4. Ibid.
5. Christian Dior, *Christian Dior et moi*, Paris, Vuibert, 2011 [Paris, Amiot-Dumont, 1956], p. 215.
6. Waldemar-George, *L'Amour de l'art*, n° 1, January 1934.
7. Christian Dior, *Christian Dior et moi, op. cit.*, p. 34.
8. Ibid., p. 27.
9. Ibid.
10. René Crevel, *Babylone*, Paris, S. Kra, 1927 [Paris, Jean-Jacques Pauvert, 1975], chap. 4.
11. Ibid., p. 33.
12. Christian Bérard had written in calligraphy on photos of the "Divine Comtesse" purchased at Galerie Druet a text reproduced by Boris Kochno in *Christian Bérard*, Paris, Herscher, 1987, p. 31.
13. Ibid.
14. Letter from Jean Cocteau to Max Jacob, March 1926, quoted in Claude Arnaud, "Introduction," *Jean Cocteau*, Paris, Gallimard, 2003, p. 11.
15. Robert de Saint Jean, *Journal d'un journaliste*, December 14, 1931, Paris, Grasset, coll. "Les Cahiers Rouges," 1974, p. 97.
16. Marcel Jouhandeau, "Le peintre," *Labyrinthe, op. cit.*
17. Jean Clair, "…la femme la plus élégante du monde…," in Boris Kochno, *Christian Bérard*, Paris, Éditions Herscher, 1987, p. 81.
18. Christian Bérard quoted in Jean Hugo, *Le Regard de la mémoire, 1914-1945*, Le Paradou, Actes Sud, 1983, p. 388.
19. Christian Dior, *Christian Dior et moi, op. cit.*, p. 43.
20. Ibid.
21. Elsa Triolet, "Le Feuilleton théâtral d'Elsa Triolet", *Les Lettres françaises*, February 17, 1949.
22. Ibid.
23. Cecil Beaton, *Cinquante ans d'élégances et d'art de vivre*, Paris, Amiot-Dumont, 1954, p. 214.
24. Christian Dior, *Christian Dior et moi, op. cit.*, p. 40.
25. Edmonde Charles-Roux, *Christian Bérard*, exhibition catalogue, Paris, Galerie Pierre Passebon, 1993.
26. Louis Jouvet collection, November 29, 1939, quoted by Ève Mascarau in "L'entrée en scène chez Louis Jouvet", https://doi.org/10.4000/agon.2391
27. Louis Jouvet collection, September 1940, *op. cit.*
28. Louis Jouvet, *Réflexions du comédien, problèmes du théâtre*, Paris, Nouvelle Revue critique, 1938, p. 40.
29. Ibid., p. 19.
30. Marie Laure de Noailles, "L'Amitié," *Labyrinthe, op. cit.*
31. Christian Dior, *Christian Dior et moi, op. cit.*, p. 126.
32. Ibid., p. 18.
33. Ibid., p. 187.
34. Ibid.
35. Ibid., p. 188.
36. Ibid., p. 184.
37. Ibid., p. 186.
38. Ibid., p. 189.
39. *Le Granvillais*, February 24, 1912, municipal archives, Granville.
40. Christian Dior, *Christian Dior et moi, op. cit.*, p. 189.
41. Ibid., p. 214.
42. Robert de Saint Jean, *Journal d'un journaliste*, May 7, 1932, *op. cit.*, p. 115.
43. Edmonde Charles-Roux, "He was as essential as a great poet can be," in Boris Kochno, *Christian Bérard*, *op. cit.*, p. 138.
44. Maurice Denis, "Définition du néo-traditionalisme," *Art et Critique*, August 30, 1890.
45. Christian Dior, *Christian Dior et moi, op. cit.*, p. 189.
46. Julien Green, *Journal intégral, 1919-1940*, January 10, 1931, Paris, Robert Laffont, coll. "Bouquins," 2019, p. 222.
47. Christian Dior, *Christian Dior et moi, op. cit.*, p. 191.
48. Ibid.
49. Ibid., p. 199.
50. Christian Dior, *Je suis couturier*, interviews by Élie Rabourdin and Alice Chavane, Paris, Éditions du Conquistador, 1951, pp. 19-20.
51. Christian Dior, *Christian Dior et moi, op. cit.*, p. 191.
52. Ibid.
53. Ibid.
54. Ibid.
55. Ibid.
56. Ibid.
57. Letter from Marthe Augustine Marie de Borniol to André Bérard, undated, Kochno collection, Bibliothèque-musée de l'Opéra (BMO), Paris.
58. Letter from André Bérard to Marthe Bérard, 1918, Kochno collection, BMO.
59. Ibid.
60. Ibid.
61. Ibid.
62. Jean Clair, *op. cit.*, p. 81.
63. Based on a recollection of Jean Hugo, in Jean Hugo, *Le Regard de la mémoire, 1914-1945, op. cit.*, p. 387.
64. Letter from André Bérard to Marthe Bérard, 1918, Kochno collection, BMO.
65. Letter from André Bérard to Marthe Bérard, undated, Kochno collection, BMO.
66. Letter from André Bérard to Marthe Bérard, 1918, Kochno collection, BMO.
67. Ibid.
68. Christian Dior, *Christian Dior et moi, op. cit.*, p. 188.
69. Ibid., p. 189.
70. Raymond A. Dior, *Les Vaches (1918-1935)*, vol. I, *Petite Chronique privée*, Paris, Nouvelle Revue critique, 1945, p. 32.
71. Christian Dior, *Christian Dior et moi, op. cit.*, p. 192.
72. Ibid., p. 218.
73. Ibid., p. 192.
74. Ibid.
75. Ibid.
76. Ibid., p. 194.
77. Marthe, Joseph, Lucien, Marcel Papillon, "Si je reviens comme je l'espère," *Lettres du front et de l'arrière, 1914-1918*, April 13, 1915, Paris, Grasset, 2003, p. 124.
78. One-act ballet performed by Serge Diaghilev's Ballets Russes at the Théâtre du Châtelet on May 18, 1917, written by Jean Cocteau, with music by Erik Satie, choreography by Léonide Massine, and sets by Pablo Picasso.
79. James de Coquet, speech upon his visit to Granville in 1976, Musée Christian Dior archives, Granville.
80. Ibid.
81. Marcel Proust, *À la recherche du temps perdu*, vol. II, Paris, Gallimard, coll. Bibliothèque de la Pléiade, 1988, p. 806.
82. James de Coquet, *Le Figaro littéraire*, November 2, 1957.
83. Ibid.
84. Letter from Christian Bérard to his father, undated, Kochno collection, BMO.
85. André Gide, *Les Caves du Vatican*, Paris, Nouvelle Revue française, 1914, p. 294.
86. Christian Bérard quoted in Jean Hugo, *Le Regard de la mémoire, 1914-1945, op. cit.*, p. 388.
87. André Gide, *Les Nourritures terrestres* followed by *Les Nouvelles Nourritures*, Paris, Gallimard, 1942, p. 15.
88. Ibid.
89. Letter from Christian Bérard to his mother, quoted in *Bérard l'enchanteur*, exhibition catalogue, Granville, Musée d'Art Moderne Richard Anacréon, 2011.
90. Jean Hugo, *Le Regard de la mémoire, 1914-1945, op. cit.*, p. 388.
91. Letter from Christian Bérard to his father, Kochno collection, BMO.
92. Letter from André Bérard to Marthe Bérard, 1917, Kochno collection, BMO.

93 Letter from Christian Bérard to his father, undated, Kochno collection, BMO.
94 Ibid.
95 Jean Cocteau, "Plain-Chant," *Poésie, 1916-1923*, Paris, Gallimard, 1925, p. 446.
96 Christian Dior, *Christian Dior et moi, op. cit.*, p. 193.
97 Hand-written letter from Christian Dior of June 17, 1924 on Dior family letterhead printed with 9 Rue Louis David, Paris 16ᵉ, acquired in 2015, Parfums Christian Dior collection, quoted in Frédéric Bourdelier, "Dior à Sciences-Po," *Dior. Les Cahiers du patrimoine*, n° 13, 2022.
98 Letter from Christian Bérard to his father, undated, Kochno collection, BMO.
99 Jean Hugo, *Le Regard de la mémoire, 1914-1945, op. cit.*, p. 387.
100 Letter from Christian Bérard to his father, undated, Kochno collection, BMO.
101 *Le Journal de Granville*, January 1904, quoted in Vincent Leret, "Maurice Dior, 1872-1946," *Dior. Les Cahiers du patrimoine*, n° 19, 2022.
102 Christian Dior, *Christian Dior et moi, op. cit.*, p. 186.
103 *Ibid.*, pp. 195-196.
104 Quotation from Bertrand Meyer-Stabley, *Christian Dior, Sous toutes les coutures*, Bernay, City Éditions, 2017, p. 55.
105 Christian Dior, *Christian Dior et moi, op. cit.*, p. 196.
106 "Maurras was at full strength, impervious to fatigue, inconveniences, threats, and danger. Right away, you were gripped by his eyes, which shone with intelligence, authority, energy, courage, friendliness, extreme attention, and sometimes cheerfulness," Pierre Gaxotte wrote in *Les Autres et moi* (Paris, Flammarion, 1975, p. 42). A brilliant student at the École normale supérieure, he was part of a generation that was fascinated by the royalist, anti-Dreyfusard writer, who openly admitted his anti-Semitism and xenophobia. For 150 francs per month (the equivalent of 350 euros in 2022), he edited Maurras' manuscript, the column that was to appear in *L'Action française* the next morning. In the middle of the night, he would go to the printer, and, on the marble, decipher the muddled handwriting of Maurras' diatribes and fit them into the daily publication.
107 See article 330 of the Penal Code of 1810 regarding "public offense to modesty." Between 1810 and 1994, the date of the new Penal Code, one hundred thousand homosexuals are said to have been sentenced for this crime (see Alexis Da Silva citing the studies of Régis Schlagdenhauffen, "Il y a quarante ans, la France 'dépénalisait' l'homosexualité," *La Croix*, August 4, 2022).
108 Christian Dior, *Christian Dior et moi, op. cit.*, p. 195.
109 Quotation in Bertrand Meyer-Stabley, *Christian Dior, Sous toutes les coutures, op. cit.*, p. 55.
110 Christian Dior, *Christian Dior et moi, op. cit.*, p. 198.
111 *Ibid.*, p. 192.
112 Journal of Galerie Pierre, p. 141, archives of Galerie Pierre, Institut national d'histoire de l'art (INHA), Paris.
113 Eyre de Lanux, "Letters from Elisabeth," *Town & Country*, September 1, 1924. Having arrived in Paris in 1918, Eyre de Lanux married the secretary of the *Nouvelle Revue française* and studied at Académie Ranson, where Christian Bérard was a pupil. "Contrary to the desultory way in which French artists conduct their work, I plunged in with unwonted zeal, for I wanted to make the most of my opportunity." (*New York Sun*, May 14, 1921.)
114 Gertrude Stein, "Christian Bérard," *Portraits and Prayers*, New York, Random House, 1934, online (https://www.poetryfoundation.org/poems/55268/christian-berard).
115 Julien Green, *Journal intégral, 1919-1940*, February 5, 1931, *op. cit.*, p. 232.
116 Robert de Saint Jean, *Journal d'un journaliste*, May 7, 1932, *op. cit.*, p. 115.
117 Letter from Christian Bérard to his father, undated, Kochno collection, BMO.
118 Jean Hugo, *Le Regard de la mémoire, 1914-1945, op. cit.*, p. 388.
119 Christian Dior, *Christian Dior et moi, op. cit.*, p. 195.
120 Roger Allard, *Le Nouveau Spectateur*, n° 2, 1919.
121 Quotation from Pablo Picasso reprinted in *L'Intransigeant*, October 19, 1926.
122 See Florence Dartois, Jean Cocteau, "Radiguet était un vieux sage et un mauvais élève," INA, July 26, 2019, online (https://www.ina.fr/ina-eclaire-actu/jean-cocteau-radiguet-etait-un-vieux-sage-et-un-mauvais-eleve).
123 Jean Cocteau, "Bébé", in *Labyrinthe*, February 1950.
124 Christian Bérard quoted in Jean-Pierre Pastori, *Christian Bérard, Clochard magnifique*, Paris, Séguier, 2018, p. 63.
125 Jean Cocteau, *Le Mystère laïc, Essai d'étude indirecte*, Paris, Éditions des Quatre Chemins, 1928, quoted by Giorgio de Chirico, *Mémoires*, French translation, la Table Ronde, 1965, p. 143.
126 Christian Dior, *Christian Dior et moi, op. cit.*, p. 198.
127 *Ibid.*
128 André Fraigneau, *En bonne compagnie*, Paris, Le Dilettante, 2009, p. 42.
129 *Ibid.*
130 Jean Hugo, *Le Regard de la mémoire, 1914-1945, op. cit.*, p. 388.
131 *Ibid.*
132 Waldemar-George, *Formes*, n° 1, December 1929.
133 *Ibid.*
134 Jean Clair, *op. cit.*, p. 82.
135 *Ibid.*, p. 85.
136 Lucien Daudet, "Styles et modes d'époque," *La Revue hebdomadaire*, May 21, 1933, p. 415.
137 *Ibid.*, p. 416.
138 Jean Clair, *op. cit.*, p. 82.
139 André Breton, *Point du jour*, Paris, Gallimard, coll. "Idées," 1970, p. 23.
140 Jean Cocteau, *Le Livre blanc*, Paris, Maurice Sachs and Jacques Bonjean, 1928, online (http://semgai.free.fr/doc_et_pdf/cocteau_livre_blanc.pdf).
141 *Ibid.*
142 *Ibid.*
143 Claude Arnaud, *Jean Cocteau*, Paris, Gallimard, coll. "NRF Biographies," 2003, p. 397.
144 Julien Green, *Journal intégral, 1919-1940*, December 24, 1930, *op. cit.*, p. 209.
145 Julien Green, *Journal Intégral, 1919-1940*, May 27, 1931, *op. cit.*, p. 260.
146 Postcard from Christian Dior to Christian Bérard, August 1927, Kochno collection, BMO.
147 Julien Green, *Journal intégral, 1919-1940*, April 2, 1931, *op. cit.*, p. 244.
148 *Ibid.*, December 24, 1930, *op. cit.*, p. 209.
149 Robert de Saint Jean, *Journal d'un journaliste*, May 7, 1932, *op. cit.*, p. 115.
150 Julien Green, *Journal intégral, 1919-1940*, December 24, 1930, *op. cit.*, p. 209.
151 *Ibid.*, December 24, 1930, p. 209.
152 Jean Cocteau, *Le Livre blanc, op. cit.*
153 *Ibid.*
154 Letter from Christian Bérard to Boris Kochno, undated, Kochno collection, BMO.
155 Christian Dior, *Christian Dior et moi, op. cit.*, p. 215.
156 Letter from Jean Cocteau to his mother, September 1936, quoted in Pierre Caizergues, *Apollinaire & Cie, Anthologie critique*, Montpellier,

285

Presses universitaires de la Méditerranée, 2018.

157 Johann Wolfgang von Goethe, "Prologue on the Theater," *Faust Parts I and II*, French translation by Gérard de Nerval, Paris, Garnier Frères, 1877, pp. 29-34, online [https://fr.wikisource.org/wiki/Faust_(Goethe,_trad._Nerval,_1877)/Faust/Prologue_sur_le_théâtre].

158 René Crevel, *Babylone, op. cit.*, chap. 2.

159 *Ibid.*
160 *Ibid.*
161 *Ibid.*
162 *Ibid.*

163 Raymond A. Dior, *Les Vaches (1918-1935), op. cit.*, p. 50. Raymond Dior seemed to take aim at his brother and family earlier in this passage: "Stuck between the old generations holding positions, favors, ethics, and the new ones conceived under the sign of the *franc papier* and homosexuality, we who straddle Edmond Rostand and Jean Cocteau, our place is nowhere, and society rejects us like worthless dregs [...]. We are enraged by our mediocrity [...]."

164 *Ibid.*, p. 67.

165 Marie-France Pochna, *Christian Dior, un destin*, Paris, Flammarion, 2021, p. 68.

166 *La Revue hebdomadaire*, May 28, 1927, n° 22, p. 131.

167 Julien Green, *Épaves, Œuvres complètes*, Gallimard, 1975, tome 2, page 30. This anguish is reflected in his perception of the mirror-water, and Bérard's paintings seem to reflect it: "the slight trembling of his body was perceived in the image of himself reflected back at him. He would never be able to take his eyes off the magical reflection. Flooded with a sinister light, it was no longer the moon he feared, but the gaze that met his own and held him as if by enchantment. [...] That face at the bottom of the water seemed to be rising, gently rising out of the tub. For a moment he recognized her, but immediately terror had brought about an extraordinary change in her, and she was no longer the same. She was about to rise out of the water, float in the air in front of him and scream," in *Leviathan, Œuvres complètes*, tome 1, p. 696.

168 René Crevel, *Babylone, op. cit.*, chapter 4.

169 Julien Green, *Journal intégral, 1919-1940*, December 28, 1930, *op. cit.*, p. 213.

170 Christian Dior, *Christian Dior et moi, op. cit.*, p. 196.

171 Jean Cocteau, "Claudine," *Ceux qui savent*, November 18, 1946, quoted in *Cahiers Jean Cocteau, Nouvelle Série*, vol. 3, *Cocteau et la Mode*, Paris, Passage du Marais, 2004.

172 René Crevel, *Détours*, Paris, La Nouvelle Revue française, 1924.

173 Letter from Christian Bérard to Boris Kochno, undated, Kochno collection, BMO.

174 *Ibid.*

175 Handwritten document by Christian Bérard, undated, Kochno collection, BMO.

176 Christian Dior, *Christian Dior et moi, op. cit.*, p. 45.

177 Letter from André Bérard to Marthe Bérard, undated, Kochno collection, BMO.

178 Paul Fierens, *Formes*, XXV, May 1932.

179 *Ibid.*

180 Boris Kochno, *Christian Bérard, op. cit.*, p. 17.

181 Julien Green, *Journal intégral, 1919-1940*, December 28, 1930, *op. cit.*, p. 213.

182 Jean Clair, *op. cit.*, p. 81.

183 Jean Hugo, *Le Regard de la mémoire, 1914-1945, op. cit.*, p. 387.

184 Giorgio De Chirico, "Sur le silence," *Minotaure*, n° 5, June 1934.

185 "Expositions," *Art et Décoration, Revue mensuelle d'art moderne*, April 1930.

186 Giorgio De Chirico, "Sur le silence," *op. cit.*

187 *Ibid.*

188 Christian Dior, *Christian Dior et moi, op. cit.*, p. 89.

189 Boris Kochno, *Christian Bérard*, Paris, *op. cit.*, p. 11.

190 Pietro Citati, *La Colombe poignardée*, Paris, Gallimard, 1998, p. 48.

191 Guillaume Apollinaire, *Calligrammes, la Colombe poignardée et le jet d'eau, Poèmes de la paix et de la guerre, 1913-1916*, Paris, Mercure de France, 1918, p. 73.

192 Jean Cocteau, *Christian Bérard*, exhibition catalogue, Paris, Musée National d'Art Moderne, 1950.

193 *Ibid.*, p. 54.

194 Boris Kochno, *Christian Bérard*, exhibition catalogue, Paris, Musée National d'Art Moderne, 1950.

195 Boris Kochno, *Christian Bérard, op. cit.*, p. 12.

196 *Ibid.*, p. 18.

197 Letter from Christian Bérard to his father, undated, Kochno collection, BMO.

198 *Ibid.*

199 Jacques Bonjean, *Les Mains pleines*, Paris, Gallimard, 1935, p. 24.

200 *Ibid.*
201 *Ibid.*

202 René Crevel, *Lettres de désir et de souffrance*, Paris, Fayard, 1996, p. 74.

203 Julien Green, *Journal intégral, 1919-1940*, December 29, 1930, *op. cit.*, p. 213.

204 Christian Dior, *Christian Dior et moi, op. cit.*, p. 192.

205 *Ibid.*, p. 173.

206 Christian Dior, *Je suis couturier, op. cit.*, p. 126.

207 *Ibid.*

208 Christian Dior, *Christian Dior et moi, op. cit.*, p. 96.

209 Letter from André Bérard to Marthe Bérard, undated, Kochno collection, BMO.

210 Cecil Beaton, *Cinquante ans d'élégances et d'art de vivre, op. cit.*, p. 188.

211 Christian Dior, *Christian Dior et moi, op. cit.*, p. 197.

212 Boris Kochno, *Christian Bérard, op. cit.*, p. 15.

213 Christian Dior, *Christian Dior et moi, op. cit.*, p. 197.

214 *Ibid.*

215 Julien Green, *Journal intégral, 1919-1940*, February 5, 1931, *op. cit.*, p. 232.

216 *Ibid.*, December 24, 1930, p. 208.

217 Boris Kochno, *Christian Bérard, op. cit.*, p. 18.

218 *Ibid.*

219 Auction catalogue "Julien Green, un siècle d'écriture", Novembre 27, 2011, lot 83, Paris, Pierre Bergé & Associés.

220 Letter from Christian Bérard to his father, undated, Kochno collection, BMO.

221 Letter from Jean Desbordes to Christian Bérard, online [https://gallica.bnf.fr/ark:/12148/btv1b525169936].

222 Letter from Christian Bérard to his father, undated, Kochno collection, BMO.

223 *Ibid.*
224 *Ibid.*

225 Jean Cocteau, "L'opium est soi en soi," untitled poem in the margin of *Opéra*, in *Œuvres poétiques complètes*, Paris, Gallimard, coll. Bibliothèque de la Pléiade, 1999, p. 575.

226 Letter from Christian Bérard to Boris Kochno, undated, Kochno collection, BMO.

227 *Ibid.*

228 Robert de Saint Jean, *Journal d'un journaliste*, May 7, 1932, *op. cit.*, p. 115.

229 Letter from Christian Bérard to his mother, quoted in *Bérard l'enchanteur, op. cit.*

230 Letter from Christian Bérard to his father, undated, Kochno collection, BMO.

231 Julien Green, *Journal intégral, 1919-1940*, December 28, 1930, *op. cit.*, p. 213.

232 Waldemar-George, *L'Amour de l'art*, n° 1, January 1934.

233 Jean Hugo, *Le Regard de la mémoire, 1914-1945, op. cit.*, p. 302.

234 Waldemar-George, *Formes*, n° 1, December 1929.

235 *Ibid.*

236 Marcel Proust, "Esquisse d'après madame," in *Le Banquet*, March 1, 1892, p. 78. "Her perfect body swells its customary white

gauzes, like unfolded wings. One thinks of a bird dreaming on an elegant, slender leg. It is also charming to see her feather fan fluttering close to her and beating with her white wing [...]. She is woman and dream, and energetic and delicate beast, peacock with wings of snow, sparrowhawk with eyes of precious stone, she gives with the idea of the fabulous the thrill of beauty." [T.N.]
237 Roger Lannes, "Exégèse poétique de Jean-Michel Frank," *Art et Décoration*, 1939.
238 *Ibid.*
239 Julien Green, *Journal intégral, 1919-1940*, December 11, 1931, *op. cit.*, p. 336.
240 Interview of Aimée Lebrun by Vincent Leret, March 2005, quoted in *Dior. Les Cahiers du patrimoine*, n° 15, 2018.
241 Record of Bernard Dior, public archives of the Centre Hospitalier de l'Estran, Pontorson, quoted in *Dior. Les Cahiers du patrimoine*, n° 15, 2018.
242 *Ibid.*
243 René Gimpel quoted by Bertrand Meyer-Stabley, in *Christian Dior sous toutes les coutures, op. cit.*, p. 61.
244 *Ibid.*
245 Salvador Dalí, "Les nouvelles couleurs du 'Sex-Appeal spectral,'" *Minotaure*, June 1934.
246 Robert de Saint Jean, *Journal d'un journaliste*, March 2, 1933, *op. cit.*, p. 146.
247 Alice Halicka, *Hier (souvenirs)*, Paris, Éditions du Pavois, 1946, p. 11.
248 *Ibid.*
249 Georges Hugnet, *Pleins et Déliés, Souvenirs et témoignages, 1926-1972*, La Chapelle-sur-Loire, Paris, Guy Authier Éditeur, 1972.
250 Julien Green, *Journal intégral, 1919-1940*, December 24, 1930, *op. cit.*, p. 209.
251 *Ibid.*
252 René Huyghe, "Auscultation de notre temps, Chapelain-Midy; Christian Bérard," *L'Amour de l'art*, n° 1, January 1931.

253 "Le Grand Prix de la peinture," *L'Amour de l'art*, n° 1, January 1932.
254 *Ibid.*
255 *Ibid.*
256 Letter from Jean Ozenne to Henri Sauguet, October 4, 1929, in Frédéric Bourdelier, and Alexandra Masse, *Jean Ozenne (1898-1969)*, unpublished correspondence of Jean Ozenne to Henri Sauguet, *Dior. Les Cahiers du patrimoine*, n° 17, 2020.
257 *Ibid.*
258 *Ibid.*
259 *Ibid.*
260 Boris Kochno, *Christian Bérard, op. cit.*, p. 19.
261 Christian Dior, *Christian Dior et moi, op. cit.*, p. 199.
262 Bill from Galerie Bonjean to Pierre Loeb, Galerie Pierre, July 29, 1930, Galerie Pierre, "bills for purchases 1930-1940" file, archives of Galerie Pierre, INHA, Paris.
263 Christian Dior, *Christian Dior et moi, op. cit.*, p. 197.
264 Jean Hugo, *Le Regard de la mémoire, 1914-1945, op. cit.*, p. 381.
265 Christian Dior, *Christian Dior et moi, op. cit.*, p. 201.
266 Robert de Saint Jean, *Journal d'un journaliste*, March 2, 1933, *op. cit.*, p. 146.
267 Letter from Christian Bérard to his father, undated, Kochno collection, BMO.
268 Christian Dior, *Christian Dior et moi, op. cit.*, p. 199.
269 Suzanne Luling, *Mes années Dior, L'Esprit d'une époque*, Paris, Le Cherche Midi, 2016, p. 139.
270 Jean Cocteau, *Le Grand Écart*, 1923, Paris, Stock, 1984, p. 34.
271 Boris Kochno, "Mes années avec Christian Bérard," in Boris Kochno, *Christian Bérard, op. cit.*, p. 11.
272 Medical report, "Bernard Dior record," exam of September 17, 1932, public archives of the Centre Hospitalier de l'Estran, Pontorson, quoted in *Dior. Les Cahiers du patrimoine*, n° 15, 2018.
273 *Ibid.*

274 Boris Kochno in *Christian Bérard*, exhibition catalogue, Paris, Musée National d'Art Moderne, *op. cit.*
275 *Ibid.*, pp. 21-22.
276 Letter from Christian Bérard to Julien Green, in *Julien Green, Un siècle d'écriture*, auction catalogue, November 27, 2011, lot n° 130, Paris, Pierre Bergé & Associés.
277 Excerpt from the journal of Jacques Bonjean, quoted in Marie-France Pochna, *Christian Dior, un destin*, Paris, Flammarion, 2021, p. 79.
278 Julien Green, *Journal intégral, 1919-1940*, Saturday, May 10, 1931, *op. cit.*, p. 255.
279 Abbé Maurice Morel, "La route du bon larron," homily at the Quimper cathedral, July 22, 1980, in *Les Cahiers Max Jacob*, n° 3, 1980, pp. 108-110.
280 Jean Cocteau on the Bœuf sur le Toit, quoted in David Gullentops and Malou Haine (eds.), *Jean Cocteau, Écrits sur la musique*, Paris, Vrin, 2016, p. 388.
281 Maurice Sachs, *Au temps du Bœuf sur le Toit*, [1939], Paris, Grasset, coll. "Les Cahiers Rouges," 2005, pp. 128-129.
282 Jean Cocteau, *Les Enfants terribles*, Paris, Grasset, 1990 [Grasset, 1929], coll. "Les Cahiers Rouges", p. 17.
283 Jean Hugo, *Le Regard de la mémoire, 1914-1945, op. cit.*, p. 268.
284 *Ibid.*, p. 278.
285 Julien Green, *Journal intégral, 1919-1940*, December 12, 1931, *op. cit.*, p. 339.
286 *Ibid.*, September 22, 1931, *op. cit.*, p. 292.
287 *Ibid.*
288 Medical report, "Bernard Dior record," exam of September 17, 1932, *op. cit.*
289 Julien Green, *Journal intégral, 1919-1940*, April 15, 1932, *op. cit.*, p. 406.
290 *Ibid.*, Thursday, January 28, 1932, p. 371.
291 *Ibid.*
292 *Ibid.*

293 Letter from Christian Bérard to Boris Kochno, private collection.
294 Letter from Christian Bérard to Boris Kochno, undated, Kochno collection, BMO.
295 Press kit for the "Bijoux de Diamants," exhibition, Chanel, hôtel de Rohan-Montbazon, 1932.
296 *Ibid.*
297 Robert de Saint Jean, *Journal d'un journaliste*, July 1932, *op. cit.*, p. 135.
298 Julien Green, *Journal intégral, 1919-1940*, June 10, 1932, *op. cit.*, p. 440.
299 Medical report, "Bernard Dior record," exam of September 17, 1932, *op. cit.*
300 Julien Green, *Journal intégral, 1919-1940*, Friday, May 6, 1932, *op. cit.*, p. 420.
301 "Le point de vue," *Vogue*, September 1933.
302 *Ibid.*
303 Waldemar-George, *Formes*, n° 1, December 1929.
304 *Ibid.*
305 Boris Kochno, *Christian Bérard, op. cit.*, p. 11.
306 *Ibid.*
307 "Le point de vue," *Vogue, op. cit.*
308 *Vogue*, May 1934.
309 *Vogue*, July 1933. Six months earlier, the same magazine had reviewed Mozartiana's "graceful and joyful ballet." Commenting on Bérard's sets and costumes, we wrote: "The work was that of a painter, sensitive and charming."
310 *Ibid.*
311 André Levinson, *Les Visages de la danse*, Paris, Grasset, 1933, p. 91.
312 Julien Green, *Journal intégral, 1919-1940*, February 5, 1931, *op. cit.*, p. 232.
313 Parker Tyler, *The Divine Comedy of Pavel Tchelitchew, A Biography*, New York, Fleet Publishing, 1967.
314 Alfred de Musset, *Le Roman par lettres, Fragment inédit*, 1896.
315 Brassaï quoted in David Higgs, *Queer Sites: Gay Urban Histories Since 1600*, London, Routledge, 1999, p. 27.
316 Christian Dior, *Christian Dior et moi, op. cit.*, p. 202.

317 *Ibid.*
318 Jean Cocteau on Christian Bérard, quoted in *Cahiers Jean Cocteau*, nº 10, Paris, Gallimard, 1985.
319 Quotation by Marie France Pochna in *Christian Dior, un destin*, *op. cit.*, p. 79.
320 Julien Green, *Journal intégral, 1919-1940*, January 8, 1931, *op. cit.*, pp. 219-220.
321 Marie-France Pochna, *Christian Dior, un destin*, *op. cit.*, p. 89.
322 Jacques-Émile Blanche and Raymond Cogniat, *Portraits contemporains*, exhibition catalogue, Galerie de Paris, Paris, 1934, unpaginated.
323 *Ibid.*
324 Christian Dior, *Christian Dior et moi*, *op. cit.*, p. 202.
325 *L'Amour de l'art*, 1935.
326 Letter from Christian Bérard to Jean Hugo, quoted in Jean Hugo, *Le Regard de la mémoire, 1914-1945*, *op. cit.*, p. 395.
327 Pierre Gaxotte, "Marchand d'eau trouble," *Candide*, October 18, 1934.
328 *Je suis partout*, July 11, 1936.
329 Pierre Gaxotte, *Candide*, April 7, 1938.
330 Raymond A. Dior, "Les Juifs," *Le Crapouillot*, September 1936. Continuing his battle against "the two hundred families," Raymond Dior published this seventy-page issue, which nevertheless cannot be reduced to simply an anti-Semitic screed; it is true that, as the journalist affirmed, this document explored "the Jewish question," thus justifying analyses of "the history of the people of Israel," to everything they had undergone, from expulsions to pogroms, to their "principles," their "mores and customs," and their "fortunes and misfortunes." Although the document denounces all at once "anti-Semites, racists, Drumont, Hitler, Gobineau, Maurras," it remains difficult to read. The tone, somewhere between an investigative report and an opinion column, veers out of control with an irony that is intolerable in light of the six million Jews gassed in the death camps of the Shoah: "The proletariat and the middle classes of our era are opposed, with more discernment, to the economic powers, trusts, and private monopolies; some Jews are in the cauldron, and it will burn them."
331 Raymond A. Dior, *Les Vaches (1918-1935)*, *op. cit.*, p. 59.
332 Invitation for "International Surrealist Exhibition," Paris, Galerie Pierre Colle, June 7-18, 1933.
333 *Ibid.*
334 Edmonde Charles-Roux, " Il fut aussi indispensable que peut l'être un grand poète," in Boris Kochno, *Christian Bérard*, *op. cit.*, p. 139.
335 *Ibid.*
336 *Vogue*, March 1940.
337 Christian Dior, *Christian Dior et moi*, *op. cit.*, p. 26.
338 Waldemar-George, *Art et Décoration*, May 1936.
339 Charles Maurras, *L'Action française*, April 9, 1935.
340 Henri Béraud, *Gringoire*, August 7, 1936.
341 Christian Dior, *Christian Dior et moi*, *op. cit.*, p. 202.
342 Boris Kochno, *Christian Bérard*, *op. cit.*, p. 19.
343 Letter from Christian Bérard to his father, undated, Kochno collection, BMO.
344 *Ibid.*
345 Jean Cocteau, *Opium, Journal d'une désintoxication*, Paris, Stock, [1930] 1983, pp. 162-163.
346 Pierre Gaxotte, *La Révolution française*, Paris, Arthème Fayard et Cie, 1927. An "explosive book" according to Léon Daudet, who, with Charles Maurras, founded *L'Action française* and was a spokesman of the French far right, aligning himself in the direct anti-Semitic, nationalist, and anti-Dreyfusard lineage of Édouard Drumont, his first employer (Daudet contributed to *La Libre Parole*, an anti-Semitic newspaper founded by Drumont in 1892).
347 Christian Dior, *Christian Dior et moi*, *op. cit.*, p. 200.
348 René Crevel, *Œuvres complètes*, vol. 1, Paris, Éditions du Sandre, 2014, p. 735.
349 René Crevel, *Babylone*, *op. cit.*, chap. 1.
350 André Beucler in *Arts et Métiers graphiques*, nº 58, July 15, 1937, quoted by Boris Kochno in *Christian Bérard*, *op. cit.*, p. 146.
351 Christian Dior, *Christian Dior et moi*, *op. cit.*, p. 189.
352 Jean Hugo, *Le Regard de la mémoire, 1914-1945*, *op. cit.*, p. 403.
353 *Ibid.*
354 Waldemar-George, "Le néo-humanisme," *L'Amour de l'art*, nº 1, January 1934.
355 *Ibid.*
356 *Ibid.*
357 *Art et Décoration*, January 1934.
358 René Huyghe, "Histoire de l'art contemporain," *L'Amour de l'art*, nº 1, January 1934.
359 Words of Picasso reported by Tériade, "En causant avec Picasso," *L'Intransigeant*, June 15, 1932.
360 Letter from Christian Dior to Klaus Gebhard, January 9, 1934, archives, Musée Christian Dior, Granville.
361 Christian Dior, *Christian Dior et moi*, *op. cit.*, p. 202.
362 Letter from Christian Dior to Abbé Morel, early 1934, part of a lot of six letters written from 1934 to 1935, sold at auction November 14, 2005 by Ferri & Associés, and purchased in 2021 by Dior Héritage, Paris. Quoted by Marie-France Pochna, in "Le testament spirituel de Christian Dior", *Dior. Les Cahiers du patrimoine*, nº 15, 2018.
363 *Ibid.*
364 See Marc Reynes, "Le sanatorium de Font-Romeu (1924)", in *Histoire de Font-Romeu*, en ligne (https://blog.font-romeu.fr/climatisme-et-architecture/).
365 Granville, Musée Christian Dior, archives.
366 Letter from Jean Ozenne to Henri Sauguet, quoted in *Dior. Les Cahiers du patrimoine*, nº 19, 2020.
367 Letter from Christian Dior to Abbé Morel, Dior Héritage, Paris.
368 Marthe Lefebvre, quoted in *Dior. Les Cahiers du patrimoine*, nº 15, 2018.
369 Letter from Christian Dior to Abbé Morel, early 1934, Dior Héritage, Paris.
370 Jean Hugo, *Le Regard de la mémoire, 1914-1945*, *op. cit.*, p. 407.
371 First letter from Christian Dior to Abbé Morel, early 1934, Dior Héritage, Paris.
372 *Ibid.*
373 Letter from René Crevel to Georges Hugnet, 1934.
374 Letter from Christian Dior to Abbé Morel, probably 1935, Dior Héritage, Paris.
375 Letter from Christian Dior to Abbé Morel, September 28, 1935, Dior Héritage, Paris.
376 Jean Ozenne quoted in *Dior. Les Cahiers du patrimoine*, nº 17, 2020.
377 *Ibid.*
378 Marie-France Pochna, *Christian Dior, un destin*, *op. cit.*, p. 148.
379 Christian Dior, *Christian Dior et moi*, *op. cit.*, p. 204.
380 James de Coquet, *Une vie pas comme les autres*, Paris, Presses de la Cité, 1983.
381 *Vogue*, January 1936.
382 Robert de Saint Jean, *Journal d'un journaliste*, June 1933, *op. cit.*, p. 165.
383 Yves Bonnefoy, *Alberto Giacometti, Biographie d'une œuvre*, Paris, Flammarion, 1991, quoted in http://theses.univ-lyon2.fr/documents/getpart.php?id=lyon2.2009.augais_t&part=158193.
384 *Art et Décoration*, 1939.
385 Honoré de Balzac, *Le Lys dans la vallée*, Paris, Gallimard, coll. "Folio classique," 2004 [Paris, Werdet, 1836], pp. 48-49.

386 Christian Bérard, evening gown design for Lucien Lelong, *Vogue*, 1938.
387 Honoré de Balzac, *Le Lys dans la vallée*, op. cit., p. 77.
388 Bettina Ballard, *In my Fashion*, Paris, Séguier, 2016, p. 189. Fashion editor Bettina Ballard (1905-1961), then Bettina Wilson, commissioned sketches from Bérard: "Every commission was a game of hide-and-seek. I always claimed I needed his plates one week before the real date. Bérard always swore he'd give them to me at the stated time, then disappeared. His requests for money were the only palpable evidence of my commission. He always desperately needed money, and that was why he worked with *Vogue*."
389 Pierre Barillet, *Quatre années sans relâche*, Paris, Éditions de Fallois, 2001, pp. 204-205.
390 It was Cocteau who introduced Bérard to Jouvet: "I didn't impose Bérard on him. I took him with me. Jouvet listened to him talk, recounting sets and costumes. The seduction exceeded my expectations. After a week, Jouvet never left Bérard's side, calling him by his nickname, consulting him on everything, big or small. And so it went on, until the two men parted and were reunited by the secret machinations of death." "Louis Jouvet raconté par 30 témoins," in *Cinémonde*, October 6, 1951, n° 896.
391 *Vogue*, September 1937.
392 Edna Woolman Chase and Ilka Chase, *Always in Vogue*, London, Victor Gollancz, 1954, quoted by Jean-Pierre Pastori, *Christian Bérard, Clochard magnifique*, op. cit., p. 114.
393 Jean Hugo, *Le Regard de la mémoire, 1914-1945*, op. cit., p. 407.
394 Christian Dior, *Christian Dior et moi*, op. cit., p. 204.
395 *Ibid.*

396 André Fraigneau, op. cit., p. 44.
397 Christian Dior, *Christian Dior et moi*, op. cit., p. 204.
398 *Ibid.*, p. 205.
399 Marie-France Pochna, *Christian Dior, un destin*, op. cit., p. 32.
400 *Vogue*, January, 1933, p. 50.
401 James de Coquet, speech given on March 4, 1967 at the unveiling of the bust of the couturier in Granville.
402 *L'Écho de Paris*, February 16, 1937.
403 *Ibid.*
404 Pierre Corneille, *L'Illusion comique*, Paris, François Targa, 1639.
405 Louis Jouvet, "Comment et pourquoi j'ai monté *L'Illusion* à la Comédie-Française," *L'Ordre*, February 11, 1937, online (https://libretheatre.fr/lillusion-comique-de-corneille/).
406 Jean Desbordes, *Comœdia*, December 22, 1936.
407 *Ibid.*
408 Georges Le Cardonnel, *Journal*, February 17, 1937.
409 File on "*L'Illusion comique* de Pierre Corneille," Paris, Bibliothèque nationale de France, Arts du spectacle department, collection of archives relating to the production by Louis Jouvet at the Comédie-Française, February 15, 1937, online (https://gallica.bnf.fr/ark:/12148/btv1b10501832j/f64.item).
410 *Le Petit Bleu de Paris*, February 17, 1937.
411 *Courrier royal*, February 29, 1937.
412 Louis Jouvet, *Le Figaro*, January 19, 1937.
413 Jean Desbordes, *Comœdia*, op. cit.
414 Maurice Martin du Gard, *Les Nouvelles Littéraires*, February 20, 1937, p. 10.
415 *Ibid.*
416 *Ibid.*
417 *Ibid.*
418 *Ibid.*
419 René Crevel, *Babylone*, op. cit., chap. 71.
420 Christian Dior, *Christian Dior et moi*, op. cit., p. 203.

421 James de Coquet, speech given on June 1976, at Granville.
422 Elsa Schiaparelli, *Shocking Life: The Autobiography of Elsa Schiaparelli*, London, Victoria and Albert Museum, 2008, p. 71.
423 https://www.bnf.fr/sites/default/files/2019-02/dp_bakst.pdf
424 Léon Bakst, *Bakst*, Paris, Flammarion, 1977, p. 6.
425 Letter from Christian Bérard to his mother, Kochno collection, BMO.
426 Lucien Rebatet, *Les Décombres*, Paris, Denoël, 1942, p. 32.
427 Pierre Gaxotte, *Je suis partout*, September 16, 1938.
428 Lucien Rebatet, *Les Décombres*, op. cit.
429 Jérémie Gauthier and Régis Schlagdenhauffen, "Les sexualités 'contre-nature' face à la justice pénale. Une analyse des condamnations pour 'homosexualité' en France (1945-1982)," *Déviance et Société*, 2019/3, vol. 43, pp. 421-459.
430 In a letter dated November 21, 1992 to Marie-France Pochna, Christian Dior's biographer, Jacques Homberg wrote about Dior: "I met him in 1941 [...]. It would be very difficult, and, I might add, very painful, for me to relive, so to speak, the period of 1941-1958." He wrote that he regretted "being unable to provide a statement about the personality of Monsieur Christian Dior" (Dior Héritage, Paris). This discretion clashes with the advertising of their relationship by the mansion at 6 Avenue Georges-Mandel, which is available to be rented for events.
431 *Le Petit Bleu de Paris*, December 21, 1938.
432 Louis Aragon, "La Ville Lumière," in *Regards*, December 29, 1938.
433 "L'entrée triomphale de Cyrano de Bergerac à la Comédie-Française," *L'Œuvre*, December 20, 1938.
434 Letter from Germain Debré, head architect of l'Odéon, to Christian Bérard, May 16, 1938, Kochno collection, BMO.
435 *Candide*, February 25, 1937.
436 Elsa Schiaparelli, *Shocking Life: The Autobiography of Elsa Schiaparelli*, op. cit., p. 91.
437 Letter from Elsa Schiaparelli to Christian Bérard, March 1939, Kochno collection, BMO.
438 Christian Dior, *Christian Dior et moi*, op. cit., p. 34.
439 Lucien François, *Comment un nom devient une griffe*, Paris, Gallimard, 1961, p. 42.
440 Christian Dior, *Christian Dior et moi*, op. cit., p. 34.
441 *Ibid.*, p. 205.
442 *Ibid.*, p. 8.
443 *Ibid.*, p. 210.
444 *Ibid.*
445 *Ibid.*
446 *Ibid.*, p. 205.
447 *Ibid.*, p. 202.
448 *Ibid.*, p. 203.
449 *Ibid.*, p. 206.
450 *Ibid.*
451 *Ibid.*
452 Alice Chavane, *France Soir*, October 25, 1957, quoted by Frédéric Bourdelier, in "Alice Chavane de Dalmassy", *Dior. Les Cahiers du patrimoine*, n° 18, 2021.
453 *Ibid.*
454 Alice Chavane's lecture in Rennes, March 4, 1967, Musée Christian Dior archives, Granville, quoted by Frédéric Bourdelier, op. cit.
455 *Ibid.*
456 Christian Dior, *Je suis couturier*, op. cit., p. 33.
457 Jean-Pierre Pastori, *Robert Piguet, Un prince de la mode*, Lausanne, La Bibliothèque des Arts, 2015, p. 221.
458 *Ibid.*
459 *Vogue*, June 1934.
460 Christian Dior, *Christian Dior et moi*, op. cit., p. 207.
461 *Ibid.*, p. 206.
462 *Ibid.*
463 Document found in Christian Bérard's correspondence, Kochno collection, BMO.
464 *Ibid.*
465 *Vogue*, June 1939.

466 Telegram from Agnès Capri to Christian Bérard, June 1940, Kochno collection, BMO.
467 Letter from André Bérard to Christian Bérard, September 21, 1940, Kochno collection, BMO.
468 Letter from André Bérard to Christian Bérard, September 21, 1940, Kochno collection, BMO.
469 This comic document, signed Georges Auric, Jean Hugo, and Boris Kochno, includes Cola's pawprints. Jacques Grange collection, reproduced in Célia Bernasconi (ed.), *Christian Bérard, Excentrique Bébé*, *op. cit.*, p. 118.
470 Pierre Barillet, *Quatre années sans relâche*, *op. cit.*, p. 205.
471 *Ibid.*, p. 205.
472 Medical file, BMO.
473 In the words of Jean Louis Forain, quoted by Yves Chèvrefils-Desbiolles, "Le critique d'art Waldemar-George. Les paradoxes d'un non-conformiste," *Archives juives*, 2008/2, vol. 41, pp. 101-117.
474 Letter from George Desvallières, president of the Salon d'automne, to Waldemar-George, November 12, 1940, quoted in Yves Chèvrefils-Desbiolles, *op. cit.*
475 According to the documents that have come to hand, the circumstances surrounding the sales of the Paul Rosenberg collection were clarified and the disputes settled at a meeting in New York in 1948 between Paul Rosenberg and the Parisian gallery.
476 Lucien Rebatet, *Les Décombres*, Paris, Denoël, 1942, p. 91.
477 Pierre Barillet, *Quatre années sans relâche*, *op. cit.*, p. 205.
478 Ernst Jünger, *Journaux de guerre*, November 23, 1941, Paris, Julliard, 1990, p. 244.
479 Letter from Max Jacob to Edmond Jabès, May 1, 1939, quoted in *Biobibliographie de Max Jacob*, published on the site of the association Les Amis de Max Jacob (http://www.max-jacob.com/biobibliographie.html).
480 *Je suis partout*, March 17, 1944.
481 http://www.maxjacob.com/arrestation.html.
482 Lucien Rebatet, *Les Décombres*, *op. cit.*
483 Lucien Rebatet, alias François Vinneuil, "Marais et marécage," *Je suis partout*, May 12, 1941.
484 Alain Laubreaux, "La Saison 1940-1941 IV. L'ancien Cartel," in *Je suis partout*, August 25, 1941.
485 Despite the success of this exhibition, Bérard did not make any profit, due to "the French customs office suing Bérard for infraction of exchange controls." See Célia Bernasconi (ed.), *Christian Bérard, Excentrique Bébé*, *op. cit.*
486 Letter from Jean Ozenne to Christian Bérard, February 27, 1942, Kochno collection, BMO.
487 *Ibid.*
488 Letter from Lily Pastré to Christian Bérard, undated, Kochno collection, BMO.
489 Letter from Roger Lannes to Christian Bérard, quoted in Jean Cocteau, *Journal, 1942-1945*, April 1943, Paris, Gallimard, 1989, p. 301.
490 Pierre Barillet, *Quatre années sans relâche*, *op. cit.*, back cover.
491 Jean Cocteau, *Journal, 1942-1945*, July 17, 1943, Paris, Gallimard, 1989, p. 320.
492 Letter from Colette to Marguerite Moreno, quoted in Jean Cocteau, *Journal, 1942-1945*, January 1944, *op. cit.*, p. 433.
493 Jean Cocteau quoted in David Gullentops (ed.), *Jean Cocteau, Écrits sur l'art*, Paris, Gallimard, coll. "Art et Artistes," 2022.
494 Louis Jouvet, *Témoignages sur le théâtre*, Paris, Flammarion, coll. "Champs arts," 2009 [Paris, Flammarion, 1951], p. 332.
495 Letter from Lily Pastré to Christian Bérard, 1943, Kochno collection, BMO.
496 Olivier Bellamy, *La Folie Pastré, La Comtesse, la Musique et la Guerre*, Paris, Grasset, 2021, p. 102.
497 Colette, "Christian Bérard," *En pays connu*, Paris, Fayard, 1986 [Paris, Ferenczi, 1950], p. 97.
498 Christian Dior, *Christian Dior et moi*, *op. cit.*, p. 27.
499 *Ibid.*
500 Jean Hugo, *Le Regard de la mémoire, 1914-1945*, *op. cit.*, p. 299.
501 *Ibid.*
502 *Ibid.*
503 Christian Dior, *Christian Dior et moi*, *op. cit.*, p. 26.
504 Lyrics of the song *Es liegt in der Luft* (1928) from the show of the same name by Mischa Spoliansky with a book by Marcellus Schiffer, exhibited during the exhibition "Allemagne, Années 1920, Nouvelle Objectivité," Centre Georges-Pompidou, 2022.
505 "I went out with a group to hear *Carmen*, and I'll tell you I was quite sad and all this cheerfulness made me feel awful," letter from Christian Bérard to his father undated, Kochno collection, BMO.
506 Letter from Edmonde Charles-Roux to Christian Bérard, March 20, 1942, Kochno collection, BMO.
507 Lily Pastré quoted in Célia Bernasconi (ed.), *Christian Bérard, Excentrique Bébé*, *op. cit.*
508 Letter from Jean-Louis Vaudoyer to Jean Cocteau, December 8, 1942, quoted in Jean Cocteau, *Journal, 1942-1945*, *op. cit.*, p. 217.
509 Jean Cocteau, *Journal, 1942-1945*, January 1943, *op. cit.*, p. 250.
510 Letter from Jean Cocteau to Christian Bérard, 1943, Kochno collection, BMO.
511 Alain Laubreaux, "Retour d'âge," *Je suis partout*, April 23, 1943.
512 *Les Cahiers du stalag*, n° 11, April 27, 1941, https://argonnaute.parisnanterre.fr/medias/customer_3/periodique/Stalag/4P_RES_1099/PDF/BDIC_4PR_01099_1941_11.pdf.
513 Alain Laubreaux, *Le Petit Parisien*, April 17, 1943.
514 Alain Laubreaux, "Retour d'âge," *Je suis partout*, April 23, 1943.
515 Pierre Barillet, *Quatre années sans relâche*, *op. cit.*, p. 204.
516 *Ibid.*
517 Jean Cocteau, *Journal, 1942-1945*, March 15, 1943, *op. cit.*, p. 285.
518 *Ibid.*, p. 284
519 *Ibid.*, February 7, 1943, p. 266.
520 *Ibid.*, March 16, 1943, p. 286.
521 Jean Cocteau, program of *Renaud et Armide*, Comédie-Française, "Renaud et Armide" file, in Jean Cocteau, *Journal, 1942-1945*, *op. cit.*, p. 674.
522 *Je suis partout*, April 23, 1943, quoted in "Renaud et Armide", in Jean Cocteau, *Journal, 1942-1945*, *op. cit.*, p. 681.
523 Pierre Jeannet, *Je suis partout*, October 15, 1943.
524 Jean Bourgoint, *Le Retour de l'enfant terrible, lettres (1923-1966)*, Paris, Desclée de Brouwer, 1975, p. 84.
525 See the blog *La Page de Marie-Jo Bonnet* at: https://mariejobon.net/2016/10/plaque-en-hommage-aux-resistants-tortures-par-la-gestapo-au-180-rue-de-la-pompe-a-paris-16e/.
526 On the subject of Christian Dior's sister, see the harrowing and detailed book by novelist Justine Picardie, who researched her entire history, in *Miss Dior, muse et résistante*, Paris, Flammarion, 2021.
527 Christian Dior, *Christian Dior et moi*, *op. cit.*, p. 208.
528 Letter from Christian Dior to his father, April 19, 1945, Dior Héritage, Paris.
529 Justine Picardie, *Miss Dior, muse et résistante*, *op. cit.*, p.109. Quote from a conversation between the author and Nicolas Crespelle, Catherine Dior's godson.

530 Ibid., p. 107.
531 Letter from Maurice Dior to his daughter Catherine, May 1945, Dior Héritage, Paris.
532 Letter from Lieutenant-Colonel Frax to Colonel Dulac, July 11, 1945, Dior Héritage, Paris.
533 Letter from Catherine Dior, Dior Héritage, Paris.
534 Christian Dior, *Christian Dior et moi*, op. cit., p. 29.
535 Christian Bérard, "Le décor de théâtre", *Labyrinthe*, op. cit.
536 Ibid.
537 *Hommage à Christian Dior, 1947-1957*, exhibition catalogue, Paris, Musée des Arts de la mode, 1986, p. 15.
538 Christian Bérard, "Le décor de théâtre", *Labyrinthe*, op. cit.
539 James de Coquet, *Le Figaro*, January 21, 1941, quoted in Alice Chavane, *Dior. Les Cahiers du patrimoine*, n° 18.
540 Letter from André Bérard to Christian Bérard, 1939, Kochno collection, BMO.
541 Christian Dior, *Christian Dior et moi*, op. cit., p. 28.
542 Ibid., p. 217.
543 Ibid., p. 13.
544 Ibid., p. 8.
545 Raymond A. Dior, *Les Vaches (1918-1935)*, op. cit., p. 47.
546 Ibid., p. 66.
547 Ibid.
548 Justine Picardie, *Miss Dior, muse et résistante*, op. cit., p. 49.
549 In 1962, Christian Dior's niece would found the French branch of the World Union of National Socialists (WUNS), an international neo-Nazi association.
550 Raymond A. Dior, *Les Vaches (1918-1935)*, op. cit., p. 34.
551 Ibid., p. 51.
552 Ibid., p. 50.
553 Christian Dior, *Christian Dior et moi*, op. cit., p. 8.
554 Christian Dior, Lecture of August 3, 1955, quoted in *Conférences écrites par Christian Dior pour la Sorbonne, 1955-1957*, Paris, Institut français de la mode/Éditions du Regard, 2003, p. 43.
555 Jean Cocteau, *Journal, 1942-1945*, May 5, 1944, op. cit., p. 510.
556 Ibid., March 4, 1945, p. 631.
557 Testament of Christian Bérard, 1945, Kochno collection, BMO.
558 Jean Clair, op. cit., p. 85.
559 Letter from Christian Bérard to his father, presented in the exhibition "Christian Bérard, Excentrique Bébé," Nouveau Musée National de Monaco, 2022.
560 Brassaï, *Conversations avec Picasso*, Friday, June 15, 1945, Paris, Gallimard, 1964, pp. 218-219.
561 See Yves Chèvrefils-Desbiolles, "Le critique d'art Waldemar-George. Les paradoxes d'un non-conformiste," op. cit.
562 Ibid.
563 Waldemar-George, "Les arts à Paris," *Résistance*, December 9, 1944, quoted in Yves Chèvrefils-Desbiolles, "Le critique d'art Waldemar George. Les paradoxes d'un non-conformiste," op. cit.
564 Louis Jouvet, "*L'Illusion comique* by Pierre Corneille", Paris, Bibliothèque nationale de France, département Arts du spectacle, collection of archives relating to Louis Jouvet's staging at the Comédie-Française, February 15, 1937, online (https://gallica.bnf.fr/ark:/12148/btv1b10501832j/f64.item).
565 "Le Théâtre de la Mode," *L'Officiel de la couture et de la mode à Paris*, March-April 1945.
566 Letter from Charles Dullin to Louis Jouvet, March 1949.
567 Christian Dior, *Christian Dior et moi*, op. cit., p. 27.
568 Ibid.
569 Christian Bérard quoted by Jean Cocteau, in Jean Cocteau, *Journal, 1942-1945*, February 16, 1943, op. cit., p. 270.
570 Jean Cocteau, *Journal, 1942-1945*, October 1944, op. cit., p. 567.
571 Ibid.
572 Ibid., p. 568.
573 Christian Dior, *Christian Dior et moi*, op. cit., p. 30.
574 Ibid., p. 35.
575 Christian Dior, program of the spring/summer 1949 haute couture collection, *Trompe-l'Œil* line, quoted in *Hommage à Christian Dior, 1947-1957*, exhibition catalogue, op. cit., Dior Héritage, Paris.
576 Christian Dior, program of the spring/summer 1947 haute couture collection.
577 Ibid.
578 Letter from André Bérard to Marthe Bérard, undated, Kochno collection, BMO.
579 Postcard shown in the exhibition "Excentrique Bébé," Nouveau Musée National de Monaco, 2022.
580 Arthur Gold and Robert Fizdale, *Misia. Ma Misia Sert*, Paris, Gallimard, 1981, p. 357.
581 Pierre Cardin, interview with the author, Paris, 2018.
582 Ibid.
583 Christian Dior, lecture, August 3, 1955 (extracts), quoted in *Conférences écrites par Christian Dior pour la Sorbonne, 1955-1957*, op. cit., p. 51.
584 Christian Dior, *Christian Dior et moi*, op. cit., p. 38.
585 Alice Chavane, quoted in *Dior. Les Cahiers du patrimoine*, op. cit.
586 Christian Dior, *Christian Dior et moi*, op. cit., p. 17.
587 Ibid., p. 71.
588 Ibid., p. 66.
589 Ibid., p. 38.
590 Bettina Ballard, *In My Fashion*, op. cit., p. 334.
591 *L'Officiel de la couture*, March 1947.
592 Attributed to Aristotle.
593 Jean Cocteau, *Journal, 1942-1945*, March 3, 1943, op. cit., p. 276.
594 Acrostic scribbled by Christian Bérard on a paper napkin for George Davis, quoted in Jean-Pierre Pastori, *Christian Bérard, Clochard magnifique*, op. cit., p. 217.
595 Louis Jouvet, in *Christian Bérard*, exhibition catalogue, Musée National d'Art Moderne, op. cit.
596 Christian Dior, program of the spring-summer 1949 haute couture collection, *Trompe-l'Œil* line, Dior Héritage, Paris.
597 Jean Cocteau, *Journal, 1942-1945*, March 3, 1943, op. cit., p. 277.
598 Christian Dior, *Christian Dior et moi*, op. cit., p. 30.
599 Letter from André Bérard to Christian Bérard, undated, Kochno collection, BMO.
600 *Paris-presse, l'Intransigeant*, March 11, 1950.
601 Henri Sauguet, in Boris Kochno, *Christian Bérard*, op. cit., p. 144.
602 Ibid.
603 Christian Dior, *Christian Dior et moi*, op. cit., p. 7.
604 *Paris-presse, l'Intransigeant*, March 11, 1950.
605 Ibid.
606 Christian Dior, *Christian Dior et moi*, op. cit., p. 38.
607 Christian Bérard, "Le décor de théâtre," *Labyrinthe*, op. cit.
608 Christian Dior, *Christian Dior et moi*, op. cit., p. 126.
609 Pierre Barillet, *Quatre années sans relâche*, op. cit., p. 205.
610 Jean Cocteau, *Journal, 1942-1945*, March 1943, op. cit., p. 285.
611 Christian Dior, *Christian Dior et moi*, op. cit., p. 212.
612 Lucien Rebatet and Pierre-Antoine Cousteau, *Dialogue de "vaincus,"* Nantes, Éditions du Pilon, 2007, p. 53. The phrase was from Cousteau, the collaborationist editor-in-chief of *Je suis partout* starting in 1943. Condemned to death during the purge, his sentence was later commuted to forced labor in perpetuity, before President Auriol pardoned him in 1953.
613 Christian Dior, *Christian Dior et moi*, op. cit., p. 43.
614 Cecil Beaton, *Cinquante ans d'élégances et d'art de vivre*, op. cit., p. 214.

615 *Ibid.*
616 Christian Dior, fall-winter 1949 haute couture collection, *Milieu du siècle* line.
617 Christian Dior, *Christian Dior et moi, op. cit.*, p. 213.
618 *Ibid.*
619 Simone Baron, "Voici les secrets de la nouvelle ligne", *Paris-presse, l'Intransigeant*, January 26, 1951.
620 Edmonde Charles-Roux, *Bérard*, exhibition catalogue, Paris, galerie du Passage, 1993.
621 *Ibid.*
622 Marie Wahl, "Christian Dior, architecte et poète", *Les Lettres françaises*, September 15, 1949.
623 Marie Wahl, in *Les Lettres françaises*, August 18, 1949.
624 Colette, "Christian Bérard", *En pays connu, op. cit.*
625 *Ibid.*
626 *Ibid.*, p. 99.
627 Christian Bérard, "Le décor de théâtre", *Labyrinthe, op. cit.*
628 Christian Dior, *Christian Dior et moi, op. cit.*, p. 212.
629 Marie Laure de Noailles, "L'Amitié", *Labyrinthe, op. cit.*
630 Christian Dior, *Christian Dior et moi, op. cit.*, p. 27.
631 *Ibid.*
632 Carmen Baron, *Instants d'une vie*, Nancy, Éditions du Saule, 1995, p. 79.
633 *Ibid.*, p. 41.
634 *Ibid.*
635 "The couture collections photographed by Simone Baron," *Paris-presse, l'Intransigeant*, August 7, 1948, p. 2.
636 Pierre Barillet, *Quatre années sans relâche, op. cit.*, p. 205.
637 *Ibid.*
638 Christian Dior, *Christian Dior et moi, op. cit.*, p. 68.
639 *Ibid.*
640 Claude Arnaud, *Jean Cocteau, les phoques de Villefranche, op. cit.*, p. 396.
641 *Ibid.*
642 Simone Baron, *Paris-presse, l'Intransigeant*, July 28, 1950, pp. 4-6.
643 Christian Dior, *Christian Dior et moi, op. cit.*, p. 151.
644 *Ibid.*, p. 216.
645 *Ibid.*, p. 84.
646 *Ibid.*, p. 17.
647 *Ibid.*, p. 19.
648 Pierre Barillet, *Quatre années sans relâche, op. cit.*, p. 206.
649 *Ibid.*
650 Edmonde Charles-Roux, "Il fut aussi indispensable que peut l'être un grand poète", in Boris Kochno, *Christian Bérard, op. cit.*, p. 140.
651 *Ibid.*
652 Simone Baron, "Carmen Colle chez Dior, Quatre Boutiquiers de Paris livrent leur hotte de Noël," *Paris-presse, l'Intransigeant*, December 6, 1949, p. 4: "Carmen Colle is the queen of baubles. She is small, with silver hair, a gray dress, and extraordinary eyes under large eyebrows. Her husband was collector Pierre Colle and artists are her friends. She wears shoes with pointed heels and toes and has a model's figure. She has the heavy responsibility of launching unexpected accessories."
653 "The cinema is modern writing whose ink is light," quotation from Jean Cocteau in Jean Cocteau, *Une encre de lumière*, rediscovered texts and previously unpublished texts published by François Amy de la Bretèque and Pierre Caizergues, Montpellier, Université Paul-Valéry Montpellier 3, 1989.
654 Liliane Dargent, "Collections de Couture, Christian Dior, les jeunes filles d'aujourd'hui ont des formes," *Paris-presse, l'Intransigeant*, August 8, 1947, p. 1.
655 Christian Dior, *Christian Dior's Little Dictionary of Fashion*, London, Cassel & Company Ltd., 1954, p. 39.
656 Boris Kochno quoted in Julien Green, *Journal intégral*, December 24, 1930, *op. cit.*, p. 208.
657 Christian Dior, *Christian Dior et moi, op. cit.*, pp. 213-214.
658 Edwige Feuillère, *Les Feux de la mémoire*, Paris, Albin Michel, 1977, p. 175, quoted in Jean-Pierre Pastori, *Christian Bérard, Clochard magnifique, op. cit.*, p. 197.
659 Jean Hugo, *Le Regard de la mémoire, op. cit.*, p. 407.
660 Christian Dior, *Christian Dior et moi, op. cit.*, p. 38.
661 *Ibid.*
662 Christian Dior on the program *Person to Person* by Edward Murrow, quoted by Frédéric Bourdelier in "Monsieur Dior et ses superstitions," *Dior. Les Cahiers du patrimoine*, n° 7, 2015.
663 *Ibid.*
664 Christian Dior, *Christian Dior et moi, op. cit.*, p. 218.
665 Jean Cocteau on the set of *Les Fourberies de Scapin*, 1948, online (http://cocteaumediterrannee.blogspot.com/2018/04/berard-le-bras-droit.html)
666 Christian Dior, *Christian Dior et moi, op. cit.*, p. 4.
667 Letter to Maritain, 1926, quoted in Jacques Biagini, *Jean Cocteau... de Villefranche-sur-Mer*, Nice, Serre, 2007.
668 Marie Laure de Noailles, "L'amitié", *Labyrinthe, op. cit.*
669 Christian Bérard, "Le décor de théâtre", *Labyrinthe, op. cit.*
670 *Ibid.*
671 Christian Dior, *Christian Dior et moi, op. cit.*, p. 196.
672 Christian Bérard to Jean Cocteau, final suggestions regarding *Orphée, La Presse*, September 17, 1950.
673 Jean Cocteau, *Cahiers du cinéma*, September 1950.
674 René Crevel, *Babylone, op. cit.*, chap. 4.
675 *Ibid.*, chap. 1.
676 *Ibid.*, chap. 6.
677 René Crevel, "La période des sommeil," *This Quarter*, vol. 5, n° 1, September 1932, p. 1.
678 René Crevel, "Note en marge du jeu de la vérité," *Documents 34*, n° 20, April 1934, p. 21.
679 *Ibid.*, p. 22.
680 Colette, dedication to Hilda Gélis-Didot, known as "Vava", in Gigi, edition commissioned by Paul Chadourne from Colette and Bérard, printed in an edition of 535 copies, lot 143, Ader sale, December 13 2016.
681 Louis Jouvet, in *Christian Bérard*, exhibition catalogue, Musée National d'Art Moderne, *op. cit.*
682 Jean Hugo, *Le Regard de la mémoire, 1914-1945, op. cit.*, p. 387.
683 Colette, in *Christian Bérard*, exhibition catalogue, Musée National d'Art Moderne, *op. cit.*
684 Christian Dior, Program for the spring-summer 1949 haute couture collection. *Trompe-l'Œil* line, Dior Héritage, Paris.
685 *Ibid.*
686 Jean-Louis Barrault, in *Christian Bérard*, exhibition catalogue, Musée National d'Art Moderne, *op. cit.*
687 Marie Laure de Noailles, "L'amitié", *Labyrinthe, op. cit.*
688 Card written by Christian Dior, Christian Dior Parfums, Paris.
689 Jean Blanchon, "Le *Captain Smith* au Rideau de Paris", *Le Figaro*, March 15, 1938.
690 Max Favalelli, "De Louis Jouvet à Jacques Fath, le théâtre, le cinéma, la danse, la peinture et la mode étaient au dernier rendez-vous de Bébé", *Paris-presse, l'Intransigeant*, February 17, 1949.
691 Christian Dior, *Christian Dior et moi, op. cit.*, p. 89.
692 Christian Bérard quoted in *Cocteau Méditerranée*, Société des amis de Jean Cocteau Méditerranée, blog at http://cocteaumediterrannee.blogspot.com/2018/04/berard-le-bras-droit.html.
693 Christian Dior, *Christian Dior et moi, op. cit.*, p. 215.
694 An incident mentioned in "Les potins respectueux", *Carrefour*, October 20, 1948.
695 Elsa Schiaparelli, "Notes sur la mode", *Labyrinthe*, March-April 1950.
696 Roger Lannes, "Les ballets des Champs-Élysées," in the column "Danse, cinéma, cirque," *La Revue des deux mondes*, 1947, quoted in *Dior. Les Cahiers du patrimoine*, n° 19, 2022.

697 Jean Cocteau, autograph manuscript, 1960, in *Livres et manuscrits*, auction catalogue, November 30, 2018, lot n° 2, Paris, Pierre Bergé & Associés.
698 Elsa Triolet, "Le feuilleton théâtral d'Elsa Triolet", *Les Lettres françaises*, February 17, 1949.
699 *Le Figaro*, May 4, 1939.
700 Christian Dior, lecture of August 3, 1955, quoted in *Conférences écrites par Christian Dior pour la Sorbonne, 1955-1957*, Paris, Institut français de la mode/Éditions du Regard, 2003, p. 49.
701 Cécile Clare, "Les neuf sources d'inspiration de Dior", *Ce soir*, August 28, 1949.
702 Program for the Christian Dior fall-winter 1949 haute couture collection, Dior Héritage, Paris.
703 Christian Dior, *Christian Dior et moi*, op. cit., p. 214.
704 *Ibid.*, p. 217.
705 Jean Cocteau quoted in Boris Kochno, *Christian Bérard*, op. cit., p. 148.
706 Alfred Lomont, "La nouvelle noblesse de robes," *Paris-presse, l'Intransigeant*, August 2-3, 1947, p. 2.
707 Elsa Triolet, "Le feuilleton théâtral d'Elsa Triolet", *Les Lettres françaises*, February 17, 1949.
708 *Ibid.*
709 Christian Dior, *Christian Dior et moi*, op. cit., p. 41.
710 *Ibid.*, p. 215.
711 Françoise Giroud, "Guide de la haute couture", *Le Crapouillot*, January 1, 1951, p. 138.
712 Georges Hugnet, "Chroniques, la peinture, Christian Bérard", in *Les Cahiers du Sud*, October 1, 1927, pp. 253-255.
713 Frank Elgar, "Christian Bérard ou le triomphe du goût", *Carrefour*, April 20, 1949.
714 *Ibid.*
715 *Ibid.*
716 *Claudine*, February 25, 1948.
717 "Cécile Sorel aux Invalides", *Carrefour*, July 4, 1951.
718 Frédéric Bourdelier, "Une rencontre avec Tony Sandro," *Dior. Les Cahiers du patrimoine*, n° 9, 2012.
719 Julien Green, *Journal intégral, 1919-1940*, February 5, 1931, op. cit., p. 232.
720 Edmonde Charles-Roux, "Il fut aussi indispensable que peut l'être un grand poète", February 5, 1931, op. cit., p. 233.
721 Edmonde Charles-Roux, in Boris Kochno, *Christian Bérard*, op. cit., p. 140.
722 Elsa Triolet, "Le feuilleton théâtral d'Elsa Triolet", *Les Lettres françaises*, February 17, 1949.
723 Jean Cocteau, *Journal, 1942-1945*, April 17, 1943, op. cit., p. 299.
724 Marie Wahl, "Portrait d'un couturier, Christian Dior", *Les Lettres françaises*, September 15, 1949.
725 *Ibid.*
726 Cecil Beaton, *Cinquante ans d'élégances et d'art de vivre*, op. cit., p. 191.
727 Marie Wahl, op. cit.
728 Simone Baron, "Christian Dior fait triompher la ligne *Trompe-l'Œil* sur le thème 'Paris'", *Paris-presse, l'Intransigeant*, February 10, 1949.
729 Boris Kochno, *Christian Bérard*, op. cit., p. 70.
730 *Ibid.*
731 Honoré de Balzac, *Le Lys dans la vallée*, op. cit., p. 151.
732 Marie Wahl, op. cit.
733 Paul Morand, *L'Allure de Chanel*, Paris, Hermann, 1976, p. 111.
734 *Ibid.*
735 Inscription by Christian Dior to Yves Saint Laurent, copy of *Christian Dior et moi* held at the Musée Yves Saint Laurent, Paris.
736 Cecil Beaton, *Cinquante ans d'élégances et d'art de vivre*, op. cit., p. 214.
737 Bettina Ballard, *In my Fashion*, op. cit., p. 336.

Index of names

Page numbers in *italics* refer to images.

A

Abetz, Otto 195
Achard, Marcel 268
Apollinaire, Guillaume 98, 166
Aragon, Louis 175
Arenberg, Princesse d' 167
Arp, Jean 67, 124
Aujame, Jean 113
Auric, Nora *58*
Avedon, Richard *215*, *224*, *258*

B

Babilée, Jean 268
Bakst, Léon 172
Balanchine, George 121, 124
Balenciaga, Cristóbal 167, 176, 276
Balthus, Balthasar Kłossowski, known as 67, 109, 150
Balzac, Honoré de 165, 166, 180, 229
Barbette, Vander Clyde Broadway, known as 75, 276
Barbey d'Aurevilly, Jules 149
Bardot, Brigitte 237
Barelli, Aimé 276
Barillet, Pierre 197
Barrault, Jean-Louis 267, 268
Beaton, Cecil *210*, *246*, *247*, *251*, 279
Beaumont, de (family) 180
Beaumont, Édith de *128*
Beaumont, Étienne de 78, *128*, 277
Béby, Aristodemo Frediani, known as 24, 76, 175
Beistegui, Charles de 195
Belline, Ira 199
Benita, Jacques (also known as Tony Sandro) 277, 281
Bérard,
 – André 11, *41*, 42, 99, 230
 – Édouard 49
 – family 11, 38, *39*
 – Marthe 11, 24, *29*, 41, 49, 50, 100, 105
Bergé, Pierre 281
Berger, Friedrich 205
Berlioz, Hector 169
Berman, Eugène 68, 106, 150, 157
Berman, Léonide 49, 93, 106, 113, 150, 157, 158, *249*
Bernard, Émile 95
Bernhardt, Sarah 37, 226
Berson, Roger *133*
Bikkiboff, Billy 179
Blanchard, Mademoiselle *182*, *183*
Blanche, Jacques-Émile 118, 150
Blum, Léon 151, 154, 175
Boivin, René *33*
Bonjean, Jacques 44, *59*, 70, 79, 97, 100, 101, 105, 106, 107, 109, 114, 115, 149, 150, 152, 157, 168, 229
Bonnard, Pierre 101
Borniol (family) 39, 47, 49, 98, 268
Borniol, Henri de 24, 37
Borniol, Marthe de 268
Borniol, Maurice de 24, 37
Bouglione, brothers 273
Bourdet (family) 108, 120
Bourdet, Édouard 164
Bourgoint (family) 119
Bourgoint, Jeanne 119
Bousquet, Marie-Louise 177, *188*, 233, 258, 269
Boussac, Marcel 237
Boussy, Thomas le 94
Braque, Georges 67, 105, 271
Brassaï, Gyula Halász known as *138*, *242*
Breton, André 70, 72, 76, 157
Brianchon, Maurice 113
Bricard, Mizza *184*, 231, 238
Brunhoff, Michel de *188*, 233
Bucher, Jeanne 44
Buffet, Bernard 94, 281
Buñuel, Luis 78, 109

C

Calet, Henri 278
Cardin, Pierre 230, 231
Carné, Marcel 273
Caron, Leslie *133*
Carone, Walter *306*
Carré, Marguerite *184*, 231, 257
Casarès, Maria 265
Castillo, Antonio del 268
Céline, Louis-Ferdinand 173
Chabrier, Emmanuel 121
Chadourne, Georgette *88*
Chanel, Gabrielle Chanel, known as Coco 101, 102, 120, 121, 124, 165, 172, 176, 178, 196, 200, 230, 278
Chapelain-Midy, Roger 113
Charbonneries, Hervé des 205, 207
Chardin, Jean Siméon 171
Charles-Roux, Cyprienne 201
Charles-Roux, Edmonde 152, 198, 200, 258
Chavane de Dalmassy, Alice 178
Chevigné, Laure de 110
Chiappe, Jean 109
Cocteau, Jean 16, 47, 51, 52, *61*, *62*, *63*, *64*, 66, 68, 69, 70, 72, 75, 76, 77, 95, 99, 100, 102, 108, 109, 110, 114, 119, 120, 122, *129*, 150, 156, 158, 167, 171, 179, *186*, 193, 195, 196, 197, 201, 205, 227, 231, 235, 258, 260, 262, 265, 268, 270, 274, 279
Colette, Sidonie-Gabrielle Colette, known as 266
Colle (family) 238, *301*, *303*
Colle, Carmen *191*, 255, 258
Colle, Pierre *58*, *59*, 60, *61*, 105, 115, 118, 124, 150, 194, 195, 228, 229, 255, 258
Colleano, Con 276
Coquet, James de 46, 163, 171, 178
Corneille, Pierre 169, 170, 227
Corot, Jean-Baptiste Camille 110, 149, 161, 172
Courbet, Gustave 110
Crevel, René 78, 79, 95, 101, 122, 150, 152, 156, 157, 159, 161, 266

D

D'Annunzio, Gabriele 172
Dahl-Wolfe, Louise *188*, 238, *301*, *303*
Daladier, Édouard 151
Dali, Salvador 106, 109, 112, 124, 150, 152, 159, 168, 271, 277
Daudet, Lucien 71
David-Weill, David 105
De Chirico, Giorgio 67, 70, 97, 98
Degas, Edgar 37, 113, 258, 259
Delacroix, Eugène 110, 119, 164
Delahaye, Madame 254, 278
Delannoy, Jean 273
Denis, Maurice 37
Derain, André 67, 271
Desbordes, Jean 107, 205
Désormière, Roger *58*
Diaghilev, Serge de 99, 112, 114, 258
Dietlin Crespelle, Liliane 205
Dietrich, Marlene 162, 178
Dior
 – Bernard 22, *25*, 111, 116, 119, 121, 178, 274
 – Ginette Marie Catherine, known as Catherine 40, 160, 168, 205, 206, 207, 208, 235, 236
 – family 20, 23, *25*, *27*, 38, 39, 52, 106, 116
 – Françoise 225
 – Jacqueline *25*
 – Louis-Jean 39
 – Lucien 38, 45, 116
 – Madeleine, Marie Madeleine Juliette Martin, known as 11, 20, 21, *25*, *29*, 40, 46, 78, 105, 116, 117, 150, 153, 225
 – Maurice 11, 20, 22, *25*, 38, 40, 42, 52, 105, 117, 161, 175, 178, 207
 – Raymond 22, *25*, 40, 43, 44, 78, 79, 121, 152, 178, 208, 225, 274
Doisneau, Robert *126*
Dora Maar, Henriette Theodora Markovitch, known as *248*

Doucet, Jacques 38, 114, 115
Drieu la Rochelle, Pierre 80
Drumont, Édouard 154
Duchamp, Marcel 124, 152
Dudognon, Georges *219*
Dufy, Raoul 105, 171

E-F

Elgar, Roger Lesbats, known as Frank 275
Éluard, Paul 124, 196
Ernst, Max 67
Errázuriz, Eugenia 199
Eugénie, empress 117
Fassbinder, Werner Rainer 76
Ferrand, Louis 150
Feuillère, Edwige *142*, 202, 260
Fini, Leonor 152, 268
Fragonard, Jean-Honoré 267
Fraigneau, André 13
Frank, Jean-Michel 77, 80, 110, 115, 153, 154, 165, 168, 171, 175, 176, 179, 193, 194, 199
Freud, Lucian 265
Froska, Froska Munster, known as 259

G

Garbo, Greta Lovisa Gustafsson, known as Greta 162
Gauguin, Paul 95
Gaulle, Charles de 237
Gaultier, Jean Paul 76
Gaxotte, Pierre 65, 151, 156, 173, 194, 238, 257, 278
Genet, Jean 76, 197, 235
Gide, André 47, 49, 75
Giotto, Giotto di Bondone, known as 50
Giraudoux, Jean *146*, *147*, 201, 202
Giroud, Françoise 11
Goldin, Moïse Goldenberg, known as Mitty 194
Goya, Francisco de 169, 171, 267, 273
Grandpierre, Henri 199
Grandpierre, Victor *91*, 199, 200, 254, 255
Green, Julien 66, 79, 97, 101, 105, 106, 107, 117, 118, 277
Grès, Germaine Krebs, known as Madame 123, 153, 268
Gruber, Jacques 113
Guillerm, Nelly *133*
Gunzburg, baron Nicolas de 77

H-I

Hahn, Raynaldo 98
Halicka, Alice 112
Haskil, Clara 198
Havet, Mireille 80
Heftler, Émile 40
Heftler-Louiche, Serge 21, *31*, 40, *186*, 254
Hélion, Jean 150
Herrand, Marcel 177, 268
Hitler, Adolf 151, 173, 226
Holy, Adrien 113
Homberg, Jacques 173, *301*
Horst, Horst P. *127*
Hugnet, Georges 69, 275
Hugo, Adèle 265
Hugo, Jean 77, *88*, 95, 115, 150, 157, 166, 200
Hugo, Victor 149
Huyghe, René 113
Ibert, Jacques 198

J-K

Jacob, Max *59*, 65, 66, 69, 70, 101, 106, 114, 115, 118, 195, 228
James, Edward 124
Jeanmaire, Renée Marcelle Jeanmaire, known as Zizi 240
Jekyll, Gertrude 52
Jongejans, Georges *91*
Jouvet, Louis 18, *92*, *148*, 166, 169, 170, 177, 180, 198, 199, 202, 227, 234, 267, 268, 281
Jünger, Ernst 195
Kahnweiller, Daniel-Henry 105

Kammerman, Eugene *3, 184, 185, 188, 216, 222*
Karinska, Barbara 269
Kelly, Grace 234
Kenna, Max 162, 163, 171
Kessel, Dmitri *304*
Khill, Marcel *63*
Kochno, Boris *56, 57*, 67, 77, *91*, 99, 100, 102, 106, 108, 110, 111, 114, 117, 119, 120, 122, 124, 177, 198, 226, 233, 259, 268, 270, *301*
Korniloff, Hélène de *190*
Kra, Simon 157

L

La Fresnaye, Roger de 79, 114, 236
Lady Mendl, Elsie Anderson de Wolfe, known as 176
Lainé, Edmond 51
Lalique, Suzanne 277
Lambert, Irma 202
Lannes, Roger 196
Lanux, Eyre de 67
Larbaud, Valery 112
Laubreaux, Alain 154, 173, 196, 201, 205
Laurencin, Marie 152
Lebrun, Aimée 111
Ledoux, Nicolas 168
Lefebvre, Marthe 40, 160
Leigh, Vivian Mary Hartley, known as Vivien 162
Lelong, Lucien *86, 87*, 165, 178, 179, 180, 208, 227, 229
Letellier, Léon 238
Levinson, André 149
Levy, Julien 159
Lido, Serge *191*
Lipnitzki, Boris *63, 132, 148, 307*
Loeb, Pierre 67, 194
Loomis Dean *184, 244*
Loren, Sofia Villani Scicolone, known as Sophia 234
Lovett, Thad 175
Luling, Suzanne 231, 254

M

Maçon, Pierre le 94
Mainbocher, Main Rousseau Bocher, known as 176, *210*
Mallet-Stevens, Robert 76
Man Ray, Emmanuel Radnitsky, known as *59*, 110, 124, 152
Manet, Édouard 171
Marais, Jean 167, 196
Marcoussis, Louis 274
Marie-Antoinette, queen 271
Marina of Greece, princess 167
Markevitch, Igor *58*
Martin du Gard, Maurice 171
Masson, André 67
Matisse, Henri 67, 105
Mathieu-Saint-Laurent, Yves
Voir Saint Laurent, Yves
Maurras, Charles 66, 151
Maxwell, Elsa 77
Maywald, Willy, *84, 142, 143, 181, 186, 190, 191, 192, 210, 249*, 258
Meller, Raquel 44
Miller, Lee *243*
Miró, Joan 67
Modigliani, Amedeo 67
Mollier, Eugène 80
Molyneux, Edward 162, 167
Montassut, Marcel 111
Moral, Jean *182, 183*
Morand, Paul 281
Morel, Maurice 118, 159, 160, 161, 162, 195
Munkácsi, Martin 161
Muñoz, Anne-Marie *136*
Mussolini, Benito 151, 158

N-O

Nabokov, Nicolas 58
Nadar, Paul 35
Napoléon III 38, 117
Noailles, de (family) 67, 107, 110
Noailles, Charles de *58*, 76, 109, 110
Noailles, Marie Laure de *3, 58*, 76, 80, 107, 108, 109, 110, 118, 124, 151, 253, 268
Noailles, Nathalie de 258
Offenbach, Jacques 169
Olinska, Sonia Irène Blache, known as Comtesse Marie 197
Ostier, André *89*
Ozenne, Jean 114, 159, 160, 162, 163, 196

P

Paley, Barbara Cushing Mortimer Paley, also known as « Babe » *178*
Paley, Nathalie 179
Paquin, Jeanne *144*, 167, 231
Pastré, Lily 197, 198, 201
Pat English *187*
Patou, Jean 167
Pecci-Blunt, Anna Laetitia, Comtesse 110
Penn, Irving *7, 6*
Pétain, Philippe 227
Petit, Roland *130-137*, 268
Philipe, Gérard 197
Picasso, Pablo 52, 67, 68, 69, 105, 112, 120, 124, 159, 196, 228, 229, 271, 275
Piéral, Pierre Aleyrangues, known as *88, 273*
Piero della Francesca 50, 71, 93, 95
Piguet, Robert *84, 89*, 176, 177, 178, 179, 208, 229, 268
Poiret, Paul 171, 172, 262
Polignac, de (family) 107, 153
Polignac, Comte Jean de 107
Polignac, Comtesse Jean de 167
Polignac, Princesse de
Voir Singer, Winnaretta
Porter, Cole 124
Poulenc, Francis 257, 258
Poussin, Nicolas 112
Printemps, Yvonne Wigniolle, known as Yvonne 164
Proust, Marcel 46, 75, 98, 110, 279
Pushkin, Alexander 258

R

Radiguet, Raymond 69, 100, 119
Rastelli, Enrico 276
Rebatet, Lucien 173, 196
Rehbinder, Wladimir *61*
Rembrandt, Rembrandt Harmenszoon van Rijn, known as 71, 96
Renaud, Madeleine 267, 268
Renoir, Auguste 72, 164, 171
Renou, Maurice 124, 150, 195
Ricci, Maria Adélaïde Nielli, known as Nina 167
Rimbaud, Arthur 166
Ristelhueber, Paul « Boulos » 197
Rosenberg, Paul 105
Rosenthal, Manuel 198
Rostand, Edmond 175
Rouault, Georges 67
Roybet, Ferdinand 43

S

Sachs, Maurice 44, *59*, 70, 100
Sade, Donatien Alphonse François de, known as Marquis de 110
Sadowska, Hélène *132*
Saint-Cyr, Claude *83*
Saint Laurent, Yves Mathieu-Saint-Laurent, known as Yves 76, *137, 184*, 281
Saint-Saëns, Camille 42
Sandro, Tony *Voir Benita, Jacques*
Satie, Erik 52, 65
Sauguet, Henri-Pierre Poupard, known as Henri *58*, 65, 67, 70, 99, 112, 114, *137*, 160, 163, 195, 228, 234, 257
Savitry, Émile *209*
Schall, Roger *126, 217*

Scherschel, Frank *134, 135, 250*
Schiaparelli, Elsa 167, 172, 176, 180, 255, 269
Sée, Edmond 175
Sert, Misia 197
Sérusier, Paul 95
Servais, Marcel 72
Shakespeare, William 198
Sheridan, Richard Brinsley 177
Singer, Winnaretta 199
Snow, Carmel 161, 166, 177, *188*, 261
Solidor, Suzanne Marion, known as Suzy 277
Sophocle 120
Soutine, Chaïm 67
Stein, Gertrude 67, 120, 159
Stravinsky, Igor 16, 43, 47, 52, 199
Strecker, Paul *54*, 206

T

Tanguy, Yves 124, 152
Tchelitchew, Pavel 68, 75, 106, 112, 149, 157, 180, 278
Terry, Emilio 107, 168
Tiepolo, Giambattista 71, 270
Toklas, Alice B. 68
Trevelyan, Florence 47
Triolet, Elsa 17
Tual, Denise 229
Tzara, Tristan 152

U-V

Utrillo, Maurice 67, 114
Valois, Liliane *91*
Valois, Rose 167
Van Dongen, Kees 67
Vasseur, Marcel *25, 26*
Vaudoyer, Jean-Louis 201
Vélasquez, Diego *88*, 171, 196, 240
Vermeer, Johannes 71
Vilmorin, Louise de 278
Viollet-le-Duc, Eugène 49
Vionnet, Madeleine 123
Vuillard, Édouard 101

W

Wagner, Richard 52
Waldemar-George, Jerzy Waldemar Jarocinski, known as 71, 110, 152, 153, 157, 158, 165, 194, 227
Wall, Jean *91*, 198
Watteau, Antoine 15, 171
Weisweiller, Francine *186*
Whistler, James Abbott McNeill 71
Winterhalter, Franz Xaver 171
Wood, Christopher 95
Wood, Roger *212*
Woolman Chase, Edna 166

Z

Zehnacker, Raymonde 231, 238, 257

Photographic credits

© Ad luminem studio: pp. 4-5, 26 (bottom), 30 (bottom), 35 (right), 252, 308.
© ADAGP, 2023 and Centre Pompidou, MNAM-CCI, dist. RMN-Grand Palais/Georges Meguerditchian: p. 248.
© André Ostier/Association des Amis d'André Ostier: p. 89 (bottom).
© Apic/Getty Images: p. 35 (left).
© Association Willy Maywald/Adagp, Paris, 2023: pp. 84, 142, 143, 181, 186, 190, 191 (bottom), 192, 210, 249 (top).
© Boris Lipnitzki/Roger-Viollet: pp. 63, 132, 148, 307.
© Cecil Beaton/Condé Nast/Shutterstock: pp. 211, 246, 247, 251.
© Centre Pompidou, MNAM-CCI, dist. RMN-Grand Palais/ Philippe Migeat: p. 64.
© Christian Dior Couture: pp. 8, 32, 85 (bottom), 86, 131, 141, 145, 146 (top), 147 (top), 214, 218, 220-221.
© Christian Dior Couture/Bryan Zammarchi: pp. 28, 34 (right), 60, 139, 144, 245.
© Christophe Josse: p. 55.
© Damien Perronnet pour Art Digital Studio: p. 147.
© Dmitri Kessel/The LIFE Picture Collection / Shutterstock: p. 304.
© Rights reserved: pp. 29 (left), 30 (top), 33 (bottom), 53, 58 (bottom), 59 (bottom), 61, 81, 82, 85 (top), 87, 89, 90, 119, 140, 191, 215, 223, 250.
© Estate Brassaï: p. 138.
© Eugene Kammerman/Gamma-Rapho: pp. 2-3, 184 (top), 185, 188-189, 216, 222.
© Fondation Paul-Strecker: p. 54.
© Fondation Richard-Avedon: p. 224.
© Georges Dudognon/adoc-photos: p. 219.
© Georgette Chadourne: p. 88 (bottom).
© Jean Moral (Brigitte Moral, Saif, 2023): pp. 182, 183.
© Lee Miller Archives, England, 2023. All Rights reserved. leemiller.co.uk: p. 243.
© Loomis Dean/The LIFE Picture Collection/ Shutterstock: pp. 184 (bottom), 244.

© Louise Dahl-Wolfe/ Center for Creative Photography, Arizona Board of Regents: p. 301.
© Man Ray 2015, Trust/Adagp, Paris 2023: p. 58 (top).
© Mark Woods: pp. 92, 241.
© Mirela Popa: p. 125.
© Musée Christian-Dior, Granville: pp. 1, 25, 26 (top), 27, 29 (right), 31, 33 (top), 34 (left), 130.
© NMNM/François Doury: pp. 57, 302, 305.
© NMNM/Lucas Olivet: p. 89 (top).
© Pat English/The LIFE Picture Collection/ Shutterstock: p. 187.
© Émile Savitry/courtesy Sophie Malexis: p. 209.
© Robert Doisneau/GAMMA RAPHO: p. 126 (top).
© Roger Berson/Roger-Viollet: p. 133.
© Roger Schall: pp. 126 (bottom), 217.
© Roger Wood/Getty Images: pp. 212-213.
© Scala, Florence/ Louise Dahl-Wolfe © Center for Creative Photography, Arizona Board of Regents: p. 303.
© The Irving Penn Foundation: pp. 6, 7.
© Walter Carone/ParisMatch/Scoop: p. 306.
Christian Dior Parfums: cover, pp. 88 (top), 136-137, 249 (bottom).
Amandine Labrune and Myrtille Ronteix collection: p. 83.
Digital image, The Museum of Modern Art, New York/ Scala, Florence: p. 62.
Frank Scherschel/The LIFE Picture Collection/ Shutterstock: pp. 134, 135.
Horst P. Horst/Condé Nast/Shutterstock: pp. 127, 129.
KEYSTONE-France: p. 128.
Musée Christian-Dior, Granville © Estate Brassaï: p. 242.
Paris, Bibliothèque nationale de France: pp. 59 (top), 146 (bottom).
Saint Louis Art Museum/Gift of Mr. and Mrs. Joseph Pulitzer Jr.: p. 36.
Ville de Marseille, dist. RMN-Grand Palais/ David Giancatarina: p. 91.

Cover: Christian Bérard, *Hommage à Christian Dior*, November 12, 1947, reproduced in the program for the ballet *Treize danses* by Roland Petit, presented at the Théâtre des Champs-Élysées, in Paris. Paris, Christian Dior Parfums.

Acknowledgements

This project was made possible thanks to the support of Bernard Arnault, Chairman and Chief Executive Officer of LVMH / Moët Hennessy · Louis Vuitton Group, Delphine Arnault, President and Chief Executive Officer of Christian Dior Couture,
Olivier Bialobos, Deputy Managing Director in charge of global communication and image of Christian Dior Couture and Christian Dior Parfums.

Christian Dior Couture would like to express its special thanks to Laurence Benaïm, the author of the book.

The couture house would like to express its deepest gratitude to Madison Cox, Peter Doig, Richard Haines, Jean-Marc Heftler-Louiche, Amandine Labrune and Myrtille Ronteix, Sylvia Lorant-Colle, Patrick Mauriès, and others who wished to remain anonymous, for opening their collections to us for this edition.

Our thanks go to the teams at Christian Dior Couture (Olivier Flaviano, Lucile Desmoulins, Perrine Scherrer, Soizic Pfaff, Solène Auréal-Lamy, Jennifer Walheim, Joana Tosta, Jessie Rupp), at Christian Dior Parfums (Frédéric Bourdelier, Vincent Leret, Aurélien Michel, Éliaz Bourez), at the Musée Christian Dior in Granville (Brigitte Richart, Barbara Jeauffroy-Mairet, Chantal Hébert) and at the Éditions Gallimard (Nathalie Bailleux, Astrid Bargeton, Clara Sfarti, Caroline Levesque), as well as all those who contributed to this book, in particular: Lisa Argento, Marie-Hélène Corre, Daphné Catroux, Jessica Miranda-Veiga, Stéphanie Pélian, Chiara Sabbiuni.

Finally, the author would like to thank Olivier Bialobos, Olivier Flaviano and Lucile Desmoulins (Christian Dior Couture) for their support, their involvement and the passion they put into this editorial project; Frédéric Bourdelier and Vincent Leret (Christian Dior Parfums) for their research (*Dior. Les Cahiers du patrimoine*); Jacques Brunel; Pierre Passebon (galerie du Passage) and Jacques Grange.

The author would like to dedicate her book to B. K.

Éditions Gallimard

Editorial Director of Illustrated Books
Nathalie Bailleux

Editorial coordination
Astrid Bargeton,
assisted by Agathe Billion

Copy-Editing
Jessica A. Volz

Artistic Director
Anne Lagarrigue

Illustrated Books Coordinator
Pascal Guédin

Graphic Design
Clara Sfarti

Production
Amélie Airiau

Partnerships Director
Franck Fertille

Partnership
Caroline Levesque

Press
Béatrice Foti,
assisted by Laetitia Copin

International rights
Mathilde Barrois,
assisted by Coline Briand

Photoengraver: Les Caméléons, Paris

Printed in August 2023 by Printer Trento (Italy) for Maestro.

The papers in this book are made from natural, renewable and recyclable fibers, and are manufactured from wood from sustainably grown forests.

© Éditions Gallimard, Paris, 2023
Legal deposit: October 2023
ISBN: 978-2-07-302064-2
Edition number: 561672

Shared solitude

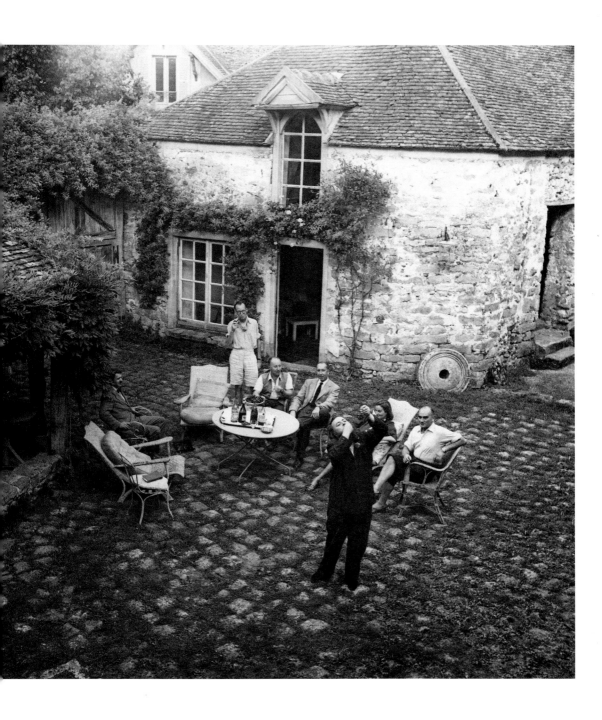

Louise Dahl-Wolfe, Christian Dior and Christian Bérard in Fleury-en-Bière, 1947.

The two artists are here at Pierre and Carmen Colle's home, in the company of Jacques Homberg and Boris Kochno.

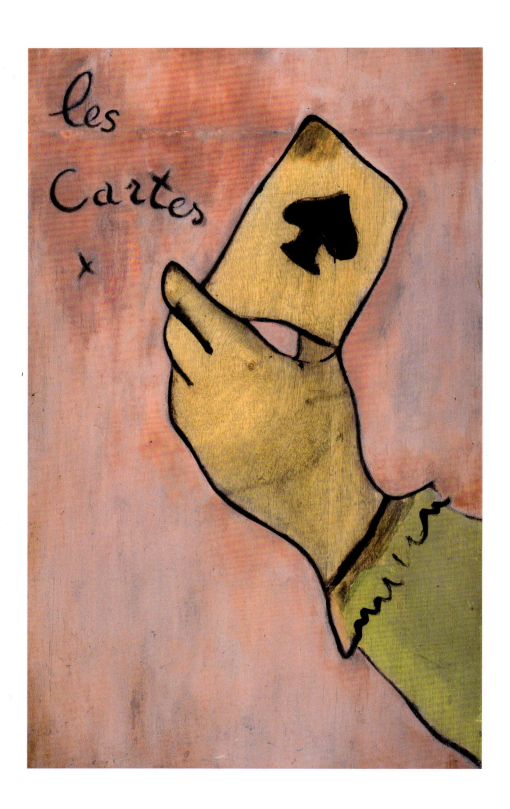

Christian Bérard, *Les Cartes* [The playing cards], 1930s.
Oil on panel. Private collection.

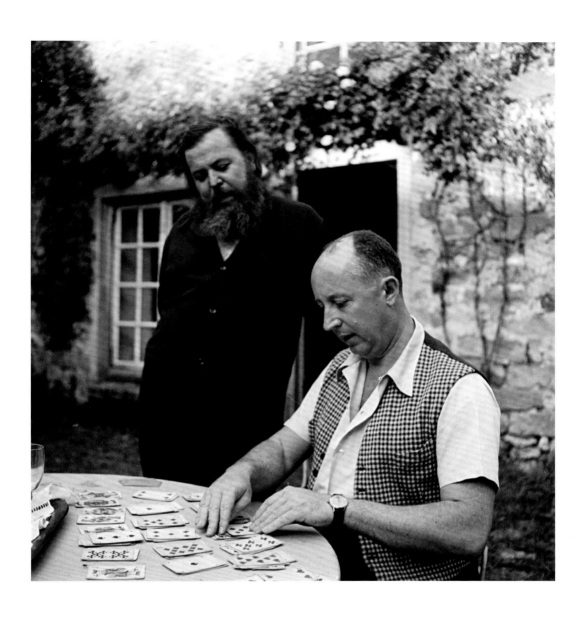

Louise Dahl-Wolfe, Christian Dior playing cards with
Christian Bérard, Fleury-en-Bière, at Pierre and Carmen Colle's
home, 1947.

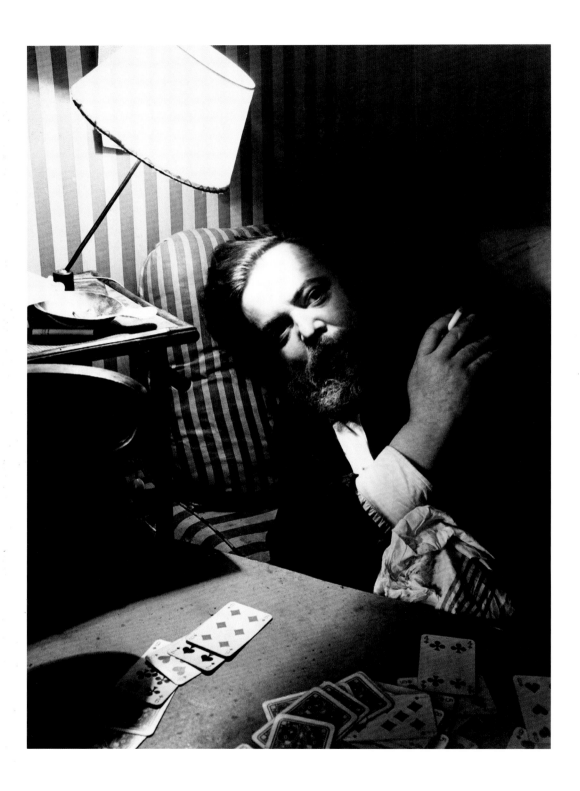

Dmitri Kessel, Christian Bérard playing a game of solitaire in his apartment at 2 Rue Casimir-Delavigne, Paris, undated.

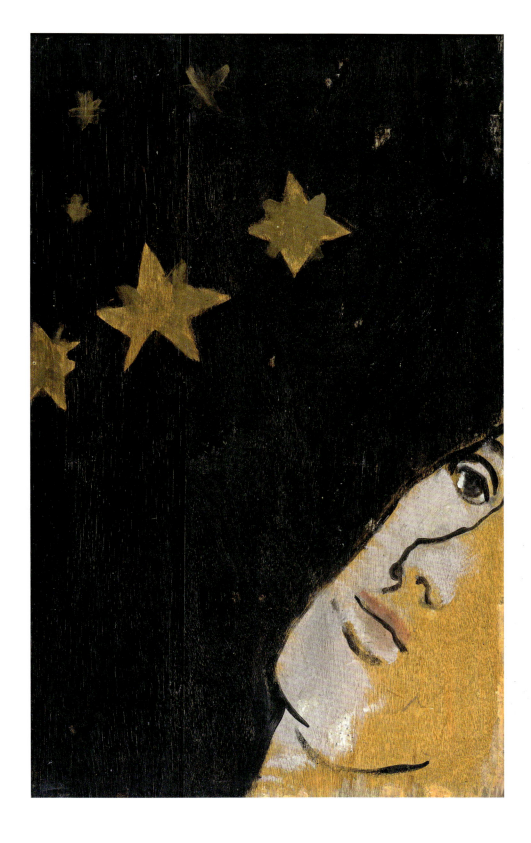

Christian Bérard, *Les Étoiles* [The Stars], 1930s. Oil on panel. Private collection.

Walter Carone, Christian Dior, 1950.

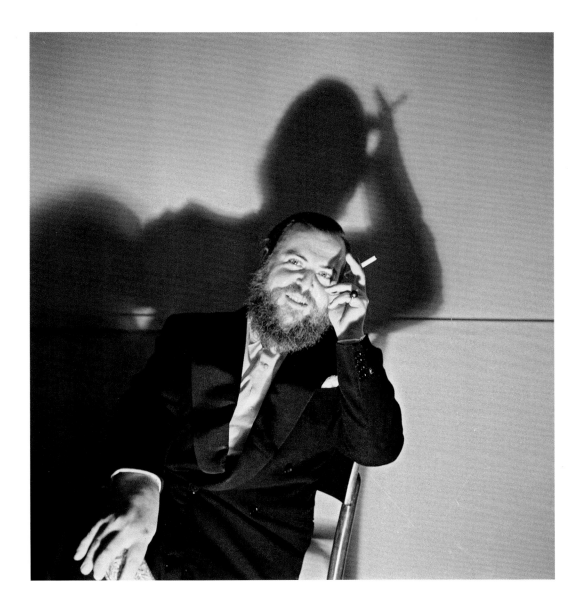
Boris Lipnitzki, Christian Bérard, 1938.

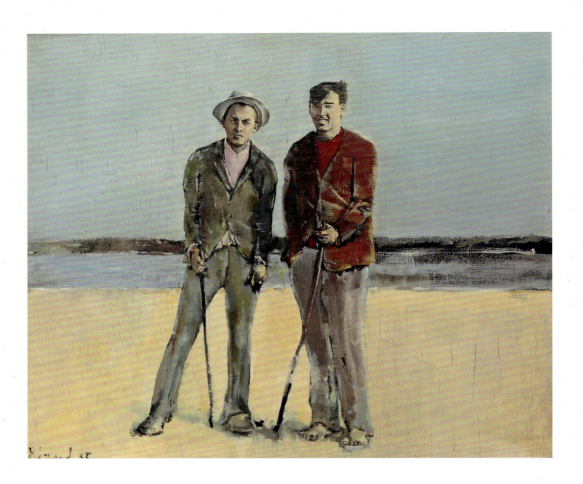

Christian Bérard, *Double autoportrait sur la plage*
[Double self-portrait on the beach], 1935.
Oil on canvas. Private collection.